STUDIES IN BRITISH ART

Francis Wheatley

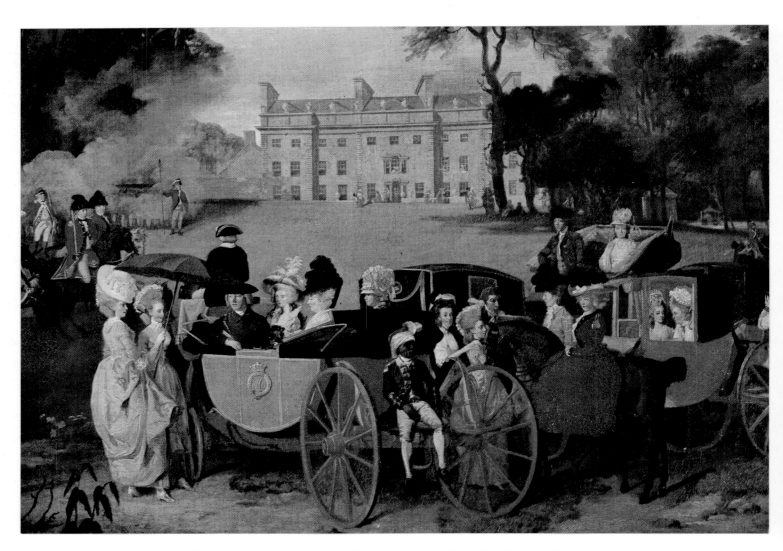

Frontispiece *Spectators at a Review in Belan Park* (detail from Fig 37)

FRANCIS WHEATLEY

Mary Webster

The Paul Mellon Foundation for British Art 1970
London Routledge and Kegan Paul Limited

First published in Great Britain 1970 by
The Paul Mellon Foundation for British Art, 38 Bury Street, London SW1
in association with Routledge & Kegan Paul Ltd
Broadway House, Carter Lane, London EC4

ISBN 0 7100 6860 3

Printed in England by W.S.Cowell Limited, Ipswich
Designed by Paul Sharp in the offices of
The Paul Mellon Foundation for British Art

Contents

Reference to the figures in the Introduction are set in Roman, in square brackets, eg [Fig 3]
References to entries in the Catalogue of Oil Paintings are set in Bold, eg **3**
References to entries in the Catalogue of Engravings are set in Bold and prefixed by the letter E, eg **E3**

List of Illustrations Figures in The Introduction

Acknowledgements

In collecting material and preparing this study I have received much kindness and assistance from many people to whom I wish to express my thanks. For allowing me to see their works by Wheatley and for providing me with information concerning them I am very grateful to the many owners who have generously offered me their time and hospitality. For placing information at my disposal and for drawing my attention to the whereabouts of works by Wheatley I particularly wish to thank Mr Michael Archer, Mrs Mildred Archer, Mr Nicholas Barker, Mr Claude Blair, Mr Martin Butlin, Mr David Carritt, Mr Edward Croft-Murray, Miss Anne Crookshank, Desmond FitzGerald Knight of Glin, Major Philip Godsal, Professor Lawrence Gowing, The Hon Desmond Guinness, Mr Sidney Hutchison, Mr M. Edward Ingram, Dr Michael Kauffmann, Mr John Kerslake, Lord Talbot de Malahide, Mr John Mallet, Mr Jonathan Mayne, Mr Oliver Millar, Mr Richard Ormond, Hartley Ramsden, Mr Graham Reynolds, Mr Kenneth Sharpe, Mr Frank Simpson, Mr Dudley Snelgrove, Dr Roy Strong, Mr James White. To members of the following firms I am indebted for information and photographs: T. Agnew & Sons, Ltd, M. Barnard, P. & D. Colnaghi Ltd, William Drown, The Fine Art Society Ltd, Gooden & Fox Ltd, M. Knoedler & Co Ltd, Leger Galleries Ltd, Leggatt Bros, Maas Gallery, Sabin Galleries, Ltd, Sotheby & Co.

My special thanks are due to the Department of Prints and Drawings of the British Museum, as they are also for the facilities and assistance I have received from the Library and Print Room of the Victoria and Albert Museum, and from the National Portrait Gallery. I gratefully acknowledge assistance afforded by the Tate Gallery, the Soane Museum, the National Gallery of Ireland, the Albertina Vienna, The Royal Academy, the Royal Society of Arts, the Courtauld Institute and Witt Library, the London Library, Messrs. Christie Manson and Woods, and the Frick Art Reference Library.

With Mr Basil Taylor, who first suggested this study should be undertaken, I have had the pleasure and encouragement of stimulating discussion; for his support I am sincerely grateful. For the sympathetic and effective interest of Sir Charles Whishaw, Sir John Witt, Mr James Byam Shaw, Mr David Piper,

Mr Colin Sorensen and Mr Angus Stirling I here record my deep gratitude. I am especially indebted to Mr Stirling for the care and attention he has very generously given to the book. The Paul Mellon Foundation has provided much practical assistance for which I am most grateful. My best thanks are due to Mrs Patricia Barnden who has so ably obtained and ordered the illustrative material, Mr Douglas Smith for his splendid photographs, and Mr Paul Sharp for the elegant design of the book. Mrs Barbara Girelli has typed the whole manuscript with great accuracy. Mr John Dent has most kindly read the proofs and compiled the index.

To my husband Ronald Lightbown for his sustained interest and material aid my thanks are boundless.

M.D.W.
London, April 1970

For
R.W. and M.V.R.
L.

Preface

Esteemed and popular during his lifetime, Francis Wheatley's work slid rapidly into obscurity in less than a decade after his death in 1801. His elegance belonged to the eighteenth century and found no favour with the taste that approved the farmyard realism of Morland. On the return to fashion of the eighteenth century in the 1880s Wheatley was rediscovered, especially by collectors of prints, a numerous and enthusiastic band. After the craze for prints went out, Wheatley's reputation naturally dropped a little, but his work still found as it still finds an eager market. A useful consequence of his Edwardian popularity was the monograph by W. Roberts published in 1910. As with all this author's books the list of engravings is by far its most valuable feature. Roberts made no serious attempt to analyse Wheatley's art; indeed his book is avowedly biased in favour of the print collector, so that it concentrates on the last years of Wheatley's production.

Since 1910, many more pictures by Wheatley have come to light. In assembling the exhibition held at the Aldeburgh Festival and the Leeds City Art Gallery in 1965 under the auspices of the Paul Mellon Foundation for British Art, I found it possible to make a more balanced representation of Wheatley's art. It became apparent that the first half of the artist's working life was very different from the second.

The present book surveys the whole of Wheatley's life and work. It attempts to trace his development as an artist and to interpret his art in the terms of the contemporary tastes with which it was intimately linked. The book is a study, not a record. Wheatley was an extremely prolific artist and, even had it been possible, it would certainly not have been rewarding to make a complete catalogue of his *oeuvre*. Nevertheless, the catalogue comprises every painting of artistic and historical significance in oils and also includes a comprehensive collection of those lesser oils that have been brought to my attention over the last four years and which I consider to be authentic. The water-colours, which are very numerous and often repetitive, are not catalogued, but the illustrations reproduce all known types. I should perhaps warn the collector that fakes and copies after engraved compositions are often to be found masquerading as original Wheatley water-colours. The catalogue of engravings gives details of

every print that I have seen and lists all those that I have found recorded in sale catalogues and other sources. It contains all the engravings after Wheatley known to me. Important compositions that have survived only in engraving are reproduced in this medium.

It is my hope that I may have succeeded in presenting a full but not over-crowded account of a charming artist.

Fig 1 Henry Singleton *Francis Wheatley*
(detail from *Royal Academicians*) 1795
The Royal Academy of Arts

Early Life and Influences

Francis Wheatley [Fig 1] was born in London in 1747, the son of a master tailor of Wild Court, Covent Garden. Covent Garden had now been largely deserted by the fashionable world which had moved further west and the district had acquired a bad reputation from its theatres, gaming houses and night cellars. The population was largely made up of shopkeepers, traders, artists and actors, and, apart from the houses on the piazza itself, Covent Garden was dark, dirty and dangerous. Little is known about Wheatley's early life there. He presumably showed some talent for drawing since his father placed him under a neighbour, Daniel Fournier (c 1700-c 1766), a drawing master, engraver and teacher of perspective.[1] Subsequently Wheatley moved to the drawing school run by William Shipley (1714-1803), the founder of the Society of Arts [Fig 2], where he received the only regular instruction of his life.[2] In 1762, at the age of fifteen, he gained a premium awarded by the Society of Arts for a 'Drawing of a human Figure after a Print or Drawing, by Youths under the Age of sixteen.' The Society's lists of prize winners record that he won the first prize and the published list of prize winners states that he was a pupil of Mr Wilson.[3] Wheatley does not appear in the apprenticeship returns as having been apprenticed either to the portrait painter, Benjamin Wilson (1721-88) or to the landscape painter Richard Wilson (1714-82) who had a number of pupils at this period. All his early biographers emphasize that Wheatley had little formal training and that he associated with young men who were or had been under the most eminent artists of the day, and it can be assumed that Wheatley did not stay with his Mr Wilson for any length of time.

In 1763 when Wheatley gained another prize from the Society of Arts, again for a 'Drawing of a human Figure after a Print or Drawing, by Youths under the Age of sixteen', it was stated that he was abroad.[4] The vagueness of this reference to Wheatley's continental travels is unfortunate because it means that it is not possible to establish what paintings Wheatley saw abroad. The silence of eighteenth century biographers makes it almost certain that he never visited Italy, at least for purposes of study. On the evidence of Wheatley's subsequent work a tour to the Low Countries and France appears more likely. The war

Fig 2 Richard Cosway
William Shipley Oil on canvas
30 × 25 in/ 76.2 × 63.5 cm
The Royal Society of Arts

1 J.Gandon and T.J.Mulvany *The Life of James Gandon, Esq* 1846, p205

2 E.Edwards *Anecdotes of Painters* 1808, p268

3 R.Dossie *Memoirs of Agriculture, and other oeconomical arts* III, 1782, p406; London, Royal Society of Arts *Minutes of Committees* 1761-2, p52

4 R.Dossie *Memoirs of Agriculture, and other oeconomical arts* III, 1782, p406; London, Royal Society of Arts *Minutes of Committees* 1763, p17

3

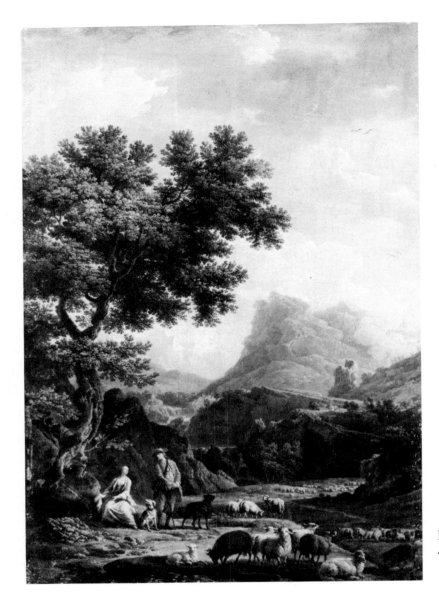

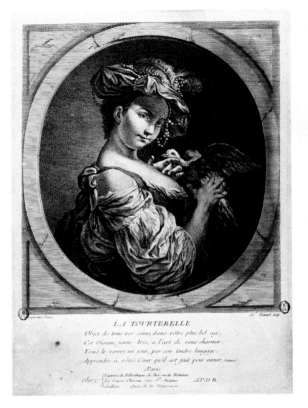

Fig 3 L.J.F.Lagrenée *La Douce Captivité*
Line engraving by Etienne Fessard
11 × 9⅜ in/ 27.9 × 23.8 cm
Bibliothèque Nationale, Paris

Fig 4 J.Vernet *La Bergère des Alpes* Oil on canvas
47 × 31½ in/ 119.5 × 80 cm Musée des Beaux-Arts, Tours

with France had ended in February 1763 and the way would have been open for him to journey to Paris in time for the Salon which opened in August of that year. There he would have seen the very latest portraits and the very latest genre, landscape, history, mythology, religious scenes and still life. In the exhibition were pictures by Boucher, amongst them a pastoral of a sleeping shepherd and shepherdess, and Lagrenée's *La Douce Captivité* [Fig 3] a sensual picture of a young woman holding a captive dove. He would also have seen the Vernet landscapes which aroused great admiration at the exhibition and Vernet's illustration to Marmontel's *La Bergère des Alpes* [Fig 4]. Loutherbourg was exhibiting at the Salon for the first time and his landscapes in the manner of Berchem were much applauded. But it was the pictures by Greuze which were at that time the vogue. At the Salon of 1763 Greuze showed a number of portraits and genre, including

Fig 5 Jean-Baptiste Greuze
La Piété Filiale ('*Le Paralytique Servi
par ses Enfans*') Line engraving by
J.J.Flipart 1767
22 × 26 in/ 55.9 × 66 cm
British Museum

Fig 6 Jean-Baptiste Greuze
L'Accordée de Village Oil on canvas
35½ × 46½ in/ 90 × 118 cm
Musée du Louvre, Paris

the most talked of picture in the exhibition, *La Piété Filiale* [Fig 5]. This showed the family of a paralysed old man gathered round his bed, a touching moral scene, in the same style and in the same vein of sentiment as *L'Accordée de Village* [Fig 6], a picture which had been so popular at the previous Salon of 1761 that it drew enormous crowds and there were many complaints that it was hard to see on account of the constant procession of admirers in front of it.

In 1765 Wheatley was again living in Covent Garden. From Duke's Court, Bow Street he exhibited for the first time at the Society of Artists, sending in a *Portrait of a Gentleman*. In the following year, 1766, he gained the second prize given by the Society of Arts in the section 'Drawings of Landscapes after Nature by Youths under the age of nineteen.' At the time of announcement of the prize he was said to be in Ireland.[1] On 13 November 1769 Wheatley was admitted as one of the first students at the Royal Academy[2] and on 14 December of the same year he applied for and received permission from the Society of Artists to draw at their Academy.[3] By this time Wheatley's work must have reached a fair degree of competence. He had exhibited a miniature and two portraits at the Society of Artists and he had drawn and engraved in 1768 a half-length portrait

1 R.Dossie *Memoirs of Agriculture, and other oeconomical arts* III, 1782, p415; London, Royal Society of Arts, *Minutes of Committees* 1765-6, pp10–12

2 S.C.Hutchison 'The Royal Academy Schools, 1768-1830' *Walpole Society* XXXVIII 1960-2, p135 No68

3 London, Royal Academy of Arts, MSS of the Society of Artists April 1760-June 1770, No11

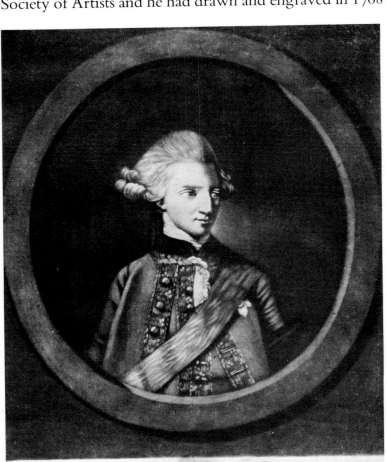

CHRISTIAN VII KING of DENMARK.

Fig 7 Francis Wheatley *Christian VII of Denmark* Mezzotint by Francis Wheatley 13⅞ × 10 in/ 35.2 × 25.4 cm Royal Library of Copenhagen **E1**

of *Christian VII of Denmark* which sold at one shilling [Fig 7]. When therefore in June 1770 he let it be known that he was desirous of becoming a member of the Society of Artists, he probably felt confident that he would be successful. He was elected on 4 September 1770.[1] At this moment the ranks of the Society were being severely depleted as almost all artists of eminence and fashion had become members of the newly founded Royal Academy. A subscribed fellow of the Society of Artists was required to exhibit exclusively at the Society for a term of seven years under pain of expulsion. Wheatley kept his bargain, not defecting to the Royal Academy until 1778 when, along with Mortimer and Stubbs, he forsook the Society to exhibit his pictures in the greater prominence of the Royal Academy.

Decorative Paintings

The Society of Artists stood Wheatley in good stead during the first years of the 1770s. He was an active member of it, being elected to an Academy Committee on 7 December 1773, and on 7 March 1774 becoming a Director in place of Durno who had resigned.[2] Many of his friends were drawn from its members, including the painter, John Hamilton Mortimer (1741–79) whose work greatly influenced his own. Highly esteemed during and shortly after his lifetime, Mortimer was a painter of portraits and history and of scenes of banditti in the manner of Salvator Rosa. Wheatley copied Mortimer's work for exercise and was said by the eighteenth century critic Edward Dayes to have derived great professional advantage from the association,[3] while his obituarist noted that 'by continually copying his (Mortimer's) drawings and paintings, he gradually acquired a style more pure than that which he originally practised.'[4] Only recently has enough of Mortimer's work been assembled for his influence on Wheatley to be assessed. That influence can now be seen to have been considerable, but restricted to Wheatley's portraits. From Mortimer's Salvator-esque imaginings Wheatley took nothing, for they were alien to his own gay and lively art. Nor did he in his drawings imitate Mortimer's wiry structures; the smooth elegance of contour which appears in Wheatley's first pencillings remains to the last untaunted by any nervous tension.

Wheatley enjoyed other advantages from this friendship. Mortimer had been employed to carry out Sandby's designs for the termination of the prospect of the grand south walk at Vauxhall Gardens by executing a scene of the ruins of Palmyra and a transparent painting for exhibition at night.[5] These decorative works were considered highly successful and it may have been through Mortimer's influence that Wheatley was commissioned to paint for Rogers, the proprietor of the Vauxhall Gardens, the large *Cascade Scene*; he was occupied on this project in March 1771 when the landscape painter, Thomas Jones (1743–1803), gave him some assistance.[6] *The Cascade Scene* had been a favourite attraction of Vauxhall from about 1760, and was regarded as an excellent 'eye-trap'; by its nature, as we shall see, it must have required frequent renewal and Wheatley was presumably engaged for repainting rather than for original work.

1 London, Royal Academy of Arts, MSS of the Society of Artists, *Minute Book of the General Meetings*, No4

2 London, Royal Academy of Arts, MSS of the Society of Artists, *Director's Rough Minutes*, 1772, unnumbered

3 'Professional Sketches of Modern Artists' in *The Works of the late Edward Dayes* ed E.W.Brayley 1805, p356

4 *Gentleman's Magazine* 1801, p857

5 *The Ambulator: or, the Stranger's Companion in a Tour Round London* 1st ed 1774, p190

6 A.P.Oppé 'Memoirs of Thomas Jones' *Walpole Society* XXXII 1946–8, p24

The Cascade was shown once each evening: 'A curious piece of machinery has of late years been exhibited on the inside of one of the hedges, situated in a hollow. . . . By drawing up a curtain is shewn a most beautiful landscape in perspective, of a fine open hilly country, with a miller's house, and a water-mill, all illuminated by concealed lights; but the principal object that strikes the eye is a cascade, or water-fall. The exact appearance of water is seen flowing down a declivity; and turning the weel of the mill, it rises up in a foam at the bottom, and then glides away. This moving picture, attended with the noise of the cascade, has a very pleasing and surprising effect on both the eye and ear. About nine o'clock the curtain is drawn up, and at the expiration of ten or fifteen minutes let down again, and the company return to hear the remaining part of the concert.'[1]

Mortimer chose Wheatley, James Durno (1750?-95), and several other assistants to paint the ceiling of the *Saloon at Brocket Hall* in Hertfordshire [Fig 9]. Brocket Hall had been begun to the designs of James Paine for Sir Matthew Lamb (1705-68), barrister and politician, who died leaving a fortune of nearly a million pounds, and was continued after Lamb's death for his son

1 *The Ambulator: or, the Stranger's Companion in a Tour Round London* 1st ed 1774, p181

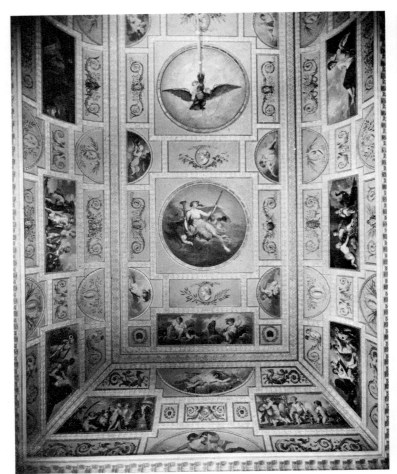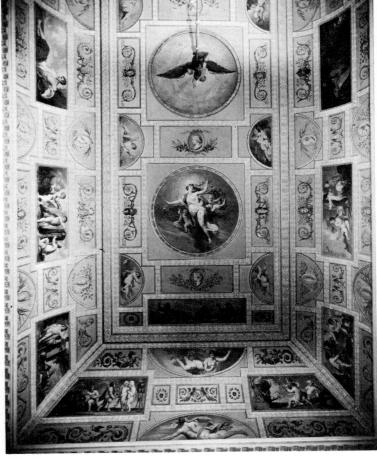

Fig 9 Francis Wheatley, J.H.Mortimer and J.Durno The Ceiling of the Saloon at Brocket Hall
Trustee of First Lord Brocket Will Trust I

8

Peniston Lamb, first Lord Melbourne (1748–1819). It was Peniston Lamb who had commissioned Mortimer, through Paine, to paint the ceiling of the Saloon. Mortimer started work on the commission in 1771 and took about two years to finish it. The ceiling is one of the last examples in the style of William Kent. It is divided into compartments, each framed in gilt stucco. The intermediate frames contain grotesques and arabesques with profile heads and medallions painted mainly in light brown, greens and pinkish mauve. The main compartments, executed largely in light, gay colours, symbolise Love, Time and Fecundity. Ganymede, Morning and Evening (roundels) are framed by the Four Continents and *putti*. Night and Day (centre), *putti* with the symbols of the Zodiac, Flora and Zephyrus, Vertumnus and Pomona decorate the cove [Figs 9A–F]. The influence of Cipriani is conspicuous in all these compositions, not surprisingly since it was from Cipriani that Mortimer had learnt the technique of ceiling painting. Mortimer very likely supplied the designs for the individual compartments but was certainly not responsible for the overall layout of the ceiling. This was the work of the architect, James Paine. A drawing by Paine [Fig 8] for the proposed decoration of the ceiling shows that his first design was of quite a different character, providing only for stucco decoration. A second architect's drawing of the ceiling is at Brocket Hall and is a scheme for the present layout of the ceiling. Inscribed in each compartment is the subject that was to be painted in it, and in Paine's published plans for the house[1] there is an engraving of part of the ceiling of the Saloon, showing the subjects disposed according to the Brocket Hall drawing. Yet there are several discrepancies between the indications of the drawing and the actual ceiling, on which some of the subjects have been moved, both for artistic and iconographical effect. The various hands that worked on the ceiling can in the main be isolated; the panels for which Wheatley was responsible are Ganymede, Flora and Zephyrus, and the small *putti* [Figs 9G–N]. Probably Wheatley also assisted in filling in several of the groups of *putti* with the signs of the Zodiac which Mortimer presumably outlined [Fig 9C,D]. Lord Melbourne, one of the more notorious characters of his day, had inherited his father's wealth, but not his father's abilities. The ceiling cost him between £1,500 and £2,000; the latter sum was what he boastfully claimed to have spent on it when telling the actress, Sophia Baddeley, whose ardent admirer he was, about his country seat.[2]

Wheatley's share in the Brocket ceiling introduced him to the notice of Lord Melbourne, and he was commissioned to paint some of the decorations for the Melbourne town house in Piccadilly. Wheatley's work on these decorations probably extended to several rooms. We know that Cipriani was responsible for the decorations in the 'two great rooms' and 'the Gallery', but no mention is made by the architect, Sir William Chambers, of those rooms that are said to have been decorated by Wheatley and Rebecca.[3] Lady Melbourne appears to have taken responsibility for the decorations of the house, on which she is said to have spent large sums.[4] The subjects represented by Wheatley are not known.

Fig 8 J.Paine Design for ceiling of the Saloon at Brocket Hall
Pen 12 × 19 in/ 30.5 × 48.2 cm
Royal Institute of British Architects
Sir Banister Fletcher Library

1 J.Paine *Plans, elevations, and sections, of Noblemen and Gentlemen's Houses* II 1783, pl LVIII

2 Elizabeth Steele *The Memoirs of Mrs Sophia Baddeley* II 1787, p205

3 Survey of London ed F.H.W.Sheppard, *The Parish of St James Westminster*, pt ii, XXXII, 1963, p370

4 W.M.Torrens *Memoirs of the Right Honourable William second Viscount Melbourne* I 1878, p18; M.L.Boyle *Biographical Catalogue of the Portraits at Panshanger* 1885, p457

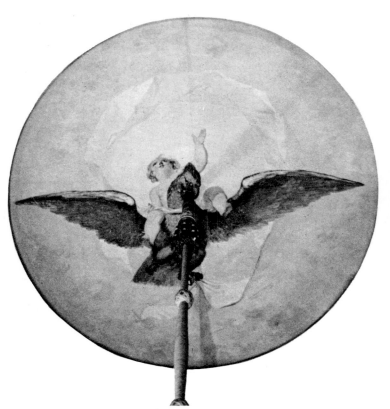

Fig 9A *Ganymede* (detail from Fig 9)

Fig 9B *Morning* (detail from Fig 9)

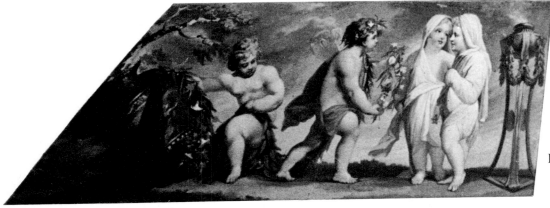

Fig 9C *Gemini* (detail from Fig 9)

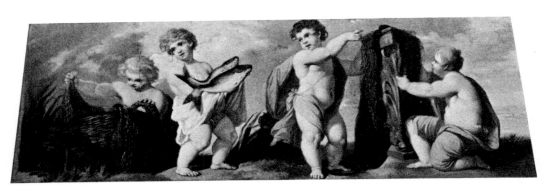

Fig 9D *Pisces* (detail from Fig 9)

Fig 9E *Zephyrus* (detail from Fig 9)

Fig 9F *Flora* (detail from Fig 9)

Fig G–N Eight details of *Putti* from Fig 9

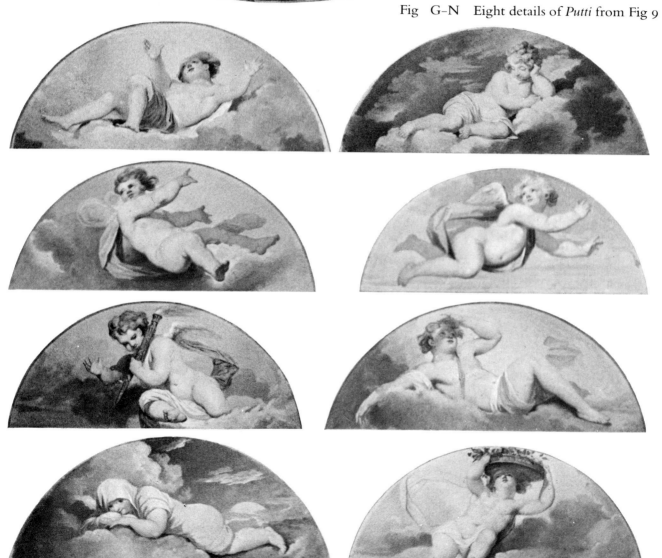

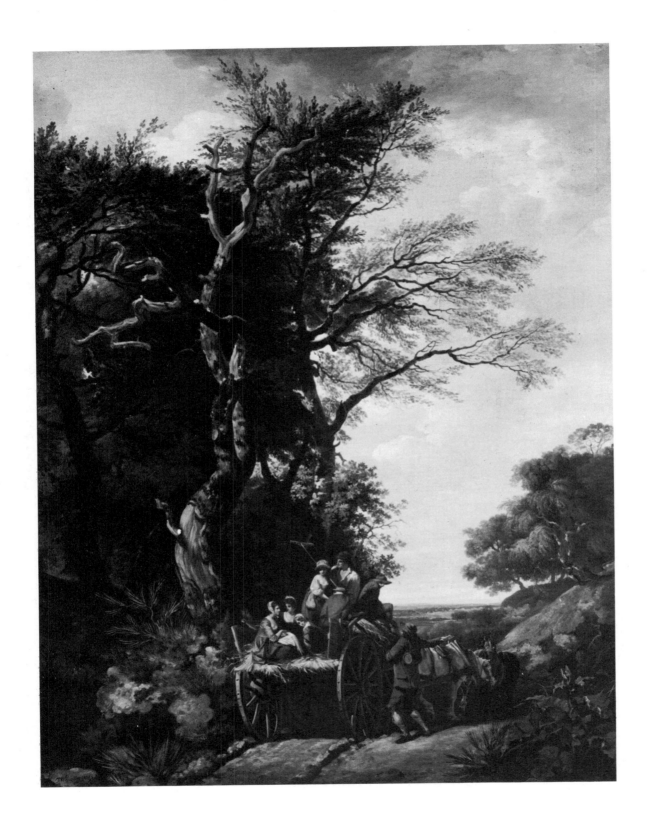

Fig 10 Francis Wheatley *The Harvest Waggon* Oil on canvas $50\frac{1}{2} \times 40$ in/ 128.3 × 101.6 cm
Castle Museum and Art Gallery, Nottingham **3**

Early Landscape

During the middle years of the eighteenth century a taste for romantic landscape awakened under the influence of Poussin and Claude, exercised either directly through their pictures, which were avidly amassed by English collectors, or indirectly through Vernet and Richard Wilson. By the middle 1760s landscapes were much in demand, for early in February 1767 Burke wrote to his protégé Barry, then in Italy: 'Barrett is fallen into the painting of Views; It is the most called for, and the most lucrative part of his Business. He is a wonderful observer of the accidents of Nature, and produces every day something new from that Source – and indeed is on the whole a delightful Painter, and possessed of great resources.'[1] Simultaneously, the lyrical pastoralism of Watteau and Lancret, with its green *bocages*, misty temples, and shady banks, was naturalized by Gainsborough, who had been a pupil of the Frenchman Gravelot. Conventional as were these props of rococo landscape, they are delicately or gaily poetical in their artifice. Gainsborough also revived the light and air, the brown heaths and bushes and dark broken foliage of Dutch landscape painting. Of the development of his landscape style Hoppner wrote in 1809: 'Gainsborough's early studies of landscape . . . are rendered touching by the simplicity of their execution, and choice of scenery. His uplands are the abode of ruddy health and labour: the by-paths, the deep intrenched roads, the team, and the clownish waggoner, all lead us to the pleasing contemplation of rustic scenery, and domesticate us with the objects which he so faithfully delineated. This sensibility to sylvan scenery, however, became weaker, as he grew more intimate with the works of the Flemish and Dutch masters, whose choice of nature he appears to have thought better than that which he had been accustomed to study; and he may be traced through those schools, from the mere imitators of weeds and moss up to the full enjoyment of Rubens. The admirers of cultivated art will find him most varied and beautiful at this period; as his works, strengthened and enriched by the study of Rubens, still possessed a uniformity of character, which, if not so simple as his first representations of nature, is not polluted by the extravagance of a style making pretensions to a higher character. His last manner, although greatly inferior to that immediately preceding it, was certainly the result of much practice

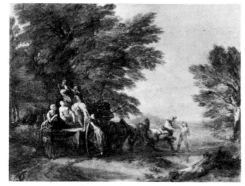

Fig 11 Thomas Gainsborough
The Harvest Waggon Oil on canvas
47½ × 57 in/ 120.7 × 144.8 cm
Barber Institute of Fine Arts
The University of Birmingham

1 *The Correspondence of Edmund Burke* I
1958, p294

and knowledge, with some leaning perhaps to the suggestions of indolence. Its principal defect seemed to be, that it neither presented the spectator with a faithful delineation of nature, nor possessed any just pretensions to be classed with the epic works of art; for the first, it was, both in its forms and effects, too general; for the last, not sufficiently ideal or elevated. The studies he made at this period of his life, in chalks, from the works of the more learned painters in landscape, but particularly from Gasper Poussin, were doubtless the foundations of this style; but he does not seem to have been aware, that many forms might pass, and even captivate, in drawings on a small scale, where an agreeable flow of lines, and breadth of effect, are principally sought, which would become uncouth and unsatisfactory, when dilated on canvass, and forced on the eye with all the vigour that light and shade, and richness of colour, could lend them.'[1]

1 J.Hoppner, reviewing Edward Edwards *Anecdotes of Painters* 1808, in *Quarterly Review* I No1 1809, p48

Gainsborough had first broken away from the earlier English topographical tradition of landscape through enthusiasm for Dutch landscapes, especially for the work of Wynants and Jacob Ruisdael whose elements he distilled and then combined with an imaginative building up of artificial landscape into creative compositions. His views on peopling landscapes are expressed with his customary lively elegance in a letter to William Jackson written from Bath 'do you really think that a regular Composition in the Landskip way should ever be fill'd with History, or any figures but such as fill a place (I won't say stop a Gap) or create a little business for the Eye to be drawn from the Trees in order to return to them with more glee.'[2]

2 *The Letters of Thomas Gainsborough* ed M.Woodall 1963, p99.

Although Wheatley may have been a pupil of Richard Wilson for a short time it was Gainsborough who was the immediate source of his inspiration. *The Harvest Waggon* [Fig 10] of 1774, the earliest of Wheatley's landscapes that has been traced, is an essay deriving from Gainsborough's painting of the same subject [Fig 11]. Having altered the axis of the composition by turning it into an upright, Wheatley found himself in need of a vertical feature to close his picture, and introduced the dead tree to the left of the cart, turning once more to Gainsborough, for this solution is commonly found in that artist's work, although of course originally Dutch. In making these alterations Gainsborough's animated scene in which the figures 'fill a place . . . or create a little business for the Eye to be drawn from the Trees in order to return to them with more glee' has been lost in the clean sweet countryside of an idyllic summer evening. *The Harvest Waggon* foreshadows Wheatley's later interpretations of country landscape and emphasizes the gulf that lay between Gainsborough's imaginative renderings of nature and the gentle placidities of other English landscape artists. Wheatley soon ceased to paint landscape in the Gainsborough manner but he was permanently influenced by it in details such as the drawing of trees and plants. He now turned instead to painting the straightforward views of places which were the taste of the day.

Wheatley painted landscape in both oil and water-colour and exhibited landscapes at the Society of Artists from 1774. In that year he showed a *Study on the Coast of the Isle of Wight*, in which the figures were painted by Mortimer, and in the following year five *Studies from Nature* and a *View near Battersea*. Two of the landscapes he exhibited in 1776 are known and show very clearly the influence

Fig 12 Francis Wheatley
*The Medway at Rochester, a view of
part of Rochester Bridge and Castle*
Oil on canvas
21¾ × 31 in/ 55.2 × 78.7 cm
Mr and Mrs Paul Mellon **13**

Fig 13 Francis Wheatley
View on the Banks of the Medway
Oil on canvas
25 × 30 in/ 63.5 × 76.2 cm
Mr and Mrs Paul Mellon **14**

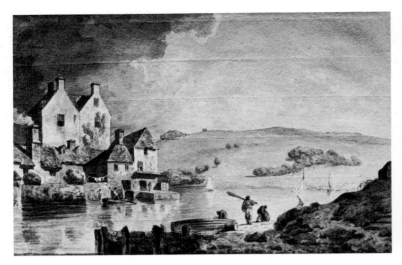

Fig 14 Francis Wheatley *Stonehouse, Plymouth*
Watercolour 7 × 10⅞ in/ 17.75 × 27.75 cm
W.A.Brandt Esq

Fig 15 Francis Wheatley *View near Ilfracombe* Signed and
dated F.Wheatley 1778 Water-colour
18¾ × 25⅝ in/ 47.7 × 65.1 cm
Victoria & Albert Museum, London

of Dutch landscape painting. The view of *The Medway at Rochester* [Fig 12], with its wide open sky emphasizing the horizontal plane which is terminated at the right by a thin line of trees, derives, in its composition and colouring, from Jacob Ruisdael. *A View on the Banks of the Medway* [Fig 13] is again markedly Dutch in colouring with its soft yellowish green and russet brown tones. The large expanse of sky, the treatment of leaves and grass, the foreshortening of the figures are all very reminiscent of landscapes by Karel Dujardin. It was not until the 1780s that Wheatley abandoned this manner.

Wheatley's landscapes in water-colour must always have been more numerous than those in oils – apart from anything else they were much easier to sell. He followed the usual practice of making sketching tours, journeying to the south coast, the Medway, Surrey, and Devonshire [Figs 14,15] as well as drawing views from near at hand in Hyde Park and St James's Park [Fig 16]. Predictably, in fact his landscapes of this period are the tasteful portraits of places popular at the time; they appear to be faithful except that trees have sometimes been added to balance the composition. His method of work in such water-colours was that standard in his day. From his tours he would return with a considerable number of 'studies from nature'; from these and other studies he worked up finished compositions. Executed in pen and ink and lightly tinted in greys, blues, greens and browns, and described as 'high finished drawings' they were sometimes made to be sold in pairs (see Appendix I). Those early examples which have been identified follow the tradition of inserting small figures going about their everyday activities. These figures are for the most part very generalized and veer towards the picturesque; they have nothing of the realism of the country people in Gainsborough's landscapes. Wheatley may have come to feel that the figures in his landscapes required greater individuality for in addition to

Fig 16 Francis Wheatley *Rosamond's Pond, St. James's Park* Signed and dated
F. Wheatley 1778 Pen, ink and water-colour $14\frac{1}{4} \times 21$ in/ 36.2 \times 53.4 cm
John Appleby Esq

the *Study on the Coast of the Isle of Wight* where the figures were painted by
Mortimer, he collaborated in other pictures. Described in an auctioneer's words,
one was 'A large capital landscape, a Romantic view, a water-fall, with figures
fishing, and deer, by Gilpin' (see Appendix II). In the portrait of *Sir Henry
Peyton* [12] the horse is by Gilpin. *A landscape and figures*, was painted jointly
with Loutherbourg.[1] Although collaboration of this kind between two artists
on the same work was a recognized eighteenth century practice, many stories
about such collaborations that appear in nineteenth century sources have to
be treated with considerable caution. So J.L.Roget[2] says that Wheatley put
in figures in Sandby's topographical views and in those of Thomas Malton.
Because of the Irish connections of Thomas Malton the younger, who worked
for three years in the office of James Gandon and who was trained as an architect
rather than as a painter, it is not impossible that he received some assistance of
this kind from Wheatley, but no examples of it have been traced. As regards
Sandby the question is much more speculative and the whole story may have
been sparked off by the nineteenth century attribution of a drawing in the Soane
Museum to the joint hands of Sandby, Mortimer and Wheatley.

1 *A Catalogue of a Capital Collection of
Drawings now exhibiting at the Great Room,
No28 Haymarket,* n.d. defective copy,
London, Royal Academy, bound in vol.
lettered *Catalogues of the Society of Artists,
Free Society etc.* (Pictures) No203 A landscape
and figures by Wheatley and Loutherbourg
£10.10.0

2 J.L.Roget *A History of the 'Old Water-
Colour' Society* I 1891, p45

17

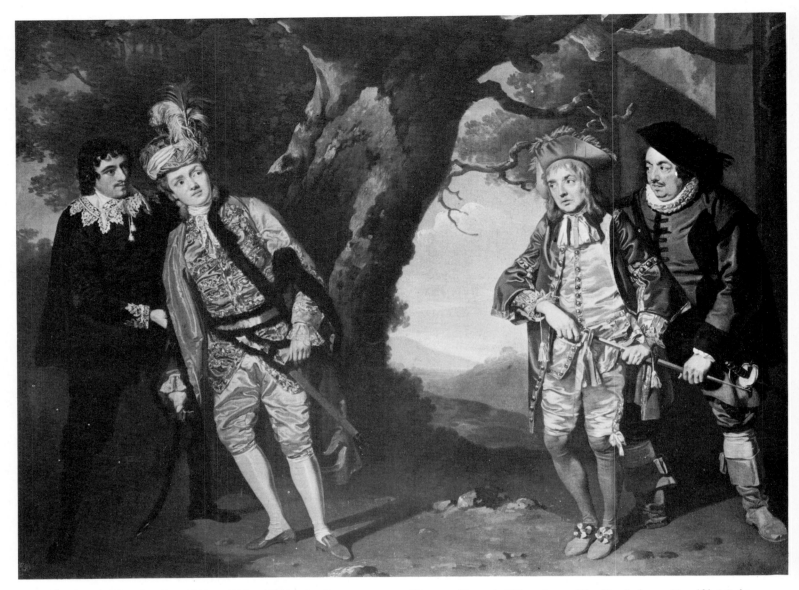

Fig 17 Francis Wheatley *The Duel*, from *Twelfth Night*
Oil on canvas 40 × 50 in/ 101.6 × 127 cm
Manchester City Art Galleries **2**

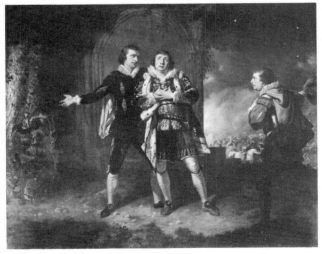

Fig 18 J.H.Mortimer *Scene from King John* Oil on canvas
39 × 49¼ in/ 99.1 × 125.1 cm The Garrick Club

Portraiture and Conversation Pieces

Early in the 1770s Wheatley drew a number of portraits in crayon, a medium then much in vogue. They were well received and Wheatley was given some friendly criticism by Mortimer and Thomas Jones who wrote in 1772 'this artist bids fair to be of the first class expecially in this Walk.'[1] None of these early crayons has been identified, but a work of the same period, a theatrical conversation piece, shows Wheatley's accomplishment and also his limitations in portrait composition at this time. It is *The Duel* from *Twelfth Night* [Fig 17]. This picture is painted with great assurance in shiny rococo colours and is obviously influenced by Mortimer's scene from *King John* (1767–8) [Fig 18]. The symmetrical arrangement of the figures and the care taken with the likenesses interferes with the expressiveness of the composition, as does the rather wooden leaning posture of Viola on the left. The same critics wrote of it 'Pictures of this Nature are always pleasing when a good Choice is made; this Gentleman has been very happy in that particular. The portraits are all very like, the Actions spirited, but upon the whole an Effect is wanted.'[2] From the first then Wheatley's portraits were commended for their good likenesses and he soon branched out from portraits in crayons to small whole lengths in oils. It has already been said that Wheatley was especially influenced by Mortimer in his early work in this genre. From Mortimer he learnt the trick of sharply silhouetting his sitters by using strong colour and outline against a background of trees or landscape and occasionally by posing them in pure profile against a dark background [Fig 19]. From Mortimer, too, he took his devices of landscape setting, sketching in the background with lightly touched foliage and placing large-leaved, dark green plants, again sharply silhouetted by the use of contrasting shadow, in the foreground. Finally Mortimer's delicately lustrous renderings of satin and silk were very successfully imitated by Wheatley in his painting of women's dress.

The small-scale portrait, a genre which owed its popularity to its suitability for the small-scale rooms of England, had been successfully established here by Hogarth, Hayman and Devis in the first half of the century. The sitter was often shown full length in an interior or landscape setting, a tradition inherited from seventeenth century Dutch art, which had invented the type for the equally

1 J.H.Mortimer and T.Jones *Candid observations on the Principal Performances now exhibiting at the New Rooms of the Society of Artists* 1772. The authors of this critique were identified by Benedict Nicolson in the catalogue of the exhibition *John Hamilton Mortimer A.R.A.* Eastbourne and London 1968

2 J.H.Mortimer and T.Jones *Candid observations on the Principal Performances now exhibiting at the New Rooms of the Society of Artists* 1772

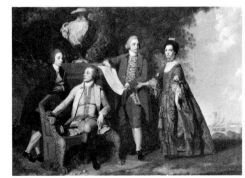

Fig 19 J.H.Mortimer
Witts Family Group Oil on canvas
27 × 35½ in/ 68.6 × 90.2 cm
Francis Witts Esq

small rooms of Holland. Wheatley's first known single portraits are all in an outdoor setting and the sitter is usually portrayed by a tree, a landscape stretching out in the background, or by an architectural motif. This freedom and informality of pose, and the fusion of sitters, frequently with supporting pet and natural action, into the landscape are an offshoot of the conversation piece and are as remote from the Baroque portrait as from the grand manner of Reynolds. Here again the vivacious example of Mortimer may have been infectious. These early paintings are simple and direct without much contrivance. In them, Mortimer's lesson of bold placing and sharp silhouetting has been well learnt, but Wheatley's handling has an overall fluidity of surface and a richer embroidery of detail than is found in Mortimer, who liked to juxtapose flat areas of paint with areas of strongly linear modelling. Nor has Wheatley any interest in the lighted interior setting, unlike Mortimer whose portraits of figures grouped in rooms are easily his most remarkable. The colouring is clear with frequent use of bright, light colours that shimmer and sparkle. The contrast between these gay little pictures and the stately life-size portraits of a Ramsay or a Reynolds lies in their informality, the relaxed poses of their sitters, in a certain unassumingness and liveliness of air. The *Man with a Dog* who stands holding a boat hook, his dog at his side [Fig 20] is a perfectly unaffected portrait of a man at ease in his surroundings. *Lord Spencer Hamilton* [**24**] has the confident poise of a fashionable man about town. *Sylvanus Bevan* [**29**] a young banker, in a clear crisp portrait, stands easily in a landscape intended to suggest his own estate. *Mr Bentley* [**6**] and *Mrs Bentley* [Fig 21] are a little more self-conscious, but without pretension. *The Portrait of a Seated Man* by the ruins of a castle [**18**] is a degree more informal; sitting on a rock, a sketch book at his side, he looks easily out at the spectator, as does the *Sportsman with his Son and Dogs* [Fig 22]. *Sir Charles Holloway* [Fig 23], *G.B.Woodd* [Fig 24] and *Mr Bailey of Stanstead Hall* [Fig 25] are perfectly straightforward examples of what was required in a small-scale, full length portrait. *Thomas Grimston* [Fig 26] is portrayed standing by a pedimented doorway with Ionic pilasters, a landscape stretching away in the background. This documented portrait of 1776 is of especial interest for its disclosure of Wheatley's use of architectural props and conventional landscape background at this time. The Grimstons were country gentlemen who owned Kilnwick Hall in Yorkshire. No doorway in this house – which still exists – resembles the doorway in the picture. No trees stand so near Kilnwick and the landscape in the picture is not a representation of its park, but merely a generalized rural view.[1] The same type of doorway was used by Wheatley on a number of occasions; another of his favourite devices was a setting of large trees and a pond near the walls of a house. Unfortunately the pictures in which these conventional features appear are all too often fondly believed to represent the sitter's very own house and garden or estate [Figs 32,33].

The conversation piece was the accepted genre for family groups during Wheatley's working life. Its antecedents were varied and widespread[2] but by the mid-eighteenth century it had acquired its classic role of showing people informally engaged in following their several or joint activities. Interest was provided by interaction amongst the sitters, one of whom generally looks out to

1 M.Edward Ingram *Leaves from a Family Tree* 1951, pl 1. I am indebted to Mr Ingram for his kind assistance in connection with this portrait

2 R.Edwards *Early Conversation Pictures from the Middle Ages to about* 1730, 1954

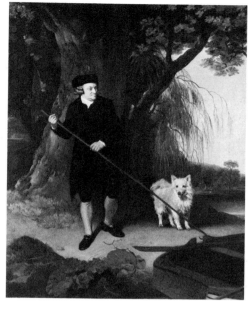

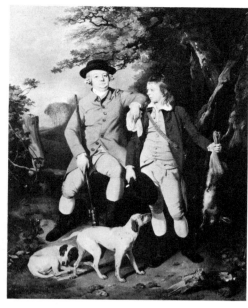
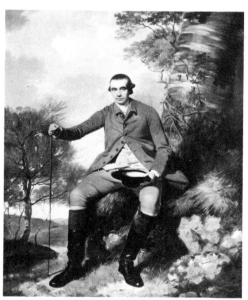
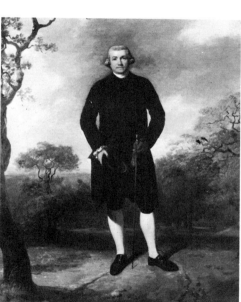
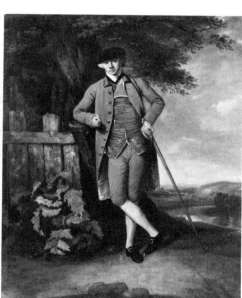

Fig 20 Francis Wheatley
Portrait of a Man with a Dog Oil on
canvas $38\frac{1}{2} \times 29$ in/ 97.8×73.6 cm
Tate Gallery, London **9**

Fig 21 Francis Wheatley *Mrs Bentley*
Oil on canvas
$35\frac{1}{4} \times 27\frac{1}{4}$ in/ 89.5×69.2 cm
Mr and Mrs Paul Mellon **7**

Fig 22 Francis Wheatley
A Sportsman with his Son and Dogs Oil
on canvas 36×28 in/ 91.4×71.1 cm
Collection unknown **28**

Fig 23 Francis Wheatley
Sir Charles Holloway Oil on canvas
$35 \times 27\frac{1}{2}$ in/ 88.9×69.8 cm
The Executors of the late Lord Wharton **8**

Fig 24 Francis Wheatley
George Basil Woodd Oil on canvas
30×25 in/ 76.2×63.5 cm
Mr and Mrs Paul Mellon **26**

Fig 25 Francis Wheatley
Mr.Bailey of Stanstead Hall Oil on canvas
29×24 in/ 73.7×61 cm
Arthur Tooth & Sons Ltd **23**

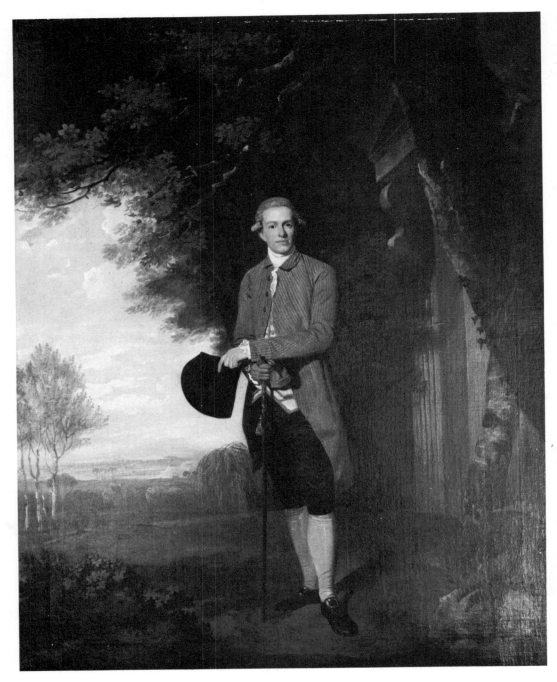

Fig 26　Francis Wheatley
Thomas Grimston　Oil on canvas
$35\frac{1}{2} \times 27\frac{1}{2}$ in/ 90.2 × 69.8 cm
Edward Eden Esq　**11**

engage the interest of the spectator. The development of the genre by such artists as Hogarth and Zoffany is a history of solutions to the formal problems inherent in drawing likenesses of numbers of people on one canvas without overwhelming the spectator either by size or by tedium. Great care with the composition of the groups was necessary to provide a lively relationship amongst the sitters and yet avoid a feeling of strain or contrivance.

Wheatley painted a number of conversation pieces, beginning with the

Fig 27 Francis Wheatley *Family Group in a Landscape* Oil on canvas $28\frac{1}{4} \times 35\frac{1}{4}$ in/ 71.7 × 89.5 cm
Mr and Mrs Paul Mellon **27**

theatrical conversation of *The Duel* from *Twelfth Night* [Fig 17] in which
the sitters were too dependent upon the spectator and not sufficiently involved
with each other. This defect was overcome in Wheatley's later work, most
successfully in the conversation piece of a *Family Group in a Landscape* [Fig 27] in
which only the mother in her best hat is directed towards the spectator, while
the other sitters, most convincingly grouped, are concerned in some way with
each other. The river and landscape are well integrated into this picture and the

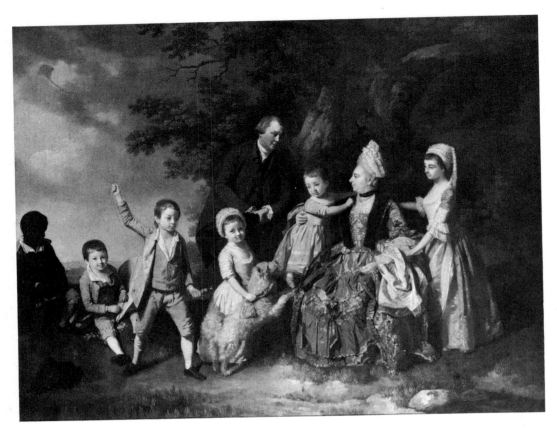

Fig 28 Francis Wheatley
Family Group with a Negro Servant
Oil on canvas
40 × 50 in/ 101.6 × 127 cm
Tate Gallery, London **4**

Fig 29 Johann Zoffany
The Bradshaw Family Oil on canvas
52 × 70 in/ 132.1 × 177.8 cm
Tate Gallery, London

tones are nicely balanced. *The Family Group with a Negro Servant* [Fig 28] is an essay in the manner in which Zoffany had been working for some years. The family is arranged in a line beneath a tree, turning towards the mother who is shown in profile, a somewhat unusual way of portraying a full length figure, but one which Wheatley used again in the Mellon *Family Group* [Fig 30] and in the *Family Group in a Landscape* [Fig 27]. This composition, which can be dated to the early years of the 1770s, is clearly inspired by Zoffany's conversation group of *The Bradshaw Family* [Fig 29], exhibited at the Society of Artists in 1769. The Bradshaw family is portrayed under a tree in a landscape, the boy at the left-hand side flying a kite, and a hat and coat lying on the ground in the left fore-ground. Although a comparison of the two pictures reveals Wheatley's group as more static – the boy pays no attention to his kite and the figures, strung out in a row, are more self-consciously posed – Wheatley shows himself a perfectly competent painter with a well developed style. Wheatley's smaller family scenes, such as the enchanting group of *Mrs Barclay with her Children* [**16**] and the Mellon *Family Group* [Fig 30] are virtually expanded versions of his single por-traits, as indeed is also the case in some of Mortimer's early outdoor groups. The composition of the Mellon picture is a little stiff, but the light, sparkling colours of the costumes show gaily against the dark background of trees and leaves and a

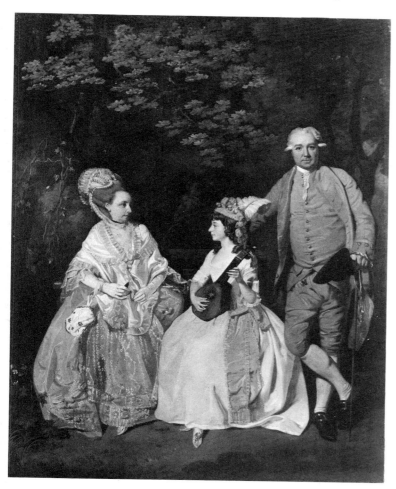

Fig 30 Francis Wheatley *Family Group*
Oil on canvas 35½ × 27½ in/ 90.2 × 69.8 cm
Mr and Mrs Paul Mellon **10**

25

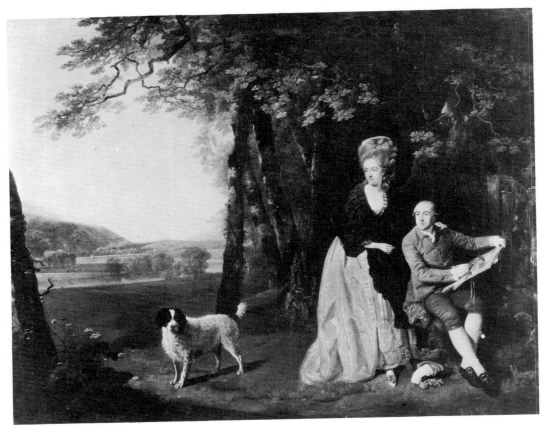

Fig 31 Francis Wheatley *An Artist and a Lady in a Landscape* Oil on canvas
Dimensions unknown Collection unknown **17**

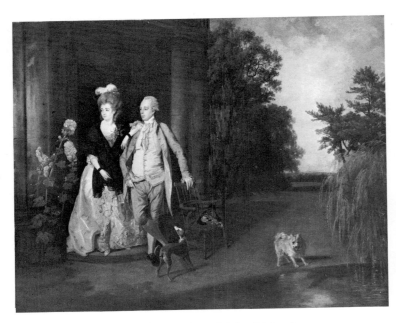

Fig 32 Francis Wheatley *Mr and Mrs Richardson*
Oil on canvas 40 × 50 in/ 101.6 × 127 cm
National Gallery of Ireland, Dublin **19**

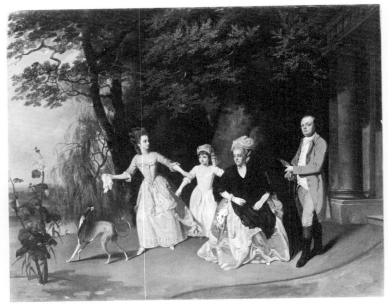

Fig 33 Francis Wheatley *The Wilkinson Family*
Oil on canvas 40¼ × 50⅜ in/ 102.2 × 127.9 cm
Detroit Institute of Arts **20**

sympathetic portrait of the man makes this an attractive composition. Unlike most of Wheatley's group portraits in which the figures are normally placed in a wide landscape background, the portraits of this family largely fill the canvas. The bag on the woman's arm and the mandolin the girl holds are studio properties that occur in other pictures. Although Wheatley undoubtedly mastered the technical trick of marking the foreground by a sharply outlined tall plant or long grasses directly from his study of Mortimer, in whose works of the 1760s it is a striking idiosyncrasy, the large leaves used for the same purpose by seventeenth century Dutch painters, in particular by Wynants, had become very common artistic currency in mid-eighteenth century English painting.

In the portrait of *An Artist and a Lady in a Landscape* [Fig 31] standing beside him, signed and dated 1777, Wheatley introduces the practice of closing both sides of his picture to contain the portraits within a compositional frame. Wheatley has used the dog to bring the spectator into the group, for the seated artist and the lady are intent upon the landscape being painted. The same trick occurs in the portrait of *Mr and Mrs Richardson* [Fig 32] exhibited in 1778. In this picture, and in *The Wilkinson Family* [Fig 33] which clearly dates from the same time, Wheatley has included an architectural feature in the shape of a doorway with Doric columns which is intended to give a suitably stately impression of the imposing residence inhabited by the sitters. But in neither case is a real house represented, for the doorway is merely a variation of the door that is seen in *Thomas Grimston* [Fig 26]. To mid-twentieth century eyes the use of a conventional architectural prop seems strange, but evidently it was as little disturbing to eighteenth century eyes as the exotic bric-à-brac of nineteenth century studio photographers was to the Victorians. Obviously, at a period when the best portraits were painted by London painters whom only the wealthiest could afford to summon to their country seats, such a convention had to be accepted. As already noted, other repetitions can be found in a number of Wheatley's pictures. In several there are the same willow trees and the same dogs. A lady's embroidered bag, a mandolin, the use of a black lace shawl to contrast with the light colour of a lady's dress are all features common to some of the single portraits and conversation groups that Wheatley was painting in the 1770s, and suggest that he worked up these pictures from one or two sittings according to a set formula. An alternative formula was to place the sitters against a group of dark trees or rocks, usually including a defined but imaginary landscape stretching into the distance. Wheatley constantly made use of these latter devices throughout his career as a portrait painter, varying them only when specific additions were required. Wheatley's ability to paint a likeness, his clear sure touch and attractive colouring, and his pretty settings made him a suitable artist for those people who wanted a small-scale portrait in a fashionable manner without necessarily requiring a penetrating interpretation of character. In the eighteenth century such people belonged to the gentry and younger professional classes who formed the contemporary equivalent of our upper middle class.

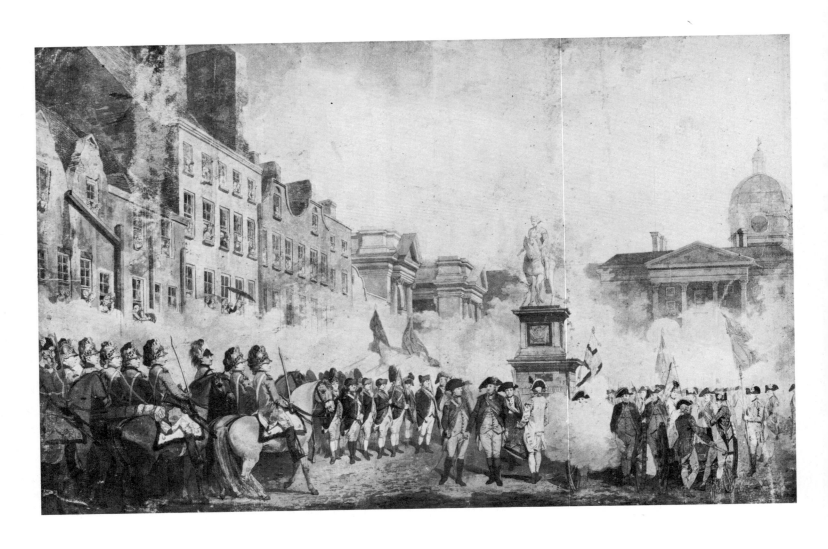

Fig 34 Francis Wheatley *A View of College Green with a Meeting of the Volunteers*
Water-colour $16\frac{7}{8} \times 25\frac{1}{2}$ in/ 42.9 × 64.8 cm
Victoria & Albert Museum, London **5**, see **E15**

Ireland

Praised by the critics – 'he possesses a considerable degree of merit, and is daily improving in ability'[1] – his work considered a positive addition to the walls of the Royal Academy exhibitions, Wheatley had by the end of the 1770s built up a good practice and though still in his early thirties was well along the path of a successful career. However, according to his contemporary, the architect James Gandon (1743–1823), the company he kept brought about his downfall. Gandon relates that Wheatley had obtained the freedom of Covent Garden Theatre from William Powell, one of the theatre managers and 'Being a handsome and fashionably-dressed young man, with a good address, and mingling with constant visitors at Covent Garden Theatre, he met company, with whom he became acquainted, that involved him in expenses his limited means did not authorize; and it is probable, that, from his having early contracted expensive habits, he found it difficult, in more advanced life, to restrain his inclinations, and live in accordance to his means. Having early in life involved himself in debt, he was induced to visit Dublin. . . .'[2]

In addition to a retreat from his creditors, Wheatley had to make a precipitous flight from an irate husband, for he had 'had the folly to engage in an intrigue'[3] with Elizabeth, the wife of a fellow artist, John Alexander Gresse. For this he was prosecuted and put into the King's Bench. Gresse brought a case of trespass and assault against him[4] stating that on the 1 December 1778 Wheatley had 'with Swords Staves Sticks and Fists made an Assault upon Elizabeth . . . and then and there beat and ill treated her and then and there Ravished (her) . . .' whereby Gresse had since that time 'lost and been deprived of the comfort and Assistance' of his wife, for which he claimed one thousand pounds damages. The jury rejected Wheatley's plea of not guilty, but reduced the damages to the sum of five shillings and threepence, with costs. Such a verdict implied a strong suspicion of Gresse's connivance in the intrigue, if not in the subsequent elopement. Costs with damages amounted to £32 and the judgment was signed on 6 May 1779. If Wheatley was really living in fear of his creditors this additional sum, though not large, must have made departure from London even more imperative. In order to escape from his pressing liabilities he took the usual

1 *Morning Chronicle* 25 April 1778

2 J.Gandon and T.J.Mulvany *The Life of James Gandon, Esq* 1846, p206

3 E.Edwards *Anecdotes of Painters* 1808, p268

4 London, Public Record Office KB 122 430, No1728

eighteenth century step of borrowing more money with which to fly the kingdom. Obtaining a loan, never repaid, from his fellow artist Benjamin West, he departed for Ireland with Mrs Gresse,[1] passing her off as his wife.

1 Windsor, Royal Library *The Farington Diary*, transcript 21 May 1797

To understand the next four years of Wheatley's career it is necessary to glance at the state of the arts in eighteenth century Ireland. The painters, sculptors and architects of Dublin, following the example of their confrères in London, had formed an association under the name of the Society of Artists which held its first exhibition in 1765. Its financial and social success encouraged the promoters to build an exhibition room and to found an academy of painting. But their first triumph was never repeated and although the Society's exhibitions continued regularly for ten years until 1775, thereafter only two were held, the last taking place in 1780. Applications for Parliamentary aid did not result in sufficient grants to establish either the exhibition room or the academy on a stable financial footing, and after the exhibition of 1780 the Society's affairs became embarrassed, its house fell into the hands of an unprincipled agent and finally was taken over by the Corporation of Dublin early in the 1790s. In spite of their attempts to interest Irish patrons, Irish artists soon found that they could expect little encouragement in their own country. Many went to London where they had successful careers. MacArdell, Barrett, Hickey and Hone all became well known, and Robert Carver the scene painter at Drury Lane and Covent Garden, neglected in Dublin, was unrivalled in London. Irish collectors for preference bought foreign pictures and copies of old masters. A Dublin writer of 1769 on asking Carver about his paintings was told 'I have some pieces at home which would be no disgrace to a gentleman's dining-room, but then they would be known to be mine, and no one would vouchsafe to look upon the paltry daubings. Indeed, if I had recourse to the dealers' arts, made use of the Spaltham pot, and gave it out that they were executed by Signor Somebodini, all the connoisseurs in town would flock about them, examine them attentively with their glasses, and cry out with rapture – 'What striking attitudes! what warm colouring! what masses of light and shade! what a rich foreground! Did you ever see anything more *riant*?'[2] Such complaints from artists had been heard in England too, but Hogarth's battles with the connoisseurs had driven the old master camp into retreat, and since the opening of the exhibitions held by the Society of Artists from 1760 and the foundation of the Royal Academy in 1768, it had quietly laid down its arms. Yet in spite of this failure as a corporate body, a glance at the first and last catalogues of the exhibitions of the Irish Society of Artists gives the impression that between 1765 and 1780 much progress had been made. Instead of the mere eighty-eight exhibits in the first exhibition there were over two hundred in the last, including portraits, landscape, topography, allegory, history, and still-life. Sculpture and painting, miniatures, crayons, drawings and watercolours were all represented.

2 J.T.Gilbert *A History of the City of Dublin* III 1859, pp347–8

The Volunteers

When Wheatley arrived in Ireland the country was in a state of feverish political excitement. The restrictions imposed by England on Irish trade had alienated

many members of the Protestant Ascendancy, who, although descended from English or Scottish colonists, had come to feel themselves Irishmen first and foremost and were suffering economically from the selfish mercantile policies of the English government. Moreover, under the system of bribery and patronage by which the English government was carried on, many of the highest and most lucrative posts in Ireland, both secular and ecclesiastical, were given to Englishmen as a reward for past or prospective services. Politically the country was administered by an English Lord Lieutenant and his staff from Dublin Castle; but Irish opinion could be voiced in the Irish Parliament, which possessed some legislative powers, if only in association with the Irish Privy Council and the English Privy Council.

The outbreak of the American War had imposed a great strain on the Irish economy, for the English government forbade the export of Irish linen and agricultural produce to the rebellious colonies, and then to France when that country took their side. On the declaration of war with France it was found that there were no English troops to protect the country against a possible French invasion and in 1778 local militias were raised spontaneously and with great enthusiasm throughout Ireland. Because these troops had been raised by the local gentry of all the districts of Ireland of their own accord, and not by governmental decree, they were known as the Volunteers. According to Lecky[1] 'nearly the whole resident landed gentry took part. . . . Volunteer rank became an object of ambition; ladies gave it precedence in society, and to be at the head of a well-appointed corps was now the highest distinction of an Irish gentleman.' But the movement, although it sprang from loyalty to the Crown, soon developed patriotic policies. Agreements were made to use only goods of Irish manufacture, and to boycott English goods until the unjust restrictions on Irish trade were removed. When Parliament met in 1779, Henry Grattan demanded free export trade for Ireland, and a demand for free trade was actually carried by the Speaker of the Irish House of Commons to the Castle through two lines of the Dublin Volunteers under the command of the Duke of Leinster. The Volunteers were publicly thanked in the Commons for 'their spirited and necessary exertions' on behalf of Ireland. Frightened into acquiescence, the English Parliament in 1779 and 1780 repealed all the restrictions on Irish trade. The Irish, encouraged by this success, now attempted to form the separate corps of Volunteers into a single, large force, and arrangements were made to hold a number of great reviews in the summer of 1780.

Wheatley could not have chosen a better moment to visit Ireland. Gandon writes of his good fortune in arriving in Dublin 'at a time favourable for his professional exertions, as, at this period, there was great excitement in the Irish Volunteer Corps, which was composed of the most respectable citizens, and the cavalry was formed of noblemen and gentlemen of the highest rank in Ireland, and commanded by His Grace the late Duke of Leinster. Wheatley availed himself of this opportunity, and, being a spectator of one of the first great public meetings, when the Volunteers were assembled together in College-green on the anniversary of a day of great public rejoicing, he made a drawing of the review, from which he shortly afterwards painted a picture in oil, in which

1 W.E.H.Lecky *A History of Ireland in the Eighteenth Century* II 1908, p236

31

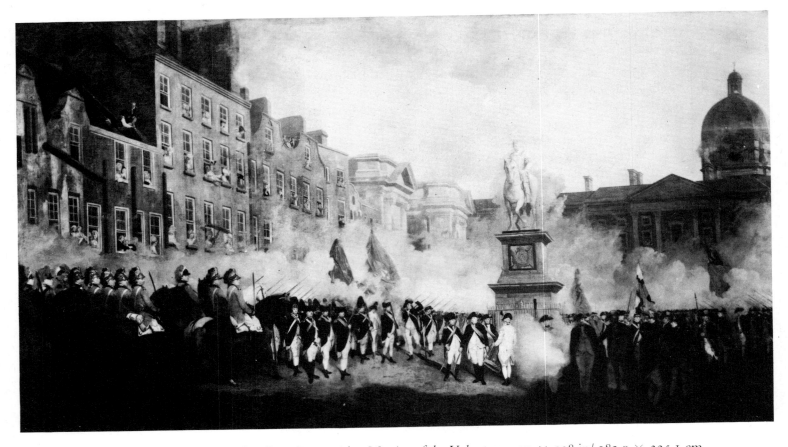

Fig 35 Francis Wheatley *A View of College Green with a Meeting of the Volunteers* 72 × 128 in/ 182.9 × 325.1 cm
National Gallery of Ireland, Dublin **30**, see **E15**

several portraits of distinguished individuals were introduced.'[1] The water-colour in the Victoria and Albert Museum [Fig 34] might just conceivably be this drawing, but as it is finished and quite large, and was used for the engraving issued in 1784, it is far more likely to be a subsequent reduction or, less probably, a preliminary sketch of the composition. It has slight differences from the oil, notably in the triangular pediments of the Irish House of Commons which are shown in correct perspective. The oil painting [Fig 35] was exhibited at the Society of Artists in William Street, Dublin, in 1780 and met with general approbation. The suggestion has been made that it was commissioned by the Duke of Leinster, but this is certainly untrue. The profits to be made from sub-scriptions to an engraving had become an accepted way of making money from paintings, and in all probability Wheatley intended from the first to have the picture engraved in the hope of a large sale, especially to those included in the picture. One at least of his fellow artists in Dublin had already rushed to profit by similar methods from the excited patriots of Ireland. On 1 January 1779 the sculptor Van Nost announced in Faulkner's *Dublin Journal*: 'To the Public in general, and particularly to the Gentleman Volunteers, Lovers of their Country,

1 J.Gandon and T.J.Mulvany *The Life of James Gandon Esq* 1846, pp206-7

and of their Noble Commander the Duke of Leinster. Mr Van Nost, Statuary, begs Leave to inform them, that he has executed a BUST of his Grace, done from the Life, to be seen at No 21, Mecklenburgh-Street, from which a curious MEDALLION in Alto Relievo, of extream Likeness is taken in his Military Dress – For which a subscription is opened . . . at Three Half Crowns each Cast . . .'[1] In order to dispose of the picture, which was still on his hands in January 1781, Wheatley announced a raffle, the outcome of which is not reported. Three years later, in 1784, *The Volunteers* was in the possession of the Duke of Leinster. No print was taken in Ireland; the engraving already mentioned was made by J.Collyer and published by R.Lane in London in 1784 with a dedication to the Duke of Leinster.

1 T.T.Faulkner *The Dublin Journal* 1 January 1779

Wheatley depicted the formations of the Volunteers as drawn up round Grinling Gibbons's statue of William III. He has included a number of recognizable likenesses in the front ranks [see **30**], whilst the mass of Volunteers behind are obscured by clouds of smoke. The architecture, rather flatly painted, gives a good impression of the colour of Dublin brick and its contrast with the stonework of the House of Commons and of Trinity College, bell tower still intact. The statue of King William III is broadly treated but receives the due prominence in the composition that its political significance demanded. Wheatley's attention is focused on those taking a leading part in the review and he has concentrated on correct detail of uniform and on making good likenesses of the sitters. No figure or group is made specially conspicuous and there is no dramatic emphasis on any one part of the picture.

To paint a public event of this kind was a new departure for Wheatley: his experience as a topographical artist and as a portrait painter equipped him to realize an adequate presentation of the physical setting and the individual actors of such a scene, but it had not trained him in the clear and interesting presentation of a complicated narrative. It cannot be said that Wheatley has succeeded in organizing the innumerable smaller components of his picture into a single convincing action. In spite of its apparent lucidity, largely the result of correct drawing and bright, attractive colour, *The Volunteers* is an accumulation of details, each of which is treated as a separate entity for its own sake. Even though this was an eighteenth century occasion when urbanity was perhaps more in evidence than at an earlier or later period, we certainly might expect to find some trace of 'excitement', especially if we reflect that this was an Irish eighteenth century occasion. In all Wheatley's later pictures of this kind the balance of merits and defects will be the same.

This picture of the first public celebration of the Volunteers, with its portraits of such influential people as the Duke of Leinster, Sir Edward Newenham, Luke Gardiner, Sir John Allen Johnston, John Fitzgibbon, David LaTouche, Counsellor Pethard, Counsellor Caldbeck, clearly brought Wheatley into prominence among the aristocracy and art conscious public. It is probable that Gandon's reports of Wheatley's success with the Irish aristocracy really reflect a social rather than a financial achievement.

Fig 35A Detail from Fig 35

Fig 35B Detail from Fig 35

35

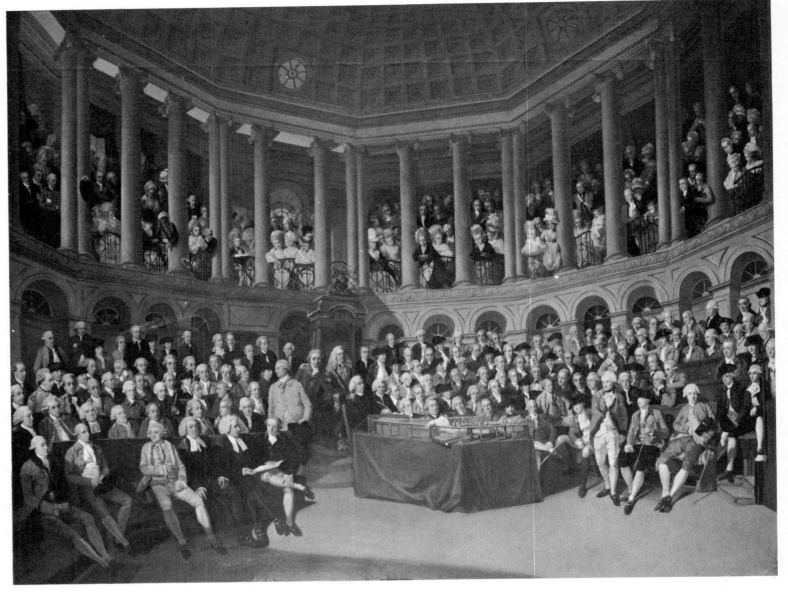

Fig 36 Francis Wheatley *The Irish House of Commons* Oil on canvas 64 × 85 in/ 162.5 × 215.9 cm
Leeds City Art Galleries, Gascoigne Collection **33**

The Irish House of Commons

The swelling excitement of political events and the waves of patriotism that
surged in Ireland almost certainly encouraged Wheatley to paint his second
large group picture. On 19 April 1780 Henry Grattan made his famous speech
before a crowded House of Commons on the repeal of Poyning's law 'That the
people of Ireland are of right an independent nation and ought only to be bound
by laws made by the King, Lords and Commons of Ireland.' The public galleries
were thronged with fashionable crowds, including a large number of elegantly

36

dressed women, listening eagerly to the fiery oratory. This was the scene of patriotic and political fervour that Wheatley now determined to paint [Fig 36 and 36A–B]. Putting the enterprise on a firmer business footing he immediately opened a subscription for an engraving of his picture, charging half-price to the sitters.[1] He was given 'special facilities' to paint the picture and the portraits were considered good likenesses of the Members of the House of Commons. In this lies the fault of the composition for as far as the laws of perspective will allow Wheatley has given equal prominence to all the Members, recording faithfully the aspect of the chamber as it really looked on the day to an unselective eye – showing rather more than half the octagonal chamber, the speaker on his throne, the mace in position and a member standing to make his speech. But the eye is not taken straight to Grattan whose pointing hand is lost against his white waist-coat, and no sparks of fiery passion kindle the audience to a state of tense emotion, not even, it might be said, of unusual attentiveness. Whatever drama the situation may have had is lost in a literal rendering of the scene.

Architecturally Wheatley's is the only accurate view of the interior of the House of Commons by Sir Edward Lovett Pearce, which was destroyed in 1803. Out of architecture and figures Wheatley has made an attractive scene. The light grey chamber with its green fittings, the gay dresses of the ladies and the colourful attire of the members punctuated by the uniform and dark hats of the Volunteers and clergy show his usual lively sense of colour. The promised engraving for the subscribers never appeared, and although an advertisement in 1801 announced a print after the picture nothing was published except a key to the identity of the sitters. A story is told of this picture, but it must be treated with suspicion as it is a story told of similar paintings by other artists, that 'several of the early subscribers, who had paid half-price as sitters for the picture, had been rubbed out to substitute others – who had also paid the half-price . . . the picture was never finished, nor, at the period produced for public approval.'[2] It was not until the early twentieth century that *The Irish House of Commons* was engraved.

Two of Wheatley's most important Irish pictures represent scenes which in retrospect have acquired heroic historical and emotional significance for Irish-men. The weaknesses in their composition have already been analysed, but it would be unfair to Wheatley to quit the subject without saying that they should not be judged as history paintings, for they were never intended as such by the artist. In the eighteenth century it was the task of history painting to represent a heroic action from the past, preferably the distant, even mythological past. It was precisely the choice of a relatively recent historical event as the subject of a history painting which made West's *Death of General Wolfe* (1727–59) such a sensation in 1771. Wheatley cannot be criticised for not investing his representations of contemporary political events with a heroic glamour and drama then considered proper to very different subjects. These pictures are lively reports; for a fiercely dramatic and emotional treatment of contemporary history we must wait for Goya.

1 J.Gandon and T.J.Mulvany *The Life of James Gandon, Esq* 1846, pp207–8

2 J.Gandon and T.J.Mulvany *The Life of James Gandon, Esq* 1846, p208

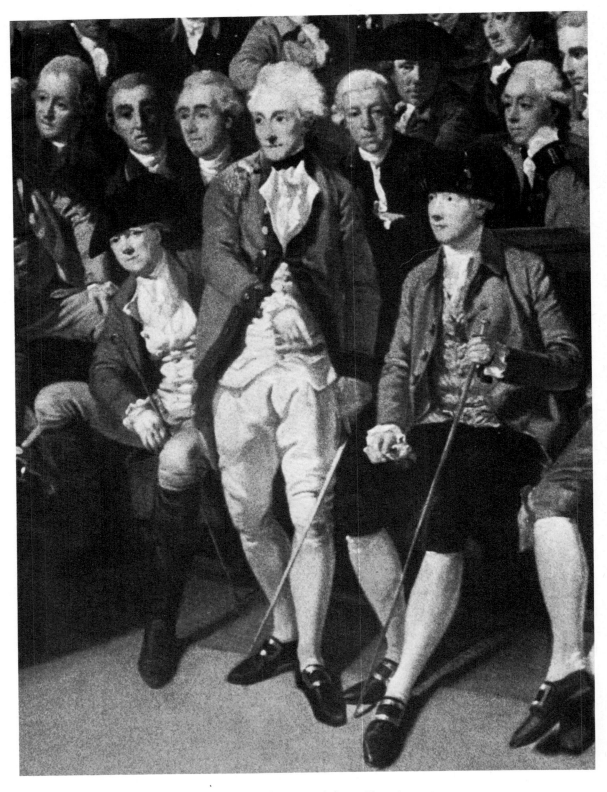

Fig 36A Detail from Fig 36

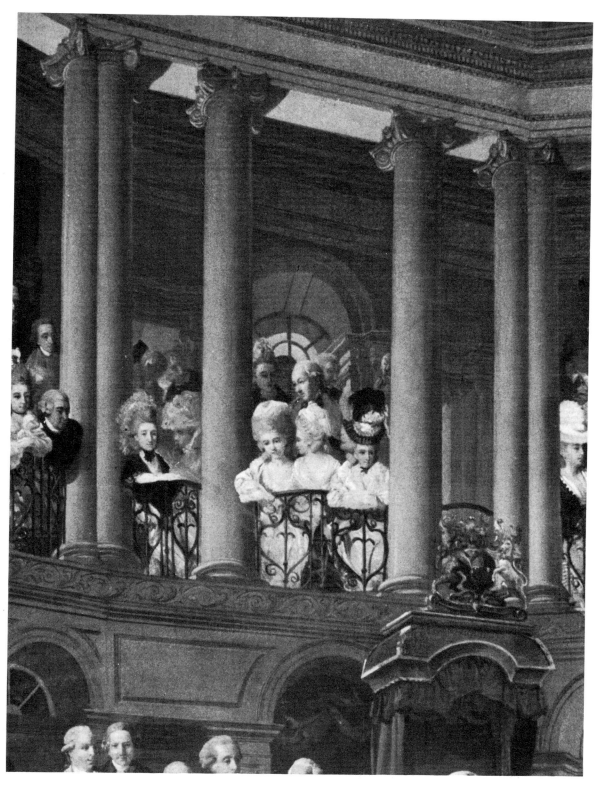

36B Detail from Fig 36

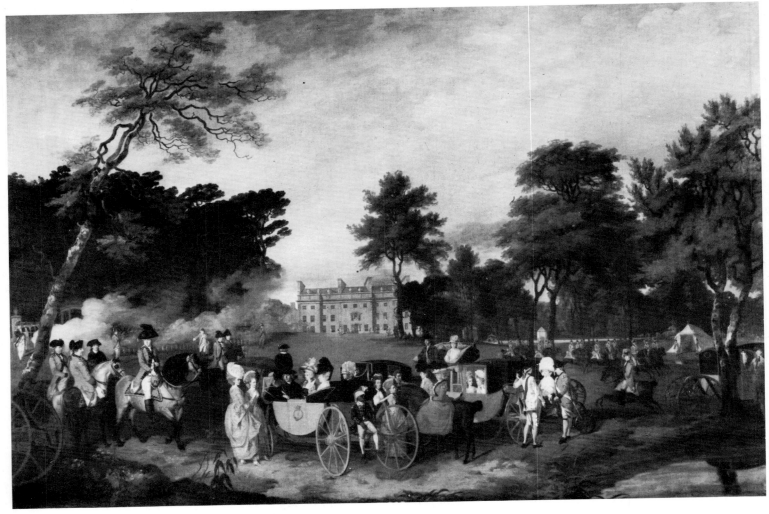

Fig 37 Francis Wheatley *Lord Aldborough on Pomposo, a Review in Belan Park, County Kildare* Oil on canvas 61 × 94½ in/ 154.9 × 239 cm The National Trust, Waddesdon Manor **35** (see Frontispiece)

Group Pictures and Portraits

Quite probably Wheatley also undertook *The Volunteers* and *The Irish House of Commons* very much with an eye to exhibiting before a wide range of possible patrons his accomplishment as a portrait painter. Certainly the success of these two pictures brought Wheatley into notice and in all likelihood led to the commissioning of at least three other large groups. It is convenient to consider first the most elaborate of these, an animated scene in the grounds of Belan Park, County Kildare [Fig 37], in which Lord Aldborough mounted on his horse, Pomposo, a concourse of carriages and many fashionable onlookers are present at a review of Volunteers. The Earl, a General of the Volunteers, is seen to the left of the picture and the troops are presumably the Aldborough legion, raised by the Earl as early as August 1777. The ladies in the foreground may be the Earl's sisters and it is certainly Lady Aldborough who is seated in the carriage

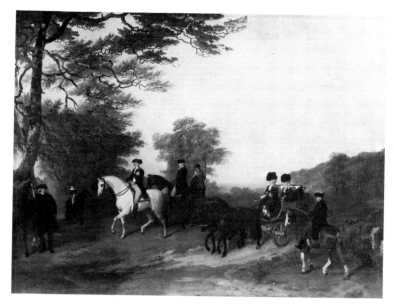

Fig 38 Francis Wheatley *The Fifth Earl of Carlisle in Phoenix Park* Oil on canvas 59 × 77 in/ 149.8 × 195.6 cm
George Howard Esq **37**

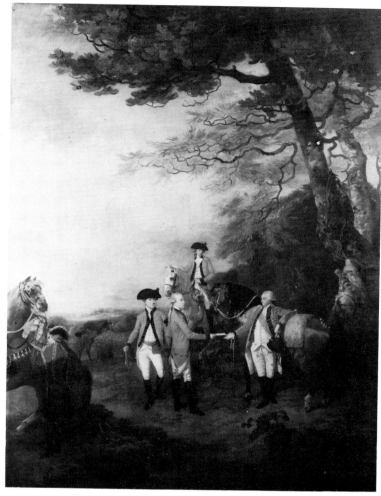

Fig 39 Francis Wheatley
Review of Troops in Phoenix Park by General Sir John Irwin
Oil on canvas 96¼ × 71¾ in/ 244.5 × 182.2 cm
National Portrait Gallery, London **36**

decorated with the coronet. A mounted lady Volunteer in uniform indicates the enthusiasm with which the movement was taken up by the Ascendancy. The Aldborough picture, in spite of what now seems a delightfully inconsequent treatment of a ceremonial occasion, surely had a real commemorative importance in the eyes of the noble lord who commissioned it. An altogether informal scene is that of *Lord Carlisle*, the Lord Lieutenant of Ireland, riding in Phoenix Park with members of his family [Fig 38]. The last large group is that of a *Review of Troops in Phoenix Park by General Sir John Irwin* [Fig 39], in which the General is portrayed with his staff, receiving a despatch. Again the treatment of the occasion seems casual to eyes accustomed to Prussian standards in such matters, but these pictures are probably not so much picturesque compositions as portrayals of what actually was to be seen in those easy going countries of Europe where the strict discipline of Potsdam had not yet become fashionable.

Fig 41 Francis Wheatley
Henry Grattan Oil on panel
$10\frac{1}{2} \times 8\frac{1}{2}$ in/ 26.7 × 21.6 cm
National Portrait Gallery, London
32, see **E11**

Fig 40 Francis Wheatley
Two Children of the Maxwell Family
Oil on canvas $40\frac{1}{4} \times 30$ in/ 102.2 × 76.2 cm
Lord Farnham **38**

In addition to these large groups, Wheatley was in demand as a painter of small portraits in both whole length and busts. They show a development towards an ever easier and less rigid posing and less tightness of line. An attractive example is the portrait of *Two Children of the Maxwell Family* [Fig 40] playing in a garden. In a *Family Group in a Landscape* [**43**], there is a greater facility of composition and handling and a surer placing of the figures in the landscape, here well integrated into the picture and not a mere backdrop for the figures. Among the head and shoulder portraits painted at this time the most important was that of *Henry Grattan* [Fig 41]. The eyes steadily fixed on some distant object and the thought behind them on an equally distant purpose, the portrait shows a refined yet determined face and is for once suggestively rendered, but there is no spark of fiery oratory in the lips. This portrait was engraved in 1782 but must have been painted in the first half of 1780 as it was used by Wheatley for the portrait of Grattan in the view of the Irish House of Commons. It is not very highly

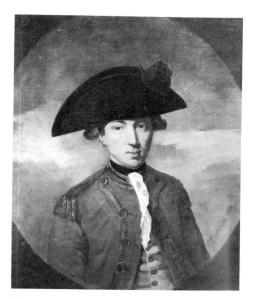

Fig 42 Francis Wheatley
Portrait of an Officer Oil on canvas
28 × 24½ in/ 71.1 × 62.2 cm
Collection unknown **40**

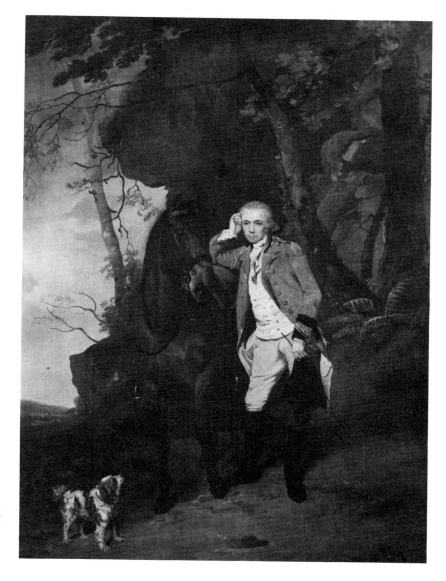

Fig 43 Francis Wheatley
Captain Charles Churchill
Oil on canvas 40½ × 29½ in/ 102.9 × 74.9 cm
Jeremy Tree Esq **31**

finished, unlike most of Wheatley's portraits, and may have been intended from the first purely as a sketch for engraving. The *Portrait of an Officer*, signed and dated 1782 [Fig 42] and a portrait of *Miss Fridiswede Moore* signed and dated 1782 [**41**] show Wheatley practising small, straightforward portraiture, a genre just as perfectly suited to the houses of Ireland as to the villas of Middlesex. In addition to other types of portraiture Wheatley essayed the single equestrian portrait while he was in Ireland, producing an attractive example in *Captain Charles Churchill* [Fig 43]. In this picture he made use of the formula of placing the horse obliquely to the front plane, a formula that he repeated in the portrait of *Sir Henry Pigott* [**39**] and on several subsequent occasions. About a dozen other portraits known to have been painted in Ireland have not proved traceable, but their existence and that of the paintings just discussed bears out Gandon's report of Wheatley's success as a portrait painter. It is certainly true that Wheatley brought from England into Ireland a more ambitious standard.

Fig 44 Francis Wheatley *St. Wolstan's near Celbridge* Water-colour
$6\frac{5}{8} \times 10\frac{1}{4}$ in/ 16.2 × 26 cm Victoria & Albert Museum, London see **E83**

Fig 45 Francis Wheatley *Malahide Castle* Signed and dated F. Wheatley del! 1782
Pen and water-colour $7\frac{1}{2} \times 10$ in/ 19 × 25.4 cm
Lord Talbot de Malahide see **E13**

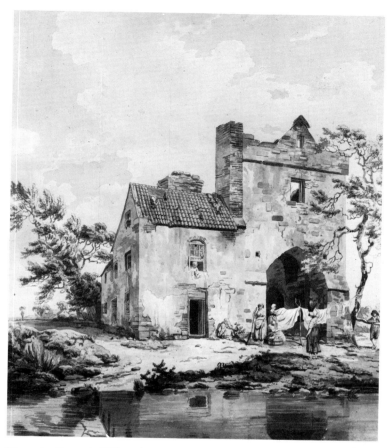

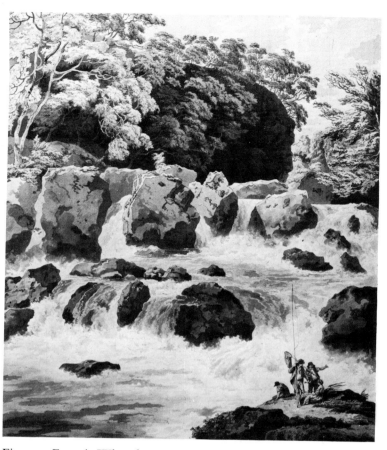

Fig 46 Francis Wheatley *A Farmstead* Signed and dated
F.Wheatley delt./1782 Pen and water-colour
$20\frac{5}{8} \times 18$ in/ 52.4×45.7 cm
Cecil Higgins Museum, Bedford

Fig 47 Francis Wheatley *Waterfall on the Liffey* Signed and
dated F.Wheatley del./1782 $22 \times 18\frac{1}{2}$ in/ 55.9×47 cm
Pen and water-colour National Gallery of Ireland, Dublin

Landscape

Wheatley did not neglect landscape during his stay in Ireland. He drew a number
of topographical water-colours of houses and specific views for engraving in
Milton's *Collection of Select Views* and for the *Copper Plate Magazine*. Two of
these small drawings of houses survive [Figs 44,45]. For the sake of a balanced
composition, the actual topographical content is altered in them and improved,
a customary practice in picturesque views of landscape, but less usual in strictly
topographical work. He also travelled out to the countryside around Dublin
and there painted studies [Fig 46]. As usual, small figures and groups enliven
these Irish water-colours which are attractively drawn and lightly tinted, pre-
dominantly in pale blues, greens and ochres, for Wheatley does not yet take the
opportunity of the costume of his figures to introduce spots of bright colour as
was later to be his practice. Some of these views of Irish scenery prelude in the
mildest and sweetest of keys the themes of Romantic painting of nature. In the
Waterfall on the Liffey [Fig 47] Wheatley has concentrated the spectator's interest
on the violence of the tumbling falls by contrasting the dark rocks and the

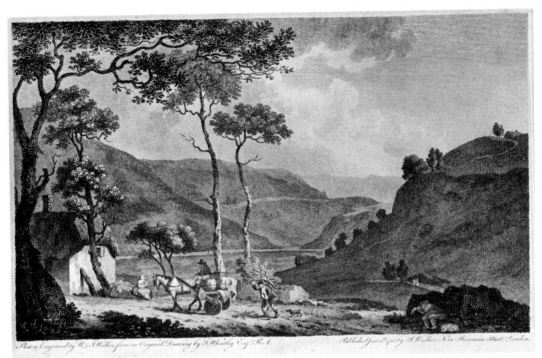

Fig 48 Francis Wheatley *Ennischerry* Line engraving by W. & J.Walker
$5\frac{7}{8} \times 8$ in/ 15×20.3 cm British Museum, London **E84**

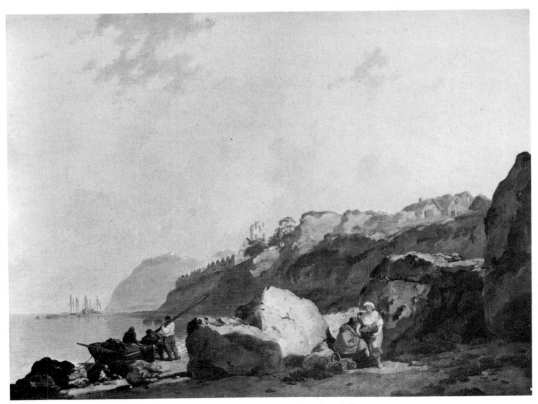

Fig 49 Francis Wheatley *Seashore at Howth, Ireland* Oil on canvas
$28 \times 35\frac{1}{2}$ in/ 71.1×90.2 cm Southampton Art Gallery **44**

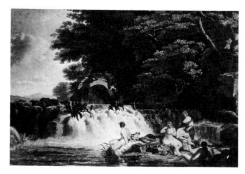

Fig 51 Francis Wheatley
Salmon Leap at Leixlip with Nymphs Bathing Engraved by R.Pollard
Aquatint by F.Jukes
$14\frac{3}{4} \times 19\frac{1}{2}$ in/ 37.5 × 49.5 cm
British Museum, London **E21**

Fig 50 Francis Wheatley
Salmon Leap at Leixlip with Nymphs Bathing Oil on canvas
$26\frac{5}{8} \times 25\frac{1}{2}$ in/ 67.6 × 64.75 cm
Mr and Mrs Paul Mellon **45**

shadowed trunks of the trees with the foaming white water and the play of sunlight on leaves. The tiny group of fishermen in the bottom right hand corner is for once not there merely for human interest, but gives an impression of grandiose scale. Unfortunately this water-colour is so faded that only a faint impression remains of what must have been one of Wheatley's most imaginative landscape views. In the view, now only known from an engraving [Fig 48], of *Ennischerry*, a place greatly admired at the end of the eighteenth century for its beautiful and romantic situation, Wheatley has omitted buildings to concentrate on the picturesque scenery.

Wheatley also painted landscape in oil, as usual peopling his pictures with small groups engaged in everyday activities. The *Seashore at Howth* [Fig 49] may have been painted after the water-colour made of the same subject, since it is primarily a composition in blue, mauve and grey, and in its lack of intense greens is not typical of Howth even on a wet day; here the sun is shining, giving

a rosy yellow sky over the cottages at the right. In his view of the *Salmon Leap at Leixlip with Nymphs Bathing* [Fig 50] Wheatley has produced a less English composition showing a reflection of Boucher, Vernet and Cipriani. None the less it is primarily a landscape with figures, as can be seen from the engraving after it [Fig 51] where the river landscape opens out on the left hand side and lessens the emphasis on the groups of bathing figures. It is an attractive painting in which Wheatley's use of contrasting greens for his trees, a device which he had employed with less success in a number of earlier pictures, balances the composition, while the lively colours of the girls' clothes blend with the blue and grey green river. In this picture too Wheatley's softening palette – bright rococo colours have given place to pale blue, dull yellow and russet – foreshadows the tonality which he was mostly to adopt in future.

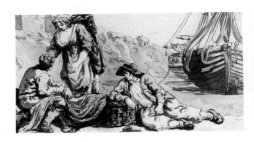

Fig 52 Francis Wheatley
Fisherfolk with Baskets and Nets
Pen and water-colour
$3\frac{1}{2} \times 6$ in/ 8.9 × 15.2 cm
Mr and Mrs Paul Mellon

Wheatley also made a large number of water-colours of scenes of Irish rustic life [Figs 52–59]. Many of these are big drawings, mostly in pen with blue and grey washes, tinted in blue, yellow, greenish yellow and red. They show the tents and whisky stills, groups of peasants and gypsies 'worthy a Wouvermans' in which Wheatley 'succeeded in delineating the characters of the peasantry, in perfect accordance with the humours he met with on these subjects.'[1] Wheatley is known to have possessed a number of drawings attributed to Wouvermans and to have been a great admirer of this artist [Fig 60]. These subjects were an immediate success, 'Being rapid in executing these rustic scenes, he disposed of his drawings as soon as finished, and was in the way of becoming wealthy and popular.'[2] It has proved difficult to identify the exact locations of the fairs in the twenty or so drawings which go by name of Donnybrook or Palmerstown fairs, probably because they are not finished versions of drawings made on the spot but compositions worked up from notes and sketches Wheatley took on his excursions. The most that can be said is that Wheatley must have found his material in fairs held around Dublin, since he seems to have confined his excursions to counties Kildare and Wicklow. So profitable were these fair scenes that Wheatley continued to make them long after he returned from Ireland. His obituarist[3] remarked in 1801, à propos the attacks of gout to which Wheatley was subject in the 1790s, that 'this infirmity, and the consequences to which it exposed him, prevented him from studying Nature as a landscape; and therefore he was obliged, too often, to have recourse to the evanescent traces of memory.' These 'evanescent traces' are more likely to have been the sound reminders of a sketchbook.

In spite of his success as a portrait painter and of the money he made by selling water-colours, Wheatley again became involved in debt. Moreover his imposture in passing off Mrs Gresse as his wife was discovered. Eighteenth century society could not sanction such an irregular situation and it became apparent that any further stay in Dublin would no longer be agreeable. Readers of Maria Edgeworth's *Absentee* (1812) will recall the horror felt by Count O'Halloran on hearing that Major Benson, an English officer quartered in an Irish garrison, has dared to introduce his mistress as his wife to Lady Oranmore, and Major Benson's anxiety to sell out to avoid being broken for this insult. Wheatley went back to England, probably in the later months of 1783.

1 J.Gandon and T.J.Mulvany *The Life of James Gandon, Esq* 1846, p208

2 J.Gandon and T.J.Mulvany *The Life of James Gandon, Esq* 1846, p208

3 *Gentleman's Magazine* 1801, p765

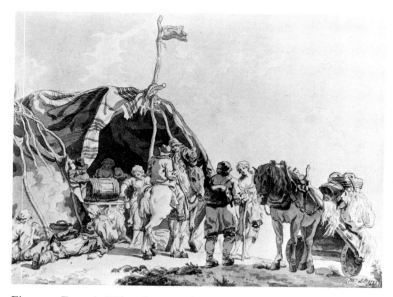

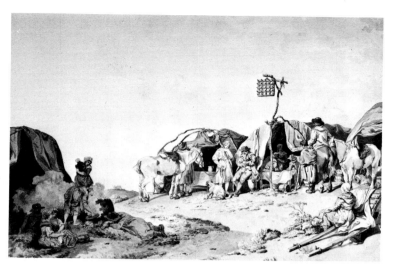

Fig 53 Francis Wheatley *Palmerston Fair* Initialled and
dated F.W.delt.1782
Water-colour $7\frac{1}{4} \times 9\frac{3}{8}$ in/ 18.5 × 23.9 cm
Henry E.Huntington Library and Art Gallery
San Marino, California

Fig 54 Francis Wheatley *A Gypsy Encampment* Signed and
dated F.Wheatley delt.1783
Pen and water-colour $14\frac{1}{2} \times 21\frac{1}{8}$ in/ 36.8 × 53.6 cm
Mrs D.A.Williamson

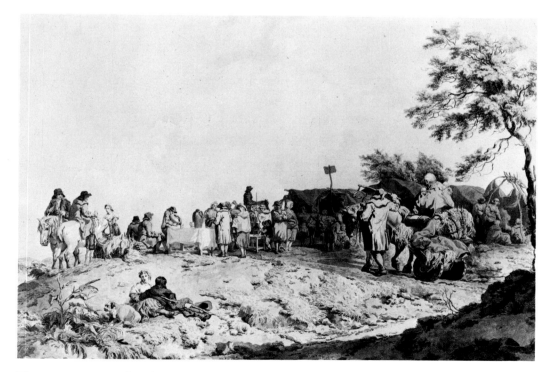

Fig 55 Francis Wheatley *At Donnybrook Fair* Signed and dated F.Wheatley/1794
Water-colour $7\frac{1}{4} \times 9\frac{3}{8}$ in/ 18.5 × 23.9 cm
Henry E.Huntington Library and Art Gallery San Marino, California

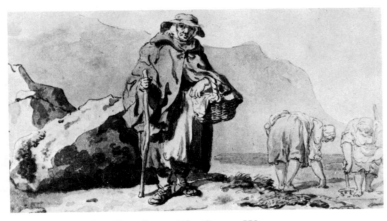

Fig 56 Francis Wheatley *The Oyster Woman*
Water-colour $3\frac{1}{2} \times 6$ in/ 8.9 × 15.2 cm
Mr and Mrs Paul Mellon

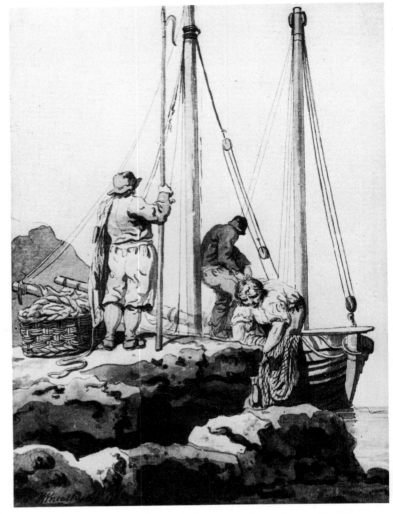

Fig 57 Francis Wheatley *Fishermen at Howth near Dublin*
Signed and dated F. Wheatley delt. 1782
Pen and water-colour $7\frac{5}{8} \times 5\frac{3}{8}$ in/ 19.3 × 13.6 cm
Colonel G.A. Barnett

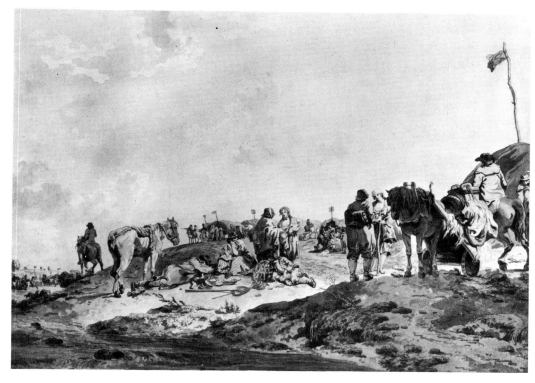

Fig 58 Francis Wheatley *Irish Fair Scene* Signed and dated F. Wheatley delt./1782
Water-colour $17\frac{3}{4} \times 25\frac{1}{4}$ in/ 45.1 \times 64.1 cm City of Birmingham Art Gallery

Fig 60 Phillip Wouvermans
Travellers at an Inn
Chalk $7\frac{7}{8} \times 12\frac{1}{2}$ in/ 20 \times 31.8 cm
Boymans-van Beuningen Museum,
Rotterdam

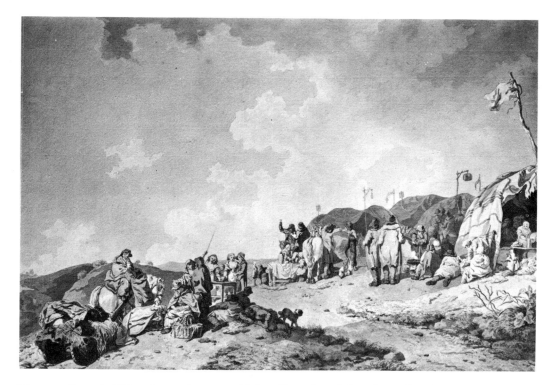

Fig 59 Francis Wheatley *Scene at a Fair* Signed and dated F. Wheatley delt/1784
Pen and water-colour $14\frac{5}{8} \times 21\frac{1}{4}$ in/ 37.2 \times 54 cm Mrs D. A. Williamson

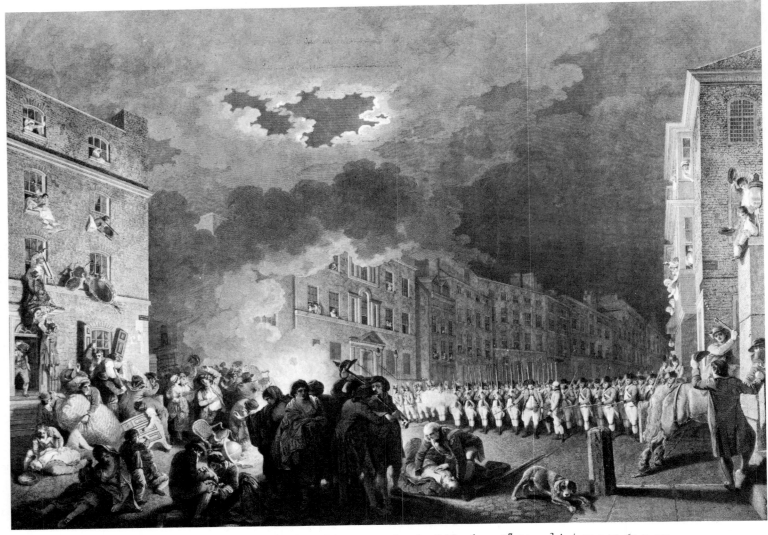

Fig 61 Francis Wheatley *The Riot in Broad Street* Line engraving by J.Heath $18\frac{7}{8} \times 24\frac{3}{4}$ in/ 47.9 × 62.9 cm
Mr and Mrs Paul Mellon **E69**

The Print

The Gordon Riots

On returning to London Wheatley began his long connection with Alderman John Boydell, the great entrepreneur, publisher and print-seller. For Boydell Wheatley painted a large canvas of *The Riot in Broad Street* which had occurred on 7 June 1780 during the great Gordon Riots. For this picture, which was engraved for Boydell by Heath [Fig 61], Wheatley received two hundred guineas.[1] Anger and violence had stirred in the Gordon Riots, so called after Lord George Gordon (1751–93), President of the Protestant Association and Member of Parliament. The riots began on 2 June 1780 when the supporters of the Association met in St George's Fields to accompany Lord George Gordon to the House of Commons with a petition protesting against the repeal of the penal acts against the Roman Catholics. At Lord George's trial on 5–6 February 1781, his defence claimed that the processions of his supporters to the House of Commons were comparatively orderly, and that it was the mob which was to blame for the rioting, the besieging of the Houses of Parliament, the breaking open of prisons, and the burning and looting of property. Not before 7 June, when the Bank was threatened, were troops called out in an attempt to quell the mob. Wheatley's picture reported a scene which took place in Old Broad Street at this stage of events. The eye is directed down the street southwards, from the point at which it is joined by London Wall. The officer giving orders to the troops 'was painted from Sir Bernard Turner', whose portrait in this attitude by Wheatley [Fig 62] was engraved in 1783, 'that which is receiving them is intended for Henry Smith, Esq at this time one of the Bank Directors, and Major-Commandant of the Camberwell Volunteers; and the figure, represented as assisting the wounded person, was painted from Sir William Blizard, surgeon . . . Lieutenant-Colonel of the Bishopsgate Volunteers; but it must be acknowledged that the two last-mentioned portraits are not such good likenesses as the first.'[2]

Wheatley cannot have been an eye-witness of the scene, as he was in Dublin and presumably putting the last touches to his picture of *The Irish House of Commons* which is in fact dated 8 June 1780. Edwards, a contemporary, states that Wheatley painted the picture of the riots on his return to London from Ireland. *The Riot in Broad Street* was destroyed in a fire whilst it was at the en-

1 British Museum *Whitley Papers sv* Wheatley. Receipt dated 13 April 1784

2 E.Edwards *Anecdotes of Painters* 1808, p269

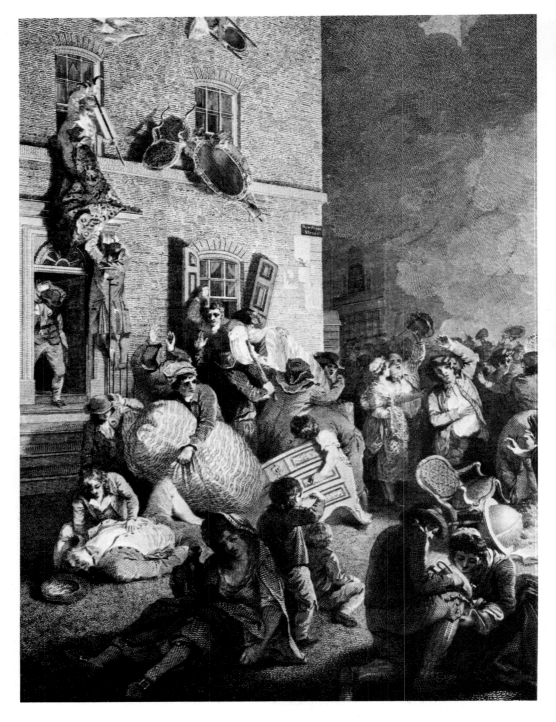

Fig 61A Detail from Fig 61

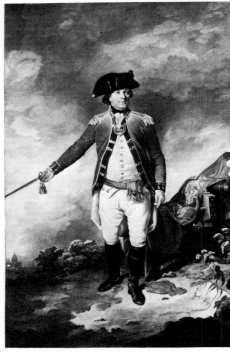

Fig 62 Francis Wheatley
Barnard Turner Esq.
Mezzotint by J.Walker
$23\frac{7}{8} \times 14\frac{7}{8}$ in/ 60.6 \times 37.8 cm
Mr and Mrs Paul Mellon **E14**

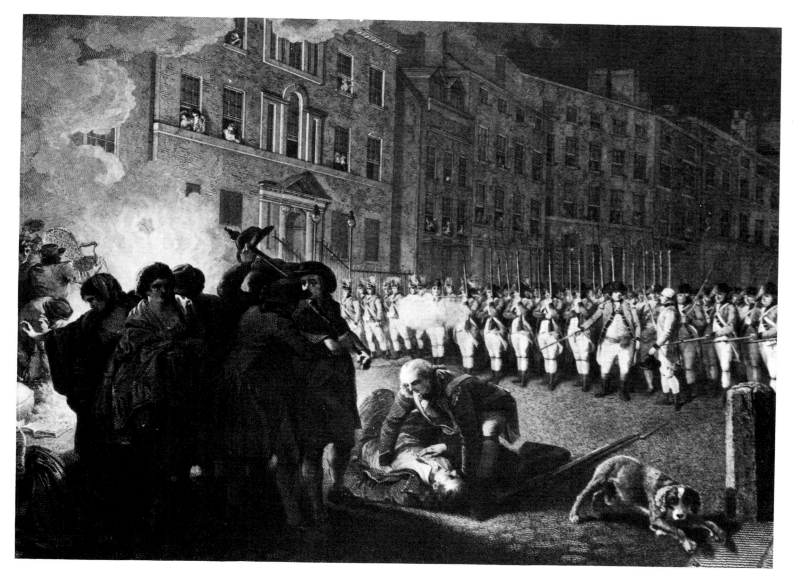

Fig 61B Detail from Fig 61

graver's house, but after the engraving had been made. The engraving was not published until 1790 when it was received with mixed comment. The grouping of the figures was thought not 'truly commendable' and the sky was considered over-dominant. To judge from the engraving the figures in the composition appear to have been treated yet again as isolated elements, rather than worked into a single whole. Yet in comparison with Wheatley's Irish pictures there is a distinct heightening of dramatic effect, although the subject of course demanded more striking treatment than a review or a Parliamentary sitting. Possibly Wheatley's need to invent gave more scope for his imagination, especially as here he was not fettered by a duty to sketches made on the spot.

Fig 63 *The Smoker Vandermyn* Mezzotint by F.Wheatley
$12\frac{5}{8} \times 9$ in/ 32.1 \times 22.9 cm British Museum, London **E2**

Wheatley and the Print

This first commission from a print-seller leads naturally to the subject of Wheatley and the print. From the date of his return to London, Wheatley turned more and more to working for the print-sellers.[1] Not only his small paintings but some of his larger pieces too were now habitually intended for engraving. To understand this change it is necessary to recall the important rôle played by the print in artistic life of the second half of the eighteenth century. The fashion which set in during the 1930s of slighting prints as merely reproductive work has obscured for us the truth that in the eighteenth century the print was regarded as an important branch of the fine arts with its own rules of connoisseurship. Prints by the best contemporary engravers were as eagerly collected and criticized, sometimes perhaps more eagerly collected and criticized than paintings. In any collection of press cuttings about art from eighteenth century newspapers, like that in the Victoria and Albert Museum for instance, about one quarter will be concerned with announcing the appearance of new prints by important engravers, and with describing and criticizing them on publication. Artist's drawings, whether old or new, were generally speaking still regarded as being of interest

[1] Wheatley appears to have had some difficulty in establishing himself at first and applied to go to the East Indies. The *Court Minutes* of the East India Company for 1 September 1784 (India Office B/100 pp.322–3) record: 'On reading several Requests; Order'd That Francis Wheatley be permitted to proceed to India, and to practise there as a Portrait Painter upon the usual terms.
It was then moved, and on the Question, Resolved That no more Painters be permitted to proceed to the East Indies this Season.'
In *Despatches to Bengal* General Letter to Bengal 9 December 1784 (E/4/628, p.361) it is stated that: 'Mr John Smart, Miniature Painter, and Messrs Ozias Humphrey and Francis Wheatley, Portrait Painters, have our leave to proceed to India to practise in their respective professions.' This information is repeated in *Despatches to Madras* 9 December 1784 (E/4/871, p.379) and *Despatches to Bombay* 9 December 1784 (E/4/1002, p.541).
I am indebted to Mrs.Mildred Archer for her kind assistance in connection with Wheatley's application to the East India Company

56

only to other artists. The English connoisseur wanted a finished work of art. The making of designs for engraving was in consequence a most important branch of their profession for all eighteenth century artists, excepting only the most successful like Gainsborough and Reynolds, and they too were usually solicited to allow their most popular compositions to be engraved.

Because of the small scale of the print and the considerable technical competence of eighteenth century engravers, many of whom were far from requiring the designer to supply their every line, changes in taste are often more freely, more clearly and more swiftly reflected in the print than in oil painting, where the claims of tradition were a conservative influence. In the case of designs or paintings specially made to be engraved, a frequent practice was for the painter to sell his work to the publisher who subsequently sold off the original after the print had been made. Wheatley himself occasionally worked as an engraver both before and after his Irish visit, his first plate being the small mezzotint portrait of *Christian VII of Denmark* of 1768 already mentioned [Fig 7]. Two other mezzotints by Wheatley, both of Flemish inspiration, are known: *The Smoker Vandermyn* [Fig 63] after Frank Van der Myn, a member of the Society of Artists, who used to smoke constantly while painting, and a *Boy lighting a Candle* after Rubens, a subject which gave scope to the effects of light and shade on the two faces. A small plate of *Gipsies cooking their kettle* [Fig 64] was etched by Wheatley in 1785. Wheatley also etched the plates which were then completed in aquatint and engraving by F.Jukes, R.Pollard and J.Hogg for the pair of prints of *St.Preux and Julia* at Meillerie and *Henry and Jessy* [Fig 75]; these were published in 1786. His familiarity with the techniques of engraving was probably very useful to Wheatley in his work as a designer.

Designd & etchd by F. Wheatly

Fig 64 Francis Wheatley
Gypsies cooking their kettle
Etching by F.Wheatley
$6\frac{1}{2} \times 9$ in/ 16.5 × 22.8 cm
British Museum, London **E4**

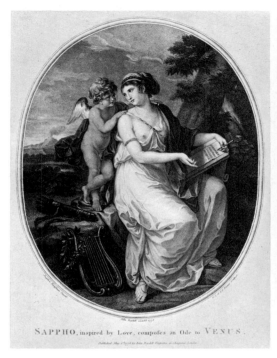

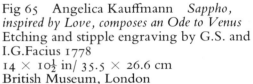

Fig 65 Angelica Kauffmann *Sappho, inspired by Love, composes an Ode to Venus* Etching and stipple engraving by G.S. and I.G.Facius 1778
14 × 10½ in/ 35.5 × 26.6 cm
British Museum, London

Fig 66 Angelica Kauffmann *Andromache weeping over the ashes of Hector* Mezzotint by T.Burke 1772
19¼ × 14 in/ 48.9 × 35.5 cm
British Museum, London

Amongst the most popular subjects of the early 1770s were single figures, usually allegorical, the allegory generally being either mythological – Ariadne, a lady as a Vestal, Hebe – or literary as Sappho [Fig 65], L'Allegra or the Virtues. Probably the best known exponent of designs for prints was Angelica Kauffmann whose illustrations to classical [Fig 66] and modern literature, history, allegory and portraits covered a wide range of subject. Allegorical motifs couched in the same dress continued to be used in large-scale portraits such as those by Reynolds and Romney. Before his Irish period, Wheatley had already produced two designs for mezzotints in the allegorical style – *Thais* [Fig 67], a subject which appealed equally to the moral and to the dissolute, and *Sidgismonda* [Fig 68]. Such themes were a last pallid manifestation of baroque imagery, much enfeebled by rococo sentiment and prettiness, and they were swept into limbo at the end of the decade.

As it reflects no stylistic evolution, Wheatley's work for the print-sellers is best divided up into its different genres so that each genre may be scrutinized separately. This method also permits a closer exploration of tradition and innovation in English print-making during Wheatley's working life. But it will be noticed that the division into genres is often purely formal, it might even be said highly artificial, as all those in which Wheatley worked are essentially simply different facets of a single sensibility, that of the Age of Sentiment.

58

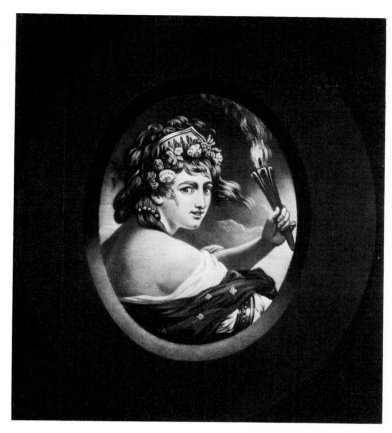 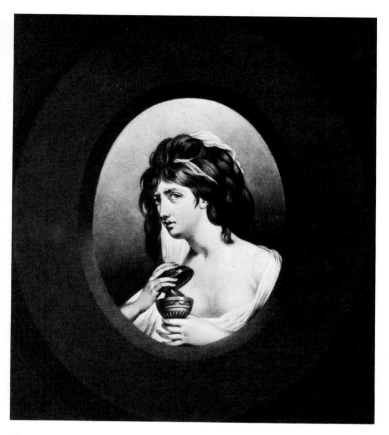

Fig 67 Francis Wheatley *Thais* Mezzotint by T.Watson 10¼ × 7¾ in/ 26 × 19.7 cm British Museum, London **E9**

Fig 68 Francis Wheatley *Sidgismonda* Mezzotint by T.Watson 10⅜ × 8¾ in/ 26.3 × 22.2 cm British Museum, London **E8**

Literature

Since Wheatley's first design for a furniture print after his return from Ireland, when the line became a large part of his livelihood, was a subject taken from literature, *St.Preux and Julia* at Meillerie signed and dated 1785 [Fig 69], such themes may claim priority of attention. By the 1780s subjects from modern literature, principally poetry, plays and novels, had become established both in painting and in prints. They were not simply book illustrations enlarged on the easel, but independent compositions in their own right. The small, upright oblong which the favourite duodecimo format of eighteenth century books of poetry and novels imposed on illustrations was disregarded, and the themes of contemporary or recent authors were handled with the same ease and freedom as custom permitted in the treatment of classical mythology. The figures are set against a background of light and shade; they come to life and assume character and expression, their inter-relationship replacing what was so often formerly mere gesticulation. In this way self-supporting compositions were evolved.

In the print, the refined and playful spirit of the Rococo had softened and lightened the strong lines and heavy contrasts of the Baroque, substituting a politer, more elegant manner even in comic subjects. In loftier genres too,

Fig 70 Joseph Highmore *Pamela shows Mr.Williams her hiding place for letters*
Oil on canvas $23\frac{3}{4} \times 29\frac{3}{8}$ in/ 60.3 × 74.6 cm
Fitzwilliam Museum, Cambridge

Fig 69 Francis Wheatley *St.Preux and Julia*
Signed and dated F.Wheatley Delt.1785
Pen and wash $20\frac{1}{2} \times 14\frac{3}{4}$ in/ 52 × 37.5 cm
British Museum, London see **E5**

rococo prints dissolve baroque monumentality and heaviness into a lighter and smoother manner. The first, most striking difference to the eye between a baroque book illustration and a rococo book illustration, to choose a type of print in which the varying treatments of the same subject can be most easily compared, is the contrast between the heavy blacks and thick hatching of the earlier period and the light greys and thin flowing lines of the later. This suave manner was established by Hayman in the middle of the century and remained dominant in engraving until its end; almost it might be said until the advent of Wilkie. The technical developments in engraving of the second half of the century – aquatint and stipple, the perfecting of printing in sepia and colour – maintain this softness and gentleness of outline.

 The first subjects taken from a contemporary novel for illustration in paintings and prints were Joseph Highmore's illustrations to *Pamela* executed in 1743-4 [Fig 70]. Highmore's object was narration: 'where the principal incidents are crowded into a moment, and are, as it were instantaneous, there is room

for the display of the painter's skill . . . such a story is better and more emphatically told in picture than in words, because the circumstances that happen at the same time, must, in narration, be successive.'[1] Unlike Hogarth, he has given his scenes a box-like stage setting enlarging the effect of immediacy and intimacy. It is probable that Highmore's set of paintings from *Pamela* originated the new genre but it would certainly be wrong to think that Highmore's inspiration was the literary charm of the novel. His contemporaries, much as they appreciated Richardson's penetrating psychology and power of exciting the feelings, were moved to approval by the excellence of his morality. It was the invaluable moral lessons of *Pamela* that Highmore, following Hogarth's precedent, was proposing in pictorial form to a public which Richardson's novel had taken by storm. But once the genre was established it developed away from the didactic premises of its infancy.

1 *Gentleman's Magazine* 1766, pp354-5

The eighteenth century was one which admired the classics. Many of its books were written to become classics and in that century of august standards, achieved the status with remarkable swiftness. Episodes of Thomson's *Seasons*, and of *The Chase* and other poems by Somerville, works which no one but the specialist now reads, were familiar and easily identified in the circle of the literate. Not many, for instance, now know the story of *Young Hobbinol and Gandaretta* which Gainsborough painted about 1788 [Fig 71], but the poem by Somerville went through more than ten editions, published both separately and in complete collections of Somerville's works before the end of the eighteenth century; and the subject had thus no need of explanation to an eighteenth century eye. The disappearance into limbo of eighteenth century authors who were standard in their day is one of the minor trials of the historian of eighteenth century art, since it makes peculiarly irritating a failure to identify what was obviously to contemporaries a familiar subject.

Fig 71 Thomas Gainsborough
Young Hobbinol and Gandaretta
Oil on canvas
49½ × 39½ in/ 125.7 × 100.3 cm
Mrs Lucius Peyton Green

Particularly important, for example, are the long forgotten *Contes Moraux* of Marmontel (1723-99). They were the rage of France and subsequently of England, where they were eagerly read both in the original and in translation, and appeared repeatedly in beautifully illustrated editions. They are not without a certain charm, even if it is rather a period charm. The morality promised in their title is of a Rousseau-esque rather than Edgeworthian cast, and would probably be better translated by sentimental than by moral, which has such unflinching associations in English. Since 1820 only one half-hearted attempt has been made to arouse interest in them, Saintsbury's selection of 1895, during the Austin Dobson period of the porcelain, powder and periwig image of the eighteenth century. Yet this unread book by a half remembered author was the source of innumerable compositions by Loutherbourg, Angelica Kauffmann, Wheatley and many other artists. How considerable a draw Marmontel's subjects were can be judged from the advertisement for a sale of Wheatley's work held at Greenwoods on 5 May 1785. This ran 'A collection of beautiful high-finished Drawings from Marmontel's Tales &c &c chiefly intended for publication, being the property and mostly the works of that ingenious artist, Mr F. Wheatley.' Yet of the 72 lots, nearly all were landscapes and only two of the drawings were illustrations of Marmontel (see Appendix II). Wheatley made

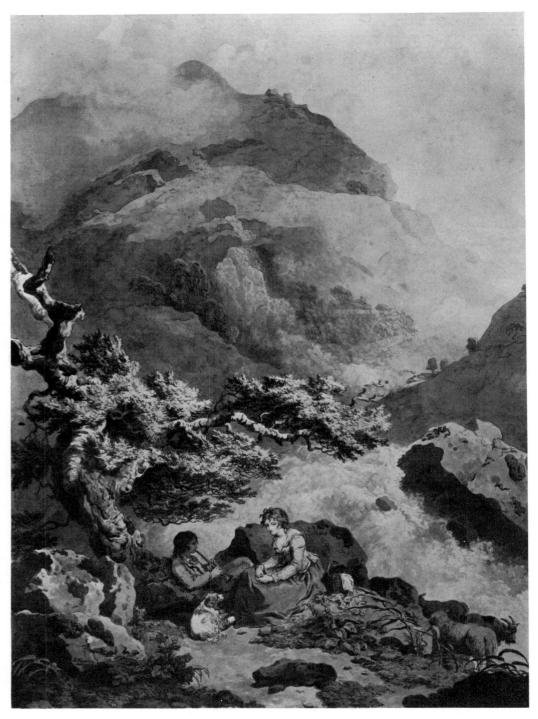

Fig 72 Francis Wheatley *Adelaide and Fonrose*
from *The Shepherdess of the Alps*
Signed and dated F.Wheatley/delt.1786
Water-colour $20\frac{1}{4} \times 25\frac{1}{4}$ in/ 51.4 × 38.7 cm
British Museum, London

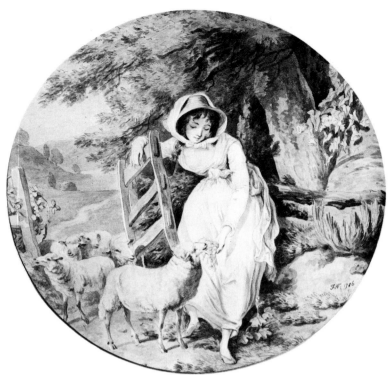

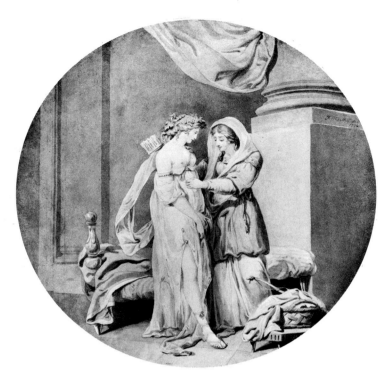

Fig 73 Francis Wheatley *Adelaide, The Shepherdess of the Alps*
Initialled and dated F:W:1786
Water-colour 12¼ in/ 31 cm diameter
Trustee of First Lord Brocket Will Trust

Fig 74 Francis Wheatley *Samnite Marriages*
Signed and dated F.Wheatley delt./1788
Water-colour 12 in/ 30.5 cm diameter
Mr Robert Halsband see **E41**

several illustrations to the *Shepherdess of the Alps* [Figs 72,73,**48**], the tale most
frequently chosen by artists. The *Four Phials* [**E42**] and the *Samnite Marriages*
[Fig 74] derive from Angelica Kauffmann's classical style. Marmontel's tales do
in fact contain some quite sharp sketches of contemporary Parisian life, but these
were hardly ever selected for illustration, though Wheatley did choose one –
The Gold-finch [**E56**]. It was the highflown sentimental subjects which appealed,
either pastoral, or pastoral-moral, or pastoral-sentimental or moral-sentimental.
Marmontel derived such themes from Rousseau and it is not surprising to find
that *St.Preux and Julia* at Meillerie is a water-colour of a celebrated scene from
Rousseau's *La Nouvelle Héloise* in which sublime emotions are expressed against
a background of sublime scenery. *St.Preux and Julia* at Meillerie [Fig 69] shows
the emotions of the two figures as they stand at the edge of a rock with dashing
alpine torrents below and high overhanging crags and trees. Rousseau was much
less generally popular in England than the blameless Marmontel, for he was
identified with moral, social and educational ideas which inspired sublime en-
thusiasm in his devotees, but repelled or estranged most of the English public.
It is significant that the only work by Rousseau laid under contribution by
English artists was *La Nouvelle Héloise*, whose passionate sentimentality and
delight in the beauties of nature were acceptable to a public which found

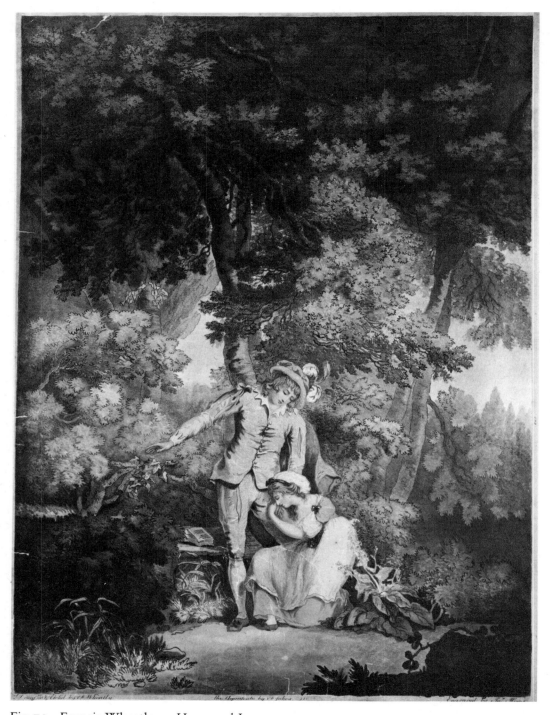

Fig 75 Francis Wheatley *Henry and Jessy*
Etched by F.Wheatley, engraved by J.Hogg, Aquatint by F.Jukes $21\frac{3}{4} \times 15\frac{3}{4}$ in/ 55.2 × 40 cm
British Museum, London **E6**

Fig 76 Francis Wheatley *A Lover's Anger*
Water-colour $12\frac{3}{8}$ × 10 in/ 31.5 × 25.5 cm
Colonel Sir Ralph Clarke KBE see **E27**

Rousseau's deism intolerable and his political and social opinions eccentric. Wheatley made a pair to this water-colour, *Henry and Jessy* from Shenstone's *Elegy* (XXVI) 'The Chase of Jessy' [Fig 75]. It is impossible to be certain whether Wheatley really felt that this rustic love story was a perfect match for a novel which changed the sensibility of Europe, but if he did so then his interpretation of the duties of an illustrator must seem to modern taste unduly decorative.

Wheatley continued to work in the genre of literary subjects until the end of his life. The rest of his themes were taken from English literature. Many of the books from which he chose subjects are still celebrated, even if others have proved hard to identify. They include Clara Reeve, *The Old English Baron* [**E145**]; Sterne, *A Sentimental Journey*; Prior, *A Lover's Anger* [Fig 76] and *To a Young Gentleman in Love*; James Fennell, *Lindor and Clara, or, the British Officer* [**E192, 193**]. All the subjects of this type that he exhibited at the Royal Academy were taken from contemporary poetry: in 1790 he showed *Evening* from Cunningham, 1794 the *Redbreast* from Thomson's *Seasons* (Winter) and in 1800 two scenes from Goldsmith's *Deserted Village* [**E149,150**]. Such designs

were all surely intended to be engraved, though in one or two instances like *Evening* and the *Redbreast*, no print is known to have been made.

The edition which came out in the 1790s of *Bell's British Theatre*, a large collection in small format of classical and contemporary plays, had a new set of illustrations, including six title pages after Wheatley which were engraved in ornamental frames. Ornamental frames of this kind, an innovation of the last decades of the eighteenth century originating in designs by earlier engravers such as Gravelot, imposed a circular composition on the artist. Two of the paintings Wheatley executed for Bell, title pages to Goldsmith's *She Stoops to Conquer* [**87**] and Cibber's *The Careless Husband* [Fig 77] are in the Victoria and Albert Museum. The compositions of the other four are only known from the engravings [**E72,73,76,77**].

Fig 77 Francis Wheatley
The Careless Husband Oil on canvas
19½ in/ 49.5 cm diameter
Victoria & Albert Museum, London
86

Bourgeois Life

The fashion for dramatizing bourgeois life in moral terms was originally a literary fashion and was of English invention. The prototype of the genre, Lillo's play *The London Merchant: or The history of George Barnwell* (1731), which presents the themes of crime and reform in the life-history of an erring and repentant apprentice was translated into French and created a taste for *comédies larmoyantes*. At first much ridiculed in traditionalist aristocratic and literary circles the sensibility expressed in these – it might be described as a 'tear and a smile' – gradually made headway until it became an influential mode of feeling in the middle decades of the century. To give it freer expression, Diderot broke the rigid laws of the French theatre – the unities, the distinction between comedy and tragedy, the insistence on nobility of style and language. His first *drame* of bourgeois life, *Le fils naturel*, was played in 1757. In 1752 Rousseau had produced his opera *Le Devin de village* in which simplicity and innocence are led to the reward of true love. There was now a cult of tears and virtue, of sentiment and sensibility, very different from the directness, detachment and restraint of Chardin's monumental figures which preceded the new fashion. It made its debut in the fine arts in 1755 with *La Lecture du Bible* by Jean-Baptiste Greuze [Fig 78]. Greuze's pictures are the classic expression of this new mode of feeling and were to be imitated throughout Europe. The new pictorial taste was perfectly characterized in Diderot's comments on Greuze's *L'Accordée de Village* in the Salon of 1761: 'Le choix de ses sujets marque de la sensibilité et de bonnes moeurs.' Its salient feature is the selection of subject from the middle and lower ranks of life where, so Diderot and Rousseau taught, the simplicity and goodness and natural frankness of the human heart were to be found untainted by aristocratic luxury and cynicism. The incidents chosen invariably illustrate the best sentiments of our nature in full and touching play, unconstrained by the stiff etiquette of a polite society whose rigidity can only be realized with effort by an imagination educated after the emotional revolution of the mid-eighteenth century. Within this general category the subjects fall into two kinds. The first

Fig 78 Jean-Baptiste Greuze
La Lecture du Bible Line engraving
by P.F.Martensie 1759
16⅜ × 18⁷⁄₁₆ in/ 41.6 × 46.8 cm
British Museum, London

comprises the chief incidents of family life in village or town, always in bourgeois or peasant homes, as in *Le Retour du Laboureur* [Fig 79], occasionally with a dramatic heightening. Of the second kind are the scenes which show middle class virtues in relation to other elements of society. A favourite theme of these is charity relieving indigence as in Greuze, *La Dame Bienfaisante* [Fig 80] and later Wheatley's *The Benevolent Cottager* [Fig 81]. This mid–eighteenth century revolution, like the earlier revolution of Caravaggio, was directed against a *style noble* which had become inexpressive through repetition, and its *mot d'ordre* was a return to realism heightened by drama. Had Greuze been a Caravaggio in creative and technical powers, the importance of his art in breaking the cramping moulds of traditional subject matter might be more willingly recognized.

The new taste took little hold in England for some twenty years. Here the middle class preferred Hogarth's stern and unsentimental moralizings on the vices of the luxurious, seeing itself implicitly praised in satires on the aristocracy – *Marriage à la Mode* – or on the drunken poor – *Gin Lane*. In the end, painting

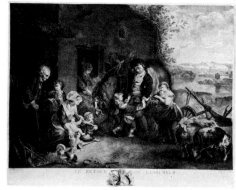

Fig 79 Charles Benazech
Le Retour du Laboureur
Line engraving by F.R.Ingouf 1781
$22\frac{1}{4} \times 26\frac{1}{4}$ in/ 56.5 \times 66.7 cm
British Museum, London

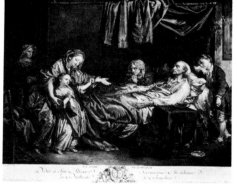

Fig 80 Jean-Baptiste Greuze
La Dame Bienfaisante
Line engraving by J.Massard 1778
$21\frac{1}{4} \times 24\frac{3}{4}$ in/ 54 \times 62.8 cm
British Museum, London

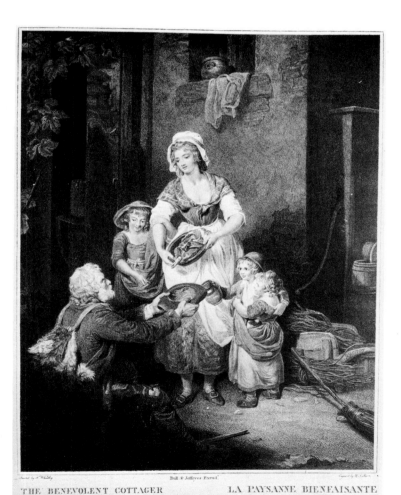

THE BENEVOLENT COTTAGER LA PAYSANNE BIENFAISANTE

Fig 81 Francis Wheatley *The Benevolent Cottager*
Stipple engraving by W.Nutter $20\frac{1}{2} \times 14\frac{1}{2}$ in/ 52 \times 36.8 cm
British Museum, London **E51**

67

lagged behind literature a little, not a matter for surprise in England. For Sterne's *Tristram Shandy* and *Sentimental Journey* [Fig 82], published between 1760 and 1768, were the first important English manifestations of the new cult of sensibility.

The new trend in French art was almost certainly made known here through prints; the work of Greuze and his imitators was much engraved. Although positive information about the importation of French engravings into England in the eighteenth century is tantalisingly scanty, books and all other kinds of scientific and literary information passed as a matter of course between London and Paris in that international age, when French was the universal language and Anglomania the universal fashion. Too many eighteenth century French books until recently filled the shelves of English country houses for their constant importation to be in doubt, and there can be little question that much the same was true of prints, and that their appearance here was little recorded simply because it was commonplace. Indeed shortly before his death Alderman Boydell was to write: 'When I first began business (*c* 1745), the whole commerce of prints in this country consisted in importing foreign prints, principally from France, to supply the cabinets of the curious in this kingdom. Impressed with the idea that the genius of our own countrymen, if properly encouraged, was equal to that of foreigners, I set about establishing a School of Engraving in England; with what success the public are well acquainted. It is, perhaps, at present, sufficient to say that the whole course of that commerce is changed, very few prints being now imported into this country, while the foreign market is principally supplied with prints from England.'[1] The extent of the two-way traffic in prints is confirmed by the appearance here of many engravings with titles in both English and French showing that the continental market was as important as the English one to London publishers. Wheatley's obituarist relates that 'On Mr. W's return to England he endeavoured to alter his manner, by copying Greuze, the French artist of much notoriety in domestic scenes; and in this sort of pursuit he has continued ever since. He appears to have imbibed the prejudices of Mr. Greuze so far as to give his low subjects the air of French peasantry. It is but bare justice to observe that Mr. W has infinitely more nature, as Greuze is hard and stony.'[2] As the obituarist says, the influence of Greuze pervades all Wheatley's later work, except in landscape and portraiture. Its importance demands that Wheatley's sole large-scale essay in the philanthropic genre, *John Howard Visiting and Relieving the Miseries of a Prison* [Fig 83], should be singled out for special mention. Painted in 1787, it shows the celebrated prison reformer John Howard listening to the tale of distress of a family whose aged father lies sick on a prison pallet. This figure is a straight imitation of Greuze, and the whole manner of grouping and of expressing incidental relationship is also reminiscent of the French artist. *La Dame Bienfaisante*, already cited [Fig 80], illustrates some points of comparison. *John Howard* was described as the 'best likeness of its amiable and Philanthropic Hero',[3] which since Howard allegedly always refused to sit for his portrait was an additional selling point for the engraving of the picture.

Fig 82 Angelica Kauffmann
Sentimental Journey
Stipple engraving by J.M.Delattre 1782
$14\frac{1}{4} \times 11\frac{7}{8}$ in/ 36.2 × 30.2 cm
British Museum, London

1 Letter from John Boydell to Sir John William Anderson 4 February 1804 in A.Chalmers *Biographical Dictionary* 1812 *sv* Boydell

2 *Gentleman's Magazine* 1801, p857

3 *Press Cuttings* albums, London, Victoria and Albert Museum, p566

68

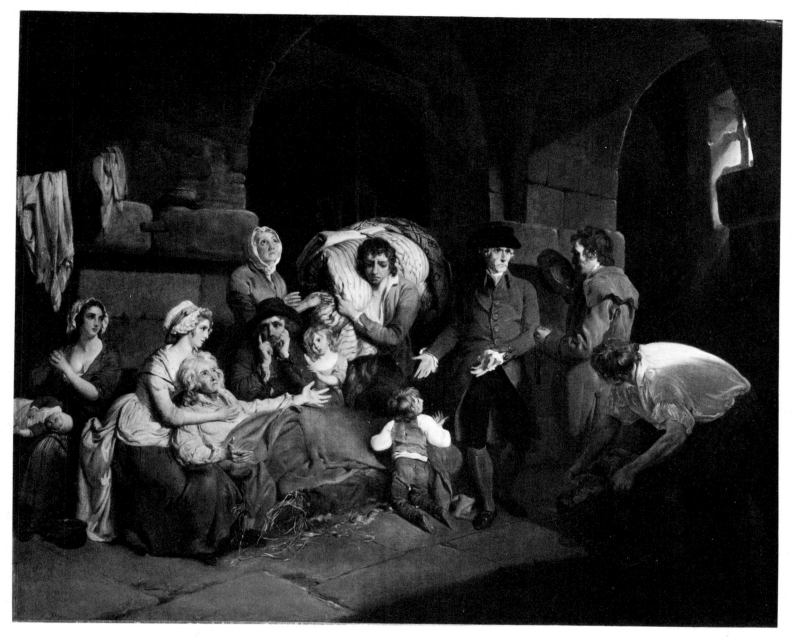

Fig 83 Francis Wheatley *John Howard Visiting and Relieving the Miseries of a Prison*
Oil on canvas 41 × 51 in/ 104.1 × 129.5 cm The Earl of Harrowby **57**

Fancy Pictures

It will already have become obvious that after Wheatley's return from Ireland in 1783 his work was profoundly modified by the changes in taste which had occurred in his absence. Yet another new genre which Wheatley found in full vogue was the fancy picture. In this line too most of Wheatley's work was probably produced with an eye to the engraver. The term fancy picture seems to have been used loosely even in the eighteenth century, but it is probably most exactly applied to genre paintings of a sentimental realism. Greuze again was the chief originator of many of the favourite themes of the fancy picture. His were amongst the first paintings of a *Girl with a Dead Bird* (Salon 1765) [Fig 84] and of girls nursing pigeons. In England other themes taken from rustic life were treated as fancy pictures. These rural subjects were really transpositions into a sentimental mode of the artificial pastoral themes of Boucher and his imitators, and were treated with much more realism than in France. Probably it was Philip Mercier [Fig 85] who first introduced French rococo pastoral into his adopted land. But so early as the 1750s Gainsborough was transmuting this decorative French style by closer observation of nature. When taste changed in the 1780s, Gainsborough's subjects at once became more akin in feeling to those which Greuze and other French *larmoyant* painters had been depicting for over twenty years. Such scenes of rural life with prominent groups of figures as *The Cottage Door* (1780) [Fig 86] and *Charity Relieving Distress* (1784) are designedly attuned to the demands of the cult of sensibility. Greuze and his French imitators of the 1760s and 1770s were a direct source of inspiration to Wheatley. The work of the brothers P.C. and F.R.Ingouf, pupils of the celebrated engraver J.J.Flipart, provides a conspectus of various sentimental subject pieces engraved after artists such as Greuze, Wille, Freudeberg and Benazech, reflecting the new taste with its cult of the domestic virtues and of the feelings, which Wheatley quickly adopted. But it was its sweetness rather than its intensity that he expressed; the sentiment is prettified out of any deeper sincerity. It is unlikely that Wheatley could ever have satisfied the cultivated Mrs Lock, wife of William, the great connoisseur, who wrote in 1789 to her friend Fanny Burney after William her eldest son had brought her back from London 'two fine prints of Greuze, *La vertu chancelante* and *La Malédiction Paternelle*. The first is very affecting. . . . I wish we had more painters of *Domestic Subjects*.'[1] Yet Wheatley hit almost at once upon formulas which became classic in the genre of the small-scale fancy picture and print, and which were obviously very successful with the large public that liked to be elegantly touched but not deeply stirred. Wheatley's first known composition of the fancy kind is *The Amorous Sportsman* [Fig 87], exhibited at the Royal Academy in 1785. Not surprisingly, this picture is less sentimental than those which followed it, and owes more to the traditions of French *galant* art in expression, gesture and a bared bosom.

The difference between this new manner of Wheatley's and his old can be seen in a drawing of a *Young Woman carrying a Sheaf of Corn*, signed and dated 1771 [Fig 88]. It is a portrait of a country girl standing in a landscape and is without a trace of the anecdote and sentimentality that characterize his work in the 1780s.

Fig 84 Jean-Baptiste Greuze
Girl with a Dead Bird Oil on canvas
20 × 18 in/ 50.8 × 45.7 cm
National Gallery of Scotland,
Edinburgh

Fig 85 Philip Mercier
The Oyster Girl Oil on canvas
36 × 28 in/ 91.5 × 71.2 cm
Mrs E.A.S.Houfe

1 Duchess of Sermoneta *The Locks of Norbury* 1940, p45

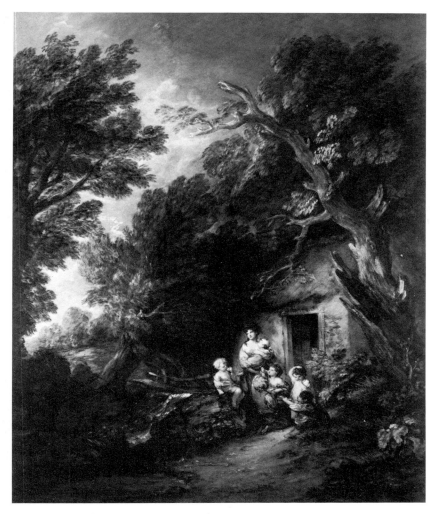

Fig 86 Thomas Gainsborough *The Cottage Door*
Oil on canvas 58 × 47 in/ 147.3 × 119.4 cm
Henry E.Huntington Library and Art Gallery
San Marino, California

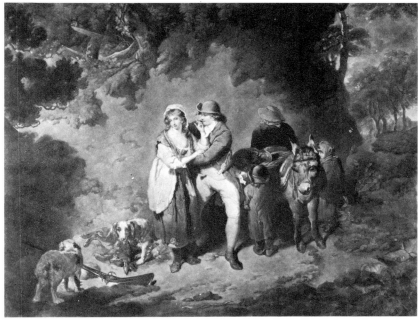

Fig 87 Francis Wheatley *The Amorous Sportsman*
Mezzotint by C.H.Hodges $17\frac{7}{8}$ × $21\frac{3}{4}$ in/ 45.3 × 55.2 cm
Mr and Mrs Paul Mellon **E29**

71

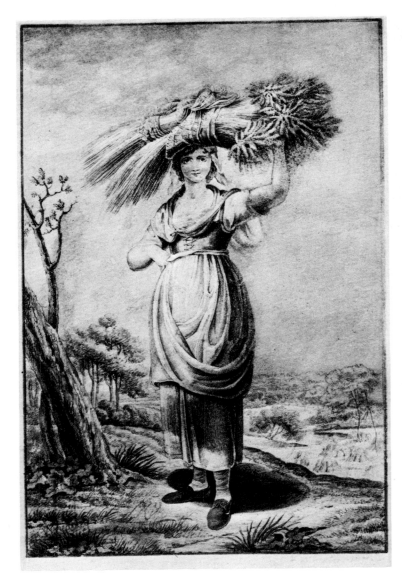

Fig 88 Francis Wheatley *Young Woman carrying a Sheaf of Corn*
Signed and dated F.Wheatley.1771 Pencil and grey wash,
heightened with white 14 × 10 in/ 35.6 × 25.4 cm
R.A.Paterson Esq

Fig 89 Francis Wheatley *Brickmakers*
Oil on canvas 16 × 23½ in/ 40.6 × 59.6 cm
Collection unknown **52**

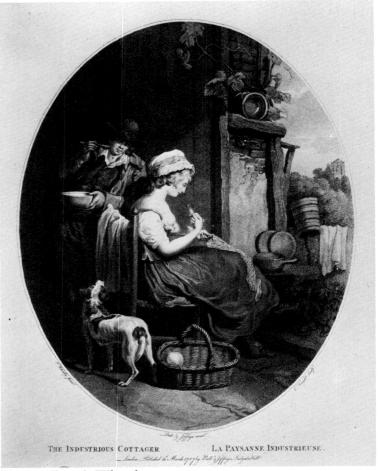

Fig 90 Francis Wheatley
The Industrious Cottager – Girl Making Cabbage Nets
Stipple engraving by C.Knight 18¾ × 15 in/ 47.6 × 38.1 cm
British Museum, London **53, E36**

72

The girl has not been prettified or given a slender waist and dainty pointed slippers; she is in the tradition of Gainsborough's early pictures of country people. The untraced *Wood Scene, with Gypsies Telling a Fortune*, exhibited at the Royal Academy in 1778, is more likely to have been in the style of Wheatley's Irish fair scenes than a true fancy picture.

In 1786 Wheatley exhibited two fancy pictures: *Brickmakers* [Fig 89] and *A Girl Making Cabbage Nets at a Cottage Door*; the latter was probably the picture engraved as *The Industrious Cottager* [Fig 90] a scene of virtue with an admixture of amorous interest. This, and a pair, *The Sailor's Return* [54] and *The Soldier's Return* [E39] of 1786, rather tear-jerking exercises in sensibility, were amongst the first fancy pictures after Wheatley to be engraved (1787). A pair of water-colours, sentimental in subject and decorative in composition, *Love in a Mill* [Fig 91] and *The Discovery* [Fig 92] are both coloured in brown and grey wash, with yellow, blue and russet details of costume. These too were engraved in 1787, along with two pictures, *The Love-Sick Maid* [E44] and *The Marriage*

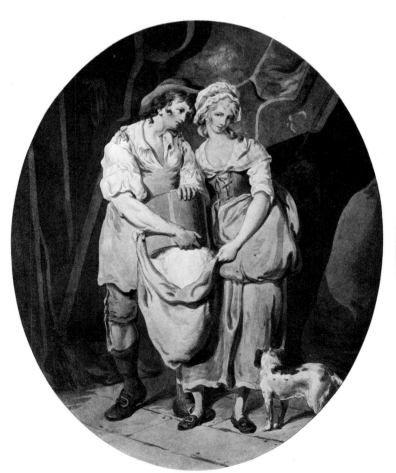 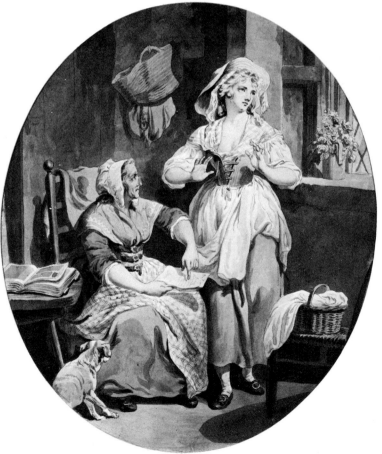

Fig 91 Francis Wheatley *Love in a Mill* Signed and dated: F.Wheatley delt:/1786
Water-colour $16\frac{1}{2} \times 13\frac{1}{2}$ in/ 41.9 × 34.3 cm oval
Collection unknown see E38

Fig 92 Francis Wheatley *The Discovery* Signed and dated F.Wheatley delt/1786 Brown and grey wash, and pen
$16\frac{1}{2} \times 13\frac{1}{2}$ in/ 41.9 × 34.3 cm oval
Collection unknown see E194

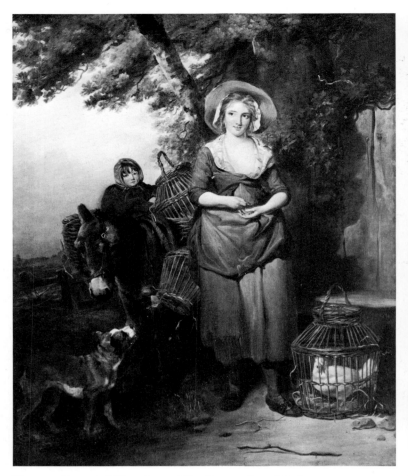

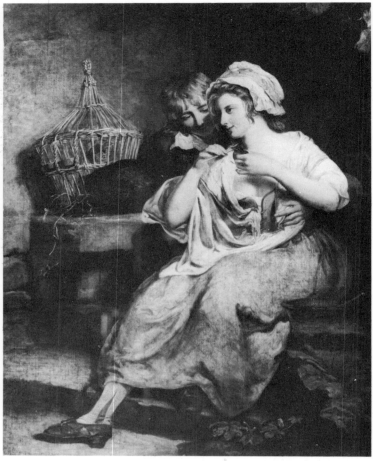

Fig 93 Francis Wheatley *The Return from Market*
Oil on canvas $29\frac{1}{2} \times 24\frac{1}{2}$ in/ 74.9 × 62.2 cm
Leeds City Art Galleries **55**

Fig 94 Francis Wheatley *A Girl feeding a Young Bird*
Oil on canvas $49 \times 64\frac{1}{2}$ in/ 124.5 × 163.8 cm
Private Collection, Germany **61**

[E45] from a series *The Progress of Love*, of which the other two were after George Morland, *Valentine's Day* and *The Happy Family*. *The Return from Market* [Fig 93] of 1786, shows a woman walking beside her child, who rides on a donkey, and counting her money as she comes home from the market. It is a clearly coloured and attractive composition. There is a freshness of approach to sentimental realism that gives a certain vigour and character to the early fancy pictures; it is lost in the later vapid productions, which are merely decorative and elegant. Already in 1787 the expressions have become weaker. *A Girl feeding a Young Bird* [Fig 94] is more broadly painted; the girl stares rather bemusedly into space, not looking at all at the bird she is holding. *The Recruiting Officer* [E47], now known only from the engraving, illustrates perfectly Gandon's remark that 'in his compositions of rural scenery all the female figures represented are uniformly beauties, and partake of an elegance and taste in appearance that made them an acquisition as furniture prints.'[1] In 1789 Wheatley exhibited two studies from nature. One is known to have shown a wheelwright's shop,

1 J.Gandon and T.J.Mulvany *The Life of James Gandon, Esq* 1846, p209

74

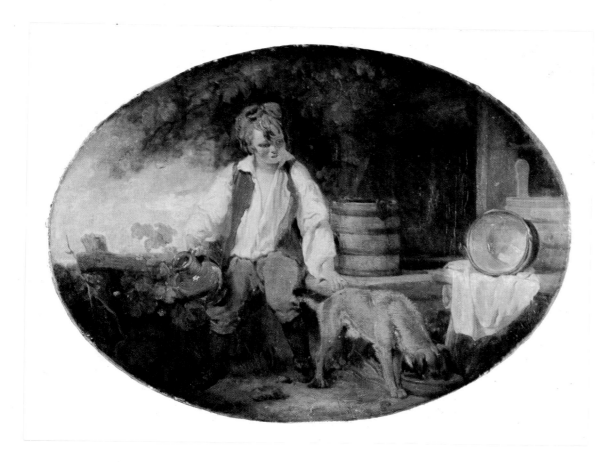

Fig 95 Francis Wheatley *A Peasant Boy* Oil on canvas $30\frac{1}{2} \times 41$ in/ 77.5×104.1 cm oval
The Royal Academy of Arts, London **76**

and it was because of this continuing interest in direct observation that Wheatley was able to give a convincing liveliness to the details of pots and pans, jugs, tables, chairs and to interior walls, often with peeling plaster which, following Greuze's example, are a feature of the backgrounds of the fancy pictures of the next few years. Wheatley's diploma work of about 1790, *A Peasant Boy* [Fig 95], shows such details in tones of brown, red and yellow, with a gleaming pan upturned on a white cloth. A series of four pictures of 1791, *Maidenhood, Courtship, Marriage* and *Married Life* [Figs 96–99] tells the moral story of the pursuit and attainment of happiness through prudence and industry; *The Pedlar* [Fig 100] of the same year points to the simple pleasures of rustic life. A number of these pictures were painted in pairs, presumably with a view to their sale as engravings – for example, *Morning* and *Evening – a farmyard* [see **E90,91**] exhibited in 1792; *Potter going to market with a Storm Approaching, morning* [see **E128**] the pair to *A Woodman Returning Home, Evening* [Fig 101] in Wheatley's sale of 13 January 1795; *Courtship* and *Matrimony* [**111,112**] *Going out Milking* and *The*

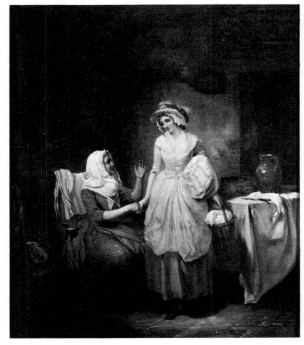

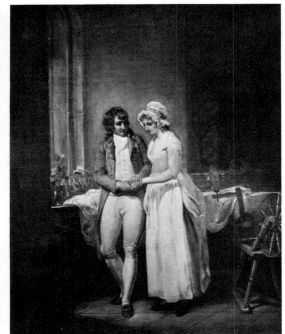

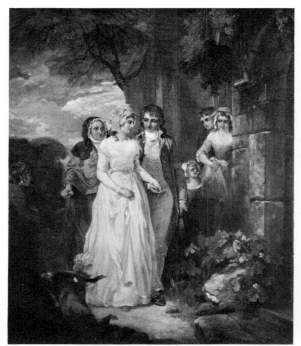

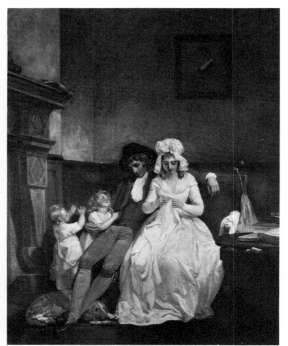

Fig 96 Francis Wheatley
The Maternal Blessing – Maidenhood
Oil on canvas $31\frac{1}{2} \times 26\frac{1}{2}$ in/ 80 × 67.3 cm
The Viscount Bearsted **88**

Fig 97 Francis Wheatley
The Offer of Marriage – Courtship
Oil on canvas $31\frac{1}{2} \times 26\frac{1}{2}$ in/ 80 × 67.3 cm
The Viscount Bearsted **89**

Fig 98 Francis Wheatley
The Wedding Morning – Marriage
Oil on canvas $31\frac{1}{2} \times 26\frac{1}{2}$ in/ 80 × 67.3 cm
The Viscount Bearsted **90**

Fig 99 Francis Wheatley
The Happy Fireside – Married Life
Oil on canvas $31\frac{1}{2} \times 26\frac{1}{2}$ in/ 80 × 67.3 cm
The Viscount Bearsted **91**

Fig 100 Francis Wheatley *The Pedlar*
Oil on canvas 20 × 25½ in/ 50.8 × 64.8 cm
Major Philip Godsal **85**

Fig 101 Francis Wheatley
A Woodman Returning Home, Evening
Oil on canvas 21½ × 17½ in/ 54.6 × 44.4 cm
Mrs Eleanor G.MacCracken **94**

Fig 102 Francis Wheatley *Going out Milking*
Oil on canvas 13½ × 11⅜ in/ 34.3 × 28.9 cm
Trustee of First Lord Brocket Will Trust **117**

Fig 103 Francis Wheatley
The Return from Milking
Oil on canvas 13½ × 11⅜ in/ 34.3 × 28.9 cm
Trustee of First Lord Brocket Will Trust **118**

Fig 104 Francis Wheatley *Children picking Apples*
Water-colour $18\frac{7}{8} \times 14\frac{1}{8}$ in/ 47.9 × 35.9 cm
Victoria & Albert Museum, London

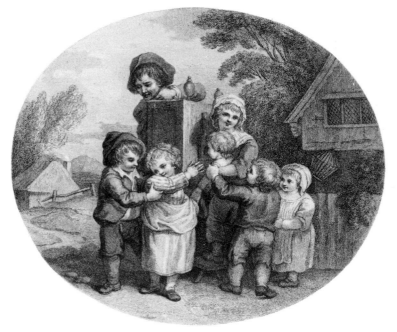

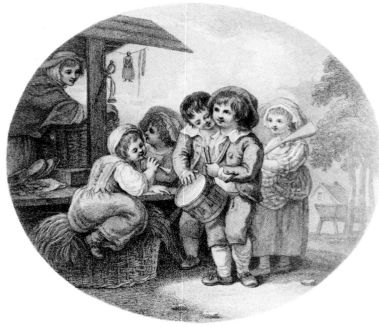

Fig 105 Francis Wheatley *The Show*
Stipple engraving by F.Bartolozzi
$7\frac{7}{8} \times 9$ in/ 20 × 22.8 cm oval
British Museum, London **E67**

Fig 106 Francis Wheatley *The Fair*
Stipple engraving by F.Bartolozzi
8×9 in/ 20.3 × 22.8 cm
British Museum, London **E66**

Return from Milking [Figs 102,103], both these last pairs probably dating about
1798. No rustic idyll is complete without a rosy cheeked child and Wheatley
makes use of the appeal of children in many of his country scenes, as in *Children
picking Apples* [Fig 104]; he also made a number of small drawings which were
engraved, of groups of children playing with all innocence, of which *The Show*
[Fig 105] and *The Fair* [Fig 106] are typical.

Wheatley's scenes of rural life were criticized even in his own day for their
affected sentimentality and unreal elegance. Anthony Pasquin exclaimed: 'When-
ever Mr.Wheatley presents us with a rural Nymph whom he wishes to be
peculiarly impressive, he decorates her head with a profusion of party coloured
ribbands, like a maniac in Coventry, which play in the breeze, offensive to
thought and propriety. As this is not the character of our village Daphnes, why
make them so prodigiously fine at the expence of truth?'[1] But these criticisms of
the connoisseurs must not be allowed to disguise Wheatley's immense success
with the general public, which had little interest in accurate description for its
own sake. His speciality became the scene of rural life, either exterior or interior.

Obviously it is worth inquiring into the reasons for the popularity of his work
in this vein. We have already seen that the tradition of populating a landscape
with rustic figures was by now well established in English painting. But the new
sensibility, with its worship of the natural affections unconstrained, led to a sort
of revived pastoralism in which rural innocence and the occupations of idealized

1 A.Pasquin *A liberal critique on the present
exhibition of the Royal Academy* 1794, pp31–2
in *Memoirs of the Royal Academicians* 1794

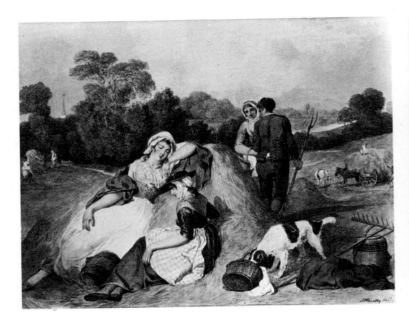

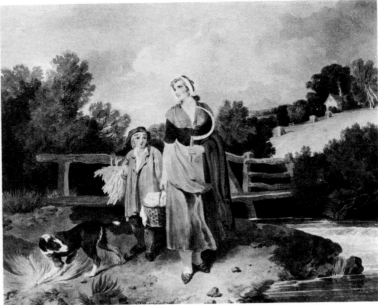

Fig 107 Francis Wheatley *Rural Repose*
Signed and dated F.Wheatley del.t 1798
Water-colour 10½ × 7⅞ in/ 26.5 × 20.1 cm
Albertina, Vienna see **E161**

Fig 108 Francis Wheatley *Returning from the Fields*
Signed and dated F.Wheatley del.t 1796
Water-colour 10 × 12 in/ 25.5 × 30.5 cm
Fine Art Society, London

country figures were exalted, often not without a certain sophisticated and in-
dulgent humour, for the edification of the town. Yet though Wheatley's figures
in these rural scenes [Figs 107–108], like those of his scenes of humble life in
towns, are highly prettified and often affected, and were castigated as such by
eighteenth century critics, it is important to realize how greatly they differ from
baroque and rococo pastoral, for they are neither allegorical, nor symbols of a
courtly convention, nor are they the mannered puppets of an erotic dreamworld.
Wheatley's embellishment of his subjects in designs for prints was undoubtedly
inspired by contemporary French prints, in which the *galant* elegance of the
rococo was still dominant, in spite of the new emphasis on sentiment. Yet if a
French print is compared with the *Amorous Sportsman* of Wheatley the great
difference in the degree of realism and of implied observation between the
Englishman and the Frenchman is at once apparent. Wheatley's rural scenes are
artificially worked up and agreeably flattered representations of country life,
but their foundation is direct observation. Rural life has been submitted to the
same process as rural landscape – nature has been improved. This may appear a
fine distinction for the pastoral mode has always been one of escapism: the in-
habitant of the town or the court flees from a world of stifling moral and physical
constriction, of falsehood and corruption, into a rural world of innocence, truth
and love. But what had become a mere convention in the previous half century
was now revitalized by a genuine longing for rustic simplicity. There is no need
to emphasize how little this vision of country life as seen through the rose

coloured spectacles of the town corresponded to the true facts of eighteenth century rural society. The disparity was denounced once and for all in 1783 by the young Crabbe, indignant at such insipid sentimentalities:

> 'I grant indeed that fields and flocks have charms
> For him that grazes or for him that farms;
> But when amid such pleasing scenes I trace
> The poor laborious natives of the place,
> And see the mid-day sun, with fervid ray,
> On their bare heads and dewy temples play;
> While some, with feebler heads and fainter hearts,
> Deplore their fortune, yet sustain their parts –
> Then shall I dare these real ills to hide
> In tinsel trappings or poetic pride?
> No; cast by Fortune on a frowning coast,
> Which neither groves nor happy valleys boast;
> Where other cares than those the Muse relates,
> And other shepherds dwell with other mates;
> By such examples taught, I paint the Cot,
> As Truth will paint it, and as Bards will not.'[1]

1 G.Crabbe 'The Village' *Poetical Works* II 1840, p76

Yet in spite of Crabbe's indignation and the sarcasms of the art critics, the extraordinary popularity of these subjects proves that the dream they expressed was widely shared. In a sense they are merely the classic late eighteenth century expression of that perennial longing of all civilized societies to have some form of escape from the rigid rules regulating behaviour and the expression of feeling they have invented for themselves. It is easy to smile now at Wheatley's tricked-out rustics in their tricked-out scenes, but the pastoralism they represent is certainly no more absurd intrinsically than the very different twentieth century pastoralism satirized in *Cold Comfort Farm*. Wheatley's sentimentality is certainly the sentimentality of 'tear and a smile', but both were as valued in his age for their own sakes as 'experience' is valued in ours. The real defect of much of Wheatley's work in this genre is not its sentimentality but its formal vapidity.

The Cries of London

By far the most famous of Wheatley's fancy subjects are *The Cries of London*, for so long the delight of collectors. The tradition of depicting itinerant merchants carrying their wares, captioned according to their cries, was already a long one by the end of the eighteenth century. The first known example, dating from *c* 1380, is French, a silver-gilt and enamelled *nef* belonging to Louis I Duc d'Anjou which was decorated with the street merchants of Paris crying their wares.[2] In England street cries have figured in ballads since the fifteenth century, beginning with the well known poem *London Lickpenny*. Woodcuts, single figures with a

2 *Inventaire de l'orfèvrerie et des joyaux de Louis I Duc d'Anjou* ed H.Moranvillé 1904–6, No689

Fig 109 Annibale Carracci
'*Vende Quadri*' from
Le Arti di Bologna Rome 1740
Etching by Simone Giulini
$10\frac{7}{8} \times 6\frac{5}{8}$ in/ 27.5 × 16.8 cm
British Museum, London

Fig 110 M.Lauron '*Buy my fat chickens*'
from *The Cryes of London*
Pen and grey wash over pencil
$8\frac{7}{16} \times 6\frac{1}{8}$ in/ 21¼ × 15.5 cm
R.E.Alton Esq

Fig 111 Paul Sandby *The Milkmaid Crye*
Water-colour $7\frac{3}{4} \times 5\frac{7}{8}$ in/ 19.7 × 15 cm
Mr and Mrs Paul Mellon

verse describing their wares beneath them had appeared in the sixteenth century and illustrated broadsheets of cries were common from the mid-seventeenth century. The series *Le Arti di Bologna* first engraved after Annibale Carracci in 1646 [Fig 109] are more imaginative and pictorial than the simple woodcuts issued in England, and were imitated both here and in France for the next hundred years. The elder Laroon's realistic single figures [Fig 110] stride across the page in their determination to sell their merchandise. Paul Sandby's *Cries* of 1760 are more decorative [Fig 111], but it was Wheatley who transformed *The Cries of London* into fancy pictures, grouping the figures into picturesque compositions. Once again his inspiration was French. The resemblances between *Les jolies crieuses* [Fig 112] an illustration by Binet for Restif de la Bretonne's *Les Contemporaines* published in 1783 are too close to be merely coincidence. And closer still are Greuze's *La Marchande de Marrons* [Fig 113] and *La Marchande de Pommes Cuites* [Fig 114]. Though scenes of vending rather than of crying, they undoubtedly influenced Wheatley's compositions in which the figures are seen against a background and in action. Of the fourteen small pictures of *The Cries of London* which were exhibited at the Royal Academy between 1792 and 1795, only two have been traced [Figs 115,116].

 The Cries of London have proved Wheatley's most lastingly popular work. Twelve of the pictures were engraved and published in pairs between 1793 and

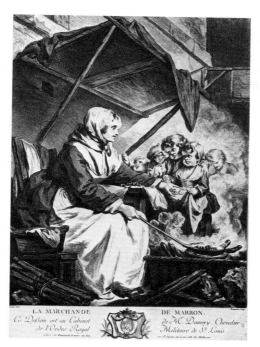

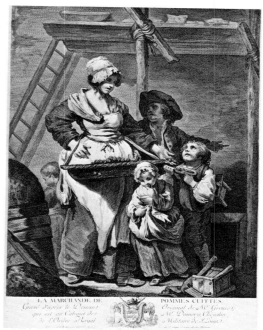

Fig 112 L.Binet *Les Jolies Crieuses*
Line engraving by Binet
$6\frac{1}{2} \times 3\frac{3}{4}$ in/ 16.5 × 9.5 cm
Restif de la Bretonne *Les Contemporaines* XXIX Leipzig 1783 Pl LXXI
opp p3 British Museum, London

Fig 113 Jean-Baptiste Greuze
La Marchande de Marrons Line engraving
by J.F.Beauvarlet after a drawing
exhibited at the Salon of 1761
$17\frac{1}{4} \times 13\frac{1}{8}$ in/ 43.9 × 33.3 cm
British Museum, London

Fig 114 Jean-Baptiste Greuze
La Marchande de Pommes Cuites
Line engraving by J.F.Beauvarlet
$17\frac{1}{4} \times 13\frac{3}{16}$ in/ 43.9 × 33.5 cm
Bibliothèque Nationale, Paris

1796, the thirteenth appeared in 1797, and the fourteenth, *Pots and Pans to Mend* [Fig 116] was not published until 1927. The prints were originally issued in both coloured and uncoloured sets by Colnaghi and sold at 16/– and 7/6 with a wrapper entitled *The Itinerant Trades of London in thirteen engravings, by the first artists, after paintings by Wheatley* [**E96,97,98,103,104,105,106,107,115,116,117, 122,123,131**]. The titles are given in both French and English, indicating, as observed above, a ready market on the continent. Sophisticated taste did not accept the absence of truthful portrayal in these subjects. Gillray made a visually acid comment [Fig 117] and Edwards condemned roundly: 'Wheatley's chief excellence was in rural subjects with figures, which when they represented females, generally bore a meretricious and theatrical air, as is very distinguishable in a set of prints representing the Cries of London, in which the women are dressed with great smartness, but little propriety, better suited to the fantastic taste of an Italian opera stage than to the streets of London.'[1] When interest in eighteenth century art revived towards the 1880s, Wheatley's *Cries of London* became highly prized, chiefly for decorative purposes, and by the beginning of the present century were cherished collectors' pieces. At Christie's in June 1901 a complete set fetched 1,050 guineas, and the highest price of all, £3,300, was paid at Sotheby's as late as June 1928. So much have the *Cries* been framed up as furniture prints that a complete set in good condition with the original wrappers

1 E.Edwards *Anecdotes of Painters* 1808, p269

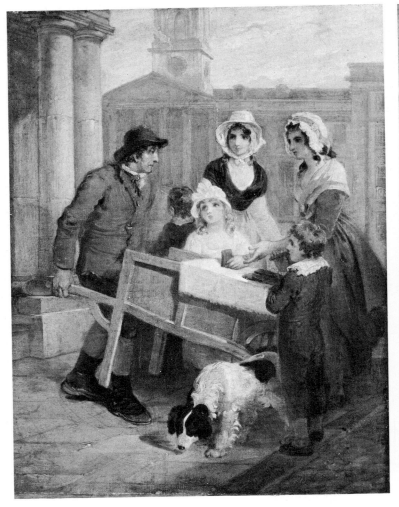

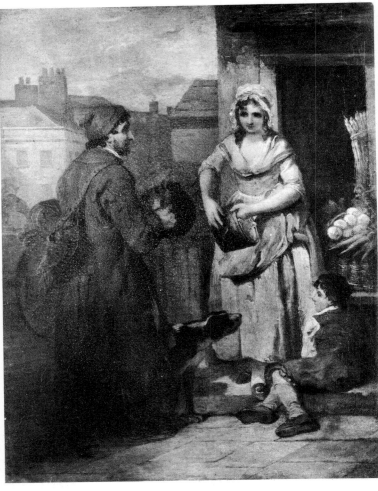

Fig 115 Francis Wheatley *Gingerbread*
Oil on canvas 14 × 11 in/ 35.5 × 28 cm
Private Collection UK **102**

Fig 116 Francis Wheatley
Pots and Pans to Mend Oil on canvas
$13\frac{3}{4}$ × $10\frac{1}{2}$ in/ 34.9 × 26.7 cm
The Viscount Bearsted **106**

is today a very great rarity. The great popularity of the series has meant that very large numbers of reprints and copies have been issued. Wheatley had learnt well what was required in the fancy genre and to judge from the modern copies with neat 'Hogarth' frames now on sale in aspiring department stores, he aimed accurately at those who require undemanding works of art to decorate their rooms. *The Cries of London* have been adapted to china and biscuit tins, to Christmas cards, waste-paper baskets and furnishing fabric, and those who wish can still purchase such versions.

How difficult now to perceive the attractions of works so hackneyed! It should be recognized that *The Cries of London* have above all a limpid elegance. Graceful compositions of a few figures are set in empty streets, and a classical balance is maintained between the figures and their setting. The accessories are treated with the same simplicity: there is not too much detail either of architecture or costume.

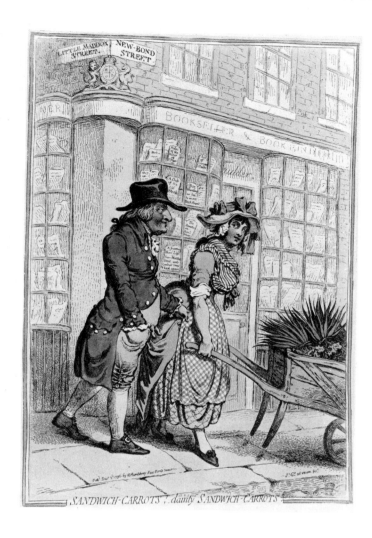

Fig 117 James Gillray *Sandwich-
Carrots! dainty Sandwich-Carrots*
Line engraving by J.Gillray
$13\frac{5}{8} \times 9\frac{3}{8}$ in/ 34.6 \times 23.8 cm
British Museum, London

Yet the settings are agreeably and picturesquely varied, showing either a fashion-
able eighteenth century house, a late medieval building – a first sight of what was
to become the Romantic fascination with ancient London – a church, a pair of
columns or a humble dwelling. Especially in the engravings with their stipple
technique there prevails a soft and harmonious arrangement of broad tones; the
original pictures have more of that light and gay sparkle so characteristic of
Wheatley's paint. Very deftly managed are the devices which transform the
compositions from the old single figure subjects – of the whole fourteen the
Match Seller [**E104**] is most nearly one of these – into fancy pictures. Sometimes
touches of local colour are introduced, like the chairman waiting for a fare in
Strawberries [**E116**], or there is an amusing amorous interest, as with the youth
who stares admiringly at the fair vendor of Turnips and Carrots [**E131**]. Then
the customers, children, fashionable ladies, carters, housemaids are artfully used
to vary the action and the interest. The popularity of the *Cries* sprang not only
from their artistic qualities but from the intense interest that the antiquarian
minded London of the late eighteenth century took in street cries and in collect-
ing the tunes of the cries.

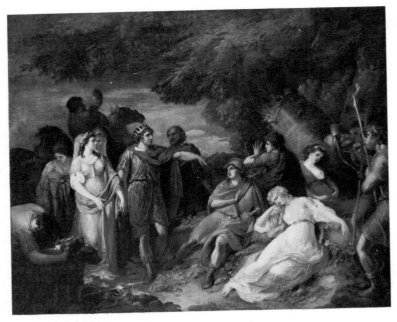

Fig 118 Francis Wheatley *Theseus and Hippolyta find the Lovers* from *A Midsummer Night's Dream*
Oil on canvas $77\frac{3}{4} \times 96$ in/ 197.5 \times 243.8 cm
Mr Lincoln Kirstein **65**

Fig 119 Francis Wheatley *The Taming of the Shrew*
Stipple engraving by I.P.Simon $19\frac{3}{4} \times 25$ in/ 49.2 \times 63.5 cm
British Museum, London **E108**

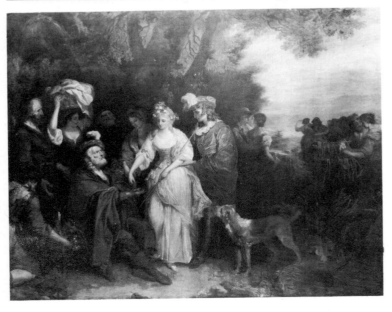

Fig 120 Francis Wheatley *The Winter's Tale*
Oil on canvas 84×105 in/ 213.2 \times 266.7
Theatre Royal, Drury Lane, London **64**

History Painting

The theory and practice of history painting became the subject of much eager discussion in England during the last three decades of the eighteenth century. Reynold's *Discourse* for 1771 is concerned with the principles of history painting: 'it is not enough in Invention that the Artist should restrain and keep under all the inferior parts of his subject; he must sometimes deviate from vulgar and strict historical truth, in pursuing the grandeur of his design.' It was the grand history painting of the Roman, Florentine and Bolognese schools, rather than the decorative history painting of the Venetian school that Reynolds tried to encourage. The subject should be lofty, the treatment generalized and great control should be exercised over the use of minuteness and particularity in invention, expression and colour. In spite of such theoretical encouragement and the possibilities opened by the Royal Academy for exhibiting history paintings – until the advent of public exhibitions artists had naturally not been anxious to paint elaborate pictures except to commission – the genre was still sickly in the mid-1780s. Its dismal condition was a frequent subject for criticism; 'I had observed with indignation that the want of (an English school of Historical Painting) had been long made a favourite topic of opprobrium against this country, among foreign writers on national taste' wrote Alderman Boydell at the end of his life.[1] And it became the Alderman's ambition to confound the reproach that the English 'had no genius for historical painting' for he felt that English painters wanted nothing but proper patronage and subjects, both of which he intended to supply. On voicing this ambition at a dinner in November 1786 where artists and literary men were present, Boydell received from John Nichols (1745–1826) the suggestion that the great national subject concerning which there could be no difference of opinion was Shakespeare, and accordingly the scheme of a Shakespeare Gallery was conceived. A prospectus was issued on 1 December 1786. The venture, into which Boydell put £350,000, involved the commissioning of two series of oil paintings of Shakespearean subjects, one large and the other small, from all the principal artists of the day, the building of a gallery for their permanent exhibition and the publication of engravings from the pictures. In June 1789 the exhibition opened with 34 pictures, of which three scenes – from *A Midsummer Night's Dream* [Fig 118], *The Taming of the Shrew* [Fig 119] and *The Winter's Tale* [Fig 120] – were by Wheatley. In the following

1 Letter from John Boydell to Sir John William Anderson 4 February 1804 in A.Chalmers *Biographical Dictionary* 1812 *sv* Boydell

year thirty-three more paintings were added, two by Wheatley – from *The Tempest* [Fig 121] and *All's Well that Ends Well* [Fig 122]. Wheatley painted thirteen pictures for the Shakespeare Gallery. In 1790 the first prints for the Shakespeare Gallery were published: twelve of Wheatley's pictures were eventually engraved.

Wheatley's paintings for the Gallery were largely of elegant and graceful figures tastefully grouped. He was not alone in depicting Shakespeare thus – William Hamilton (1751–1801), an almost exact contemporary, much of whose work runs parallel to Wheatley's own, was likewise essentially decorative in his approach to history painting. Following Reynolds's injunctions about general ideas, Wheatley used gesticulation rather than expression to indicate action, and there is no marked characterization. The first pictures Wheatley painted were for the large series. *Theseus and Hippolyta* from *A Midsummer Night's Dream* [Fig 118] shows an awareness of the formulae of baroque history painting; the main figures are dramatically posed; the huntsmen are identified by their ruddy colouring. Humphrey Repton's comment on this picture is true of most of Wheatley's history painting: 'The subject is made interesting by the beauty of the Female Figures and that surely will be allowed by those who can see nothing else to praise in this performance.'[1] He observed of *The Taming of the Shrew* [Fig 119], now known only from the engraving, 'that nothing is so difficult as to preserve beauty with an angry face; yet Katherine is here a vixen without being ugly: it was a dangerous experiment.'[2] Wheatley then was here attempting a spirited interpretation, within Reynolds's framework of rules, of the scene in which Petruchio takes Katherine away from Baptista's house. The third picture exhibited in 1789, the scene from *The Winter's Tale* [Fig 120] is an ornamental rather than a history picture: the old man is reminiscent of Wheatley's *Charity relieving distress* pictures, Florizel in his shepherd's clothes and Perdita are overdressed rustics. Yet Repton felt that the landscape, the group in the background of the pedlar selling his wares and the young countryfolk dancing made this 'by far the best Picture of the three painted by this Artist.'[3] The following year, 1790, *Ferdinand and Miranda playing at Chess* [Fig 121] from *The Tempest* was praised by an anonymous critic for its breadth of tasteful composition, expression and colouring. The scene from *All's Well that Ends Well* [Fig 122] was described in an auctioneer's words as being one of Wheatley's 'most capital pictures, finely composed and drawn, and painted in a rich and harmonious tone of colouring.' This praise was borne out by the price it fetched at the sale of the Shakespeare Gallery.[4] All these pictures are anecdotal rather than heroic compositions and the spectator is always uneasily conscious of Wheatley's fancy pictures when looking at them. Yet like so many late eighteenth century history paintings they have an undeniable interest as prototypes of an important genre of Romantic art. They show for example that steady trend to greater accuracy and detail in the representation of historical costume which became so marked during the second half of the eighteenth century as English interest grew in the medieval and Renaissance past. In contemporary French art, figures from European history were invariably attired in the costume of Frans Hals, whatever their true period, and the vague draperies and stage helmets of the Baroque were still the ordinary costume of classical or mythological figures.

1 H.Repton *The Bee; or a Companion to the Shakespeare Gallery* 1789, p24 NoXI

2 H.Repton *The Bee; or a Companion to the Shakespeare Gallery* 1789, p29 NoXV

3 H.Repton *The Bee; or a Companion to the Shakespeare Gallery* 1789, p33 NoXVIII

4 Christie's 20 May 1805 [37] £54.12.0

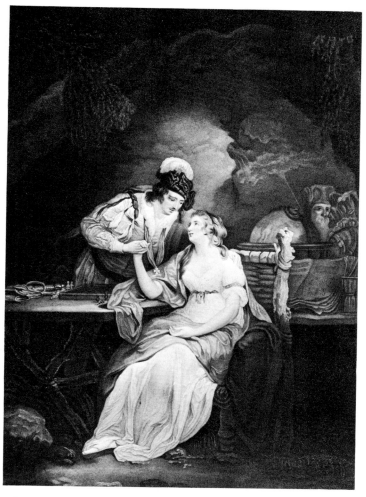

Fig 121 Francis Wheatley
The *Tempest. Ferdinand & Miranda playing at Chess*
Mezzotint by Caroline Watson $22\frac{3}{8} \times 16\frac{3}{8}$ in/ 56.8 × 41.6 cm
Mr and Mrs Paul Mellon **E119**

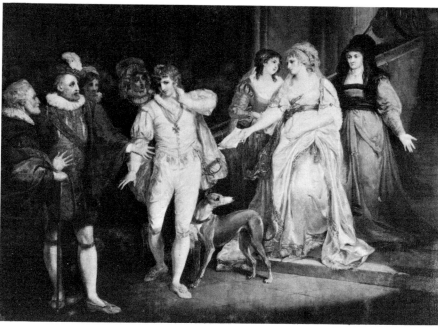

Fig 122 Francis Wheatley
All's Well that Ends Well, Act V, Scene 3
Oil on canvas $75 \times 88\frac{3}{4}$ in/ 190.5 × 225.5 cm
Collection unknown **72**

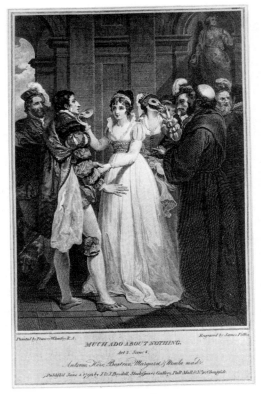

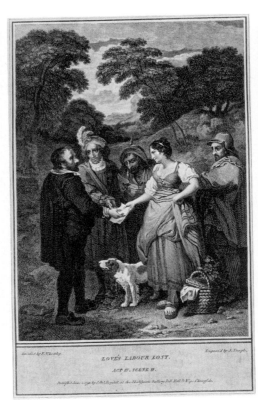

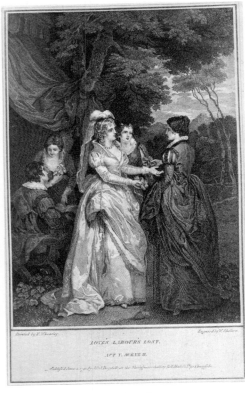

Fig 123 Francis Wheatley
Much Ado about Nothing, Act V, Scene 4
Line engraving by James Fittler
16⅝ × 13¼ in/ 42.2 × 33.6 cm
British Museum, London **E114**

Fig 124 Francis Wheatley
Love's Labour Lost, Act IV, Scene 2
Line engraving by J.Neagle
16⅝ × 13¼ in/ 42.2 × 33.6 cm
British Museum, London **E93**

Fig 125 Francis Wheatley
Love's Labour's Lost, Act V, Scene 2
Line engraving by W.Skelton
16⅝ × 13¼ in/ 42.2 × 33.6 cm
British Museum, London **E94**

 The smaller pictures Wheatley painted for the Shakespeare Gallery (Figs 123–
128] all show characteristics similar to those already described, with the excep-
tion of *The Rescue of Aemilia and the Infants* from *The Comedy of Errors* [Fig 128].
This is an attempt at a historical painting in the Grand Manner. The figures are
on an heroic scale, and dominate the composition in the approved fashion. Two
men are borrowed from Raphael's *The Miraculous Draught of Fishes* and the
female figure from Poussin's *Plague*. Well composed and attractively coloured
in blues, greens, whites and browns, the hair of the two men dramatically black,
this successful essay proves that Wheatley was capable of painting movement
and action with unexpected dignity and without taint of sentimentality.
 Two other ventures to support history painting followed Boydell's Shake-
speare Gallery. Thomas Macklin founded the Poet's Gallery in 1787. For this
Wheatley painted a scene from *The Deserted Village* [**E112**] by Goldsmith and an
illustration to *The Schoolmistress* [**93**] by Shenstone; both were subsequently en-
graved. Such scenes were of course much more in Wheatley's normal vein. In
1792, Robert Bowyer planned a similar project to illustrate Hume's *History of*

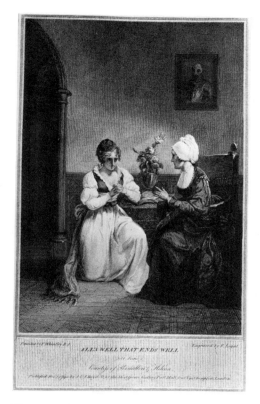

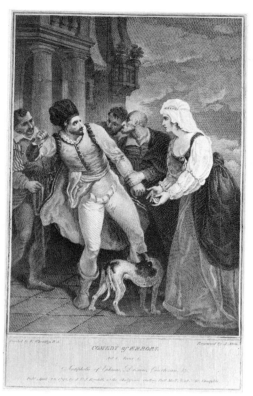

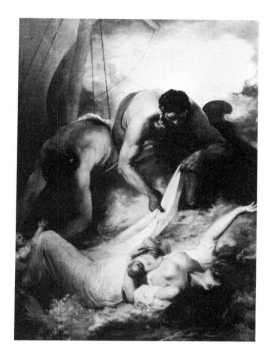

Fig 126 Francis Wheatley
All's Well that Ends Well, Act I, Scene 3
Line engraving by F.Legat
$16\frac{5}{8} \times 13\frac{1}{4}$ in/ 42.2 × 33.6 cm
British Museum, London **E118**

Fig 127 Francis Wheatley
Comedy of Errors, Act IV, Scene 4
Line engraving by J.Stow
$16\frac{5}{8} \times 13\frac{1}{4}$ in/ 42.2 × 33.6 cm
British Museum, London **E134**

Fig 128 Francis Wheatley
*The Rescue of Aemilia and the Infants
Antipholus and Dromio of Ephesus from
Shipwreck* from *The Comedy of Errors*
Oil on canvas
$30\frac{1}{2} \times 21\frac{1}{2}$ in/ 77.5 × 54.6 cm
The Royal Shakespeare Theatre,
Stratford-upon-Avon **105**

England; part of the money for this project was put up by Benjamin Bond
Hopkins whose portrait Wheatley painted [Fig 142]. For Bowyer, Wheatley
painted two pictures which were subsequently engraved. *Alfred in the House of
the Neatherd* [Fig 129] is simply the usual rustic interior with large-scale figures;
only from the pains taken to give expression, flowing hair and strange costume
can we suspect that we are confronted with an historical rather than a domestic
episode. In *The Death of Richard II* [Fig 130] Wheatley was more ambitious and
represented a mêlée of gentlemen in armour. This composition, now known
only from the engraving, met with hard criticism: 'If Mr Wheatley ever prays
we hope he will repeat in the words of the Litany "to be defended from all privy
conspiracy and rebellion, from battle and murder, and from sudden death".'[1]

All these attempts to encourage high art eventually proved failures. Their
financial viability depended upon selling engravings of the pictures abroad as
well as at home and the French Revolution was fatal to them. Boydell, Macklin
and Bowyer were all given parliamentary permission to run lotteries for the
disposal of their galleries early in the nineteenth century.

1 *Press Cuttings* albums, London, Victoria
and Albert Museum, p636 1793

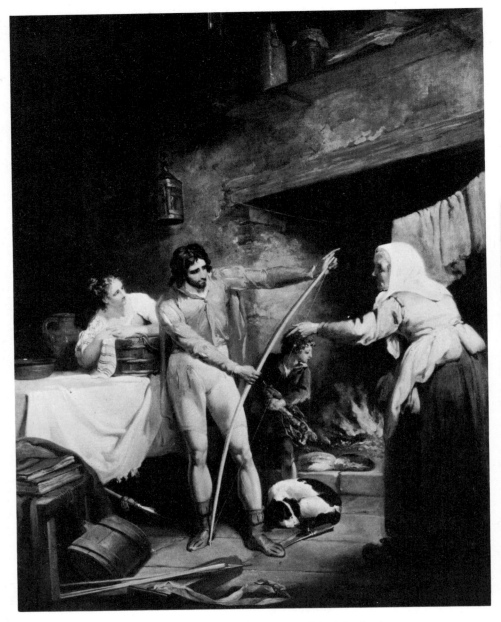

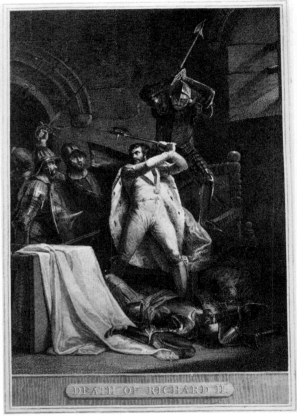

Fig 129 Francis Wheatley *Alfred in the House of the Neatherd*
Oil on canvas 79 × 59 in/ 206 × 149.8 cm
Collection Unknown **98**

Fig 130 Francis Wheatley *The Death of Richard I*
Line engraving by A.Smith
18½ × 13⅛ in/ 47 × 33.3 cm
British Museum, London **E110**

Later Landscapes and Portraits

Wheatley continued to produce many landscapes after his return to England [Figs 131-137]. In 1784 he went on an expedition to the north of England to make a series of drawings which were subsequently engraved in the *Copper Plate Magazine*. In the second half of the 1790s Wheatley executed for Mr Chamberlain a number of large landscape water-colours now at Cranbury Park. These fine water-colours are the best surviving examples of Wheatley's ability to treat landscape atmospherically. Country people compose themselves into picturesque groups, the trees have softened into rounded shapes, cows and sheep browse placidly on the gentle slopes and the jagged and inhospitable mountains in the distance only enhance the limpid tranquillity of the foreground. Unreal though these compositions undeniably are, there is something very attractive in

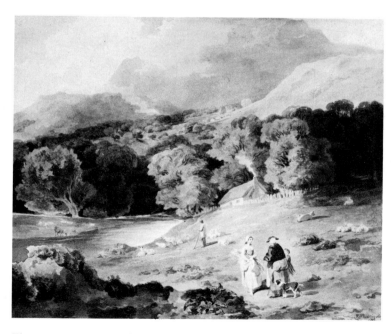

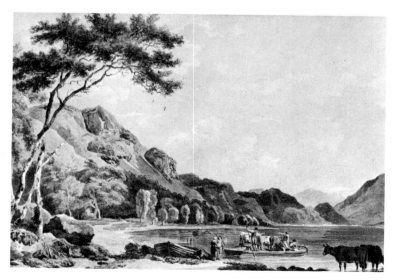

Fig 131 Francis Wheatley *Landscape with Figures near a River*
Signed and dated F.Wheatley delt/1795
Water-colour 11½ × 14 in/ 29.25 × 35.5 cm
The Royal Academy of Arts, London

Fig 132 Francis Wheatley *Lake Scene with Ferry*
Initialled and dated FW 1788
Water-colour 12⅛ × 18¾ in/ 30.75 × 47.5 cm
Leeds City Art Galleries

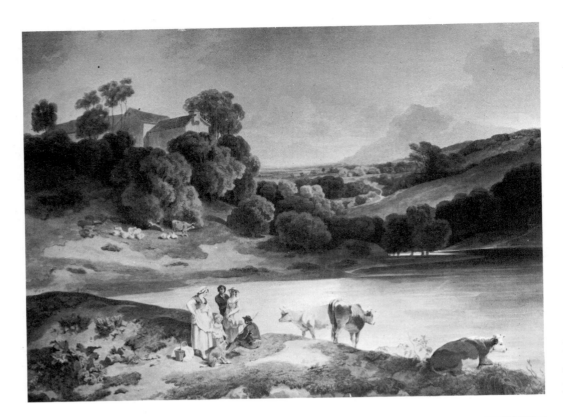

Fig 133 Francis Wheatley
Group of Figures by a Lake
Water-colour 36 × 26 in/ 91.4 × 66 cm
Mrs Chamberlayne Macdonald

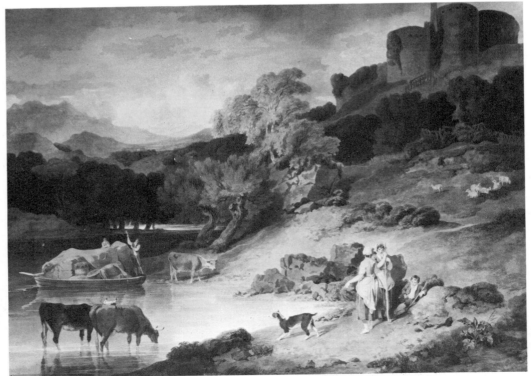

Fig 134 Francis Wheatley
Group of Figures by a Lake below a Castle
Water-colour 37 × 26 in/ 94 × 66 cm
Mrs Chamberlayne Macdonald

94

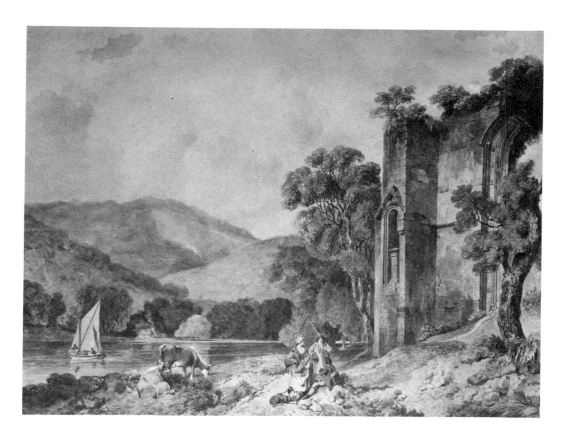

Fig 135 Francis Wheatley
Lake Scene with Ruins
Signed and dated F.Wheatley delt.1798
Water-colour
$14\frac{1}{2} \times 18\frac{3}{4}$ in/ 136.8 \times 147.5 cm
With M.Bernard in 1969

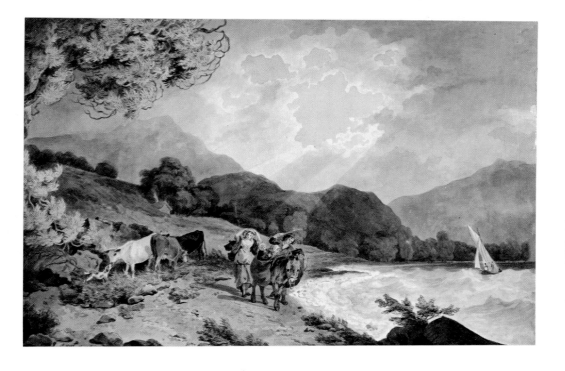

Fig 136 Francis Wheatley
Figures Walking beside a Lake
Signed and dated F.Wheatley delt. 1798
Water-colour
$18\frac{5}{8} \times 11\frac{3}{4}$ in/ 47.2 \times 29.7 cm
Albertina, Vienna

Fig 137 Francis Wheatley *View near Keswick* Signed and dated F.Wheatley 1784
$10\frac{1}{2} \times 15\frac{3}{8}$ in/ 26.7 × 39.1 cm Victoria & Albert Museum, London
see **E33**

Fig 138 Francis Wheatley
Group of Figures in a Landscape
Signed and dated F.Wheatley delt:1799
Water-colour $11 \times 8\frac{3}{4}$ in/ 28 × 22.2 cm
Mrs Chamberlayne Macdonald

their calm waters and fresh pastures on which a warm sun shines. But to compare these water-colours of the mid-1790s with a *Group of Figures in a Landscape* [Fig 138] drawn at the end of his life in 1800 is to see a decline in Wheatley's skill. The difficulty Wheatley experienced during his last years in holding the brush is all too evident in the broad treatment of his late landscape water-colours. This is also true of his late figure studies, where the clear firm drawing and the clever use of light and shade have been lost in a more generalized statement. The loss is not only in line and colour, but in the impoverished rendering of character, expression and action. The old, surely touched in landscape backgrounds have disappeared into unlikely mountain peaks, roughly drawn trees and ill-placed church spires.

Throughout the period after his return from Ireland, Wheatley continued his practice as a portrait painter, exhibiting portraits at the Academy until 1795. He produced firmly drawn and clearly coloured likenesses. In the portrait of *Arthur Phillip* [Fig 139], vice-admiral and first governor of New South Wales,

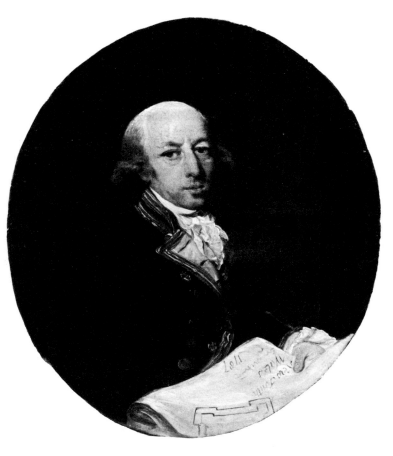

Fig 139 Francis Wheatley *Arthur Phillip* Oil on canvas 36 × 27¾ in/ 91.4 × 70.5 cm National Portrait Gallery, London **49**

Fig 140 Francis Wheatley *Arthur Phillip* Oil on canvas 11¹¹⁄₁₆ × 9¹¹⁄₁₆ in/ 29.7 × 24.6 cm The Mitchell Library, Sydney, NSW **50**

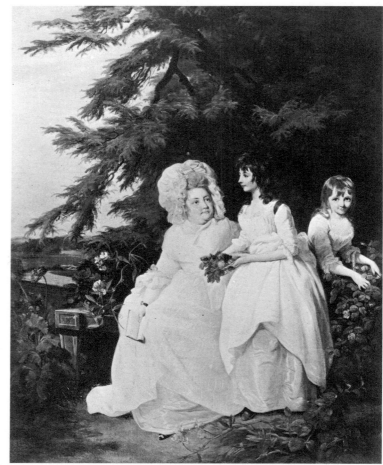

Fig 141 Francis Wheatley
Mrs Ralph Winstanley Wood with her Daughters
Oil on canvas 36 × 28½ in/ 91.4 × 72.3 cm
Henry E.Huntington Library and Art Gallery,
San Marino, California **58**

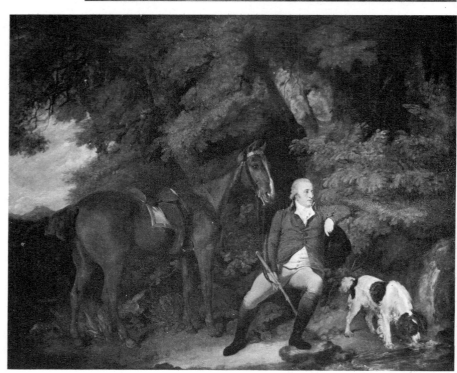

Fig 142 Francis Wheatley *Benjamin Bond-Hopkins*
Oil on canvas 39⅞ × 49⅝ in/ 100.3 × 126 cm
Fitzwilliam Museum, Cambridge **75**

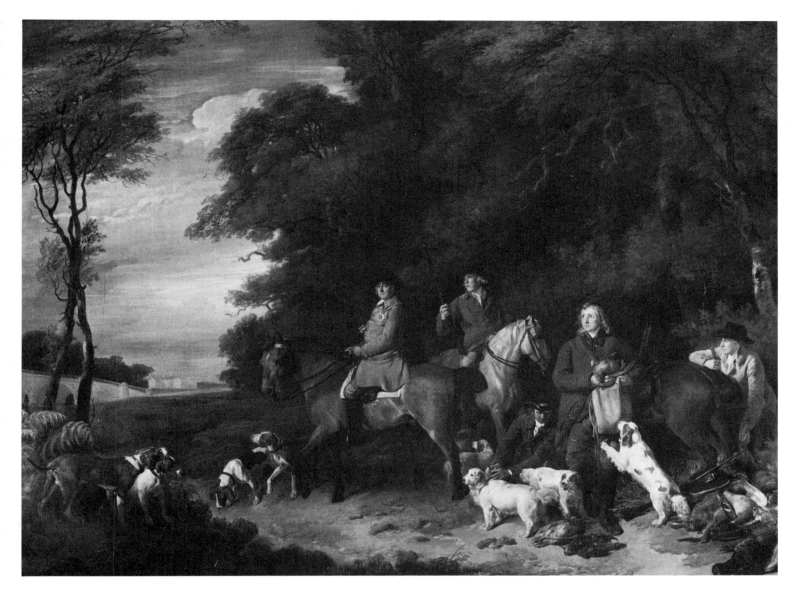

Fig 143 Francis Wheatley *The Return from Shooting* Oil on canvas $61\frac{1}{2} \times 82\frac{1}{2}$ in/ 156.2 × 209.5 cm
Trustees of the Seventh Duke of Newcastle, deceased **63**

the lively colouring has produced an attractive picture and Wheatley has achieved some indication of character in the determined face. A second portrait of Phillip [Fig 140] painted in the same year was engraved as the frontispiece to Phillip's *Voyage to Botany Bay*. The sitter is shown looking out to catch the interest of the spectator and to draw attention to the plan he holds. In the pair of portraits of *Mr* and *Mrs Winstanley Wood* [**59**, Fig 141] and their children, there is a more studied informality of pose and a greater spontaneity than in the conversation groups Wheatley produced before his Irish visit. The portrait of *Benjamin Bond-Hopkins* [Fig 142] with a horse and spaniel is a straightforward picture of a country gentleman.

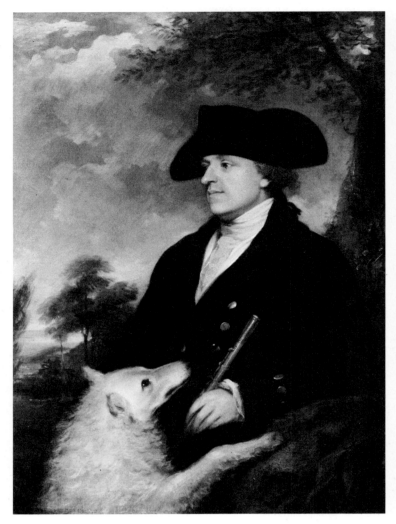

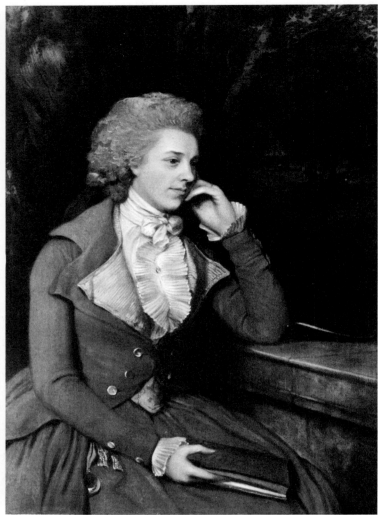

Fig 144　Francis Wheatley　*Captain Stevens*　Oil on canvas
26 × 18⅜ in/ 66 × 46.8 cm　Mr and Mrs Paul Mellon　**108**

Fig 145　Francis Wheatley　*Mrs.Stevens*　Oil on canvas
25⅞ × 18⅜ in/ 65.8 × 46.8 cm　Mr and Mrs Paul Mellon　**109**

The Return from Shooting [Fig 143] in which the Duke of Newcastle with Colonel Litchfield and others are seen in a wooded landscape with Clumber House in the distance appears to be Wheatley's last known essay in large-scale group portraiture. Painted in 1788, it shows the sure broad touch that Wheatley developed in the last years of the 1780s. His portrait style became broader and looser in the 1790s and in the portraits of *Captain* and *Mrs Stevens* [Figs 144,145] Wheatley posed his sitters for the now fashionable half-length. His last exhibited portraits were of his wife and of Mrs Monro (both untraced).

Marriage

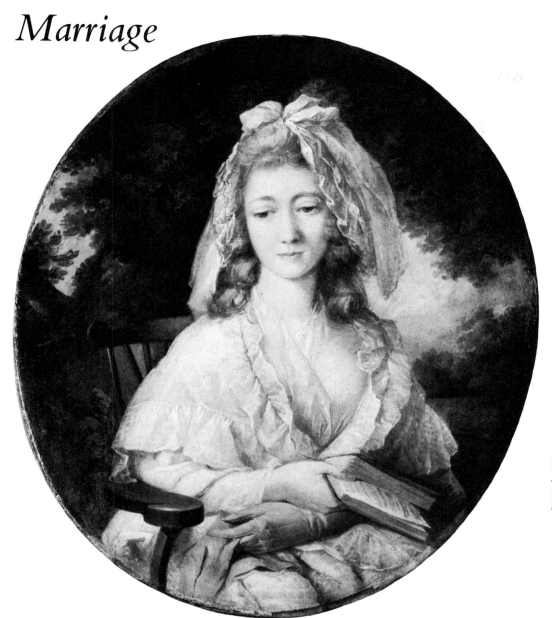

Fig 146 Francis Wheatley
Mrs.Wheatley Oil on canvas
$15\frac{3}{8} \times 13\frac{1}{8}$ in/ 39×33.3 cm oval
Mrs Barbara Brookes **62**

Wheatley's financial affairs presumably benefited from his large and successful output for he was able to embark on marriage with Clara Maria Leigh, daughter of Jared Leigh (d 1769), a proctor in Doctor's Commons and an amateur artist. Clara Maria is said to have married Wheatley at an early age, and certainly before 1788 when he exhibited a portrait of her as Mrs Wheatley at the Royal Academy [Fig 148]. In another charming portrait of the same year [Fig 146] she wears a white dress and a white cap with pink ribbons over light brown hair, and is seated against a background of brownish green and olive with a sky of pale blue

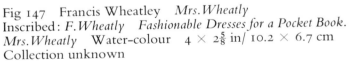

Fig 147 Francis Wheatley *Mrs.Wheatly*
Inscribed: *F.Wheatly Fashionable Dresses for a Pocket Book.*
Mrs.Wheatly Water-colour $4 \times 2\frac{5}{8}$ in/ 10.2 × 6.7 cm
Collection unknown

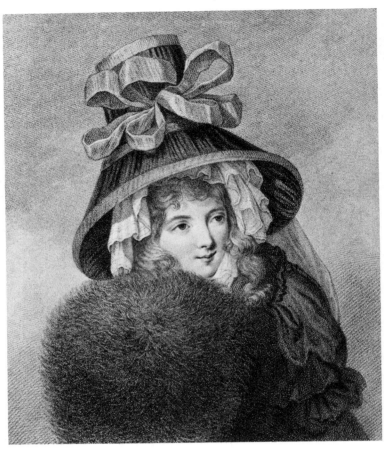

Fig 148 Francis Wheatley Mrs.Wheatley as *Winter*
Stipple engraving by F.Bartolozzi $9\frac{1}{2} \times 7\frac{1}{4}$ in/ 24.1 × 18.4 cm
Mr and Mrs Paul Mellon **E54**

and pinkish grey. There were four children of the marriage. According to Edwards[1] Clara Maria was Wheatley's second wife, but nothing is known of an earlier marriage. Mrs Wheatley became an artist in her own right. She taught drawing in order to make money during Wheatley's last years of ill health, and after his death to help provide for her children; she exhibited at the Royal Academy from 1796 until 1838, the year of her death. As Mrs Alexander Pope, she became well known as a flower painter.[2] In a pretty water-colour she is the model for a fashion plate [Fig 147], but of all Wheatley's portraits of her that which shows her as *Winter* wearing a tall, beribboned hat and holding a large muff [Fig 148] is the most delightful. It was engraved in 1789 as one of a set of the

1 E.Edwards *Anecdotes of Painters* 1808, p269

2 M.Webster 'A Regency Flower Painter, Clara Maria Pope' *Country Life* CXLI 1967, pp1246–8

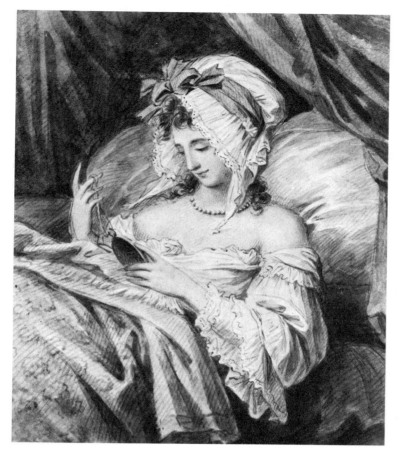

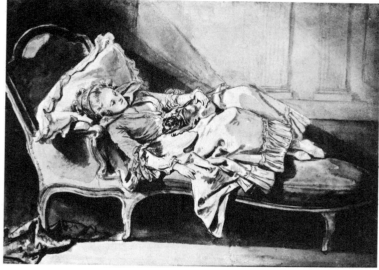

Fig 149 Francis Wheatley
The Miniature: a portrait of Mrs. Wheatley
Pencil and water-colour 1787-8 $8\frac{5}{8} \times 7\frac{1}{8}$ in/ 22 × 18 cm
British Museum, London

Fig 150 Jean–Baptiste Greuze *Madame Greuze*
Black stone, chinese ink, pen, plumbago
$13\frac{1}{2} \times 18\frac{1}{2}$ in/ 34.3 × 47 cm
Rijksmuseum, Amsterdam

Four Seasons. Mrs Wheatley [Figs 146-9] is said to have been the model for many of the country girls in Wheatley's fancy pictures, but she is responsible for their elegance, not for their insipidity. There is a notably French influence in the delicate, politely erotic sensibility to feminine charm in these pictures of Mrs Wheatley: Wheatley had obviously turned the work of Greuze [Fig 150] once more to advantage, though to a lesser extent than Matthew William Peters (1742-1814) whose portraits of *Lydia* (engraved 1776), *Belinda* (engraved 1777) and other ladies 'in an undress' met with considerable success and brought the artist much unwanted notoriety later in life.

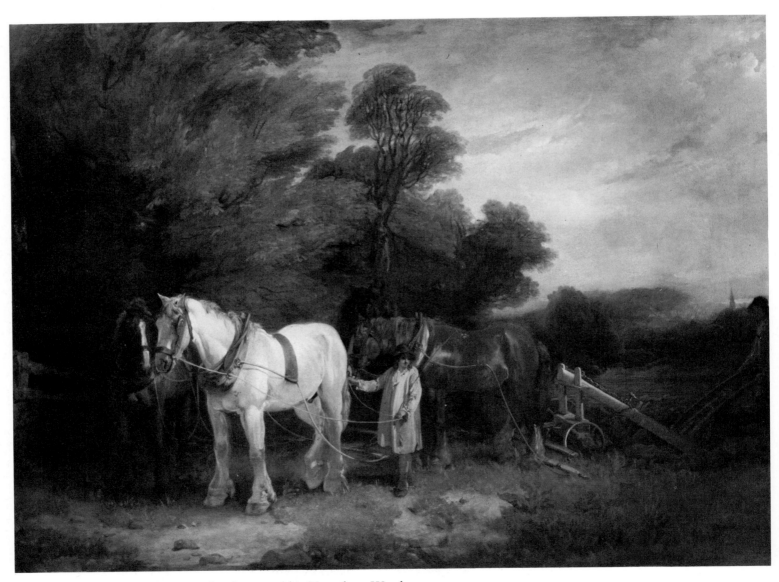

Fig 151 Francis Wheatley *A Ploughman and his Team by a Wood*
Oil on canvas 61 × 85 in/ 154.9 × 215.9 cm With M.Bernard in 1969 **107**

The Last Years

By the end of the 1780s Wheatley had become very well known and he had even achieved some celebrity through his work for Boydell which was generally admired. Betsy Sheridan singled out one of Wheatley's pictures for praise: 'Tuesday 19th May 1789. . . . to Shakespeare's Gallery. I liked some of the pictures very well, in particular two from the *Winter's Tale* – . . . by Wheatly when Polixenus and Camillo are in the shepherd's hut.'[1] His election to the Royal Academy was now thought to be overdue.[2] On 1 November 1790 Wheatley became an associate of the Royal Academy, having been successfully opposed to the royal candidate, Lawrence, who was below the minimum age, and on 18 February following, he was elected Royal Academician. In December 1794 he was appointed Visitor, a post for those competent in Academical Studies, to which Wheatley had been 'early bred'[3] and in which he retained a professional interest. He possessed 60 plaster casts after the antique which were included in the enforced sale of his effects at Christie's on 13 January 1795 (lots 41–43).

But in spite of these professional successes and this professional seriousness Wheatley's last years are mostly a wretched story of ill-health and debt, which is fully recorded in the diary of the landscape painter, Joseph Farington (1747–1821). Farington was a constant friend of the family and his concern for their welfare continued after Wheatley's death. By the end of 1793 Wheatley was seriously in debt and at a meeting of his creditors called in November it was agreed that there should be a sale of his effects, including his house and its contents. The sale took place at Wheatley's house, 14 Russell Place, Fitzroy Square on 12 and 13 January 1795 (Appendix III) with rather disappointing results. Farington tells us that 'the pictures sold low . . .'

During the last seven years of his life, Wheatley's health, which for many years had given him trouble, his biographers declare on account of youthful excesses, began to deteriorate seriously: he suffered repeated and lengthy attacks of gout which deprived him of the use of his hands for weeks at a time. In 1796 his eyesight became troublesome and he was not able to 'touch small parts witht. glasses.'[4] In July 1796 when his physician, Dr Pitcairne, advised a cure at Bath, Wheatley applied for the assistance of the Royal Academy. On 9 July Farington wrote 'Wheatly I called on this morning, and recd. from Mrs. Wheatly

1 *Betsy Sheridan's Journal* ed W.LeFanu 1960, p159, 19 May 1789

2 *Press Cuttings* albums, London, Victoria and Albert Museum, p524, 1789

3 Windsor, Royal Library *The Farington Diary* transcript 10 December 1794 and 10 December 1795

4 Windsor, Royal Library *The Farington Diary* transcript 17 July 1796

his Petition to the Academy. She said He was very low last night at the thought of applying for money.' The motion was proposed by Farington at the Academy Council meeting on the same day and it was resolved unanimously that one hundred guineas be given to Mr Wheatley.[1] Wheatley left for Bath in the second half of July, remaining there until the spring of 1797. The Bath waters seem to have improved his health for a time, but in July 1797 he was taken ill 'after an interval of eleven weeks, which has not been the case before in 3 years.'[2]

Now too he was in debt again, having been arrested at Bath, and had put himself into the King's Bench. Farington, who spent much time in persuading members of the Academy to come to Wheatley's assistance, records that his debts to fellow artists were considerable and long-standing. In May 1797 he owed Byfield 6 guineas, Hoppner 8 guineas, Groves 25 guineas, Perry 30 guineas and Tresham about 50 guineas. Not surprisingly there was a feeling that Wheatley was unprincipled and had thrown himself into the King's Bench in order to force contributions from artists.[3] Farington found it difficult to raise a subscription on his behalf – 'went . . . to Cosway, who wd. give nothing to W. as an Artist but a guinea as a distrest man, – to Richards twice, "who wd. give nothing to save him from starving." Sir G.Beaumont – Wheatley best where He is . . .'[4] At the beginning of July Farington was busy with meetings of the creditors and he extracted promises of careful living from Mrs Wheatley. On 11 July he wrote 'Mrs.Wheatley I called on & gave her Stacies discharge to free Wheatley . . . Wheatley & Mrs.W. called at passed 10 this eveng. He had just been released – cried – I gave her 8 guineas & recommended prudence.' But Wheatley must have offended Farington, for on 23 September he wrote 'Mrs.Wheatley called on me in great distress, has no money – He confined . . . told her Wheatleys want of candour had prevented my visiting them.' By 9 October Farington had relented, for he called on Wheatley whom he found 'much altered – legs & thighs little more than Bone – He was drawing & is in good spirits – does not outline with a Pen as the Collectors call all such *Sketches* and will not pay so much for them.'

Wheatley's health grew worse and in July 1800 Farington wrote 'Wheatley is now so crippled in his hands that he can only use his right thumb and the finger next to it. Mrs.W: mixes his tints when He paints. He cannot dress himself.'[5] In his last working months Wheatley can only have done drawings and water-colours. The last four oils that Wheatley exhibited at the Royal Academy in 1801 – the series of *Four Rustic Hours* [Figs 152, **119,120,122**] were painted in 1799. By March 1801 Wheatley was 'in a worse state than ever. Dr Mayo was with him yesterday, and told her (Mrs Wheatley) afterwards that His constitution was so broken there could be nothing done for him. – Still he might linger many months. – He was seized this time at Christmas Day & has never been able to do anything since.'[6] The Royal Academy gave some financial assistance. On 28 June 1801 Farington records 'poor Wheatley died this morning . . . Mrs.Wheatley desired to see me. – This trial I could not today sustain.' West called a council of the Academy and at Farington's suggestion first money and then a pension were voted to Mrs Wheatley.

1 London, Royal Academy of Arts *Council Meeting Minutes* II, p273, 9 July 1796

2 Windsor, Royal Library *The Farington Diary* transcript 18 July 1797

3 Windsor, Royal Library *The Farington Diary* transcript 17, 21, 28 May 1797

4 Windsor, Royal Library *The Farington Diary* transcript 28 May 1797

5 Windsor, Royal Library *The Farington Diary* transcript 7 July 1800

6 Windsor, Royal Library *The Farington Diary* transcript 18 March 1801

Fig 152 Francis Wheatley *Evening*
Oil on canvas $17\frac{1}{2} \times 21\frac{1}{2}$ in/ 44.5 × 54.6 cm Mr and Mrs Paul Mellon **121**

Wheatley's Style

Fig 153 Francis Wheatley *The Entry of the Speaker into the Irish House of Commons* Signed and dated F.Wheatley fec 1782 Water-colour 19½ × 25¼ in/ 49.7 × 63.8 cm National Gallery of Ireland, Dublin

According to his biographers, Wheatley's early style lay between the rather coarse manner of Hayman and the light elegance of Gravelot, who had imported into England the slender figures of French rococo pastoral, especially that tall slim, smooth limbed, white complexioned young woman with rosy cheeks who became the ideal of feminine beauty in England and can be seen in late paintings by Hogarth and in Gainsborough's early portraits. None of the works Wheatley exhibited in the 1760s has been identified but his portrait groups of the next decade show tall slender young women of elegant line, though Protestant modesty did not allow the tender, complimentary eroticism of their French counterparts. As we have seen, his copying of Mortimer profoundly influenced his early work. Towards the end of the 1770s Wheatley's figure style became less tight and rigid; he was able to pose and group his sitters more naturally. Light, clear colours give his pictures an attractive brightness and gaiety, and the land-scape settings in which he places his conversation groups are softly and sym-pathetically painted, even if the figures are not always fitted into them con-vincingly. In these earlier conversation groups the bright colours contrast with the rather sharp shadows, an unsatisfactory feature that Wheatley gradually, though not entirely, eliminated towards and during his Irish period, when for the most part the shadows became softer and better integrated into the com-position. Wheatley's first two large pictures painted in Ireland, *The Volunteers* and *The Irish House of Commons* [Figs 35,36] are clearly and firmly drawn, but with an overall feeling of hardness, not lessened by the backdrop effect of the architecture. In *Lord Aldborough on Pomposo* [Fig 37], *The Review of the Troops at Phoenix Park* [Fig 39] and *The Fifth Earl of Carlisle* [Fig 38] the figures move easily in a gentle landscape. From now onwards in pictures of this period the tonality is more muted though the individual colours retain all their clarity. Wheatley's method of painting rocks and trees was highly idiosyncratic up to the time of his return to London. The rough textures of the stone and of the tree trunks are indicated by unworked up blobs of colour and large areas of shadow; branches and twigs are highly articulated and leaves are painted with a flick of the brush. The colours used for leaves are frequently both summer and autumn

tints, a practice for which Gainsborough was criticized, and areas of dark green leaves are juxtaposed to a brighter pale green, either as the light falls on the leaves or from a different tree.

In Wheatley's water-colours until his return from Ireland the colouring is subdued. Washes in pale tints are laid lightly over an outline drawn in ink or pencil; blue, grey, green, and greenish yellow are used for the landscape with touches of reddish brown, blue and yellow ochre in the costume. These fluent passages of wash are strengthened in the shadows by additional layers of wash, while grass and some foreground plants in the more highly finished drawings are done with the tip of the brush [Figs 58, 153]. After Wheatley's return from Ireland his landscape water-colours gradually changed in style. Outline, whether in pen or pencil, became much slighter and was eventually dispensed with altogether, for the reason already recorded that collectors considered drawings in this technique as sketches and would not pay as much for them. From about 1788 a greater fluidity and softness became apparent [Fig 131]. Changes also began in the management and key of colour. The washes are stronger and there is greater use of contrast. Small areas of bright colour, especially on drapery, transform these drawings from lightly tinted water-colours into strongly coloured, highly finished decorative landscapes. Unfortunately their decorativeness has for too many of these drawings meant exposure to light, so that their crispness and sparkle has entirely faded away. It is often difficult to imagine now the fresh and lively colours of Wheatley's work as it left his studio. But three water-colours dating from 1798 are preserved in mint condition in the Albertina in Vienna [Figs 107, 136]. Acquired early in the nineteenth century, they have been kept in cases ever since, and so have hardly seen the light of day. Their limpid atmospheric colour is a revelation and no condemnation of Wheatley's water-colours can prudently be made by anyone who has not seen them. Many flat and pallid stretches of rustic-populated landscape which now seem only tedious and dull are in fact merely ghosts of their original selves.

After Wheatley's return from Ireland he produced some of his best paintings in oil. In portraiture his style had lost its rigidity and he had learnt to group his figures and arrange his compositions more convincingly. The colouring is clear and the tones have become more muted, with greater use of greys, dull blue, russet, of ochre and brown, more in line with the subdued colouring of Greuze and Aubry. The manner has become even softer in the 1788 portrait of Mrs Wheatley [Fig 146]. In the last large group portrait of the Duke of Newcastle the rather hard clarity of Wheatley's first style has melted into warm colouring against a low scaled brown and green. The foliage of the trees has become more feathery and impressionistic, and is well controlled and lightly handled. About 1790, this soft manner begins to disintegrate into a careless imprecision. In the portrait of *Benjamin Bond-Hopkins* [Fig 142] exhibited in that year the sitter with his horse and spaniel are firmly drawn and painted, but the foliage already shows signs of becoming rather loose and blurred. In the fancy pictures of the last decade of the century too, the confident settings and lively faces and bright eyes of the girls in Wheatley's earlier work disappear as his style and colours become too melting and his drawing less clear. This weakness is partly to be explained

by the pressure of financial distress during these last years of Wheatley's life; the need to produce large numbers of designs to relieve sickness and debt obviously induced Wheatley to leave more and more to the engraver. The result is a number of works which have neither the merits of the sketch nor those of the highly finished painting. Whatever of piquancy or archness the earlier pictures possessed is lost in a dully and sometimes over-sweetly sentimental conception far too broadly handled. But Wheatley's crippling physical handicaps must also account for much of the perfunctoriness of his last designs. Technically he was skilled, for his oil paintings are with very few exceptions still in remarkable condition.

Fig 154 Francis Wheatley *Children with Cat*
Oil on canvas 40 × 50 in/ 101.6 × 127 cm Major Philip Godsal **83**

Payments

Price still directly controlled many elements in an eighteenth century painting, so that what is known of the payments Wheatley received has a more than a marginal interest. His first print of Christian VII of Denmark sold for a shilling in 1768. Though much of Wheatley's early work, especially portraiture, was painted to direct commission, only one record of the price he charged for a single portrait has been traced. 'May 16 (1776) To cash to T.Grimston's Expenses of his Picture 21.16.2'[1] [Fig 26]. We do not know his fee for conversation groups. A number of the landscapes Wheatley exhibited at the Society of Artists were marked as for sale in the exhibition catalogues, but again there is no record of what he charged for these pictures. Whatever he may have received Wheatley clearly spent his money faster than he earned it. In Ireland Wheatley 'was in the way of becoming wealthy and popular'[2] had not debt and the exposure of Mrs Gresse ended his career there. At a sale of Wheatley's drawings held in London after his return in 1784 a number of his Irish views of fairs fetched from seven to nine guineas each, with other landscape views making similar prices. The surprisingly high sum of £26.5.-. was given for a *View in Dublin Bay with the Wicklow Mountains taken from Clontarf* and £19.19.-. paid for *The waterfall at the Dargle, the seat of the Rt.Hon.Lord Powerscourt*. From 1784 too, we have the first record of a price paid to Wheatley for a large commissioned oil painting in the 200 guineas Boydell paid him for *The Riot in Broad Street*. It is not known what Boydell gave for the large pictures commissioned for the Shakespeare Gallery, but in 1793 Wheatley received 20 guineas each for four smaller pictures of scenes from *All's Well that Ends Well* and from *Much Ado about Nothing*[3] [101,E113; Figs 126,123]. Philip Godsal bought three fancy pictures from Wheatley in 1791, giving 35 guineas for a large picture of *Children with cat* [Fig 154] and £36 for the small pair *The Pedlar* and *The Smithy* [Figs 100,155].[4] Many of the pictures that Wheatley exhibited at the Royal Academy from 1784 onwards were for sale and some of these were bought for engraving. We have no knowledge of what Wheatley received when he painted directly for the print-sellers, or for the book illustrations and title-pages that were commissioned from him. At the sale of Wheatley's effects in 1795 the results were, as Farington re-

1 M.Edward Ingram *Leaves from a Family Tree* 1951, p111

2 J.Gandon and T.J.Mulvany *The Life of James Gandon, Esq* 1846, p208

3 London, British Museum, Anderdon Collection, Royal Academy Catalogue 1793. Receipt dated 28 October 1793

4 Philip Godsal's pocket book for 1791, entries dated 12 January and 8 June. Information kindly communicated by Major Philip Godsal

111

marked, disappointing but political events were responsible for many financial disappointments in the last years of the century. £17.10.-. was the highest sum given for a picture 'a large picture of Plough Horses [Fig 151] in a frame which cost 20 guineas sold £17.10.-. Two of a smaller size sold in frames for £24.3.-.'[1] These were the *Potter going to market with a Storm Approaching, morning* and *A Woodman Returning Home, Evening* [Fig 101]. At this sale five water-colours for a total of £6.10.-. were bought by Dr Thomas Monro, physician, connoisseur and a patron of young artists, including Turner. Dr Monro commissioned two small drawings from Wheatley in 1796 for which he paid 5 guineas each.[2] He thought highly of Wheatley's water-colours and hung them in the drawing room of his house. At his sale in 1833, his water-colours by Wheatley came to twelve lots. A portrait of Mrs Monro by Wheatley was exhibited at the Royal Academy in 1795. The collection belonging to Dr Pitcairn, Wheatley's physician, included nine of Wheatley's water-colours, for one of which Dr Pitcairn had paid 30 guineas.[3] The same price was paid for a large water-colour in 1796 by Mr Chamberlain who was a generous patron of Wheatley. 'Mr Chamberlain called to look at drawings by Wheatley . . . always . . . ready to attend to any recommendations of mine in favor of Wheatley' and bought direct from Wheatley, on one occasion giving him £10 for a six or seven guineas picture.[4] After his death, Lawrence purchased the remainder of Wheatley's drawings and sketch books for 30 guineas.[5] So far as it is possible to judge so complex a question from our very imperfect information, these prices seem mostly to have been those current during Wheatley's lifetime for the type of work he produced.

1 Windsor, Royal Library *The Farington Diary* transcript 13 January 1795

2 Windsor, Royal Library *The Farington Diary* transcript 9 July 1796

3 Windsor, Royal Library *The Farington Diary* transcript 9 July 1796; Christie's, 16 June 1809

4 Windsor, Royal Library *The Farington Diary* transcript 18 December 1797

5 Windsor, Royal Library *The Farington Diary* transcript 10 August 1801

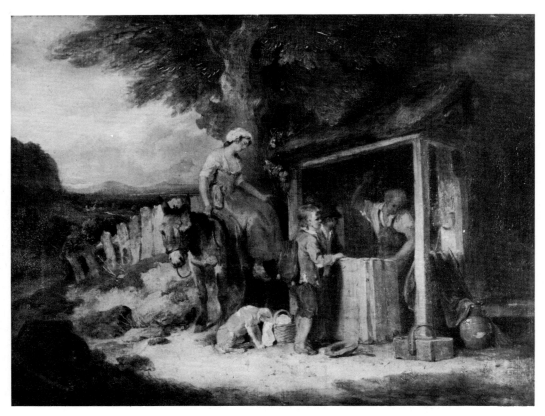

Fig 155 Francis Wheatley
The Smithy Oil on canvas
20 × 25½ in/ 50.8 × 64.8 cm
Major Philip Godsal **84**

Epilogue

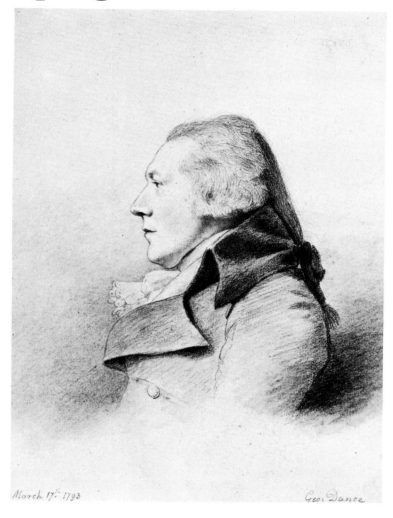

March 17. 1793

Geo: Dance

Fig 156 George Dance *Portrait of Francis Wheatley*
Black chalk 10 × 7½ in/ 25.4 × 19 cm
Royal Academy of Arts, London

Two portraits of Wheatley are known, one a chalk drawing by George Dance [Fig 156] in profile dated 1793, which was subsequently issued as a print. The other appears in a group portrait of the Royal Academicians painted by Singleton [Fig. 1]. Both were made much too late to show the fascinations of the youthful man about town. There is no known self-portrait.

Wheatley's life story is strictly that of a hard working professional artist. About his private life his contemporaries agree. 'He was a handsome man, of elegant manners, and generally a favourite in genteel company. He understood his art, and spoke with great taste and precision on every branch of it.'[1] His obituarist says that Wheatley was 'a very personable man, fond of dress, and polite in his manners, which makes him a great favourite with the ladies.'[2] But it was also agreed that his gay and pleasure loving temperament made him far too careless about money matters. Edwards laments that 'youthful irregularity

1 A.Chalmers *Biographical Dictionary* 1817 *sv* Wheatley

2 *Gentleman's Magazine* 1801, p857

113

and intemperance had entirely ruined . . . (his) constitution . . . so that for many years he was at intervals unable to employ his pencil, being much afflicted by long and severe paroxysms of the gout.'[1] Gandon too notes with disapproval that in Ireland 'it only required some attention to economy to afford him an opportunity of acquiring an independence . . . but his habits of expense became too unbounded for his means, and he became again involved in debts he was unable to defray, and returned to London, where he was eventually compelled to paint and draw for the print-sellers.'[2] Thus Wheatley presented the not uncommon duality of industry in his chosen art with cheerful irresponsibility in the management of his affairs. Pasquin indeed extends the castigation to claiming that Wheatley's art was injured by his insouciance: 'This gentleman appears to have too small a portion of ambition in his system, to accomplish any great and durable undertaking; to copy a mean model satisfies his unaspiring soul.'[3] But given Wheatley's state of health and his chronic indebtedness it is hardly surprising that he chose to paint what he could readily sell; the existence of a number of water-colours in two or more versions proves the ease with which they found a market.

The charm of Wheatley's art was most strongly felt in the late nineteenth and early twentieth centuries when Georgian elegance was confused with prettiness. The age of Austin Dobson admired chiefly prints after Wheatley because they seemed to justify the Hugh Thomson image of eighteenth century Dresden china daintiness. To modern taste Wheatley's paintings are infinitely more attractive. It is in these that his manner is at its freshest and liveliest, making it possible for us to believe with his obituarist that he was 'an artist of talents that might have raised him to the highest distinction in the arts, either in the province of landscape or portrait.'[4] Yet historically his prints were Wheatley's most influential achievement. Their simple treatment of rustic subjects created formulas which persisted with surprising vitality long after his death. Coarsened, even vulgarized in Morland, who provides a farmer's version of Wheatley's genteel art, their example still haunts the cottage landscapes of the Victorian age.

1 E.Edwards *Anecdotes of Painters* 1808, p270

2 J.Gandon and T.J.Mulvany *The Life of James Gandon, Esq* 1846, pp207–8

3 A.Pasquin *Memoirs of the Royal Academicians* 1794, p136

4 *Gentleman's Magazine* 1801, p765

Jo: Wheatley del: 1799

Catalogue of Oil Paintings

List of Illustrations

1 Ceiling of the Saloon, Brocket Hall
Figs 9, A–N

1771–3

Brocket Hall was built to the design of James Paine for Sir Matthew Lamb and was continued after Lamb's death in 1768 for his son, Peniston Lamb, first Lord Melbourne. Melbourne commissioned J.H.Mortimer through Paine to paint the ceiling of the Saloon.[1] Mortimer's principal assistants were Wheatley, James Durno and Sinclair a carver and gilder; it was known that he was also assisted in 1773 by Barnaby Mayor, a friend of Wheatley's[2] and a Director of the Society of Artists, and Thomas Jones the landscape painter.[3] The ceiling is decorated in compartments which show the Signs of the Zodiac, the Four Times of the Day, the Four Continents, Flora, Zephyrus, Ganymede, Vertumnus and Pomona, with grotesques and medallions containing profile heads and vases between. Work on the ceiling had begun in 1771 and it was probably finished in February 1773.[4] Payment for the decoration of the ceiling appears to have been exceptionally high: 'The Ceiling was designed and painted by *Mortimer* and *Wheatley*, as we are informed, at the Expense of fifteen hundred Pounds.'[5] Lord Melbourne, who was an ardent admirer of the actress Mrs Baddeley, told her that 'he gave a painter two thousand pounds, to paint only one ceiling at his seat at Brocket Hall.'[6]

References: 1 G.Benthall, *The Life and Works of John Mortimer,* unpublished typescript, pp22–3, Victoria and Albert Museum Library. 2 Mayor and Wheatley lived at the same addresses from 1767–72. 3 Memoirs of Thomas Jones, *Walpole Society* XXXII, 1946–8, pp26–7. 4 *Farington Diary* 14 November 1795; Memoirs of Thomas Jones, *Walpole Society* XXXII, pp26–7. 5 W.Angus, *Seats of the Nobility and Gentry in Great Britain and Wales* 1787, opp. pl II. 6 Elizabeth Steele, *The Memoirs of Mrs Sophia Baddeley* II, 1787, p205.

Trustee of First Lord Brocket Will Trust

2 The Duel, from Twelfth Night
Fig 17

Oil on canvas

1772

40 × 50 in / 101.6 × 127 cm
1772

PROVENANCE Anon. sale 1781, bought Tassant; Sir Frederick William Shaw.
EXHIBITIONS Society of Artists 1772(374); Royal Hibernian Academy, *Old Masters*, 1902–3(87), attributed to Zoffany; *Francis Wheatley R.A.* Aldeburgh and Leeds, 1965(1).
ENGRAVING Mezzotint by J.R.Smith, published 1 March 1774. Mezzotint exhibited at the Society of Artists in 1774(263).
LITERATURE J.Mander and J.Mitchenson, *Picture History of the British Theatre*, 1957, p52, no126.

The subject is taken from *Twelfth Night*, Act II, scene 4. Miss Younge with Dodd, Love and Waldron appear in the characters of Viola, Sir Andrew Aguecheek, Sir Toby Belch and Fabian. At the left, Miss Younge as Viola, holding in her right hand a sword which trails on the ground, is supported by Waldron. At the right, Love as Sir Toby Belch attempts to encourage Dodd as Sir Andrew Aguecheek to draw his sword against Viola. Miss Elizabeth Younge (1740–97) was trained by Garrick. In 1785 she married Alexander Pope, the actor and miniature painter, who later became the second husband of Mrs Wheatley. James W.Dodd (1741–96) first appeared on the London stage in 1765. James Love (1722–74) the name assumed by Dance, one of the sons of the city surveyor, author, was patronized for a while by Walpole. Francis Waldron (1744–1818), actor and dramatist, kept a bookseller's shop. A performance of *Twelfth Night* with these actors in their respective parts was given at Drury Lane on 10 December 1771.

City Art Gallery, Manchester

3 The Harvest Waggon
Fig 10

Oil on canvas
50½ × 40 in / 128.3 × 101.6 cm

SIGNED AND DATED F.Wheatley 1774
PROVENANCE F.Godson Millns, who bequeathed it to the City Art Gallery, Nottingham in 1904.
EXHIBITION *Francis Wheatley R.A.* Aldeburgh and Leeds, 1965(2)

The composition of this picture derives from Gainsborough's painting of the same subject [Fig 11].

Castle Museum and City Art Gallery, Nottingham

4 Family Group with a Negro Servant
Fig 28

Oil on canvas
40 × 50 in / 101.6 × 127 cm
c 1774–5

PROVENANCE Moore sale, Christie's 28 November 1903(57) as by Zoffany; William Asch, bequeathed to the National Gallery in 1922; transferred to the Tate Gallery in 1953.
EXHIBITIONS Whitechapel 1906(118); Burlington Fine Arts Club 1919(25); *English Conversation Pieces of the 18th Century*, 1946(21); in all as by Zoffany.
LITERATURE V.Manners and G.C.Williamson, *John Zoffany, R.A.,* 1920, pp107, 110, 173; S.Sitwell, *Conversation Pieces,* 1936, pl 36; M.Davies, *National Gallery Catalogue,* 1946, p193;

Encyclopaedia Italiana, s.v. Zoffany. All attributing the picture to Zoffany.

This picture was until recently attributed to Zoffany but a comparison with other portrait groups by Wheatley indicates that it is by his hand. The sitters remain unidentified. The composition reflects Zoffany's group of the *Bradshaw Family* [Fig 29] which was exhibited at the Society of Artists in 1769(359).

Tate Gallery, London

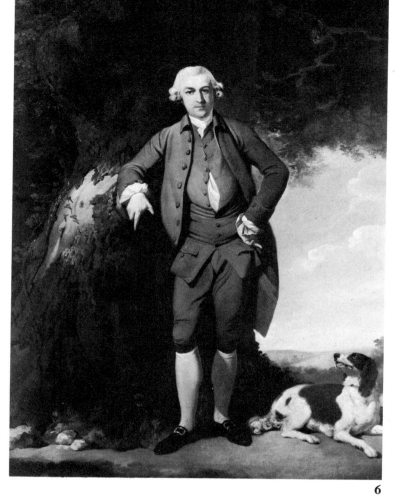

6

5

5 Two Girls
Oil on canvas
$33\frac{1}{2} \times 28$ in / 85×71 cm
c 1775

This picture was formerly attributed to Zoffany. A comparison with the *Family Group* [10] indicates that it is by Wheatley, and that it dates from the mid-1770s.

Brighton Art Gallery

6 Mr Bentley
Oil on canvas
$35\frac{1}{4} \times 27\frac{1}{4}$ in / 89.5×69.2 cm
c 1775

Mr and Mrs Paul Mellon

7 Mrs Bentley Fig 21
Oil on canvas
$35\frac{1}{4} \times 27\frac{1}{4}$ in / 89.5×69.2 cm
c 1775

Mr and Mrs Paul Mellon

8 Sir Charles Holloway
Oil on canvas
35 × 27½ in / 88.9 × 69.8 cm
c 1775–6

PROVENANCE Christie's 25 May 1934(185).

Sir Charles Holloway (1749–1827), was commissioned as 2nd Lieutenant, Royal Engineers on 16 January 1776. He took a prominent part in the defence of Gibraltar during the siege (1779–83), and figured in the picture of the principal officers serving in the siege painted by Copley for the City of London. In 1798 he went to Turkey to help reorganize the Turkish army, and joined in the Turkish campaign in Palestine against the French in 1800. He was knighted on 2 February 1803 as major of the Royal Engineers and died at Devonport. Datable on grounds of style, the picture was possibly painted after receiving his commission in the Royal Engineers.

The Executors of the late Lord Wharton

9 Portrait of a Man with a Dog
Oil on canvas
38½ × 29 in / 97.8 × 73.6 cm
c 1775–6

As the sitter is wearing black this is likely to be a portrait of a clergyman.

Tate Gallery, London

10 Family Group
Oil on canvas
35½ × 27½ in / 90.2 × 69.8 cm
c 1775–6

EXHIBITIONS *English Painting 1700–1850*. Virginia Museum of Fine Arts, 1963(265); *Painting in England 1700–1850*. R.A. 1964–5(221) and Yale University Art Gallery, 1965(221).

The attribution of this picture to Wheatley, formerly attributed to Zoffany, was first made by Basil Taylor.[1]

Reference: 1 *English Painting, 1700–1850*. Virginia Museum of Fine Arts, 1963(265).

Mr and Mrs Paul Mellon

Fig 23

Fig 20

Fig 30

Fig 26

11 Thomas Grimston
Oil on canvas
35½ × 27½ in / 90.2 × 69.8 cm

SIGNED AND DATED F.Wheatley 1776
PROVENANCE Painted for the sitter; by family descent to the present owner.
LITERATURE M.Edward Ingram, *Leaves from a Family Tree* 1951, p111, pl VIII.

The sitter is Thomas Grimston (1753–1821) of Kilnwick Hall, Yorkshire. Thomas Grimston's accounts for 1776 show: 'May 16. To Cash to T.Grimston's Expences of his Picture 21.16.2.' (I am indebted to Mr.M.Edward Ingram for his kind help in connection with Thomas Grimston's account book.)

Edward Eden Esq

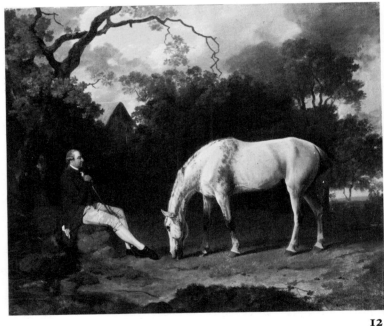

12

12 Sir Henry Peyton
Oil on canvas
25 × 30¼ in / 63.5 × 76.8 cm

SIGNED AND DATED F.Wheatley (under portrait)
 S.Gilpin 1776 (under horse)

Sir Henry Peyton (d 1789) of Doddington, MP for the County of Cambridge. Henry Dashwood, who assumed the surname and arms of Peyton when he succeeded his uncle Sir Thomas Peyton (d 1771), was created a baronet in 1776,[1] the year in which this portrait was painted.

In this example of collaboration the portrait and the landscape background are by Wheatley; the horse is painted by Sawrey Gilpin who is well known as a painter of animals.

Reference: 1 J.Burke *A Genealogical and Heraldic History of the extinct and dormant Baronetcies of England, Ireland and Scotland,* London, 1844, pp412-3

Private Collection UK

13 The Medway at Rochester, a view of part of Rochester Bridge and Castle Fig 12
Oil on canvas
$21\frac{3}{4} \times 31$ in / 55.2 × 78.7 cm

SIGNED AND DATED F.Wheatley 1776
PROVENANCE Christie's, 8 February 1806(20)
EXHIBITIONS Society of Artists 1776(137); *From Hogarth to Crome*, Tooth, 1943(18); *English Painting* 1700-1850 Virginia Museum of Fine Arts 1963(29); *Painting in England*, 1700-1850, R.A. 1964-5(46) and Yale University Art Gallery 1965(219).

Mr and Mrs Paul Mellon

14 View on the Banks of the Medway Fig 13
Oil on canvas
25 × 30 in / 63.5 × 76.2 cm
1776

PROVENANCE Christie's 17 March 1967(88)
EXHIBITIONS Probably Society of Artists 1776(139)

A view of the remains of Halling Hall, up river and on the opposite bank of the Medway from Rochester. The ruins have disappeared, but a ferry is still operating. This picture was presumably painted on the same expedition down the Medway to Rochester as *The Medway at Rochester* [13].

Mr and Mrs Paul Mellon

15

15 View on the Banks of the Medway
Oil on canvas
25 × 30 in / 63.5 × 76.2 cm
1776

A comparison with the *View on the Banks of the Medway* [14] shows similarities of composition and treatment. The ruin, grouping of the trees and river bend which are however simpler than [14] may indicate a first version of this composition.

With M.Bernard in 1969

16 Mrs Barclay with her Children
Oil on canvas
c 35 × 27 in / 89 × 68.5 cm
1776

PROVENANCE Lady Swinfen; Seymour Lucas
EXHIBITION Probably Society of Artists 1777(160)

Formerly attributed to Zoffany. A comparison with Wheatley's work of the mid-1770s, especially the portrait of *Thomas Grimston* [11] and the *Family Group* [10] indicates that this group is by Wheatley and that it was painted about 1776.

Colonel D.G.C.Sutherland

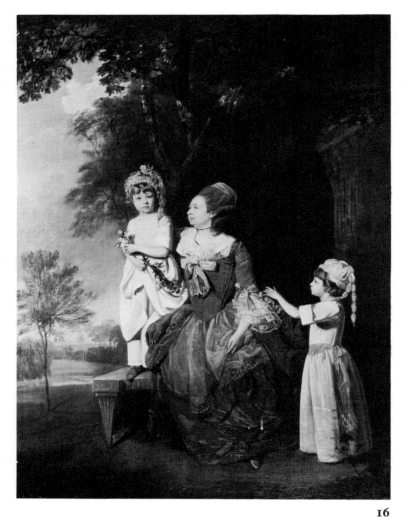

16

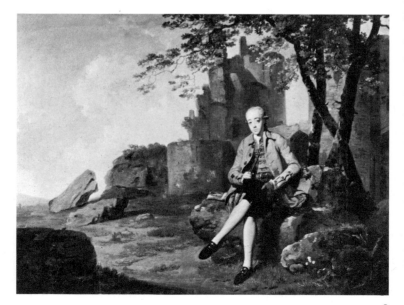

18

17 An Artist and a Lady in a Landscape Fig 31

Oil on canvas
Dimensions unknown

SIGNED AND DATED F.Wheatley px. 1777

Collection unknown

18 Portrait of a Seated Man

Oil on canvas
$15\frac{1}{2} \times 20\frac{1}{2}$ in / 39.4 × 52 cm
c 1777

PROVENANCE Sutton sale, Christie's, 12 February 1926(97);
Hugh Smith collection, London

Datable by comparison with the portrait of *An Artist and a
Lady in a Landscape* [17].

Collection unknown

19 Mr and Mrs Richardson Fig 32

Oil on canvas
40 × 50 in / 101.6 × 127 cm
1777–8

PROVENANCE J.H.Robinson.
EXHIBITIONS R.A. 1778(333 or 334);[1] Japan–British Exhibition
1910(16) as by Benjamin Wilson: *Francis Wheatley R.A.*
Aldeburgh and Leeds, 1965(3).
LITERATURE *The Graphic*, August 30 1913.

This portrait was formerly attributed to Benjamin Wilson and
to Zoffany; it was identified as being by Wheatley in 1965. 'If
there be not much sublimity in his pictures, there is generally
a great deal of vraissemblance, and where the subject is
personal, the latter is certainly the most substantial requisite of
the two. In that family picture . . . the portrait of Mr and Mrs
Richardson are given, a piece of intelligence which can be no
secret to those who know the originals; and who that has
dabbled in the lottery for the last ten years, and desired to deal
with the honest and the fortunate, does not recollect the master
of Richardson and Goodluck's Offices?'[2] An attempt to end
the various malpractices and ingenious but illegal methods of
making money out of the state lotteries was made in 1778 when
lottery office keepers were required to take out a licence.[3] The
names of those to whom licences had been granted were
published by the Lottery Office, Whitehall on 13 November
1778. The firm of Richardson and Goodluck, who were well
known as very respectable and honest office keepers, were listed

as follows: 'James Richardson, Peter Richardson and William Goodluck, nos 101 and 104 Bank Buildings, Cornhill and no8 Charing Cross'.[4] It is not known whether this portrait is of James or Peter Richardson; the latter continued as a lottery office keeper until the last state lottery in 1826.

References: 1 W.T.Whitley, *Artists and their friends in England* II, 1928, p396. 2 *Morning Chronicle* May 1 1778. 3 John Ashton, *A History of English Lotteries* 1893, p118; C.L'Estrange Ewen, *Lotteries and Sweepstakes*, 1932, pp252, 271, 278-9. 4 *Public Advertiser* 14 November 1778.

National Gallery of Ireland, Dublin

20 The Wilkinson Family

Fig 33

Oil on canvas
$40\frac{1}{4} \times 50\frac{3}{8}$ in / 102.2 × 127.9 cm
c 1778

PROVENANCE John Wilkinson of Roehampton; by descent to James Fuidge Crowdy (1924); J.R.Aldred, New York, sale Parke-Bernet 15 May 1946(45); acquired for the Detroit Institute of Arts in 1946.
EXHIBITIONS *English Conversation Pieces of the Eighteenth Century* Detroit Institute of Arts, 1949(pl 180); *Paintings Notable for the State of Preservation* Worcester Art Museum, Mass, 1951(30); *The Century of Mozart*, Nelson Gallery – Atkins Museum, Kansas City, 1956(108); *Romantic Art in Britain* Detroit Institute of Arts – Philadelphia Museum, 1968(75).
LITERATURE Edgar P.Richardson, 'Conversation for the Eye,' *Art News* XLVII, 1948, pp34, 57; *Francis Wheatley R.A.* Aldeburgh and Leeds, 1965(96).

Until 1924 this picture was in the possession of the heirs of the Wilkinson family with a traditional attribution to Cotes; attributions to Wheatley, Zoffany and Benjamin Wilson have also been proposed. Stated, incorrectly, to be signed by Benjamin Wilson,[1] the painting is not signed. The picture shows close stylistic affinities to *Mr and Mrs Richardson* [19], the *Family Group* [10] and the portrait of *An Artist and a Lady in a Landscape* [17]. According to a descendant of the oldest girl in the picture, Sibella Wilkinson, into whose possession the picture passed, she was born in 1761, which would date the picture *c* 1778. Both the costume and a comparison with the portrait of *Mr and Mrs Richardson* confirm this dating. (I am indebted to Mr F.J.Cummings of the Detroit Institute of Arts for kindly informing me of the history of the picture and its previous attributions.)

Reference: 1 John Hulton, *Leeds Art Calendar*, Autumn 1947.

The Detroit Institute of Arts

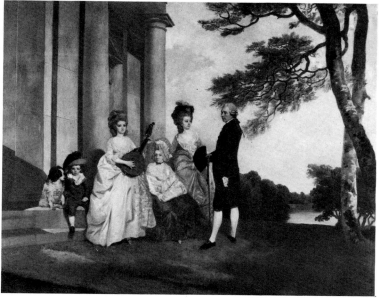

21

21 The Pitt Family

Oil on canvas
$47\frac{1}{2} \times 59\frac{1}{2}$ in / 120.6 × 151.1 cm
c 1778

PROVENANCE C.Newton Robinson; Sheffield sale, Christie's, 16 July 1943(134).
EXHIBITION R.A. 1908(93) as Gainsborough.

The family of George Pitt, Lord Rivers (1722–1803), author and politician.

Viscount Rothermere

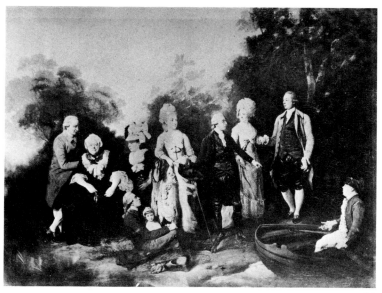

22

22 The Garden Party
Oil on canvas
48 × 62 in / 121.9 × 157.5 cm
c 1778

PROVENANCE Arthur Oliver 1886; by family descent to the
Olivers of Bath; destroyed by enemy action during the last
war. (Information kindly communicated by Miss Vivien
Layard.)
EXHIBITION R.A. *Old Masters* 1886(2).
LITERATURE *Country Life* CXXXIII, 21 February 1963, p362.

Mrs Ward and her family with Charles Peter Layard, Dean of
Bristol, his wife and others.

Destroyed by enemy action

23 Mr Bailey of Stanstead Hall Fig 25
Oil on canvas
29 × 24 in / 73.7 × 61 cm
c 1778

PROVENANCE Eric Sanders, sale Sotheby's 24 November
1965(67).

Stanstead Hall is at Stanstead Abbotts, Hertfordshire.

Arthur Tooth & Sons Ltd

24 Lord Spencer Hamilton
Oil on canvas
$30\frac{1}{8}$ × 25 in / 76.75 × 63.5 cm
c 1778–9

PROVENANCE Presented to George IV by General Lister in 1817.
EXHIBITIONS *British Art* R.A. 1934(400); *Francis Wheatley R.A.*
Aldeburgh and Leeds 1965(4).
LITERATURE C.H.Collins Baker, *Windsor* 1937, p310.

Lord Spencer Hamilton (1742–91), third son of the 5th Duke of
Hamilton was Major General (1776) and Colonel (1782) in the
2nd Foot Guards. He was appointed Gentleman of the
Bedchamber to the Prince of Wales in November 1783. See
also [25].

Her Majesty the Queen, Windsor Castle

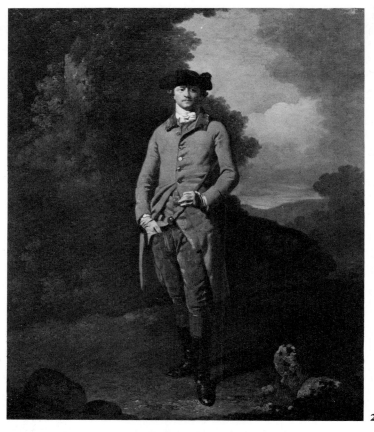

24

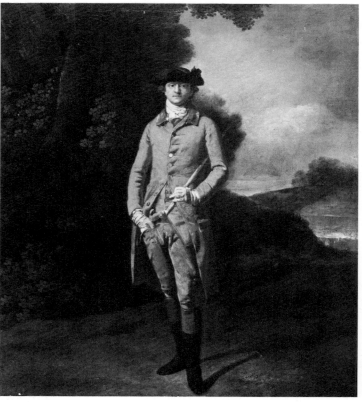

25

25 Lord Spencer Hamilton

Oil on canvas
29 × 24½ in / 74 × 62.2 cm
1778-9

PROVENANCE Arthur, 1st Marquis of Donegall who bequeathed it to his son, Lord Spencer Chichester, father of Arthur, 1st Baron Templemore.
EXHIBITION Winchester 1938(39).

A version of [24] probably painted at the same time for Lord Spencer's sister, the 1st Marchioness of Donegall.

Lord Templemore

26 George Basil Woodd Fig 24

Oil on canvas
30 × 25 in / 76.2 × 63.5 cm
c 1778-9

George Basil Woodd was born in London on 8 January 1724 and died on 11 March 1784, being buried at Richmond, Surrey. He married first Elizabeth, daughter of William Price of Richmond, Surrey in 1749. After her death at Weymouth in 1771 aged 47, he married Gertrude, daughter and eventually heiress of George Ballard, Counsellor-at-Law, of Leatherhead, Surrey. He had in all 16 children, of whom 8 died in infancy.[1] This portrait was probably painted shortly before Wheatley left for Ireland.

Reference: 1 J.Foster, *Pedigrees of the County Families of Yorkshire* I, London, 1874. Pedigree of Woodd of Conyngham Hall, Knaresborough, formerly of Shinewood, Co. Salop, and Brize Norton, Co. Oxon.

Mr and Mrs Paul Mellon

27 Family Group in a Landscape Fig 27

Oil on canvas
28¼ × 35¼ in / 71.7 × 89.5 cm
c 1779

PROVENANCE Sotheby's, Mrs Wilson sale, 14 June 1939(146) as J.Downman; Sir Austin Harris.
EXHIBITIONS *Painting in England, c 1700-1850.* Virginia Museum of Fine Arts, 1963(264); *Painting in England, 1700-1850.* R.A. 1964-5(220); Yale University Art Gallery 1965 (220).

Formerly known as a portrait of *The Browne Family* of Frampton Dorset, with whom it can no longer be identified. Francis John Browne of Frampton, M.P. for Dorset, (1754-

1833), married Frances, second daughter of the Reverend John Richards of Long Bridy, she died 25 March 1806 in her thirty-first year. There were no children of the marriage.[1]

Reference: 1 J.Hutchins, *The History and Antiquities of the County of Dorset* II, 1863, pp297-8, 302.

Mr and Mrs Paul Mellon

28 A Sportsman with his Son and Dogs Fig 22

Oil on canvas
36 × 28 in / 91.4 × 71.1 cm

SIGNED AND DATED F.Wheatley/Pxt 1779.
PROVENANCE Dwight Davis sale, Parke-Bernet, 15 November 1946(260).
LITERATURE Walter Shaw Sparrow, *British Sporting Artists*, 1922, pp224-5.

Collection unknown

29 Silvanus Bevan

Oil on canvas
30 × 25 in / 76.2 × 63.5 cm
c 1779

PROVENANCE Sotheby's 21 January 1924(120) as a portrait by Zoffany of Charles James Fox as a young man. Mrs Laura Maude Owen.
EXHIBITION *Essex and Suffolk Houses*, Colchester, 1964, p1,(7) as by Zoffany.

Silvanus Bevan, (1743-1830), the son of Timothy and Elizabeth (née Barclay) Bevan was born at Plough Court, Lombard Street, then a pharmacy established by Silvanus Bevan, brother of Timothy, in 1715. The sitter became a partner in Barclays Bank, Lombard Street, in 1768. He first married, in 1769, Isabella Wakefield who died in November 1769 at the age of 17. In 1773 he married Louisa Kendall by whom he had seven sons. He was born a Quaker and ended as a pillar of, and generous subscriber to, the Evangelical movement in the Church of England. Datable by analogy with the portrait of *A Sportsman with his Son and Dogs* [28], a version with slight differences has remained in the family of the sitter and is now in the possession of the Reverend Richard Bevan. (I am indebted to Mr R.A.Bevan for kindly communicating to me the history of the picture and the biography of the sitter.)

R.A.Bevan Esq

29

The portraits include the Duke of Leinster, Luke Gardiner, Sir John Allen Johnston, the Rt Hon David La Touche, J.Fitzgibbon and J.N.Tandy, Sir Edward Newenham, Counsellors Pethard and Caldbeck, the commanders of the corps of Volunteers represented.[2] In a window overlooking the scene, with a parasol held over her, is the Russian Princess Dashkow. Gandon informs us that Wheatley was a spectator at this review and that he made a drawing of it.[3] Wheatley has, however, omitted the decorations that were placed on the statue of the King and the placards that were hung from the four sides of the pedestal, which included 'Relief to Ireland', 'the Volunteers, quinquaginta millia juncti, parati pro patria mori'. The canons bore labels inscribed 'Free trade or speedy revolution'.[4] This was one of the first reviews in which the Volunteers took an active part in the pressing political questions of the day. The buildings in the background, accurately drawn, include the campanile of Trinity College by Richard Castle, demolished in 1798.

A version in water-colour with some differences, from which the engraving was made, is in the Victoria and Albert Museum. A copy by Archibald McGoohan was commissioned c 1910 by Henry C. Hartnell of Wilson Hartnell & Co Ltd (Oil on canvas $22\frac{1}{2} \times 39\frac{1}{2}$ in / 57.1 × 100.3 cm). It was published in colour by Wilson Hartnell & Co Ltd c 1910.[5]

References: 1 *Hibernian Journal*, 8–10 January 1781. 2 *Hibernian Magazine*, November 1779, p654. 3 J.Gandon and T.J.Mulvany, *The Life of James Gandon*, 1846, pp206–7. 4 T.Mac-Nevin, *The History of the Volunteers*, 1845, p118. 5 Information kindly communicated by Mr N.C.Hartnell.

National Gallery of Ireland, Dublin

30 A View of College Green with a Figs 35, A,B
meeting of the Volunteers on
4 November 1779 to commemorate the
birthday of King William
Oil on canvas
72 × 128 in / 182.9 × 325.1 cm
1779

PROVENANCE In January 1781 it was announced that the picture would be disposed of by raffle at Wheatley's house, no39 Grafton Street, Dublin;[1] the result of the raffle is not recorded. William Robert, 2nd Duke of Leinster; deposited in the National Gallery of Ireland on loan by Charles William, 4th Duke of Leinster in 1875; presented by Gerald; 5th Duke of Leinster in 1891.
EXHIBITIONS Society of Artists, Dublin 1780; Dublin Exhibition 1853(317); R.A. 1954–5(387); *Francis Wheatley R.A.* Aldeburgh and Leeds, 1965(5).
ENGRAVING Line engraving by J.Collyer, published 19 May 1784 with some differences.

31 Captain Charles Churchill Fig 43
Oil on canvas
$40\frac{1}{2} \times 29\frac{1}{2}$ in / 102.9 × 74.9 cm
1779–80

EXHIBITIONS Probably Society of Artists, Dublin 1780(165); *Paintings by J.S.Copley*, Metropolitan Museum, New York, 1936(47).

Captain Charles Churchill belonged to the 19th Regiment of Foot which was in Ireland in 1779; he no longer appears in the Army List of 1780. Churchill was probably a personal friend: 'Some of his (Mortimer's) captious enemies alleged against him "that he was fond of playing cricket"; so he was, and many a game he and I, accompanied by Charles Churchill, had together'.[1]
 The attribution of this picture to Wheatley was first made by John Kerslake in 1965.

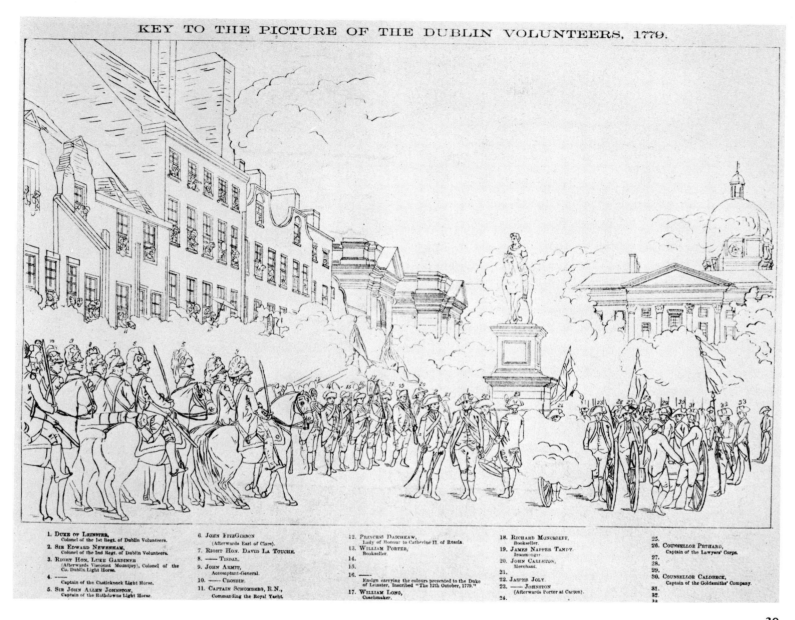

KEY TO THE PICTURE OF THE DUBLIN VOLUNTEERS, 1779.

1. DUKE OF LEINSTER,
 Colonel of the 1st Regt. of Dublin Volunteers.
2. SIR EDWARD NEWENHAM,
 Colonel of the 2nd Regt. of Dublin Volunteers.
3. RIGHT HON. LUKE GARDINER
 (Afterwards Viscount Mountjoy), Colonel of the
 Co. Dublin Light Horse.
4. ——
 Captain of the Castleknock Light Horse.
5. SIR JOHN ALLEN JOHNSTON,
 Captain of the Rathdowne Light Horse.

6. JOHN FITZGIBBON
 (Afterwards Earl of Clare).
7. RIGHT HON. DAVID LA TOUCHE.
8. —— TISDAL.
9. JOHN ARMIT,
 Accountant-General.
10. —— CROSBIE.
11. CAPTAIN SCHOMBERG, R.N.,
 Commanding the Royal Yacht.

12. PRINCESS DASCHKAW,
 Lady of Honour to Catherine II. of Russia.
13. WILLIAM PORTER,
 Bookseller.
14.
15.
16. ——
 Ensign carrying the colours presented to the Duke
 of Leinster, Inscribed "The 12th October, 1779."
17. WILLIAM LONG,
 Coachmaker.

18. RICHARD MONCRIEFF,
 Bookseller.
19. JAMES NAPPER TANDY,
 Ironmonger.
20. JOHN CARLETON,
 Merchant.
21.
22. JASPER JOLY.
23. —— JOHNSTON
 (Afterwards Porter at Carton).
24.

25.
26. COUNSELLOR PETHARD,
 Captain of the Lawyers' Corps.
27.
28.
29.
30. COUNSELLOR CALDBECK,
 Captain of the Goldsmiths' Company.
31.
32.
33.

30

Reference: 1 J.Gandon and T.J.Mulvany, *The Life of James Gandon*, 1846, p203.

Jeremy Tree Esq

32 Henry Grattan Fig 41
Oil on panel
$10\frac{1}{2} \times 8\frac{1}{2}$ in / 26.7 × 21.6 cm
1780

PROVENANCE Given by the executors of D.C.Bell, 1888.
ENGRAVING Mezzotint by Valentine Green, published 10
September 1782

Grattan is wearing the uniform of the Dublin Independent
Volunteers, of which he was Colonel. Henry Grattan (1746–
1820), was born in Dublin, son of the Recorder of Dublin. He
entered the Irish Parliament for the borough of Charlemont in
1775, was soon distinguished by his eloquence, and became
leader of the opposition, advocating measures of free trade,
Catholic emancipation and legislative independence from
Great Britain. In England during the rebellion of 1798, he
entered the British Parliament as M.P. for Malton in 1805.
M.P. for Dublin from 1806 to 1820 in The Irish House of
Commons.

National Portrait Gallery, London

33 The Irish House of Commons
Figs 36, A,B

Oil on canvas

64 × 85 in / 162.5 × 215.9 cm

SIGNED AND DATED Fs Wheatley pxt:/Dublin, 8 June 1780.
PROVENANCE The early history of the picture is unclear. By
1783 it had been disposed of by raffle in Dublin.[1] It appeared at
Christie's on 6 March 1790(86) at the sale of pictures belonging
to Dr Charlton of Bath, but it did not find a purchaser. It was
in the possession of Mrs Gresse when she died (probably 1796).
According to H.Philips the auctioneer she 'bequeathed it by
will, and claimed it to be her own, as, when it was raffled for,
she had *thrown a higher number* than any of subscribers who *had
then thrown*'. Lord Aldborough put in a claim for the picture,
but according to Philips both he and Wheatley were
'precluded from putting in any claim, as they have allowed 6
years to elapse without making any demand, Philips also said,
that some years ago, when He was with Christie, this picture
was proposed to be sold, and at that time a letter from
Wheatley was produced which went far to prove that the
picture was not his property.'[2] In the possession of Sir Thomas
Gascoigne early in the nineteenth century, where it remained
until presented by Sir Alvary Gascoigne to the Leeds City Art
Galleries in 1969.
EXHIBITIONS In May 1801 the picture was on exhibition in
Bond Street;[3] May 1805 exhibited at Philips' rooms;[4] Dublin
Exhibition 1853(316); Temple Newsam 1938(74); Leeds City
Art Gallery 1948; *Francis Wheatley, R.A.* Aldeburgh and Leeds,
1965(6).
ENGRAVINGS A key to the identity of the sitters in the picture
was published by W.Skelton, 26 February 1801 [**E152**]. An
advertisement for 'A Print of the House of Commons, after the
picture painted by F.Wheatley, to be engraved in the line
manner by Mr.Skelton' appeared in the *Dublin Evening Post*
10 October 1801. This engraving was never published. A
photogravure was published by Wilson Hartnell & Co Ltd,
Dublin, in 1906 with a copy of the Key.

The interior of the Irish House of Commons with Henry
Grattan making a speech on the repeal of Poyning's Law. On
19 April 1780 a debate, which began at half-past three and
lasted until six o'clock the next morning, was opened by
Grattan on the motion 'That the people of Ireland are of right
an independent nation and ought only to be bound by laws
made by the King, Lords and Commons of Ireland.' On this
occasion the galleries were thronged with fashionable crowds,
the women being most elegantly dressed. Throughout the
house were a number of officers of the Volunteers in uniform.
Gandon relates that Wheatley 'again availed himself of the
excitement of the times by making an internal view of the
Irish House of Commons'[5] and we are informed that 'from the
peculiar advantages afforded the artist the portraits of the
Members (148) are allowed to be correct likenesses'.[6] Some
members of Parliament not originally included became anxious
to be introduced in the picture, but a rumour circulated that in
order to make these additions 'several of the early subscribers,
who had paid the half price as sitters for the picture, had been
rubbed out to substitute others who had also paid the half-
price as subscribers . . . the picture was never finished, nor, at
the period produced for public approval.'[7] This picture is the
only accurate view of the interior of the Irish House of
Commons. It shows slight differences from the drawing of the
internal elevation of the House of Commons, Dublin, by Sir
Edward Lovett Pearce, which provides for single columns at
the angles of the gallery and sculpted keystones on the lower
arches.[8]

References: 1 J.Gandon and T.J.Mulvany, *The Life of James Gandon*
1846, p208; *Gentleman's Magazine* 1801, p857. 2 *Farington Diary*
4 May 1799. 3 *Farington Diary* 5 May 1801. 4 *Morning Post* 20 May
1805. 5 J.Gandon and T.J.Mulvany, p207. 6 *Morning Post, ibid.*
7 J.Gandon and T.J.Mulvany, p208. 8 Howard Colvin and Maurice
Craig, *Architectural Drawings in the Library of Elton Hall by Sir John
Vanburgh and Sir Edward Lovett Pearce* 1964, Cat no1, pl XLV.

Leeds City Art Galleries, Gascoigne Collection

34

34 Barry Coles aged eighty-five
Oil on canvas
$50\frac{1}{2} \times 40\frac{1}{4}$ in / 127.6 \times 102.2 cm

SIGNED AND DATED F.Wheatley 1780.
PROVENANCE Sotheby's 13 February 1957(140).
VERSION A half-length portrait in the same pose in an oval signed F.Wheatley and indistinctly dated was on the London Art Market in 1949.

Collection unknown

35 Lord Aldborough on Pomposo, a Fig 37
 Review in Belan Park, County Kildare Frontispiece
Oil on canvas
61 \times $94\frac{1}{2}$ in / 154.9 \times 239 cm
1780-1

EXHIBITIONS R.A., 1888(1); R.A. *British Art* 1934(268).

Edward Stratford, 2nd Earl of Aldborough (c 1740-1801) succeeded to the earldom in 1777. A General of the Volunteers, he raised the Aldborough legion in August 1777, and these are presumably the troops represented. Belan Park was the seat of the Earl of Aldborough. Belan House was built in 1743 by Francis Bindon; the south front is accurately shown in this picture. To the right of the house Wheatley has included the Chinese bridge and the dove-cot which still exist. It was customary for ladies to attend reviews in their handsomest equipages and clothed in their gayest attire; amongst the spectators is the Earl's first wife, Barbara Herbert (1742-85), who is seated in the carriage decorated with the coronet. Behind her, mounted on a horse, is a lady wearing Volunteer uniform.

National Trust, Waddesdon Manor

36 Review of Troops in Phoenix Park by Fig 39
 General Sir John Irwin
Oil on canvas
$96\frac{1}{4} \times 71\frac{3}{4}$ in / 244.5 \times 182.2 cm

SIGNED AND DATED F.Wheatley px/1781.
PROVENANCE W.H.Hughes; Christie's, 22 December 1877(105) as George III and staff at a Review; bought by the National Portrait Gallery, March 1878.
EXHIBITIONS on loan to the National Gallery of Ireland 1897-1934; *Francis Wheatley R.A.* Aldeburgh and Leeds 1965(7).

Wheatley exhibited at the Society of Artists in 1783(320), a *Review of the Irish Volunteers in the Phoenix Park, Dublin* with which this picture has been equated. The only contemporary criticism that has come to light of the picture exhibited in 1783 is unspecific; 'Wheatley, if he fails, fails however not unattempting. His Review of the Irish Volunteers in the Phoenix Park has a great deal of Work in it, and is in its Disposition not without much Contrivance'.[1] So far the identity of the sitters, the uniforms and the occasion have proved elusive. It is reasonable to assume that the K.B. is Sir John Irwin (1722-88, K.B. 1779, Commander in Chief Ireland 1775-82) but no other portraits of him and his staff are known. The uniforms differ from those in Wheatley's other Irish Reviews, *The Volunteers* [30] and *Lord Aldborough on Pomposo, a Review in Belan Park* [35]. The topographical content, if not imaginary, is too slight for identification.

Reference: 1 *Public Advertiser* 10 June 1783.

National Portrait Gallery, London

37 The Fifth Earl of Carlisle in Phoenix Park Fig 38
Oil on canvas
59 \times 77 in / 149.8 \times 195.6 cm

SIGNED AND DATED F.Wheatley pxt 1781.
PROVENANCE Painted for the sitter; by family descent.
EXHIBITIONS R.A. 1954-5(416).
LITERATURE Lord Hawkesbury, Catalogue of the Portraits, Miniatures &c at Castle Howard; *Transactions of the East Riding Antiquarian Society*, XI, 1904, no195, pl XI; S.Sitwell, *Conversation Pieces* 1936, p110, pl 109

Frederick Howard, K.T., 5th Earl of Carlisle (1748-1825) was Lord Lieutenant of Ireland 1780-2. He is portrayed with his family, Lady Carlisle driving with his sister, Lady Julia Howard, his eldest son, George, Viscount Morpeth, and with members of his staff, who include Mr Ekins (rector of Morpeth), Mr Emly, Mr Corbett and the groom Samuel Waterwith.

George Howard Esq

38 Two Children of the Maxwell Family Fig 40
Oil on canvas
$40\frac{1}{4} \times 30$ in / 102.2 \times 76.2 cm
1780-1

PROVENANCE Painted for the sitter's family; by family descent.
EXHIBITION *Pictures from Ulster Houses.* Belfast 1961(67).

39

41

Barry Maxwell, 1st Earl of Farnham, married firstly Margaret King (d 1766), secondly 5 August 1771, Grace, daughter of Arthur Burdett Esq, by whom he had the two daughters represented here, Lady Grace and Elizabeth (who died in January 1782).[1]

Reference: 1 J.Lodge and M.Archdall, *The Peerage of Ireland* III, 1789, pp397-8.

Lord Farnham

39 Equestrian portrait of Sir Henry Pigott
Oil on canvas
$24\frac{7}{8} \times 29\frac{5}{8}$ in / 63.2 × 75.2 cm

SIGNED AND DATED F.W. 1782.
PROVENANCE Evan Charteris.

The son of Admiral Hugh Pigott, Henry Pigott (1750–1840) was a cornet in the 1st dragoons 1769; Lieutenant-colonel

1783; Major-general 1795. He commanded the blockade of Valetta in 1800 and G.C.M.G. 1837.[1]

Reference: 1 *Gentleman's Magazine* 1840, pt ii, pp429-30.

Miss Frederica Leser

40 Portrait of an Officer Fig 42
Oil on canvas
$28 \times 24\frac{1}{2}$ in / 71.1 × 62.2 cm

SIGNED AND DATED F.Wheatley px 1782.
PROVENANCE Christie's, 18 May 1962(23); Sotheby's 25 March 1963(120).

Collection unknown

41 Miss Fridiswede Moore

Oil on canvas
25 × 30 in / 63.5 × 76.2 cm

SIGNED AND DATED F.Wheatley/pxt/1782.
PROVENANCE Formerly in the collection of a grandchild of the sitter.

The sitter was the daughter of John Moore Esq, M.D. of Tullyallen, Co Louth. She married in 1786 Robert Henry, 2nd son of the 1st Viscount Southwell of Castle Hamilton, Co Cavan, who was MP for Downpatrick 1776–83 and Lt Col of the 8th Dragoons.

Collection unknown

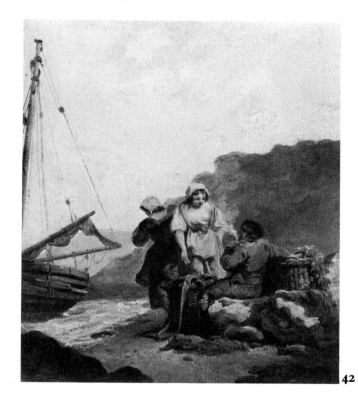

42

42 Fisherfolk

Oil on panel
10⅝ × 9 in / 27 × 22.9 cm

SIGNED AND DATED F.Wheatley pxt./1782(?).
EXHIBITION *Francis Wheatley, R.A.,* Aldeburgh and Leeds, 1965(12).
ENGRAVING Etching in reverse by T.Rowlandson, inscribed F.Wheatly and dated 1786, published in Rowlandson's *Imitations of Modern Drawings,* 1784-8. There are slight differences in the sky and rocks, and in the man who wears a hat and whose head is turned further to the right.

A wash drawing of the subject was with F.R.Meatyeard in 1934, and another was with Colnaghi in 1954. Both show the man as he appears in the etching, but otherwise they differ in many respects and show less of the composition than appears in the etching.

43

43 Family Group in a Landscape

Oil on canvas
50 × 40 in / 127 × 101.6 cm
c 1782

PROVENANCE Probably Right Hon W.Ellison Macartney.
EXHIBITION Probably Whitechapel 1906(114) as by Zoffany.

Formerly known as a portrait of William Macartney MP (1715-97) and his family. If members of this family are represented they are most likely to be William Macartney's elder son Arthur Chichester (1744-1827), married 1779, Anne daughter of the Rev Samuel Lindsay of Turin Castle, Co Mayo, and their eldest child. The helmet appears to be that of a

Volunteer regiment. It is datable *c* 1782 by analogy with the *Review of Troops in Phoenix Park* [36]; if the sitters are correctly identified the age of the child would suggest a date not earlier than 1782.

Art Gallery of Ontario; gift of Agnes E. Wood Estate, 1951

44 Seashore at Howth, Ireland Fig 49
Oil on canvas
28 × 35½ in / 71.1 × 90.2 cm
c 1782–3

EXHIBITION *Francis Wheatley, R.A.*, Aldeburgh and Leeds, 1965(8).

A small water-colour, taken from the same view point is in the Victoria and Albert Museum. The subject was engraved by W. & J. Walker and published 1 September 1792 in the *Copper Plate Magazine*, no VIII, pl XVI. There are substantial differences between the placing of the rocks and the grouping of the boats and figures in the foreground.

Southampton Art Gallery

45 The Salmon Leap at Leixlip with Fig 50
 Nymphs bathing
Oil on canvas
26⅝ × 25½ in / 67.6 × 64.75 cm

SIGNED AND DATED F. Wheatley pinx 1783.
PROVENANCE Greenwood sale, 5 May 1785(63); E.P. Jones; Sotheby's 19 April 1961(78).
EXHIBITIONS *English Painting, 1700–1850*, Virginia Museum of Fine Arts, 1963(269); *Painting in England, 1700–1850*, R.A. 1964–5(222); *Francis Wheatley, R.A.*, Aldeburgh and Leeds 1965(9).
ENGRAVING Etching and stipple engraving by R. Pollard with aquatint by F. Jukes, 1785. The proportions of the engraving differ from the painting; the landscape extends further at the left side.

The canvas has presumably been cut down on the left by about 8 inches; emphasis on the bathing figures is heightened thereby.

Mr and Mrs Paul Mellon

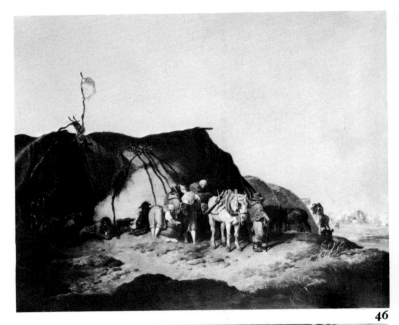

46

47

46 A Gypsy Encampment in Ireland
Oil on panel
$16\frac{5}{8} \times 20\frac{1}{8}$ in / 42.2 × 51.1 cm

SIGNED AND DATED F.Wheatley 1783.
EXHIBITION *English Landscapes from Colonel Grant's Collection*,
Arts Council, 1953(67).

Collection unknown

**47 Equestrian portrait of the first Viscount
Sidmouth when Mr Addington**
Oil on canvas
50 × 40 in / 127 × 101.6 cm
c 1785-6

PROVENANCE Painted for the sitter and thereafter by family
descent to the sixth Viscount Sidmouth; UpOttery sale (Lord
Sidmouth) J.Trevor & Sons 22 July 1954(255) as portrait of
John Addington by Gainsborough.
EXHIBITION *English Painting, 1700-1850*, Virginia Museum of
Fine Arts 1963(266).

Henry Addington (1757-1844) created first Viscount Sidmouth
in 1805 was Speaker of the House of Commons (1789-1801),
Prime Minister and Chancellor of the Exchequer (1801-4) and
Home Secretary 1812-21.

Mr and Mrs Paul Mellon

48 Adelaide and Fonrose
Oil on canvas
$33\frac{1}{2} \times 26\frac{1}{2}$ in / 85.1 × 67.3 cm (oval)
1786

EXHIBITIONS *Francis Wheatley, R.A.*, Aldeburgh and Leeds,
1965(10).

An illustration to 'La Bergère des Alpes' in Marmontel's
Contes Moraux; Adelaide and Fonrose are shown by the oak
tree beneath which Adelaide's husband lies buried. The
composition derives from de Loutherbourg's version of the
same subject. A water-colour with slight differences in
composition is dated 1786 [Fig 72].

D.C.Paterson Esq

49 Arthur Phillip
Oil on canvas
$36 \times 27\frac{3}{4}$ in / 91.4 × 70.5 cm

Fig 139

SIGNED AND DATED FW:/1786.
PROVENANCE Believed to have been in the collection of Miss
Harriet Lane before 1860; Mrs Elizabeth Gayton, who
bequeathed it to the National Portrait Gallery in 1907.
EXHIBITION *Francis Wheatley R.A.* Aldeburgh and Leeds 1965
(11).

Arthur Phillip (1738-1814) became vice-admiral and was the
first governor of New South Wales. Here he wears Captain's
undress uniform (over three years) of 1774-87. In 1786 Phillip
was assigned the duty of forming a convict settlement in
Australia; he set sail on 13 May 1787 with a fleet of 11 ships.
The portrait was presumably painted on his appointment, a
personal triumph to which there was powerful opposition.
The scene may anticipate Phillip's landing in Australia, but it
does not represent either Botany Bay or Sydney Harbour. See
also [50]

National Portrait Gallery, London

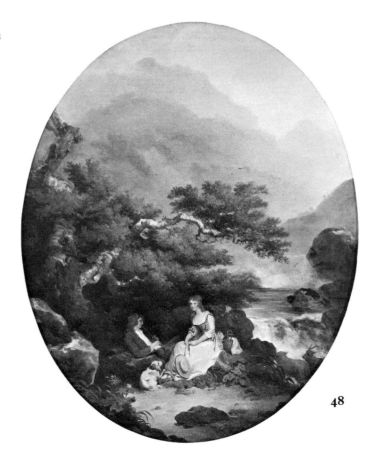

48

50 Arthur Phillip Fig 140
Oil on canvas
$11\frac{11}{16} \times 9\frac{11}{16}$ in / 29.7 × 24.6 cm (oval)

SIGNED AND DATED F.W. 1786 (The plan which Phillip holds is
inscribed *New South Wales* 1787).
ENGRAVINGS Line engraving by W.Sherwin, published 1 May,
1789 by J.Stockdale as the frontispiece to A.Phillip, *A Voyage to
Botany Bay*, London, Stockdale 1789; stipple engraving by
Page, published 31 January 1812 by Joyce Gold; stipple
engraving by Ermer, n.d.
See [49] for the sitter.

The Mitchell Library, Sydney, New South Wales

51

51 Mrs Pearce
Oil on canvas
49 × 39 in / 124.5 × 99.1 cm

SIGNED AND DATED F.W. px.1786.
PROVENANCE Christie's, 18 December, 1936(19).
Daughter of Mrs Bryan

Collection unknown

53

**53 The Industrious Cottager – a girl
 making cabbage nets**
Oil on canvas
$72\frac{1}{2} \times 53\frac{3}{4}$ in / 184.2 × 136.5 cm

SIGNED AND DATED 1786

PROVENANCE W.H.Gibson Fleming, Sotheby's, 23 March
1960(57).
EXHIBITION R.A. 1786(237).
ENGRAVING Stipple engraving by Charles Knight, published
31 March 1787.

A version of the subject in water-colour, signed and dated 1786
was with the Fine Art Society in 1965.

J.Paul Getty Esq

52 Brickmakers Fig 89
Oil on canvas
16 × $23\frac{1}{2}$ in / 40.6 × 59.6 cm
1786

PROVENANCE Lord Fairhaven.
EXHIBITION R.A. 1786(194).

Collection unknown

54

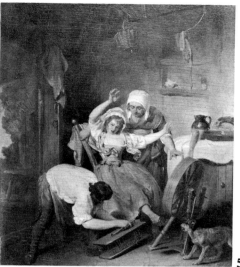

56

54 The Sailor's Return
Oil on canvas
$18\frac{1}{2} \times 15$ in / 47×38.1 cm

SIGNED AND DATED F.Wheatley 1786.
PROVENANCE Greenwood, 20 February 1790(31); 5 February
1791(10); Christie's, 15 February 1808(24); Christie's, 2 June
1808(49); Caird Collection.
EXHIBITION *Francis Wheatley R.A.* Aldeburgh and Leeds,
1965(13).
ENGRAVING Mezzotint by W.Ward, published 14 June 1787.

The companion to *The Soldier's Return* formerly in the John
McFadden Collection (untraced), see [**E39**].

National Maritime Museum, Greenwich

55 The Return from Market Fig 93
Oil on canvas
$29\frac{1}{2} \times 24\frac{1}{2}$ in / 74.9×62.2 cm

SIGNED AND DATED F.W. px/1786.
PROVENANCE A.McKay: Lord Northbrook: F.J.Nettlefold who
presented it to Leeds in 1948.
EXHIBITIONS R.A. 1788(37); R.A. 1877(289); R.A. 1951-2(40);
Francis Wheatley R.A. Aldeburgh and Leeds, 1965(14).
ENGRAVING Stipple engraving by Charles Knight, published
21 April 1789.
LITERATURE C.R.Grundy and F.G.Roe, *A Catalogue of the
Collection of F.J.Nettlefold* IV, 1938, p122.

Leeds City Art Galleries

56 The Rat Trap
Oil on panel
$21\frac{1}{4} \times 17\frac{3}{4}$ in / 54×45.1 cm
1786

SIGNED FW.
PROVENANCE Greenwood 20 February 1790(120); Sotheby's,
7 July 1965(76).
EXHIBITION C.E.M.A. *The English 1700-1942* British
Institute of Adult Education, Chester, Brighouse and
Harrogate, 1943(11).

A wash drawing of the subject, signed and dated 1786, was in
the Gilbey sale, Christie's, 26 April 1940(218).

With G.Norman Esq in 1965; present whereabouts unknown

57 John Howard Visiting and Relieving the Fig 83
Miseries of a Prison
Oil on canvas
41×51 in / 104.1×129.5 cm

SIGNED AND DATED F.W. Px.t/1787.
PROVENANCE Christie's, 25 February 1809(110), bought by the
1st Earl of Harrowby; by family descent.
EXHIBITIONS R.A. 1788(31); British Institution 1849(98); R.A.
1873(277); Birmingham 1934(295); R.A. 1951-2(39); British
Council, *Painting in Britain in the Eighteenth century* 1957-8(72).
ENGRAVING Line engraving by James Hogg, published 9 April
1790.

Important as a good likeness of John Howard (1726?–90), philanthropist, prison reformer and author of *The State of Prisons*, 1777. Howard allegedly refused ever to sit for a portrait. The engraving after this picture was announced in the press as containing the 'best likeness of its Amiable and Philanthropic hero'.[1] Howard visiting a prison was the subject of many compositions by Romney.

Reference: 1 Victoria and Albert Museum Library, *Press Cuttings*, p566.

The Earl of Harrowby

58 Mrs Ralph Winstanley Wood with her Fig 141
 Daughters
Oil on canvas
36 × 28½ in / 91.4 × 72.3 cm

SIGNED AND DATED F.W. 1787.

PROVENANCE By family descent to Major J.W.Cobb; Christie's 3 May 1929(33); Sotheby 20 April 1955(79).

Mary Margaretta Pearce (1746–1808) became the wife of Ralph Winstanley Wood to whose portrait with his son [59] this forms the pendant. On her tomb in the church-yard at Frensham was inscribed the following:

'Here lieth the body of Mary Margaretta Wood, wife of Ralph Winstanley Wood Esq. who died October the 23rd, 1808, aged 62 years.

> Though long the victim of disease and pain,
> Ne'er heard when friends were near her, to complain;
> Whether ordain'd to distant climes to roam,
> Or back returning to her native home;
> With that best cordial in her heart, Content,
> She went her way, rejoicing "as she went;"
> With him she lov'd pass'd cheerfully through life,
> An anxious mother and a faithful wife'.[1]

Reference: 1 O.Manning and W.Bray, *The History and Antiquities of the County of Surrey* III, 1814, p171.

Henry E. Huntingdon Library and Art Gallery, San Marino, California

59 Ralph Winstanley Wood with his Son,
 William Warren
Oil on canvas
28 × 35 in / 71.1 × 88.9 cm
1787

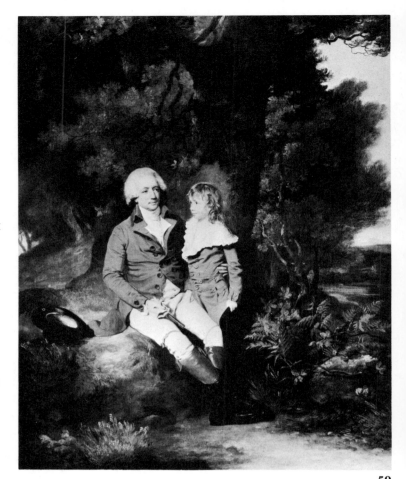

59

PROVENANCE See [58] until 1929

Ralph Winstanley Wood (1745–1831) married Mary Margaretta Pearce [see **58**], made his fortune as a salt agent in India where he met Warren Hastings who became godfather to his son. He had one son and three daughters. In 1785 he bought Pierrepont Lodge, Frensham. He built a new house on the land called Highfield for a Mr.Webber who had married his daughter. She, however, chose not to live there, Mr Wood moved to it himself and pulled down the old house.[1] He later lost his fortune.

Reference: 1 O.Manning and W.Bray, *The History and Antiquities of the County of Surrey* III, 1814, p167.

Private collection, U.S.A.

60 Prospero, Miranda, Ferdinand and
 Hippolito
Oil on canvas
40 × 49¾ in / 101.6 × 126.3 cm

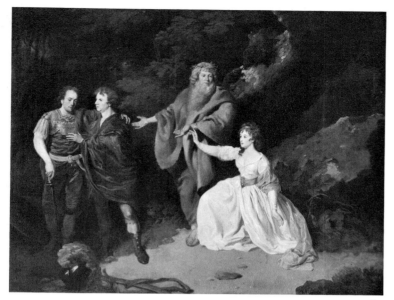

60

SIGNED AND DATED F.Wheatley px/1787.
PROVENANCE Sir H.Davies 1913; Christie's 17 February 1913
(37): C.Carstairs, presented by him to Buck's Club, 1920;
Herbert Buckmaster; Christie's 7 March 1958(120).
EXHIBITION *Francis Wheatley R.A.* Aldeburgh and Leeds, 1965
(16).

Possibly a scene from the version of *The Tempest* written by
Dryden and Davenant. It should represent Act IV scene 3, but
Dorinda is not present. By 1787 Shakespeare's original version
was again being played. It has also been suggested that it may
be a representation of the final scene of Garrick's play *Arthur
and Emmeline* adapted from Dryden's *King Arthur*. Neither of
these suggestions is entirely satisfactory and for the time being
the play depicted must remain in doubt. The front of
Prospero's robe and his right hand are unfinished.

City Art Gallery, Birmingham

61 A Girl feeding a young bird Fig 94
Oil on canvas
49 × 64½ in / 124.5 × 163.8 cm

SIGNED AND DATED F.Wheatley 1787.
PROVENANCE Earl Farquhar
EXHIBITION R.A. 1787(135).

Private Collection, Germany

62 Mrs Wheatley Fig 146
Oil on canvas
15⅜ × 13⅛ in / 39 × 33.3 cm (oval)
1788

PROVENANCE Sir Herbert Hughes Stanton.
LITERATURE For the sitter, see Mary Webster, 'A Regency
Flower Painter, Clara Maria Pope,' *Country Life* CXLI, 18 May
1967, pp1246–8.

An old label on the reverse reads 'Mrs Wheatley 1788'.

Mrs Barbara Brookes

63 The Return from Shooting Fig 143
Oil on canvas
61½ × 82½ in / 156.2 × 209.5 cm

SIGNED AND DATED F.W. Pinxt. 1788.
PROVENANCE Painted for the sitter; by family descent.
EXHIBITIONS R.A. 1789(17); National Portrait 1867(649); R.A.
1879(14).
ENGRAVINGS Stipple engraving by F.Bartolozzi and S.Alken,
published 10 January 1792, and 1 January 1803 without the star
on the Duke's breast.
LITERATURE *Clumber Catalogue* 1923, p56 no134.

Henry Fiennes Pelham-Clinton, 2nd Duke of Newcastle (1720–
94), riding a chestnut horse, wears a grey coat with the Star of
the Garter, behind him is Col Litchfield; Mansell the keeper is
coupling two Clumber spaniels; Day the under-keeper stands
putting game into a sack; on the extreme right is Rowlands, the
Duke's valet. Clumber House is in the distance. Henry Fiennes
Pelham-Clinton, the second son of Henry Clinton, 7th Earl of
Lincoln, who preferred the pleasures of the country and sport to
politics, married in 1774 Catherine Pelham, elder daughter of
his uncle Henry Pelham, the Prime Minister. In 1775 on a visit
to France he received as a gift from the Duc de Noailles several
couples of the breed of spaniels which became known as
Clumber spaniels.

Trustees of the Seventh Duke of Newcastle, deceased

64 The Winter's Tale Fig 120
Oil on canvas
84 × 105 in / 213.2 × 266.7 cm

SIGNED AND DATED Francis Wheatley 1788.
PROVENANCE Painted for the Shakespeare Gallery; Christie's

18 May 1805(39); Dudley Sale, Christie's 9 May 1947(73).
ENGRAVING Line engraving by James Fittler, published
1 August 1792.
LITERATURE J.Boydell, *A Catalogue of the Pictures &c in the
Shakespeare Gallery* 1790, pp33-4, no XVIII.

This subject is taken from *The Winter's Tale* Act IV, scene 3:
a shepherd's cottage in Bohemia. 'Perdita, the innocent
Babe . . . is now grown up, and, as a Shepherd's Daughter,
beloved by the young Prince Florizel, who has put on a
shepherd's dress, to do honour to a sheep-shearing. The *King*,
his father, with *Camillo*, disguised, are witnesses to the scene;
and she is welcoming them as strangers, and giving them
flowers suitable to their age:

. . . 'Reverend, Sirs,
For you, ther's Rosemary and Rue: these keep
Seeming and savour, all winter long.'

'In the background is a *Pedlar*, with his wares amusing the Lads
and Lasses. The Landscape, the figure of the old Man, and
particularly the Dog, make this by far the best Picture of the
three painted by this Artist.'[1]

A reduction made for the engraver is at the Shakespeare
Memorial Theatre, Stratford-upon-Avon.[2]

References: 1 H.Repton, *The Bee; or, a companion to the Shakespeare
Gallery*, 1789, p33. 2 *Plan of the Shakespeare Lottery*, 5 April 1804,
the 24th-26th tickets drawn each contained ten pictures 'Painted
from Part of the large Shakespeare Pictures', for the Artists to
engrave from.

Theatre Royal, Drury Lane, London

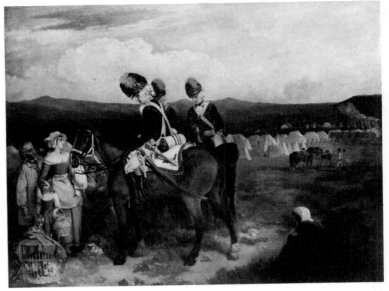

66

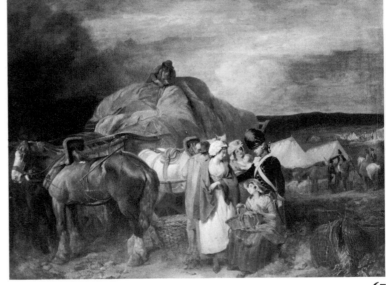

67

65 Theseus and Hippolyta find the Lovers Fig 118
Oil on canvas
77¾ × 96 in / 197.5 × 243.8 cm

SIGNED AND DATED F.Wheatley/pxt 1788 (or 9).
PROVENANCE Painted for the Boydell Shakespeare Gallery;
Christie's 17 May 1805(40).
EXHIBITIONS *William Shakespeare* M.Knoedler & Co Inc New
York 1964(76); *Francis Wheatley R.A.* Aldeburgh and Leeds,
1965(15).
LITERATURE J.Boydell, *A Catalogue of the Pictures in the
Shakespeare Gallery* 1790, pp21-2, no XI.

A scene from *A Midsummer Night's Dream*, Act IV scene 1,
painted for the Shakespeare Gallery. It was not engraved.
Humphrey Repton commented, 'the subject is made

interesting by the beauty of the Female Figures; and that
surely will be allowed by those who can see nothing else to
praise in this performance. We may also commend the foliage
and landscape.'[1]

Reference: 1 H.Repton, *The Bee; or, a companion to the Shakespeare
Gallery* 1789, p24, no XI.

Mr Lincoln Kirstein

66 Scene from a camp with an officer buying chickens

Oil on canvas
40 × 50 in / 101.6 × 126 cm
1788

SIGNED AND DATED Francis Wheatley F.1788.
PROVENANCE Christie's 19 November 1892(14).
ENGRAVING Mezzotint by J.Murphy published 1 May 1796 as *The Encampment at Brighton.*

The companion to *Scene from a camp with an officer buying ribbons* [67]. The following comment probably refers to these two pictures: 'The elegant pencil of Wheatley, has of late been employed in two capital subjects derived from the late *encampment* at Bagshot, in which he is said to have introduced some military horse with astonishing effect.'[1] One of these pictures was exhibited at the Royal Academy in 1793(326). Since the militia camps at Brighton in 1793, 1794 and 1795 were important and notorious, it is not inconceivable that engravings after the Bagshot pictures should have been published with a change of location.

Reference: 1 Victoria and Albert Museum Library *Press Cuttings* 1789(?).

Major W.H.Callander

67 Scene from a camp with an officer buying ribbons

Oil on canvas
40 × 50 in / 101.6 × 127 cm
1788

SIGNED AND DATED Francis Wheatley F.1788.
PROVENANCE Christie's 19 November 1892(13).
ENGRAVING Mezzotint by J.Murphy published 1 May 1796 as *The Departure from Brighton.*

[See 66.]

Major W.H.Callander

68 The Disaster

Oil on canvas
30¾ × 26¼ in / 78.1 × 66.7 cm

SIGNED AND DATED F.W. 1788.
PROVENANCE Greenwood, 20 February 1790(126); 5 February 1791(44); by family descent to Sir Edward Marwood Elton,

68

Christie's, 18 April 1885(60); Sir Charles Tennant; by family descent. Parke Bernet 25 September 1968(20).
EXHIBITIONS Grosvenor Gallery, 1888(211); R.A. 1906(61).
ENGRAVING Mezzotint by W.Ward, published 26 July 1789.

Mr Eli W. Tullis

69

69 Portrait of a Lady as a Pilgrim

Oil on canvas
85 × 57½ in / 216 × 146 cm

70

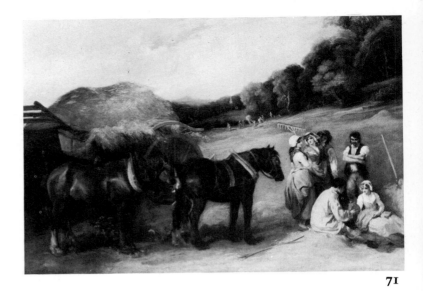
71

SIGNED AND DATED Francis Wheatley 1790.
PROVENANCE Lord Reay; Princess Royal Sale, Christie's,
18 December 1931(137).
EXHIBITION R.A. 1790(290).

Collection unknown

70 Ruth and Boaz
Oil on canvas
49 × 39 in / 124.4 × 99.1 cm

SIGNED AND DATED Francis Wheatley 1790.
PROVENANCE Christie's, 26 July 1957(90).
ENGRAVING Line engraving by H.B.Hall, published by Fisher
Son & Co, 1840.

Collection unknown

71 Haymaking, a View near a Wood
Oil on canvas
40 × 49 in / 101.6 × 124.4 cm

SIGNED AND DATED 1790.
PROVENANCE Maskelyne Collection; Christie's 6 February
1953(139).
EXHIBITION British Institution, 1867(138).

Ministry of Public Buildings and Works, London (Crown
Copyright)

72 All's Well that Ends Well Fig 122
Oil on canvas
75 × 88¾ in / 190.5 × 225.5 cm
1790

PROVENANCE Painted for the Shakespeare Gallery; Christie's
20 May 1805(37)
ENGRAVING Line engraving by G.S. and J.G.Facius published
4 June 1794.
LITERATURE J.Boydell, *A Catalogue of the Pictures &c. in the
Shakespeare Gallery*, 1790, pp88–9 no XLIV.

All's Well that Ends Well Act V, Scene 3

'This is a most pleasing picture, the story is well told, the
characters are well drawn and properly marked; the figure of
Helena is most elegantly beautiful, and the general hue of the
whole most brilliantly clear. We are happy to see the tone of
Mr Wheatley's colouring so much improved, and that his
outline is so much more firm and decided than it was in some
of his former works. There is a general taste in the whole
design, and a general spirit in the composition, which proves,
that whenever we have had occasion to remark any little errors
in his former works, they have proceeded from want of
attention, and not from want of power'.[1]

Reference: 1 Victoria & Albert Museum Library. *Press cuttings*,
P559.

Collection unknown

73

74

73 Portrait of an Old Lady seated under a Tree
Oil on canvas
30 × 25 in / 76.2 × 63.5 cm
c 1790

EXHIBITION *Pictures from Ulster Houses*, Belfast, 1961(99) as Zoffany.

A comparison with *Benjamin Bond-Hopkins* [75] indicates that this portrait is by Wheatley and that it dates from *c* 1790.

Lord Dunleath

74 The Sportsman's Return
Oil on canvas
22½ × 18½ in / 57.1 × 47 cm
c 1790

PROVENANCE The Duchess of Montrose.

H.M.Treasury; on loan to National Trust of Scotland

75 Benjamin Bond-Hopkins Fig 142
Oil on canvas
39⅞ × 49⅝ in / 100.3 × 126 cm
1790–1

PROVENANCE Given to the Fitzwilliam Museum by Lt Col B.E.Coke, 1953, in memory of Mrs Sarah Coke and the Rev G.C.O.Bond.

EXHIBITIONS R.A. 1791(85); *Francis Wheatley R.A.* Aldeburgh and Leeds 1965(18).

Said to have been painted in the grounds of Pain's Hill, Cobham, Surrey, which was built by Benjamin Bond-Hopkins (1747–94). The sitter assisted Robert Bowyer in financing the Historic Gallery.

Fitzwilliam Museum, Cambridge

76 A Peasant Boy Fig 95
Oil on canvas
30½ × 41 in / 77.5 × 104.1 cm (oval)
1790–1

PROVENANCE Diploma work, deposited by the artist on his election as a Royal Academician in 1791.
EXHIBITIONS British Institution 1857(134); Nottingham University 1959(49); Arts Council Touring Exhibition 1961–2 (43); *Francis Wheatley R.A.* Aldeburgh and Leeds 1965(17).

Presumably painted shortly before presentation.

The Royal Academy of Arts, London

77

77 The Angler's Return

Oil on canvas
$28\frac{1}{2} \times 36$ in / 72.4 \times 91.5 cm
c 1790

Datable by comparison with the portrait of Benjamin Bond-Hopkins [**75**].

Collection unknown

78 Lord Mayor's Day November 9th The Procession by Water, By Richard Paton, the figures in the foreground by Wheatley

Oil on canvas
61 \times 85 in / 156 \times 215.75 cm
c 1790

One of the pictures included in Alderman Boydell's gift to the Corporation of the City of London in 1793. 'The Lord Mayor and Court of Aldermen attended to by the different Livery Companys in their Rich Barges, to Westminster Hall to receive the approbation of his Majesty. . . . This picture represents a fine View of the Citys of London and Westminster, of the principal Public Buildings on the Banks of the Thames, a number of Spectators attending the Ceremony, and on the Surry side viewing the Procession.' (This event probably took place in 1789.) 'Painted by Rich[d] Paton Esq the Figures on the Surry side by Wheatley Esq R.A.'[1]

Reference: 1 Guildhall MS.198, pp2-3.

Guildhall Art Gallery, London

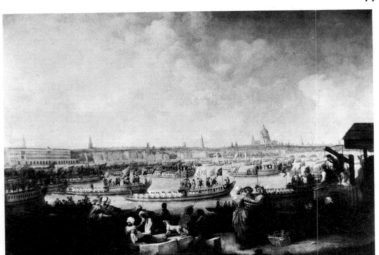

78

79 The Oyster Girl

Oil on panel
9 \times 7 in / 22.8 \times 17.8 cm
c 1790

SIGNED AND INDISTINCTLY DATED F.W.17.
PROVENANCE Sotheby's, 11 October 1967(35).
ENGRAVING Stipple engraving by D.Orme n.d.

Datable on grounds of style.

Mrs Pamela de Meo

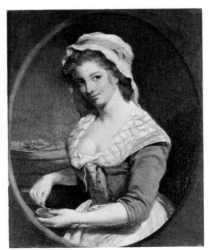

79

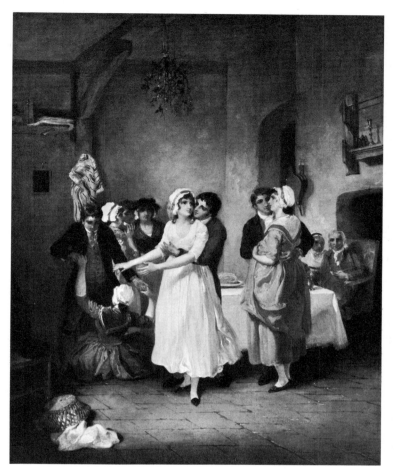

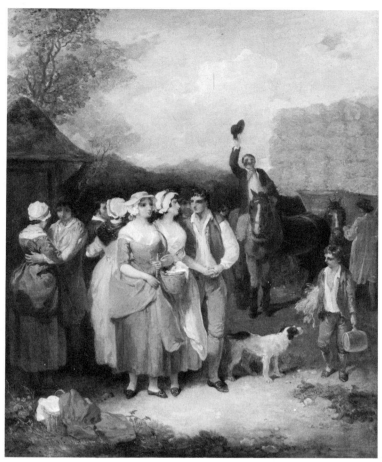

80

81

80 **The Mistletoe Bough**
Oil on canvas
22 × 18 in / 55.9 × 45.7 cm
c 1790

PROVENANCE Christie's 24 February 1809(76) with *The Harvest Home* [81].
EXHIBITIONS *English Painting 1700–1850*, Virginia Museum of Fine Arts, 1963(268); *Painting in England 1700–1850* 1964–5 (255); *Francis Wheatley R.A.* Aldeburgh and Leeds, 1965(24).

Mr and Mrs Paul Mellon

81 **The Harvest Home**
Oil on canvas
22 × 18 in / 55.9 × 45.7 cm
c 1790

PROVENANCE Christie's 24 February 1809(76).

With M.Bernard in 1969

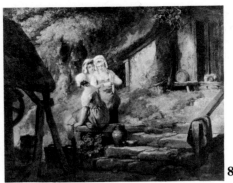

82

82 Three Country Girls by a Well
Dimensions unknown
c 1790

Collection unknown

83 Children with Cat Fig 154
Oil on canvas
40 × 50 in / 101.6 × 127 cm

SIGNED AND DATED F.Wheatley/p^xt 1791.
PROVENANCE Painted for Philip Godsal who bought the picture from Wheatley for 35 guineas in 1791.[1] By family descent.
EXHIBITION On loan to the Ferens Art Gallery, Hull, 1926–60.

Reference: 1 Philip Godsal's pocket book for 1791, 12 January: 'Paid Wheatley for the large picture of Cottage Children £36.15.1d.' Information kindly communicated by Major Philip Godsal.

Major Philip Godsal

84 The Smithy Fig 155
Oil on canvas
20 × 25½ in / 50.8 × 64.8 cm
1791

PROVENANCE Painted for Philip Godsal who bought the picture with its companion, *The Pedlar* [85] from Wheatley for £36 in 1791.[1] By family descent.
EXHIBITION On loan to the Ferens Art Gallery, Hull, 1926–48.

Reference: 1 Philip Godsal's pocket book for 1791, 8 June: 'Mr Wheatley in full for 2 pictures of Pastoral Subjects £36.' Information kindly communicated by Major Philip Godsal.

Major Philip Godsal

85 The Pedlar Fig 100
Oil on canvas
20 × 25½ in / 50.8 × 64.8 cm
1791

PROVENANCE [See **84**].
EXHIBITIONS Possibly R.A. 1791(223); on loan to the Ferens Art Gallery, Hull, 1926–48.

Major Philip Godsal

86 The Careless Husband Fig 77
Oil on canvas
19½ in / 49.5 cm (circular)
1791

PROVENANCE J.James 1880; Christie's 17 December 1926(166); Lawrence Currie; F.J.Nettlefold who presented it to the Victoria and Albert Museum in 1947.
ENGRAVING Line engraving by J.M.Delatre, published by J.Bell, 30 September 1791.
LITERATURE C.R.Grundy and F.G.Roe, *A Catalogue of the Collection of F.J.Nettlefold,* IV, 1938, p124.

The subject is taken from *The Careless Husband* by Colley Cibber, Act V, scene 5.
Lady Easy: If he should wake offended at my too busy care, let my heart breaking patience Duty, and my fond affection lead my pardon.
The engraving of the picture was published as part of the title page to the play in Bell's *British Theatre.*

Victoria and Albert Museum, London

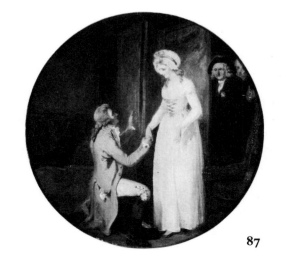

87

87 Young Marlow and Miss Hardcastle
Oil on canvas
$19\frac{1}{2}$ in / 49.5 cm (circular)
1791

PROVENANCE Christie's 17 December 1926(166). Lawrence
Currie; F.J.Nettlefold who presented it to the Victoria and
Albert Museum in 1947.
EXHIBITION *Francis Wheatley R.A.* Aldeburgh and Leeds,
1965(19).
ENGRAVING Line engraving by J.Hall for Bell's *British Theatre*
published 12 December 1791.
LITERATURE C.R.Grundy and F.G.Roe, *A Catalogue of the
Collection of F.J.Nettlefold*, IV, 1938, p126.
She Stoops to Conquer by Oliver Goldsmith.
Act V scene 3. Young Marlow kneeling before Miss
Hardcastle, Sir Charles Marlow and Hardcastle enter from
behind the screen.
Marlow: Does this look like security? Does this look like
confidence? No madam; every moment that shows me your
merit, only serves to increase my diffidence and confusion.
Here let me continue –
Sir Charles: I can hold it no longer.
Charles, Charles how hast thou deceived me!

Victoria and Albert Museum, London

88 The Maternal Blessing—Maidenhood Fig 96
Oil on canvas
$31\frac{1}{2} \times 26\frac{1}{2}$ in / 80 × 67.3 cm

SIGNED AND DATED F.Wheatley px.t 1791.
PROVENANCE Sir Randolph Baker in whose family it had been
since the eighteenth century; Christie's, 8 June 1928(111).
EXHIBITIONS R.A. 1792(107); *Daily Telegraph*, Olympia 1928
(X60); *English Conversation Pieces* 25 Park Lane 1930(48);
Francis Wheatley R.A. Aldeburgh and Leeds, 1965(20).

The first of a set of four paintings [see **89,90,91**] exhibited in
1792. The critic of the *Morning Herald* wrote of them: 'To
Mr.Wheatley belongs the great and peculiar praise of blending
the 'utile dulci Lectorem delectando pariterque monendo' and
by elevating the arts to the dignity of a moral in this series of
pictures, he has, with singular felicity, employed his pencil in
delineating the progress and manners of humble life –
pursuing and attaining happiness through the channels of
prudence and industry. . . . The story is well told, and the scene
in *The Happy Fireside* is particularly interesting. If we knew a
man whose mind, soured and contracted by the presence of
undeserved calamity, was verging to misanthropy, we should

place this picture before him, and we think his social affections
would revive'.[1]

Reference: 15 May 1792.

The Viscount Bearsted

89 The Offer of Marriage—Courtship Fig 97
Oil on canvas
$31\frac{1}{2} \times 26\frac{1}{2}$ in / 80.25 × 67.3 cm

SIGNED AND DATED F.Wheatley px.t 1791.
PROVENANCE [See **88**].
EXHIBITIONS R.A. 1792(119); *Daily Telegraph*, Olympia 1928
(X60); *English Conversation Pieces* 25 Park Lane 1930(44);
Francis Wheatley R.A. Aldeburgh and Leeds 1965(21).

[See **88**.]

The Viscount Bearsted

90 The Wedding Morning—Marriage Fig 98
Oil on canvas
$31\frac{1}{2} \times 26\frac{1}{2}$ in / 80 × 67.3 cm

SIGNED AND DATED F.Wheatley px.t 1791.
PROVENANCE [See **88**].
EXHIBITIONS R.A. 1792(137); *Daily Telegraph*, Olympia 1928
(X60); *English Conversation Pieces* 25 Park Lane 1930(49);
Francis Wheatley R.A. Aldeburgh and Leeds 1965(22).

[See **88**.]

The Viscount Bearsted

91 The Happy Fireside—Married Life Fig 99
Oil on canvas
$31\frac{1}{2} \times 26\frac{1}{2}$ in / 80 × 67.3 cm

SIGNED AND DATED F.Wheatley px.t 1791.
PROVENANCE [See **88**].
EXHIBITIONS R.A. 1792(155); *Daily Telegraph*, Olympia 1928
(X60); *English Conversation Pieces* 25 Park Lane 1930(45);
Francis Wheatley R.A. Aldeburgh and Leeds 1965(23).

[See **88**.]

The Viscount Bearsted

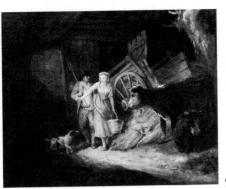

92 The Milkmaid
Oil on canvas
12 × 14 in / 30.5 × 35.6 cm

SIGNED AND DATED F.W.1791.

With Gooden & Fox Ltd in 1969

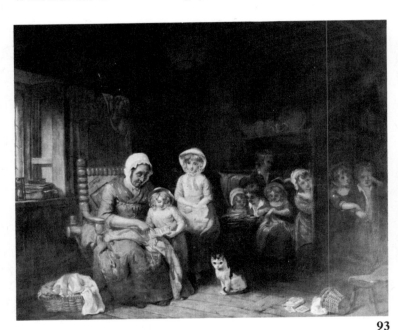

93 The Schoolmistress
Oil on canvas
39 × 49 in / 99 × 124.4 cm

SIGNED AND DATED F.Wheatley pxt 1791.
PROVENANCE Painted for Macklin's *Poet's Gallery*; Christie's
3 December 1937(123); Sotheby's 11 October 1967(32)
ENGRAVING Stipple engraving by J.Coles, published 20 March
1794.

An illustration to *The Schoolmistress* by William Shenstone.

Collection unknown

94 A Woodman Returning Home, Evening Fig 101
Oil on canvas
21½ × 17½ in / 54.6 × 44.4 cm

DATED 1791.
PROVENANCE Christie's, 13 January, 1795(70).
ENGRAVING Stipple engraving by J.Whessell published
1 January 1797.

This is the companion to *The potter going to market with a storm
approaching, morning* (untraced) at Wheatley's sale, Christie's
13 January 1795(69).

Mrs Eleanor G.MacCracken

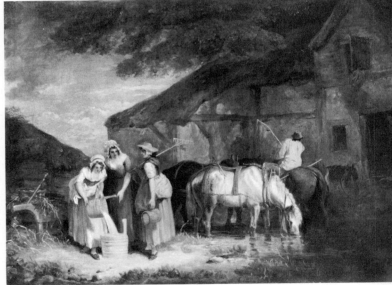

95 Evening, a Farmyard
Oil on canvas
20 × 26 in / 50.8 × 66 cm
1791–2

EXHIBITION Probably R.A. 1792(453).
ENGRAVING Engraving by J.Barney, published February 1793.

Private collection, U.K.

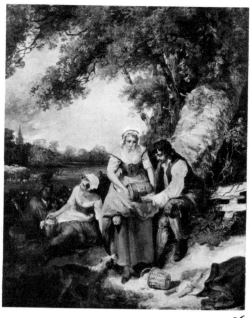

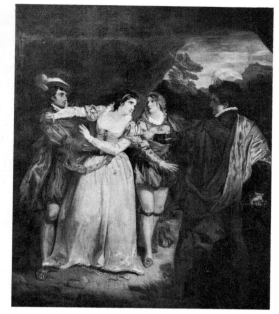

96

97

96 A Harvest Dinner
Oil on canvas
20 × 26 in / 50.8 × 66 cm
1791–2

PROVENANCE J.B.Jago.
EXHIBITION R.A. 1792(147).

Collection unknown

97 Two Gentlemen of Verona
Oil on canvas
65½ × 52½ in / 166.3 × 133.3 cm

SIGNED AND DATED F.Wheatley px 1792.
PROVENANCE Sotheby's 15 March 1967(121).
ENGRAVING Line engraving by R.Rhodes, published 1 January
1817.

The subject is taken from *Two Gentlemen of Verona* Act V,
Scene 4:
'*Val* – Ruffian, let go that rude uncivil touch'.

Mr and Mrs Paul Mellon

98 Alfred in the House of the Neatherd Fig 129
Oil on canvas
79 × 59 in / 206 × 149.8 cm

SIGNED AND DATED F.Wheatley px.ᵗ/1792.
PROVENANCE Painted for Bowyer's Historic Gallery.
ENGRAVING Line engraving by W.Bromley, published 20
February 1795.

Collection unknown

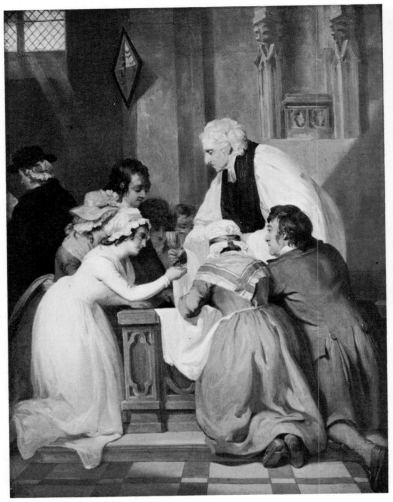

99

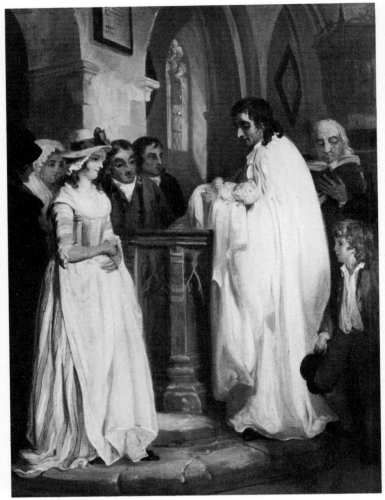

100

99 The Communion
Oil on canvas
20 × 16 in / 50.8 × 40.6 cm

SIGNED AND DATED F.Wheatley pxt 1792.
PROVENANCE Mrs L.S.Wood; Sotheby's 6 April 1949(74).
EXHIBITION *Francis Wheatley R.A.* Aldeburgh and Leeds 1965 (25).
ENGRAVING Engraved by A.Suntach, date unknown.

The companion to *The Baptism* [**100**].

The Dean and Chapter, York Minster; on loan to York Art Gallery

100 The Baptism
Oil on canvas
22½ × 17 in / 57.1 × 43.2 cm
1792

PROVENANCE Mrs L.S.Wood, Sotheby's 6 April 1949(74).
EXHIBITION R.A. 1793(202).
ENGRAVING Engraving by Michael Sloane, date unknown

The companion to *The Communion* [**99**].

The Dean and Chapter, York Minster; on loan to York Art Gallery

Fig 115

102 Gingerbread
Oil on canvas
14 × 11 in / 35.5 × 28 cm
1793

PROVENANCE Otto Beit; Sir Alfred Beit.
EXHIBITIONS Probably R.A. 1793; *English Conversation Pieces* 25 Park Lane 1930(128); *Old London Exhibition* 1938.
ENGRAVING Stipple engraving by Vendramini published 1 May 1796.
LITERATURE J.Brinckmann and E.F.Strange, *Japanese Colour-prints and other engravings in the collection of Sir Otto Beit* 1924 pp30–33.

One of the *Cries of London*. The stretcher is inscribed: 'Colnaghi Sala & Co. Late Torre No 53 Cockspur Street facing Great Suffolk Street, London'. It is probable that there were two versions of *Gingerbread*; this with six figures would have been the first. It is thought that an accident occurred to the engraved plate and that Wheatley painted a second version, altering the present composition, from which a new plate was engraved.

Private Collection, UK

103 Winter
Oil on canvas
35 × 27¼ in / 88.9 × 69.2 cm
1793–4

EXHIBITION Probably R.A. 1794(187).
LITERATURE A Pasquin, *A Liberal Critique . . .* in *Memoirs of The Royal Academicians*, 1794, pp31–2.

The companion to *Spring* [**104**].

Los Angeles County Museum of Art; lent by the Estate of Miss Marion Davies

104 Spring
Oil on canvas
34¾ × 27¼ in / 88.2 × 69.2 cm
1793–4

EXHIBITION Probably R.A. 1794(122).
LITERATURE See [**103**].

The companion to *Winter* [**103**]. A water-colour version shows the boy handing down apples instead of a bird's nest and has differences in foreground and background detail [Fig 104].

Los Angeles County Museum of Art; lent by the Estate of Miss Marion Davies

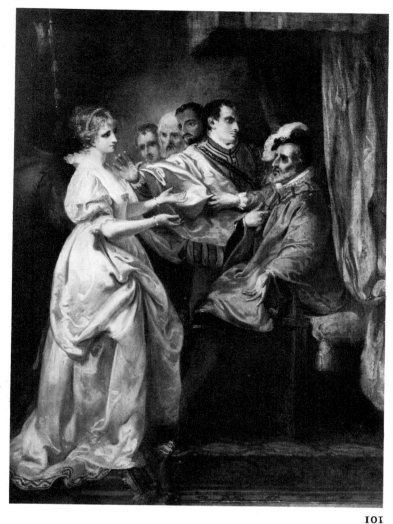

101

101 All's Well that Ends Well
Oil on canvas
31 × 22 in / 77.7 × 55.9 cm
1793

PROVENANCE Painted for the Shakespeare Gallery; Christie's 18 May 1805(9).
ENGRAVING Line engraving by L.Schiavonetti, published 1 September 1797.
LITERATURE J.Boydell, *A Catalogue of the Small Pictures painted for the Shakespeare Gallery* 1802, p162, no CIX.

The subject is taken from *All's Well that Ends Well* Act II, scene 3: The King, Helena, Lords.
Wheatley was paid 20 guineas for this picture in 1793.[1]

Reference: 1 British Museum, Anderdon Collection, Royal Academy Catalogue, 1793. Receipt dated 28 October 1793.

The Folger Shakespeare Library, Washington

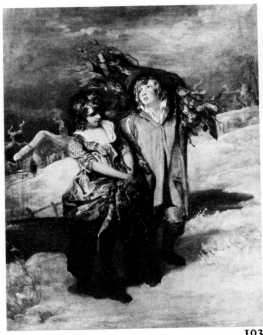

103 104

105 The Rescue of Aemilia and the Infants Fig 128
Antipholus and Dromio of Ephesus
from Shipwreck
Oil on canvas
$30\frac{1}{2} \times 21\frac{1}{2}$ in / 77.5 × 54.6 cm
SIGNED AND DATED F.Wheatley f.1794.
PROVENANCE Painted for the Boydell Shakespeare Gallery;
Christie's 20 May 1805(23); Christie's, 23 July 1909(62).
EXHIBITIONS Francis Wheatley R.A. Aldeburgh and Leeds,
1965(26); *Angelika Kauffmann und ihre Zeitgenossen* Bregenz and
Vienna, 1968(483).
ENGRAVING Line engraving by J.Neagle published 29
September 1796.
LITERATURE John Boydell, *A Catalogue of Small Pictures* 1802,
p154, XCIV; T.S.R.Boase, Illustrations of Shakespeare's Plays,
Journal of the Warburg and Courtauld Institutes X, 1947, p100,
pl 29b; T.S.R.Boase, Shipwrecks in English Romantic
Painting, *Journal of the Warburg and Courtauld Institutes* XXII,
1959, p336, pl. 31f.

The subject is from *The Comedy of Errors* Act I scene 1; it is
Wheatley's only attempt at an historical painting in the grand
manner.

The Royal Shakespeare Theatre, Stratford-upon-Avon

106 Pots and Pans to Mend Fig 116
Oil on canvas
$13\frac{3}{4} \times 10\frac{1}{2}$ in / 34.9 × 26.7 cm

SIGNED AND DATED F.Wheatley px.t/1795.
PROVENANCE William Gillilan 1925; Middleton sale Christie's,
15 May 1925(140).
EXHIBITIONS R.A. 1795(53 or 97); Burlington Fine Arts Club
1927–8(76).
LITERATURE M.Webster, 'Francis Wheatley's Cries of London',
Auction III 1970, pp44–9.

One of the *Cries of London*. This subject was not engraved until
1927.

The Viscount Bearsted

107 A Ploughman and his Team by a Wood Fig 151
Oil on canvas
61 × 85 in / 154.9 × 215.9 cm

SIGNED AND DATED F.Wheatley pinx.t 1795.
PROVENANCE Christie's 13 May 1960(39); Christie's 17 April
1964(100).

With M.Bernard in 1969

110

III **112**

108 Captain Stevens Fig 144
Oil on canvas
26 × 18⅜ in / 66 × 46.8 cm
c 1795

PROVENANCE Clark sale Christie's 20 January 1928(137) as
L.F.Abbott; Lord Davies
LITERATURE J.Steegman, *Portraits in Welsh Houses* I, 1957,
pp258-9, No4

The companion to the portrait of Mrs Stevens [**109**]

Mr and Mrs Paul Mellon

109 Mrs Stevens Fig 145
Oil on canvas
25⅞ × 18⅜ in / 65.8 × 46.8 cm
c 1795

PROVENANCE [See **108**].
LITERATURE J.Steegman, *Portraits in Welsh Houses* I, 1957,
pp258-9, No5.

The companion to the portrait of Captain Stevens [**108**].

Mr and Mrs Paul Mellon

110 The Fisherman's Return
Oil on canvas
18 × 22 in / 45.8 × 55.9 cm

SIGNED AND INDISTINCTLY DATED F.Wheatley 179?.
c 1795
PROVENANCE T.Macklin, sale Christie's 5 May 1800(14);
William Wells sale Christie's, 10 May 1890(80).
ENGRAVING Engraving by J.Barney, date unknown.

The companion to *The Fisherman going out* (untraced).

Philadelphia Museum of Art

III Courtship
Oil on canvas
13½ × 10¾ in / 34.3 × 27.3 cm
c 1795

PROVENANCE Sotheby's 25 April 1934(145).

The companion to *Matrimony* [**112**].

Private Collection, Jersey

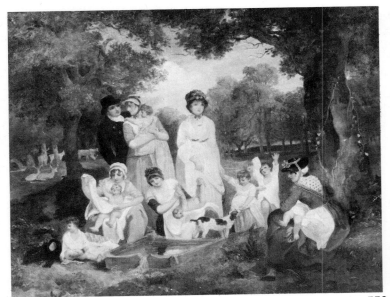

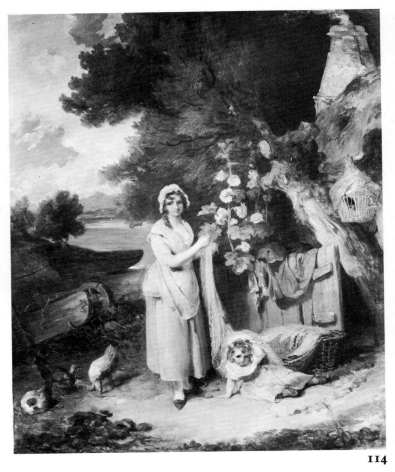

113

114

112 Matrimony
$13\frac{1}{2} \times 10\frac{3}{4}$ in / 34.3 × 27.3 cm
c 1795

PROVENANCE Sotheby's 25 April 1934(145).

The companion to *Courtship* [**111**].

Private Collection, Jersey

113 The Dipping Well in Hyde Park
Oil on canvas
$17\frac{1}{2} \times 22\frac{1}{2}$ in / 44.5 × 57.1 cm
c 1795

ENGRAVING Stipple engraving by J.Godby published 3 July 1802.

With M.Bernard in 1969

114 The Fisherman's Wife
Oil on canvas
$21\frac{1}{2} \times 17\frac{1}{2}$ in / 54.6 × 44.5 cm

SIGNED AND DATED F.Wheatley px.1796.
PROVENANCE Peter Coxe 14 April 1813(27); Lord Astor of Hever, sale Christie's 28 June 1963(48).

Mrs Dorothy Hart

115 Mary's Dream
Oil on canvas
19 × 22 in / 48.2 × 55.9 cm

SIGNED AND DATED F.W.1796.
PROVENANCE W.H.Forman; Sotheby's 27 June 1899(54); Purchased by National Gallery of Ireland 1903.
EXHIBITION *Francis Wheatley R.A.* Aldeburgh and Leeds 1965(27).
ENGRAVING Engraving by W.Ward published by R.Ackermann 1801(?).

'She from her pillow gently raised
Her head to ask who there might be,
And saw young Sandy
 shiv'ring stand,
With pallid cheek and hollow eye.'

The source of the subject has not been identified.

National Gallery of Ireland, Dublin

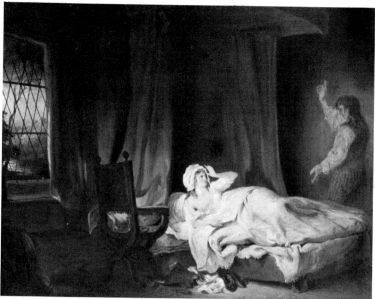

115

116

116 Fishergirl

Oil on canvas

$13\frac{1}{2} \times 11\frac{1}{2}$ in / 34.3 × 27.9 cm

SIGNED AND DATED F.Wheatley / px.t 1796.

The Countess of Drogheda

117 Going out Milking Fig 102

Oil on canvas

$13\frac{1}{2} \times 11\frac{3}{8}$ in / 34.3 × 28.9 cm

SIGNED F.Wheatley pxt.
1798–9

PROVENANCE Barrett, sold at Milton House, Steventon, Bucks,
8 June 1910
EXHIBITION *Francis Wheatley R.A.* Aldeburgh and Leeds 1965
(28).
ENGRAVING Mezzotint by C.Turner published 1 January 1800.

The companion to *The Return from Milking* [**118**]. Datable on
grounds of style.

Trustee of First Lord Brocket Will Trust.

118 The Return from Milking Fig 103

Oil on canvas

$13\frac{1}{2} \times 11\frac{3}{8}$ in / 34.3 × 28.9 cm
1798–9

PROVENANCE [See **117**].
EXHIBITION *Francis Wheatley R.A.* Aldeburgh and Leeds 1965
(29).
ENGRAVING Mezzotint by C.Turner published 1 January 1800.

The companion to *Going out Milking* [**117**].

Trustee of First Lord Brocket Will Trust

119 Morning

Oil on canvas

$17\frac{1}{2} \times 21\frac{1}{2}$ in / 44.5 × 54.6 cm
1799

PROVENANCE [See **122**].
EXHIBITION R.A. 1801(68).
ENGRAVING Mezzotint by H.Gillbank published 3 May 1800.

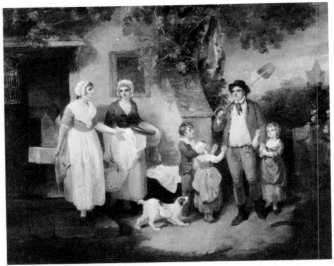

119

One of the *Four Times of the Day (Rustic Hours)* [see **120,121, 122**].

Mr and Mrs Paul Mellon

120 Noon
Oil on canvas
$17\frac{1}{2} \times 21\frac{1}{2}$ in / 44.5 × 54.6 cm
1799

PROVENANCE [See **122**].
EXHIBITION R.A. 1801(70).
ENGRAVING Mezzotint by H.Gillbank published 29 June 1800.

One of the *Four Times of the Day (Rustic Hours)* [see **119, 121, 122**].

Mr and Mrs Paul Mellon

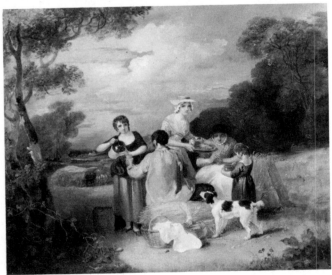

120

121 Evening Fig 152
Oil on canvas
$17\frac{1}{2} \times 21\frac{1}{2}$ in / 44.5 × 54.6 cm
1799

PROVENANCE [See **122**].
EXHIBITION R.A. 1801(87).
ENGRAVING Mezzotint by H.Gillbank published 29 September 1800.

One of the *Four Times of the Day (Rustic Hours)* [see **119,120, 122**].

Mr and Mrs Paul Mellon

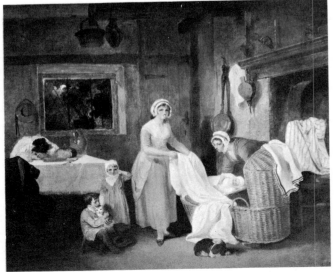

122

122 Night
Oil on canvas
$17\frac{1}{2} \times 21\frac{1}{2}$ in / 44.5 × 54.6 cm

SIGNED AND DATED F.Wheatley px.^t 1799.
PROVENANCE Barrett, sold Milton House, Steventon, Bucks, 8 June 1910; Christie's 8 February 1946(67).
EXHIBITIONS R.A. 1801(90); *English Painting 1700–1850*; Virginia Museum of Fine Arts 1963(269); *Francis Wheatley R.A.* Aldeburgh and Leeds 1965(30).
ENGRAVING Mezzotint by H.Gillbank published 29 September 1800.

One of the *Four Times of the Day (Rustic Hours)* [see **119,120, 121**].

Mr and Mrs Paul Mellon

154

Catalogue of Engravings

Dated engravings are arranged in chronological order, undated engravings are arranged in alphabetical order according to the engraver's name.

List of Illustrations

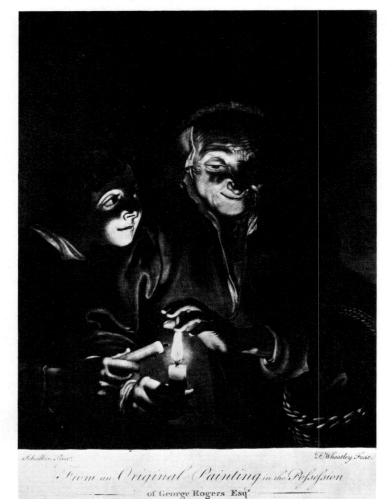

Schalken Pinx. F.Wheatley Fecit.

From an Original Painting in the Possession

of George Rogers Esq.

Engravings by Francis Wheatley

1768

E1 Christian VII of Denmark Fig 7

F.Wheatley ad.vivum delint et fecit. Christian VII King of Denmark.

Publish'd according to Act of Parliament Sept[r] ye 19 1768 & Sold by J.Bowen Printseller at ye Golden Pallet Opposite ye Haymarket Piccadilly. Pr 1s

Mezzotint $13\frac{7}{8} \times$ 10 in / 35.2 \times 25.4 cm

LITERATURE J.Chaloner Smith, *British Mezzotinto Portraits* IV, 1883, p1570, no1.

UNDATED (*c* 1770)

E2 Frank Van der Myn Fig 63

Smoker Vandermyn Pinxit Wheatly Sculp. (scratched letter)

i before inscription

ii as above

iii inscribed 'The Smoaker Vandermyn Pinxit. Wheatley Sculp. Sold by Ryland, Bryer & Co in Cornhill.'[1]

Mezzotint $12\frac{7}{8} \times$ 9 in / 32.1 \times 22.9 cm (cut close)

LITERATURE J.Chaloner Smith, *British Mezzotinto Portraits* IV, 1883, p1571, no2.

Reference: 1 R.Weigel, *Kunstcatalog* VII, 1838, p64, no8318a.

E3 Boy lighting a candle

Schalken Pinx! F.Wheatley Fecit

From an Original Painting in the Possession of George Rogers Esqr

Printed for T.Bowen opposite the Hay Market Piccadilly.

After Rubens

Mezzotint $12\frac{3}{4} \times$ $9\frac{1}{4}$ in / 32.5 \times 23.3 cm

LITERATURE M.Rooses, *L'oeuvre de P.P.Rubens* IV, 1890, pp91-3; C.G.Vorhelm Schneevoogt, *Catalogue des Estampes Gravées d'après P.P.Rubens* 1873, p153 no136 bis

E3

1785

E4 Gypsies cooking their kettle Fig 64
Wheatley 1785
Design'd & Etch'd by F.Wheatly

Etching $6\frac{1}{2} \times 9$ in / 16.5 × 22.8 cm

LITERATURE E.Edwards, *Anecdotes of Painting* 1808, p270.

1786

E5 S.^t Preux and Julia see Fig 69
Design'd & Etch'd by F.Wheatley the Aquatinto by F.Jukes
Engraved by R.Pollard
From Rousseau's New Eloisa Vol 3.rd page 84
London Publish'd June 14th 1786 by J.R.Smith N.º 83 Oxford
Street.

Line & stipple engraving, etching, aquatint
$22 \times 16\frac{1}{4}$ in / 55.9 × 41.3 cm

A As above.
B F.Wheatley, inv. Borgnet, Sculp.
 Etching and line engraving.
 $9\frac{1}{8} \times 6\frac{1}{8}$ in / 23.2 × 15.5 cm
 In *Oeuvres Complètes de J.J.Rousseau*, III, Paris 1788, opp.
 p398.

E6 Henry & Jessy Fig 75
Design'd & Etch'd by F.Wheatly the aquatinto by F.Jukes
Engraved by Jas.Hogg

Etching, aquatint, line engraving
$21\frac{3}{4} \times 15\frac{3}{4}$ in / 55.2 × 40 cm (cut close; defective, lacks title)
The pair to **E5**

From Shenstone,[1] 'The Chase of Jessy', *Elegy* XXVI

Reference: 1 R.Weigel, *Kunstcatalog*, XXVI, 1855, p82, no20430.

1774

E7 Miss Younge, M.^r Dodd, M.^r Love & see Fig 17
M.^r Waldron, in y.^e Characters of Viola,
S.^r Andrew Aguecheek, S.^r Toby Belch
& Fabian
Painted by Francis Wheatly Engrav'd by J.R.Smith
Shakespear's 12.th Night, Act 4.th
Publish'd March 1.st 1774 by Rob.^t Sayer, N.º 53 Fleet Street.

Mezzotint $17 \times 19\frac{7}{8}$ in / 43.2 × 50.5 cm

EXHIBITIONS Society of Artists 1774(263)
LITERATURE J.Chaloner Smith, *British Mezzotinto Portraits* III,
1883, p1311, no178; J.Frankau, *John Raphael Smith* 1902,
pp244-5.

1779

E8 Sidgismonda Fig 68
Painted by F.Wheatley Engrav'd by Thos.^s Watson
London Publish'd March 10th 1779 by Dickinson & Watson
No 158 New Bond Street.

Mezzotint $10\frac{1}{4} \times 7\frac{3}{4}$ in / 26 × 19.7 cm

LITERATURE J.Chaloner Smith *British Mezzotinto Portraits* IV,
1883, p1566, no 44.

E9 Thais Fig 67
Painted by F.Wheatley Engrav'd by Thos.^s Watson
London, Publish'd March 10.th 1779 by Watson & Dickinson
N.º 158 New Bond Street.

Mezzotint $10\frac{1}{4} \times 7\frac{3}{4}$ in / 26 × 19.7 cm

LITERATURE J.Chaloner Smith, *British Mezzotinto Portraits* IV,
1883, p1567, no45.

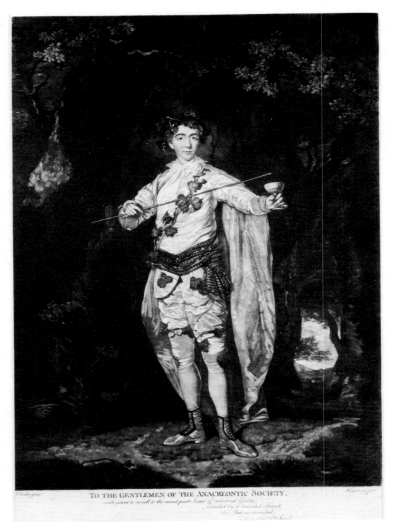

see Fig 41

E11 Henry Grattan Esqr

Painted by F.Wheatley Engraved by V.Green Mezzotinto
Engraver to His Majesty & to the Elector Palatine
A Real Representative of the People, who by his repeated
exertions in the Senate, was a great instrument in forwarding
the emancipation of his country.
Publish'd Septr 10th 1782 by V:Green, No 29 Newman Street,
Oxford Street, London.

i scratched letter omitting 'A Real Representative . . .
 country.
ii as described.

Mezzotint $14\frac{3}{4} \times 10\frac{3}{4}$ in / 37.5 × 27.2 cm

LITERATURE J.Chaloner Smith, *British Mezzotinto Portraits* II,
1883, p556, no52; A.Whitman, *Valentine Green*, 1902, p97,
no115.

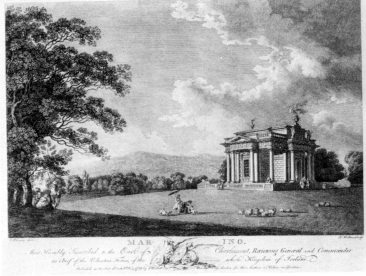

E12

E10

E10 Anthony Webster as Comus

Wheatley pinxt Kingsbury fecit
'To the Gentlemen of the Anacreontic Society, with intent to
recall to the mind past Scenes of convivial Gaiety, enriched by
a lamented Friend, this Plate is inscribed, by their obedt hble
Servt John Smith
Pub. Jany 10th 1781.

Mezzotint $19\frac{1}{2} \times 13\frac{7}{8}$ in / 49.5 × 35.4 cm

LITERATURE J.Chaloner Smith, *British Mezzotinto Portraits* II,
1883, p787, no15.

E12 Marino

F.Wheatly, delin. T.Milton, Sculp.
Most Humbly Inscribed to the Earl of Charlemont, Reviewing
General and Commander in Chief of the Volunteer Forces, of
the Whole Kingdom of Ireland.
Publish'd as the Act directs 1st July 1783 by J.Walter Charing
Cross London, for the Author T.Milton in Dublin.
Milton's *Collection of Select Views from the different Seats of the
Nobility and Gentry in Ireland* pl V.

Line engraving $6\frac{1}{4} \times 8$ in / 15.9 × 20.3 cm

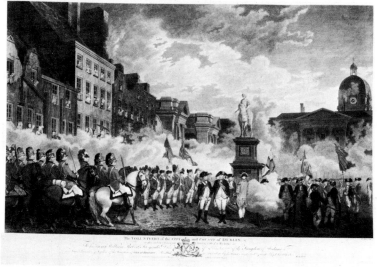

E15

1784

E15 **The Volunteers of the City and** see **30**
 County of County of Dublin, as they met on Fig 34,35, A,B
 College Green, the 4ᵗʰ of Novʳ 1779
F.Wheatley pinxᵗ J.Collyer sculpᵗ
'To his Grace William Robert Fitzgerald, Duke of Leinster,
&c, of the Kingdom of Ireland – and Viscᵗ Leinster & Taplow
of the Kingdom of Great Britain – This Plate is Inscribed by
his Grace's most obedᵗ & much oblig'd humble Servᵗ R.Lane.'
London, Published as the Act directs, 10 May 1784 by R.Lane,
and Sold by J.Boydell.

E16 The plate from which **E15** was printed came into the
possession of William Kelly, bookseller and publisher, of
8 Grafton Street, Dublin, who issued false proofs taken from it.[1]

Line engraving 19⅛ × 26½ in / 48.9 × 68 cm

Reference: 1 W.G.Strickland, *A Dictionary of Irish Artists* II, 1913,
s.v. Wheatley, p521.

1785

E17 **Coniston Lake**
Drawn by F.Wheatly. Engraved by S.Middiman.
Published as the Act directs, Janʸ 21ˢᵗ 1785 by S.Middiman,
London.
Select Views in Great Britain engraved by S.Middiman, London,
Boydell, 1812, pl X.

Line engraving 6½ × 8¼ in / 16.5 × 20.9 cm

E18 **Coniston-Lake**
Painted by F.Wheatly. Engraved by S.Middiman.
Published as the Act directs, May 25, 1785 by S.Middiman,
London.
Select Views in Great Britain engraved by S.Middiman, London,
Boydell, 1812, pl XIV.

Line engraving 6¼ × 8 in / 15.9 × 20.3 cm

E19 **View near Dalton**
Painted by F.Wheatly Engraved by S.Middiman.
Published as the Act directs, May 25 1785, by S.Middiman,
London.
Select Views in Great Britain engraved by S.Middiman, London,
Boydell, 1812, pl XV.

Line engraving 6⅜ × 8⅛ in / 16.2 × 20.6 cm

E13 **Mallahide—Castle in the Co: of Dublin** see Fig 45
F.Wheatley delᵗ T.Milton Sculpᵗ
Most Humbly Inscribed to Richᵈ Talbot Esqʳ by Thoˢ
Milton.
Published as the Act directs 1ˢᵗ July 1783 by J.Walter, Charing
Cross, London, for the Author T.Milton in Dublin.
Milton's *Collection of Select Views from the different Seats of the
Nobility and Gentry in Ireland*, pl VII.

Line engraving 6¼ × 8 in / 15.9 × 20.3 cm

E14 **Barnard Turner Esqʳ Alderman &** Fig 62
 Sheriff of London
Painted by F.Wheatley Engrav'd by James Walker
Colonel of the Red Regiment of City Militia, Mayor of the
Honorable Artillery Company, and Commandant of the
Gentlemen of the London Military Foot Association, during
the Riots in 1780.
Publish'd as the Act directs, July 15ᵗʰ 1783, by Jaˢ Walker,
Nᵒ 49 Upper Mary Le Bone Street.

Mezzotint 23⅞ × 14⅞ in / 60.6 × 37.8 cm

LITERATURE J.Chaloner Smith, *British Mezzotinto Portraits* IV,
1883, p1436, no18; H.Bromley, *A Catalogue of Engraved
British Portraits* 1793, p351

E20

E20 View near Ambleside
Drawn by F.Wheatly The Figures by J.Heath. Engraved by
S.Middiman.
Published as the Act directs, Dec.ʳ 12, 1785, by S.Middiman,
London
Select Views in Great Britain engraved by S.Middiman, London,
Boydell, 1812, pl XVII.

Line engraving 6⅛ × 8 in / 15.5 × 20.3 cm

E21 The Salmon Leap at Leixlip with Fig 51
 Nymphs Bathing
Painted by F.Wheatley The Aquatinto by F.Jukes Engraved
by R.Pollard
1785

Aquatint, etching, stipple engraving
14¾ × 19½ in / 37.5 × 49.5 cm cut close

E22 The Sheds of Clontarf
Aquatint by T.Malton 1785
Listed by W.G.Strickland, *A Dictionary of Irish Artists*, II, 1913,
p526
Not seen

E23 The Bay of Dublin
Aquatint by T.Malton, 1785
Listed by W.G.Strickland, *A Dictionary of Irish Artists*, II, 1913,
p526
Not seen

1786

E24 Howth House
F.Wheatley, del. T.Milton, sculp.
Most Humbly Inscribed to The Earl of Howth, by Thoˢ
Milton.
Published as the Act directs March 1ˢᵗ 1786, by Thoˢ Milton,
London.
Milton's *Collection of Select Views from the different seats of the
Nobility and Gentry in Ireland*, pl XIV.

Line engraving 6⅛ × 8 in / 15.5 × 20.3 cm

E25 Glen Molaur
F.Wheatley, del. T.Milton, sculp.
Most Humbly Inscribed to Samuel Hayes Esqʳ by Thoˢ
Milton.
Published as the Act directs, March 1ˢᵗ 1786, by Thoˢ Milton,
London
Milton's *Collection of Select Views from the different Seats of the
Nobility and Gentry in Ireland* pl XVI.

Line engraving 6¼ × 8 in / 15.8 × 20.3 cm

E26 Winandermere Lake
Drawn by F.Wheatly Engraved by S.Middiman
Published as the Act directs, May 25, 1786, by S.Middiman,
London.
Select Views in Great Britain engraved by S.Middiman, London,
Boydell, 1812, pl XXI.

Line engraving 6¼ × 8 in / 15.8 × 20.3 cm

E27 A Lover's Anger see Fig 76
P.Simon
'Lord bless me' said she; 'let a body but speak:
Here's an ugly hard rose-bud fall'n into my neck;
It has hurt me, and vex'd me to such a degree –
See here! for you never believe me; pray see,
On the left side of my breast what a mark it has made!'
So saying, her bosom she careless display'd:
That seat of delight I with wonder survey'd,
And forgot every word I design'd to have said.
29 August 1786 Prior a Lover's Anger

12½ × 10 in / 31.8 × 25.4 cm

Not seen

CELADON CELIA

E28

E28 Celadon and Celia

Love is a jest and vows are vain

P.Simon
He thank'd her on his bended knee;
Then drank a quart of milk and tea:
And leaving her ador'd embrace,
Hasten'd to court, to beg a place.
While she, his absence to bemoan,
The very moment he was gone,
Call'd Thyrsis from beneath the bed!
Where all this time he had been hid.
<div align="right">Prior's To a Young Gentleman in Love</div>

Not seen

E29 The Amorous Sportsman Fig 87
Painted by F.Wheatley Engraved by C.H.Hodges
London Published October 30th 1786; by J.R.Smith № 31
King Street Covent Garden

Mezzotint $17\frac{7}{8} \times 21\frac{3}{4}$ in / 45.3 × 55.2 cm

E30 Fishermen by the shore
Wheatly 1786 (by T.Rowlandson)
Rowlandson's *Imitations of Modern Drawings* p33

Etching $14 \times 9\frac{7}{8}$ in / 35.5 × 25.1 cm

LITERATURE J.Grego, *Rowlandson the Caricaturist* I, 1888, p151, no1.

E31 Fishermen by the shore
Wheatly 1786 (by T.Rowlandson)
Rowlandson's *Imitations of Modern Drawings* p3

Etching 13 × 10 in / 33 × 25.4 cm

LITERATURE J.Grego, *Rowlandson the Caricaturist* I, 1888, p151, no2.

E32 Group of Gipsies
F.Wheatly 1786 (by T.Rowlandson)
Rowlandson's *Imitations of Modern Drawings* p7

Etching $8\frac{1}{4} \times 9\frac{7}{8}$ in / 21 × 25.1 cm

LITERATURE J.Grego, *Rowlandson the Caricaturist*, I, 1888, p151, no5.

1787

E33 View near Keswick see Fig 137
Drawn by F.Wheatly. Engraved by S.Middiman.
Published as the Act directs, Jan.25.1787, by S.Middiman, London
Select Views in Great Britain, engraved by S.Middiman, London, Boydell, 1812, pl XXV.

Line engraving $6\frac{1}{8} \times 8$ in / 15.5 × 20.3 cm

E34 Comb Bank in Kent, the Seat of Lord Fred^k Campbell
F.Wheatley del^t W.Angus Sculp^t
Published as the Act directs, Feb^y 1, 1787 by W.Angus, № 4 Gwynne's Buildings, Islington
The Seats of the Nobility and Gentry in Great Britain and Wales. In a Collection of Select Views, Engraved by W.Angus. From Pictures and Drawings by the most Eminent Artists. With Descriptions of each View, pl IV.

Line engraving $6\frac{1}{4} \times 8$ in / 15.9 × 20.3 cm

E35　The Rustic Lover　Le Rustique Amoureux
F.Wheatley Pinx! Bull & Jeffryes Excudit C.Knight Sculp.
Publish'd 31st March 1787 by Bull & Jeffryes, Ludgate Hill

Stipple engraving $18\frac{3}{4} \times 15$ in / 47.6 × 38.1 cm

E36　The Industrious Cottager　La Paysanne Industrieuse　Fig 90
F.Wheatley pinx! Bull & Jeffryes execud! C.Knight sculp!
London, Published 31st March 1787 by Bull and Jeffryes Ludgate Hill

Stipple engraving $18\frac{3}{4} \times 15$ in / 47.6 × 38.1 cm

A coarser stipple engraving of this subject was published in France (n.d.) with the title La Bonne Ménagère, Dessiné par Thompson Gravé par Rousseau. $17\frac{1}{4} \times 14$ in / 43.8 × 35.5 cm

E37　Winandermere Lake
Drawn by F.Wheatly. Engraved by S.Middiman.
Published as the Act directs, May 25. 1787, by S.Middiman, London
Select Views in Great Britain engraved by S.Middiman, London, Boydell, 1812, pl XXIX.

Line engraving $6\frac{1}{4} \times 8$ in / 15.5 × 20.3 cm

E38　Love in a Mill　L'amour au Moulin　see Fig 91
F.Wheatley Pinxit T.Simpson excud I.M.Delatre Sculp!
London Pubd June 1, 1787 by T.Simpson, S! Pauls Church Yard, & R.Stainer No 15 Villers Street, Strand

Stipple engraving $21\frac{1}{2} \times 16$ in / 54.6 × 40.6 cm

E39　The soldiers return
Painted by F.Wheatley Engraved by W.Ward
Honour, beauty, love & wealth are his rewards
London Publish'd June 14th by J.R.Smith No 31 King Street Covent Garden

Mezzotint $19\frac{7}{8} \times 13\frac{7}{8}$ in / 50.5 × 35.2 cm

E40　The sailors return　see Cat 54
Painted by F.Wheatley Engraved by W.Ward
Her filial duty paid, Virtue & Love shall reward his constancy & Faith
London Publish'd June 14.th by J.R.Smith No 31 King Street Covent Garden

Mezzotint $19\frac{7}{8} \times 13\frac{7}{8}$ in / 50.5 × 35.2 cm

E41　Samnite Marriages　see Fig 74
W.Ward
Published June 14, 1787
Not seen

E42　The Four Phials
W.Ward
Published June 14, 1787
Not seen

E42

E39

E43 View near Lancaster Sands
Drawn by F.Wheatly Engraved by W.Ellis
Published as the Act directs, July 2 1787, by S.Middiman,
London
Select Views in Great Britain engraved by S.Middiman, London,
Boydell, 1812, pl XXX.

Line engraving $6\frac{1}{4} \times 8$ in / 15.8 \times 20.3 cm

E44 The love-sick maid
Painted by F.Wheatley Engraved by J.Dean
Nº 2 Progress of Love
Published Novr 15th 1787, by J Dean, Bentinck Street, Soho

Mezzotint $20 \times 13\frac{7}{8}$ in / 50.8 \times 35.2 cm
From a set *The Progress of Love* by Wheatley and Moreland [see
E45]

E45 The Marriage
Painted by F.Wheatley Engraved by J.Dean
Nº 3 Progress of Love
Published Novr 15th 1787, by J.Dean, Bentinck Street, Soho

Mezzotint $19\frac{7}{8} \times 13\frac{7}{8}$ in / 50.5 \times 35.2 cm
[See **E44**]

E46 A Bacchante
Wheatly 1787 (by T.Rowlandson)
Publish'd by R.Pollard Spafields London

Line engraving $8 \times 6\frac{1}{4}$ in / 20.3 \times 15.9 cm (cut)

THE RECRUITING OFFICER

E47

1788

E47 The Recruiting Officer
Painted by F.Wheatly Engrav'd by R.Stanier

O Tempt me not kind Sir I pray,
Or wish to lead an innocent astray,
To ruin first, You are inclin'd,
And then Desert the injur'd mind,
In virtues path I wish to move,
A stranger to ungenerous love.

Publish'd January 1788 by Torre & Cº Nº 132 Pall Mall,
London

Stipple engraving 20×15 in / 50.8 \times 38.1 cm

E48 Interest
V.M.Picot after Wheatley
Feb.20, 1788

Etching & stipple engraving
$8\frac{7}{8} \times 11\frac{1}{4}$ in / 22.5 \times 28.5 cm cut close, lacks letter

E49 Love
V.M.Picot after Wheatley
Feb. 1788

Etching & stipple engraving
$8\frac{7}{8} \times 11\frac{3}{8}$ in / 22.5 \times 28.9 cm cut close, lacks letter

All that of Love can be expres'd
In these soft numbers see,
But Lucy, would you know the rest,
It must be read in me.
Lyttleton
London Pub.^d March 4 1788 by Molteno Colnaghi & C.^o N.^o 132 Pall Mall.

E50

London Publish'd 21 March 1788 by Bull & Jeffryes Ludgate Hill

Stipple engraving $20\frac{1}{2} \times 14\frac{1}{2}$ in / 52 × 36.8 cm (cut close)

1789

E52 Silvia
J.Hogg
She was in the happy moment to rescue the little innocent from the irresistible violence of the torrent, and as she fondly hurried with it up the precipice, a smile of ineffable sensibility triumphed in her eyes.
1 January 1789

12 × 12 in / 30.5 × 30.5 cm

Not seen

E50 Mrs Wheatley
Drawn by F.Wheatley Engrav'd by R.Stanier

All that of Love can be expres'd
In these soft numbers see,
But Lucy, would you know the rest,
It must be read in me.
Lyttleton
London, Pub.^d March 4. 1788 by Molteno Colnaghi & C.^o N.^o 132 Pall Mall.

Stipple engraving $10\frac{1}{2} \times 12$ in / 26.7 × 30.5 cm

LITERATURE F.O'Donoghue, *Catalogue of Engraved British Portraits in the British Museum* III, 1912, p492.

E53 Summer
Painted by F.Wheatley Engrav'd by F.Bartolozzi R.A. Engraver to his Majesty
What fragrance in the gentle breeze. Quelle douceur dans le zephir!
Pub.^d Feb.^y 1.1789 by T.Simpson S.^t Pauls Church Yard

Etching and stipple engraving $9\frac{1}{2} \times 7\frac{1}{4}$ in / 24.1 × 18.4 cm

LITERATURE A.de Vesme and A.Calabi, *Francesco Bartolozzi* 1928, no718

From a set of *The Four Seasons* by Wheatley and R.Westall. The sitter was Mrs Troward, Wheatley's sister-in-law.

E51 The benevolent cottager La paysanne bienfaisante Fig 81
Painted by F.Wheatley Bull and Jeffryes Excud.^t Engrav'd by W.Nutter

Pity the sorrows of a poor old man,
Whose trembling limbs have born him to your door,
Whose days are dwindled to the shortest span,
Oh! give relief and Heaven will bless your store,
These tatter'd cloaths my poverty bespeak,
These hoary locks proclaim my lengthened years,
And many a furrow in my grief worn Cheek,
Has been the Channel to a flood of tears.

E54 Winter Fig 148
Painted by F.Wheatley Engrav'd by F.Bartolozzi R.A. Engraver to his Majesty
Bless my heart how cold it is. Ah mon Dieu qu'il fait froid!
Pub.^d Feb.^y 1.1789 by T.Simpson S.^t Pauls Church Yard

Etching and stipple engraving $9\frac{1}{2} \times 7\frac{1}{4}$ in / 24.1 × 18.4 cm

LITERATURE A.de Vesme and A.Calabi, *Francesco Bartolozzi* 1928, no720

From a set of *The Four Seasons* by Wheatley and R.Westall. The sitter was Mrs Wheatley.

E55 Lauretta
Wheatly delin! F.Bartolozzi sculp!
Vide Marmontels Tales
Scarce had she strength . . .
London Pub.d March 1. 1789 by T.Macklin

Etching and stipple engraving 15 × 13½ in / 38.1 × 34.2 cm

LITERATURE A.de Vesme and A.Calabi, *Francesco Bartolozzi*
1928, no1408

Not seen

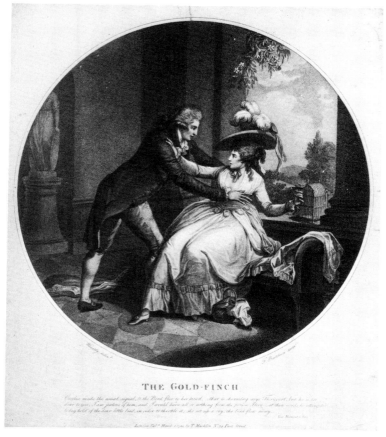

THE GOLD-FINCH

E56 The Gold-finch
Wheatly delin! F.Bartolozzi sculp!
Cecilia made the usual signal, & the Bird flew to her hand. –
that is charming says Floricourt, but he is too dear to you, I am
jealous of him, and I would have all or nothing from the person
I love. – at these words he attempted to lay hold of the dear
little bird, in order to throttle it; she set up a cry, the bird flew
away.
 Vide Marmontels Tales
London, Pub.d March 1 1789 by T.Macklin N.o 39 Fleet Street.

Etching and stipple engraving 14¾ × 12¾ in / 37.4 × 32.5 cm
cut close

LITERATURE A.de Vesme and A.Calabi, *Francesco Bartolozzi*
1928, no1407

**E57 La Belle Francaise returning from
Shooting La Belle Anglaise on
horseback**
April 1 1789
Prints 'ready to deliver to subscribers from drawings by
Mr.Wheatley'[1]

Reference: 1 Victoria and Albert Museum Library, *Press Cuttings*,
p512.

Not seen

E58 The Return from Market Le Retour see Fig 93
du Marche
Painted by F.Wheatley Engrav'd by C.Knight

At Luxury's shrine to drink delirious joy,
Grieve without cause, enamour'd of a toy;
To tread the windings of the midnight maze,
And borrow brightness from the diamonds blaze,
Was ne'er the lot of this sequester'd maid;
Who if she charm, must charm with simpler aid:
Yet a fond swain has caught her to his heart,
And boasts a treasure not the work of art;
To him, more dear for what she never knew,
A prudent house-wife, virtuous, fond and true;
And lo' the pledge of truth, a rosy boy;
The father's opening form, the mothers joy.

London Pub.d April 21, 1789 by T.Simpson S.t Pauls Church
Yard

Stipple engraving 21¼ × 15⅞ in / 54 × 40.3 cm

E59A Arthur Phillip Esq. 1738–1814 see Fig 140
**Captain General & Commander in
Chief, in & over the Territory of
new South Wales**
From an original picture painted by F.Wheatley Engraved by
W.Sherwin.
Published May 1. 1789 by J.Stockdale, Piccadilly.

Stipple engraving 9 × 5⅝ in / 22.2 × 14.3 cm

167

B Arthur Philip Esq. Vice Admiral of the Red Squadron
Page sc.
Pub. Jan 31. 1812, by Joyce Gold, 103 Shoe Lane, Fleet Street, London

Stipple engraving $8\frac{3}{4} \times 5\frac{3}{4}$ in / 22.2 \times 14.6 cm

C S.r Arthur Philip Esq.r
Ermer sc.

Stipple engraving $5\frac{1}{2} \times 3\frac{7}{8}$ in / 14 \times 9.8 cm

1789

E60 The Disaster see Cat 68
Painted by F.Wheatly Engraved by W.Ward
London, Publish'd July 26.th 1789 by J.R.Smith N.o 31 King Street, Covent Garden

Mezzotint $21\frac{7}{8} \times 15\frac{3}{4}$ in / 55.6 \times 40 cm

E61 Alms Giving
J.M.Delatre
Published by Ann Bryer, 5 Poland Street, Soho
1 August 1789

Not seen

E62 The Temptation
J.M.Delatre
1 August 1789

$11\frac{3}{4} \times 11\frac{3}{4}$ in / 29.9 \times 29.9 cm

Not seen

E63 Broome in Kent, the Seat of Sir Henry Oxenden
F.Wheatley del.t W.Angus Sculp.t
Published as the Act directs, Sept. 1 1789 by W.Angus, N.o 4, Gwynne's Buildings, Islington
The Seats of the Nobility and Gentry in Great Britain and Wales. In a Collection of Select Views, Engraved by W.Angus. From Pictures and Drawings by the most Eminent Artists. Descriptions of

each View, pl XVIII

Line engraving $6\frac{1}{4} \times 8$ in / 15.9 \times 20.3 cm

E64 The Full of the Honey-moon
R.Laurie
1 September 1789

Not seen

E65 The Wane of the Honey-moon
R.Laurie
1 September 1789

Not seen

E66 The Fair Fig 106
F.Wheatley inv. F.Bartolozzi Sculps.
Published according to Act of Parliament, 25 Nov.r 1789, by Ann Bryer, N.o 5, Poland Street, Soho
i as described
ii as above, published 28 Feb.y 1803 by A.Molteno

Stipple engraving $7\frac{1}{8} \times 9$ in / 20 \times 22.8 cm

LITERATURE A.de Vesme and A.Calabi, *Francesco Bartolozzi* 1928 no1274

E67 The Show Fig 105
F.Wheatley inv. F.Bartolozzi sculps.
Published according to Act of Parliament, 25 Nov.r 1789, by Ann Bryer, N.o 5, Poland Street, Soho
i as described
ii as above, London, Published 28.Feb.y 1803, by A.Molteno

Stipple engraving $7\frac{7}{8} \times 9$ in / 20 \times 22.8 cm

LITERATURE A.de Vesme and A.Calabi, *Francesco Bartolozzi* 1928 no1273

1790

E68 John Howard, Esq. Visiting and Relieving the Miseries of a Prison

see Fig 83

Painted by F.Wheatley T.Simpson Excud! Engraved by Ja.ˢ Hogg
Published April 9 1790 by Thomas Simpson S! Pauls Church Yard, and James Hogg N.º 52 Berwick Street, Soho, London

Line engraving $19\frac{1}{2} \times 24$ in / 49.5 × 61 cm

E69 The Riot in Broad Street on the Seventh of June 1780

Figs 61, A,B

Painted by Fra.ˢ Wheatley Engraved by Ja.ˢ Heath
To the Gentlemen of the London Light Horse Volunteers, and Military Foot Association, This Memorial of their Patriotic Conduct, is Inscribed by their obliged Servants – John & Josiah Boydell.
Published Sep.ʳ 29.ᵗʰ 1790, by John and Josiah Boydell, Cheapside, & at the Shakespeare Gallery Pall Mall London

Line engraving $18\frac{7}{8} \times 24\frac{3}{4}$ in / 47.9 × 62.9 cm

E70 Alma

J.F.Bolt
1790

Not seen

1791

E71 The Storm

M.C.Prestel
1 January 1791

13 × 19 in / 33 × 48.2 cm

Not seen

E72 Love in a Village

Wheatly delin Grignion scu
Will you accept of them for yourself then
Act I Scene 3
London Printed for I Bell British Library Strand Jan.ʸ 6.ᵗʰ 1791.

Line engraving $6\frac{7}{8} \times 4\frac{1}{2}$ in / 17.5 × 11.4 cm

Title-page to Isaac Bickerstaff, *Love in a Village,* Bell's British Theatre, XIII, 1797.

E73 Country Lasses

Wheatley pinx! Heath sculp
Heart – In the mean time here is something to drink the lady's health
Act IV Scene II
London Printed for John Bell British Library Strand Jan.ʸ 7. 1791.

Line engraving $7\frac{1}{2} \times 4\frac{1}{2}$ in / 19 × 11.4 cm

Title-page to Charles Johnson, *The Country Lasses; or, the Custom of the Manor,* Bell's British Theatre, IX, 1797.

E74 The turkey cock

F.Wheatley inv. J.M.Delattre sculp.
Published according to Act of Parliament, 8 Jan.ʸ 1791, by Ann Bryer, N.º 5, Poland Street, Soho.

Stipple engraving $7\frac{1}{2} \times 8$ in / 19 × 20.3 cm

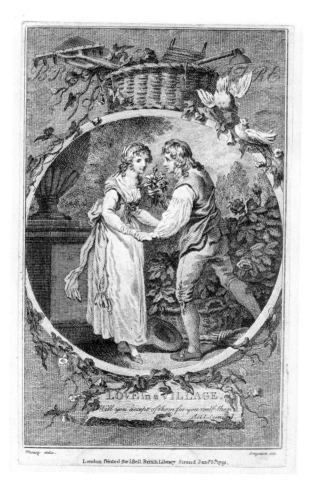

E72

E75 The Wheelbarrow
J.M.Delattre
8 January 1791

$5\frac{3}{4} \times 6\frac{1}{4}$ in / 14.6 × 15.9 cm

Not seen

E76 Rule a Wife and have a Wife
Wheatley pinx! Hall sculp
Estif: And here's a chain of Whitings eyes for pearls,
 A Musselmonger would have made a better
Act IV, Scene 1
London. Printed for J.Bell, British Library, Strand, April 27, 1791.

Line engraving $6\frac{5}{8} \times 4$ in / 16.8 × 10.2 cm

Title-page to Beaumont and Fletcher, *Rule a Wife and have a Wife*, Bell's British Theatre, VIII, 1797.

E77 The Spanish Friar
Wheatley pinx! Delattre sc.
Elv. What game have you in hand, that you hunt in couples?
Lor. I'll shew you that immediately
London. Printed for J.Bell, British Library, Strand. 10.th Aug! 1791.

Line engraving $6\frac{7}{16} \times 4\frac{1}{4}$ in / 16.3 × 10.8 cm

Title page to Dryden, *The Spanish Fryar*, Bell's British Theatre, II, 1797.

E78 The Careless Husband see Fig 77
Wheatley pinxt. Delattre sculp.
Lady Easy: If he should wake offended at my too busy care, let my heart breaking patience, Duty, & my fond affection plead my pardon
Act V, scene V
London, Printed for J.Bell, British Library Strand Sept.r 30 1791.

Line engraving $6\frac{1}{2} \times 4\frac{1}{4}$ in / 16.5 × 10.8 cm

Title-page to Colley Cibber, *The Careless Husband*, Bell's British Theatre, VIII, 1797.

E79 She stoops to Conquer see Cat 87
Wheatly pinx! Hall sculp!
Mar. Madam every moment that shews me your merit, only serves to encrease my diffidence
Act V Scene III
London Printed for J.Bell British Library Strand. Dec.r 12th 1791.

Line engraving $6\frac{3}{8} \times 4$ in / 16.8 × 10.1 cm

Title-page to Goldsmith, *She Stoops to Conquer; or, the Mistakes of a Night*, Bell's British Theatre, IX, 1797.

1792

E80 The Return from Shooting see Fig 143
Painted by F.Wheatley R.A. Engraved by F.Bartolozzi R.A.; the Landscape &c by S.Alken
To His Grace the Duke of Newcastle This Print of the Return from Shooting is by Permission dedicated by his Grace's most obliged & most humble servant Francis Wheatly
Published January 10, 1792 by Joseph Barney.

Stipple engraving $20\frac{1}{2} \times 25\frac{1}{4}$ in / 52 × 64.1 cm cut close

A i As described
 ii Without star on the Duke's breast. Without dedication. London Published Jan.y 1. 1803, by Colnaghi & C.o N.o 25 Cockspur Street, Charing Cross.

B Proof before inscription
Stipple engraving $5\frac{7}{8} \times 7\frac{3}{4}$ in / 14.9 × 18.7 cm
Attendant sportsmen and dogs omitted.

LITERATURE A. de Vesme and A.Calabi, *Francesco Bartolozzi* 1928, no2507

E81 The Affectionate Daughter
Painted by Wheatley R.A. Engrav'd by J.Eginton
Pub.d March 12, 1792 by I.Eginton, Birmingham; & I.F. Tomkins N.o 49 New Bond Street, London.

Stipple engraving $15\frac{7}{8} \times 12\frac{1}{2}$ in / 40.3 × 31.7 cm

E82 Filial Piety
J.Eginton
12 March 1792

12 × 10 in / 30.5 × 25.4 cm

Not seen

E83 S.ᵗ Woolstons, Kildare see Fig 44
Plate 6, Engr.ᵈ by W. & J.Walker from an Original Drawing by
F.Wheatly Esq.ʳ R.A.
Published April 2, 1792, by Harrison & C.ᵒ N.ᵒ 18, Paternoster
Row, London.
*The Copper Plate Magazine, or Elegant Cabinet of Picturesque
Prints consisting of Sublime and Interesting Views* . . . , I, No.III,
pl 6

Line engraving $5\frac{7}{8}$ × $7\frac{7}{8}$ in / 14.9 × 20 cm

E84 Ennischerry Fig 48
Plate 9, Engraved by W. & J.Walker, from an Original
Drawing by F.Wheatley Esq.ʳ R.A.
Published June 1ˢᵗ 1792 by Harrison & C.ᵒ N.ᵒ 18 Paternoster
Row, London.
*The Copper Plate Magazine, or Elegant Cabinet of Picturesque
Prints consisting of Sublime and Interesting Views* . . . , I, no V,
pl 9.

Line engraving $5\frac{7}{8}$ × 8 in / 15 × 20.3 cm

E85 Shakspeare Winter's Tale, Act IV, see Fig 120
 Scene III
Painted by Fra.ˢ Wheatley Engrav'd by Ja.ˢ Fittler, Marine
Eng.ʳ to his Majesty

Per. Sir, welcome! [To Pol. & Cam.
It is my father's will, I should take on me
The hostesship o' the day:– you're welcome, sir!
Give me those flowers there, Dorcas. – Reverend sirs,
For you there's rosemary, and rue; these keep
Seeming, and savour, all the winter long:
Grace, and remembrance, be to you both,
And welcome to our shearing!

Publish'd Aug.ᵗ 1, 1792, by John & Josiah Boydell, at the
Shakspeare Gallery Pall Mall, & N.ᵒ 90, Cheapside London.

Line engraving $19\frac{5}{8}$ × 25 in / 49.8 × 63.5 cm

E86 Howth
Plate 16 Engraved by W. & J.Walker from an Original
Drawing by F.Wheatly Esq.ʳ R.A.
Published 1ˢᵗ Sep.ʳ 1792 by Harrison & C.ᵒ N.ᵒ 18 Paternoster
Row, London.
*The Copper Plate Magazine, or Elegant Cabinet of Picturesque
Prints consisting of Sublime and Interesting Views* . . . , I, no VIII,
pl XVI

Line engraving 6 × 8 in / 15.2 × 20.3 cm

E87 The Pet Lamb or folding the flock
J.Barney
1 November 1792

$11\frac{3}{4}$ × $11\frac{3}{4}$ in / 29.8 × 29.8 cm

Not seen

E88 Setting out to the Fair
Painted by F.Wheatley, R.A. Engraved by J.Eginton

Beware, my Daughter! a warm Lovers wiles,
Lest Faithless Flattery thy Soul deceive
Trust not too easily his Sighs or Smiles
Nor ev'ry vow, nor ev'ry oath believe.

That Lover, Mary! only can be true;
Who, trembling wooes a Virgin for his Wife
Not he who would by daringness subdue;
And make her wretched thro remaining life.

London Published Nov.ʳ 10ᵗʰ 1792 by Jee & Eginton & sold by
J.F.Tomkins N.ᵒ 49 New Bond Street.

Stipple engraving $23\frac{1}{4}$ × $18\frac{1}{2}$ in / 59 × 47 cm

E89 The Fairings
Painted by F.Wheatley, R.A. Engraved by J.Eginton

Thy Daughter's injury, I never meant;
I flatter'd not; for flatt'ry always lies.
See in her hand the proof of my intent
I never sought for selfish Transient Joys

Not Beauty only is the boon I ask,
My Flame is perminent, my Fondness pure.

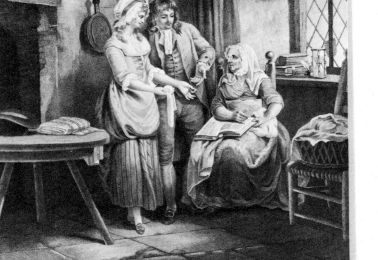

E88

E89

To make her Blest shall be my tender task
To keep her heart serene, her Health secure.

London Published Nov.ʳ 10.ᵗʰ 1792 by Jee & Eginton & sold by J.F. Tomkins Nᵒ 49 New Bond Street.

Stipple engraving 23¼ × 18½ in / 59 × 47 cm

1793

E90 Morning
J. Barney
February 1793

Not seen

E91 Evening
J. Barney
February 1793

Not seen

E92 Tarbert
F. Wheatly, del. T. Milton, sculp.
Most Humbly Inscribed to Sir Edw.ᵈ Leslie Bar.ᵗ by Thoˢ Milton.
Published as the Act directs, June 1ˢᵗ 1793, by Thoˢ Milton, London.
Milton's *Collection of Select Views from the different Seats of the Nobility and Gentry in Ireland*

Line engraving 6¼ × 8 in / 15.9 × 20.3 cm

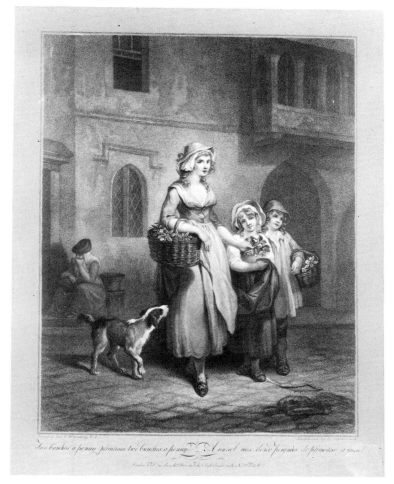

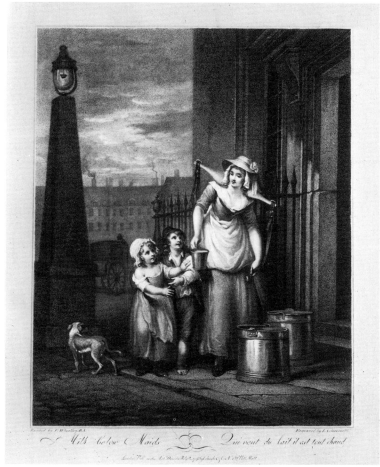

E97 i E98 ii

E93 Love's labour lost Act IV, Scene II Fig 124
Painted by F.Wheatley Engrav'd by J.Neagle
Publish'd June 4, 1793, by J. & J.Boydell, at the Shakspeare
Gallery, Pall Mall, & Nº 90 Cheapside.

Line engraving $16\frac{5}{8} \times 13\frac{1}{4}$ in / 42.2 × 33.6 cm

E94 Love's labour's lost Act V, Scene II Fig 125
Painted by F.Wheatley Engraved by W.Skelton
Publish'd June 4 1793, by J & J Boydell, at the Shakspeare
Gallery, Pall Mall & Nº 90 Cheapside.

Line engraving $16\frac{5}{8} \times 13\frac{1}{4}$ in / 42.2 × 33.6 cm

E95 Sᵗ Johns Abbey. C: Kilkenny
J.Newton direxit
Published August 3ᵈ 1793 by M.Hooper Nº 212 High
Holbourn.
Francis Grose, *The Antiquities of Ireland* I, 1791, pl 51, p33

Line engraving $6\frac{1}{8} \times 7\frac{7}{8}$ in / 15.5 × 20 cm

**E96 The Itinerant Trades of London, in
 thirteen engravings, by the first
 artists, after paintings by Wheatley**
London: Published by Colnaghi and Co. Pall Mall.

Wrapper $18\frac{1}{2} \times 14\frac{1}{8}$ in / 47 × 35.9 cm

LITERATURE J.Brinckmann & E.F.Strange, *Japanese Colour-Prints and other engravings in the Collection of Sir Otto Beit*, London 1924, pp27–45. M.Webster, '*Francis Wheatley's Cries of London', Auction*, III, 1970, pp44–9. For the many later copies, produced both in England and on the continent, see also *Country Life*, CXIX, March 29, 1956, pp608–9.

E97 i Two bunches a penny primroses, two bunches a penny – A un sol mes deux poignèes de primerose, a un sol
Painted by F.Wheatley R.A. Engraved by L.Schiavonetti
London Pubd as the Act Directs July 2 by Colnaghi and Co No 132 Pall Mall.

Stipple engraving $16\frac{1}{2} \times 13$ in / 41.9×33 cm

ii As iii, without 'Cries of London Plate 1t'

iii **Cries of London Plate 1t**
Two bunches a penny primroses, two bunches a penny – A un sou mes deux poignèes de primeroses, a un sou
Painted by F.Wheatley R.A. Engraved by L.Schiavonetti
London Pubd as the Act Directs July 2 1793 (under) by Colnaghi and Co No 132 Pall Mall

Stipple engraving $16\frac{1}{2} \times 12\frac{7}{8}$ in / 41.9×32.7 cm

E98 i Milk below Maids
Painted by F.Wheatley R.A. Engraved by L.Schiavonetti
London Pubd as the Act Directs June 2 by Colnaghi and Co No 132 Pall Mall.
Scratched letter

Stipple engraving 16×12 in / 40.6×30.5 cm cut

ii **Milk below Maids – Qui veut du lait il est tout chaud**
Painted by F.Wheatley R.A. Engraved by L.Schiavonetti
London Pub as the Act Directs July 2. 1793 by Colnaghi & Co No 132 Pall Mall.

Stipple engraving $16\frac{3}{8} \times 12\frac{7}{8}$ in / 41.6×32.7 cm

iii **Cries of London Plate 2d**
Milk below Maids – Qui veut du lait il est tout chaud
Painted by F.Wheatley, R.A. Engraved by L.Schiavonetti
London Pubd as the Act Directs July 2. 1793 by Colnaghi & Co No 132 Pall Mall.

Stipple engraving $16\frac{3}{8} \times 12\frac{7}{8}$ in / 41.6×32.7 cm

174

1794

E99 The School Mistress see Cat 93
F.Wheatly R.A. pinxt J.Coles sculpt

In every village marked with little spire
Embower'd in trees and hardly known to fame
There dwells in lowly shed and mean attire
A matron old whom we school mistress name
Who boasts unruly brats with birch to tame.
They grieven sore in piteous durance pent
Aw'd by the power of this relentless dame
And oft times on vagaries idly bent
For unkempt hair or task unconn'd are sorely shent.
 Vide. Shenston's School Mistress

London, Publish'd March 20th 1794, by Thos Macklin, Poets Gallery, Fleet Street.

Stipple engraving $17 \times 19\frac{3}{4}$ in / 43.2×50.1 cm

E100 A Girl picking Roses
Drawn by F.Wheatley R.A. Engraved by J.W.Tomkins
Engraver to Her Majesty
Pubd as the Act Directs March 27 1794 by Walker & Co No 7 Cornhill.

Stipple engraving $7 \times 4\frac{3}{4}$ in / 17.8×12.1 cm

E101 Morning Cottagers going out Haymaking
J.Yeatherd
18 April 1794

Mezzotint 20×25 in / 50.8×63.5 cm

Not seen

E102 Shakspeare. All's well that ends see Fig 122
** well, Act V, Scene III**
Painted by F.Wheatley R.A. Engrav'd by G.S. & J.G.Facius

King, Countess, Laseu, Lords, Attendants &c. Bertram guarded, Diana & a Widow
Hel. Oh, my good lord, when I was like this maid,
 I found you wond'rous kind. – There is your ring;
 And, look you, here's your letter :– This it says,
 – This is done:
 Will you be mine now you are doubly won?

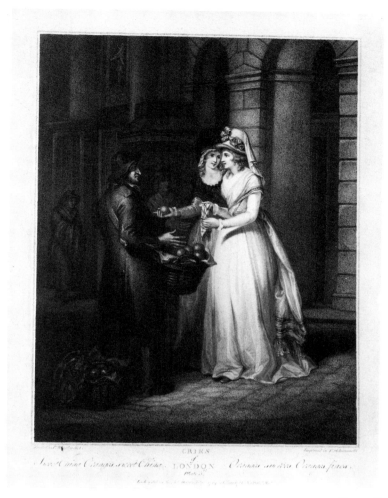

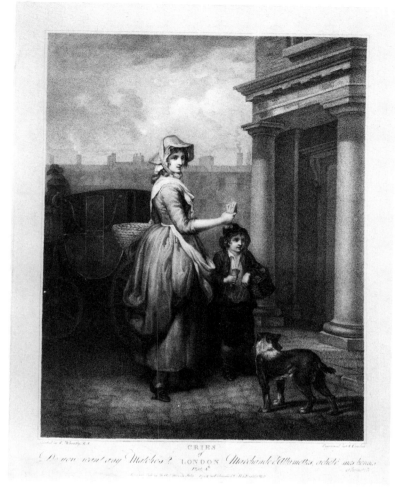

E103 ii E104 ii

Publish'd June 4 1794, by John & Josiah Boydell, Shakspeare Gallery Pall Mall, & Nº 90, Cheapside.

Line engraving $19\frac{5}{16} \times 25$ in / 49.9 × 63.5 cm

E103 i Sweet China Oranges, Sweet China!
Painted by F. Wheatley R.A. Engraved by L. Schiavonetti
London Pubd as the Act Directs July 1794 by Colnaghi & Co
Nº 132 Pall Mall.
Scratched letter

Stipple engraving $16\frac{1}{2} \times 12\frac{7}{8}$ in / 41.9 × 32.7 cm

ii **Cries of London Plate 3rd** (inset in centre)
**Sweet China Oranges, sweet China –
Oranges sucrées, Oranges fines**

Painted by F. Wheatley R.A. Engraved by L. Schiavonetti
London Pubd as the Act Directs July 1794 by Colnaghi & Co
Nº 132 Pall Mall.

Stipple engraving $16\frac{1}{2} \times 12\frac{7}{8}$ in / 41.9 × 32.7 cm

E104 i Do you want any Matches?
Painted by F. Wheatley R.A. Engraved by A. Cardon
London Pubd as the Act Directs July 1794 by Colnaghi & Co.
Nº 132 Pall Mall.
Scratched letter

Stipple engraving $16\frac{3}{8} \times 12\frac{7}{8}$ in / 41.6 × 32.7 cm

ii **Cries of London Plate 4th** (inset in centre)
Do you want any Matches? Marchande

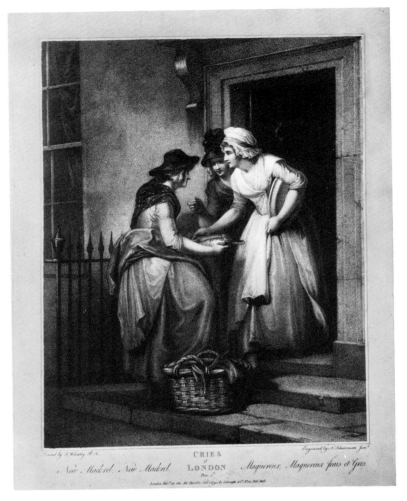

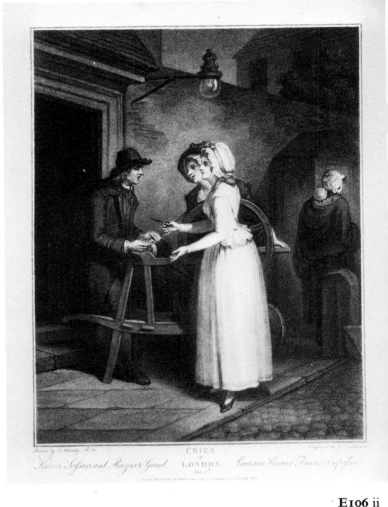

**d'Allumettes, achetè mes bonnes
Allumettes**
Painted by F.Wheatly R.A. Engraved by A.Cardon
London Pub as the Act Directs July 1794 by Colnaghi & Co
Nº 132 Pall Mall.

Stipple engraving 16⅜ × 12⅞ in / 41.6 × 32.6 cm

ii **Cries of London Plate 5ᵗʰ** (inset in centre)
New Mackrel, New Mackrel
Maquereux. Maquereux frais et Gros
Painted by F.Wheatly R.A. Engraved by N.Schiavonetti Junʳ
London Pubᵈ as the Act Directs, Jan.1.1795, by Colnaghi & Cº
Nº 132 Pall Mall.

Stipple engraving 16½ × 12¾ in / 41.9 × 32.4 cm

1795

E105 i New Mackrel New Makrel
Painted by F.Whealy (sic) R.A. Engraved by N.Schiavonetti
junior
London Pubᵈ as the Act Directs January 1 1795 by Colnaghi &
Co Nº 132 Pall Mall.
Scratched letter

Stipple engraving 16½ × 12¾ in / 41.9 × 32.4 cm Proof

**E106 i Knives Scissars, and Razars to
Graind –**
Pained (sic) by F.Wheally (sic) R.A. Engraved by
G.Vendramini
London Pubᵈ as the Act Directs Janʸ 1 1795 by Colnaghi & Co
Nº 132 Pall Mall.
Scratched letter

Stipple engraving 16⅜ × 12⅞ in / 41.6 × 32.7 cm

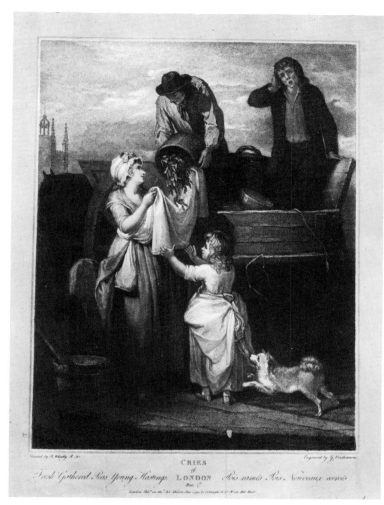

ii Cries of London Plate 7. (inset in centre)
Fresh Gathered Peas Young Hastings
Pois ramés Pois Nouveaux ecorcés
Painted by F.Wheatly R.A. Engraved by G.Vendramini
London Pub.d as the Act Directs, Jan:1, 1795, by Colnaghi &
Co No 132 Pall Mall.

Stipple engraving $16\frac{5}{8} \times 12\frac{7}{8}$ in / 42.2 × 32.7 cm

E108 Shakspeare. Taming of the Shrew, Fig 119
Act II, Scene II
Painted by Francis Wheatley, R.A. Engraved by I.P.Simon

Baptista's house. – Petruchio, Katherine, Bianca, &c.
Pet. But for my bonny Kate, she must with me.
 Nay, look not big, nor stamp, nor stare, nor fret;
 I will be master of what is mine own:
 She is my goods, my chattels; she is my house,
 My household-stuff, my field, my barn,
 My horse, my ox, my ass, my anything;
 And here she stands, touch her whoever dare;
 I'll bring mine action on the proudest he
 That stops my way in Padua. – Grumio,
 Draw forth thy weapon, we're beset with thieves;
 Rescue thy mistress, if thou be a man; –
 Fear not, sweet wench, they shall not touch thee, Kate:
 I'll buckler thee against a million.
Published Jany 1st 1795, by John & Josiah Boydell, at the
Shakspeare-Gallery, Pall-Mall, & at No. 90. Cheapside, London.

Stipple engraving $29\frac{3}{8} \times 25$ in / 49.2 × 63.5 cm

E109 The Smitten Clown
Wheatly pinx.t Reynolds Sculp.t

The little God of soft desires
Who wounds Kings, Lords, and Country Squires
At Colins heart let fly
O gen'rous Maid assuage his pain,
The Lad is honest, fond, and plain
T'were pity he shou'd die

Pub.d Jan 1, 1795 by I.Read No. 133 Pall Mall, London.

Mezzotint $13\frac{5}{8} \times 14\frac{3}{4}$ in / 34.5 × 37.5 cm

E107 ii

ii Cries of London Plate 6 h (inset in centre)
Knives, Scissars, and Razors to Grind
Couteaux, Ciseaux, Rasoirs a repasser
Painted by F.Wheatly R.A. Engraved by G.Vendramini
London Pub.d as the Act Directs Jan.1, 1795 by Colnaghi & Co
No 132 Pall Mall

Stipple engraving $16\frac{3}{8} \times 12\frac{7}{8}$ in / 41.6 × 32.7 cm

E107 i Fresh gathered Peas Young Hastings
Painted by F.Wheatley R.A. Engraved by G.Vendramini
London Pub.d as the Act Directs January 1 1795 by Colnaghi &
Co No 132 Pall Mall.
Scratched letter

Stipple engraving $16\frac{5}{8} \times 12\frac{7}{8}$ in / 42.2 × 32.7 cm

E110 Death of Richard II Fig 130
Painted by F.Wheatley R.A. Engraved by A.Smith
Published as the Act directs by Robʔ Bowyer, at the Historic
Gallery, Pall Mall, Janʸ 1795.

Line engraving 18½ × 13⅛ in / 47 × 33.3 cm

E111 Alfred in the house of the Neatherd Fig 129
Painted by F.Wheatley R.A. Engraved by W.Bromley
Published by R.Bowyer, Historic Gallery, Pall Mall Feb.20,
1795.

Line engraving 18½ × 13⅛ in / 47 × 33.3 cm

E112 The Deserted Village
F.Wheatly R.A. pinxʔ F.Bartolozzi sculpʔ

Good Heaven! what sorrows gloom'd that parting day,
That call'd them from their native walks away;
When the poor exiles every pleasure past,
Hung round the bowers, and fondly look'd their last,
The good old sire the first prepar'd to go
To new-found worlds, and wept for others woe;
But for himself, in conscious virtue brave,
He only wish'd for worlds beyond the grave.
His lovely daughter, lovelier in her tears,
The fond companion of his helpless years,
Silent went next, neglectful of her charms,
And left a lover's for her father's arms.
With louder plaints the mother spoke her woes,
And blest the cot where every pleasure rose;
And kist her thoughtless babes with many a tear,
And claspt them close, in sorrow doubly dear.

London, Published May 1ˢᵗ 1795 by Thoˢ Macklin, Poets
Gallery, Fleet Street.

Stipple engraving 17 × 20 in / 43.2 × 50.8 cm

LITERATURE A.de Vesme and A.Calabi, *Francesco Bartolozzi* 1928
no1440

E113 Much ado about nothing
Painted by Francis Wheatley R.A. Engraved by George Noble
Act 3. Scene 3. Borachio, Conrade, and Watchmen
Publish'd June 4, 1795, by J. & J.Boydell, Shakspeare Gallery,
Pall Mall, & No.90, Cheapside.

Line engraving 16⅝ × 13¼ in / 42.2 × 33.7 cm

E112

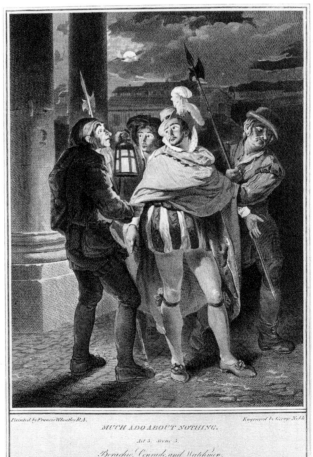

E113

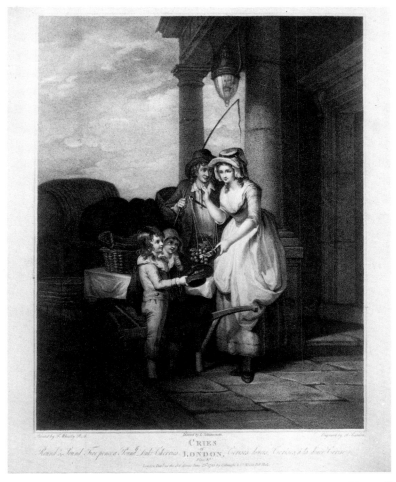

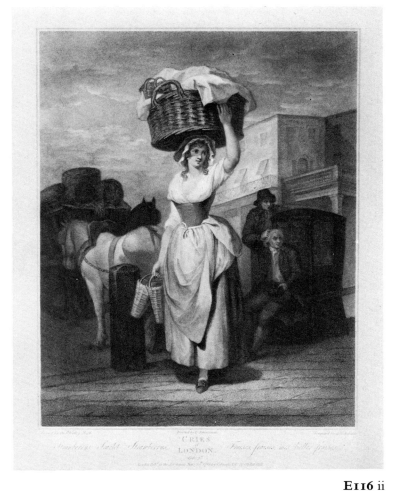

E115 ii

E116 ii

E114 Much ado about nothing Fig 123
Painted by Francis Wheatley R.A. Engraved by James Fittler
Act 5. Scene 4. Antonio, Hero, Beatrice, Margaret & Ursula
mask'd
Publish'd June 4, 1795, by J & J Boydell, Shakspeare Gallery,
Pall Mall, and Nº 90, Cheapside.

Line engraving $16\frac{5}{8} \times 13\frac{1}{4}$ in / 42.2 × 33.6 cm

ii **Cries of London Plate 8.th** (inset in centre)
Round & Sound Five pence a pound
Duke Cherries Cerises douces, Cerises
â la douce Cerise
Painted by F.Wheatly R.A. Directed by L.Schiavonetti
Engrav'd by A.Cardon
London Pubd as the Act directs June 25th 1795 by Colnaghi &
Cº Nº 132 Pall Mall.

Stipple engraving $16\frac{3}{8} \times 12\frac{7}{8}$ in / 41.6 × 32.7 cm

E115 i Round, and Sound Five Pence a
Pound Duke Cherrys!
Painted by F.Wheatley R.A. Directed by L.Schiavonetti
Engraved by A.Cardon
London Publish'd as the Act directs June 25 1795 by Colnaghi
& Cº Pall Mall.
Scratched letter

Stipple engraving $16\frac{3}{8} \times 12\frac{7}{8}$ in / 41.6 × 32.7 cm

E116 i Strawberrys, Scarlet Strawberrys!
Painted by F.Wheatley Directed by L.Schiavonetti Engraved
by Vendramini
London Publish'd as the Act directs June 25 1795 by Colnaghi
& Cº Nº 132 Pall Mall.
Scratched letter

Stipple engraving $16\frac{5}{8} \times 13$ in / 43.2 × 33 cm

179

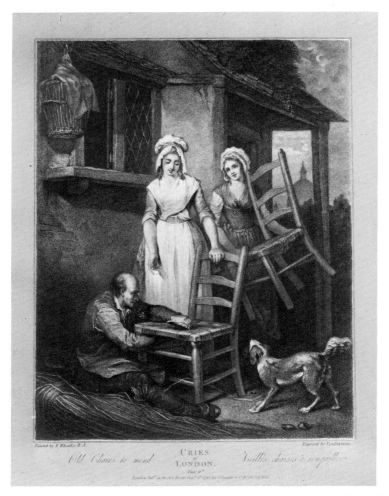

E117 ii

ii **Cries of London Plate 10.th** (inset in centre)
Old Chairs to mend Vieilles chaises à rempailler
Painted by F.Wheatley R.A. Engrav'd by Vendramini
London Pub.^d as the Act directs Sep.^{tr} 1st 1795 by Colnaghi &
C.^o N.^o 132 Pall Mall.

Stipple engraving $16\frac{1}{2} \times 12\frac{3}{4}$ in / 41.9×32.4 cm

E118 All's well that ends well Fig 126
Painted by F.Wheatley R.A. Engraved by F.Legat
Act 1 Scene 3. Countess of Rousillon & Helena
Publish'd Dec.1, 1795 by J. & J.Boydell, at the Shakspeare
Gallery, Pall Mall, & at N.^o 90, Cheapside, London.

Line engraving $16\frac{5}{8} \times 13\frac{1}{4}$ in / 42.2×33.6 cm

E119 Shakspeare Tempest, Act V, Scene I Fig 121
Painted by Fran.Wheatley R.A. Engraved by Caroline Watson

Ferdinand & Miranda playing at Chess
Mira. Sweet lord, you play me false.
Fer. No, my dearest love, I would not for the world.
Mir. Yes, for a score of kingdoms, you should wrangle;
 And I would call it fair play

Publish'd Dec.1. 1795, by John & Josiah Boydell, at the
Shakspeare Gallery, Pall-Mall; & N.^o 90, Cheapside, London.

Mezzotint $22\frac{3}{8} \times 16\frac{3}{8}$ in / 56.8×41.6 cm

ii **Cries of London Plate 9.th** (inset in centre)
Strawberrys Scarlet Strawberrys
Fraises, fraises, mes belles fraises
Painted by F.Wheatley R.A. Directed by L.Schiavonetti
Engraved by Vendramini
London Pub.^d as the Act directs June 25th 1795 by Colnaghi &
C.^o N.^o 132 Pall Mall.

Stipple engraving $16\frac{5}{8} \times 13$ in / 42.2×33 cm

E117 i Old Chair to Mend
Painted by F.Wheatley R.A. Engraved by Vendramini
London Pub as the Act Sept.^r 1: 1795 by Colnaghi & C.^o
Scratched letter.

Stipple engraving $16\frac{1}{2} \times 12\frac{3}{4}$ in / 41.9×32.4 cm

1796

E120 Rustic Sympathy
Wheatly Pinx.^t Keating Sculp.^t

By Angels caught, all hallow'd as they flow,
Are tears we shed for Sorrows not our own;
And Bosoms heaving for anothers Woe.
Waft their own incense to the Heavenly Throne.

London Published 1 Jan.^y 1796 by John Jeffryes Ludgate Hill.

Mezzotint $20\frac{1}{8} \times 25\frac{1}{2}$ in / 51.1×64.7 cm

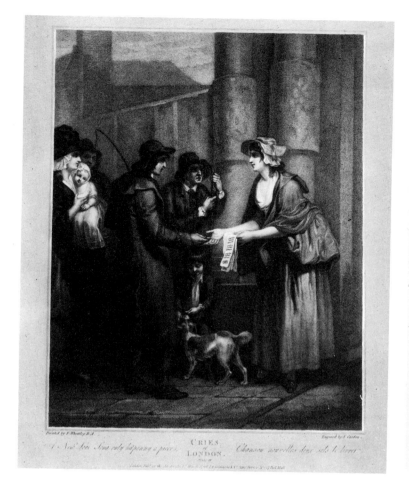

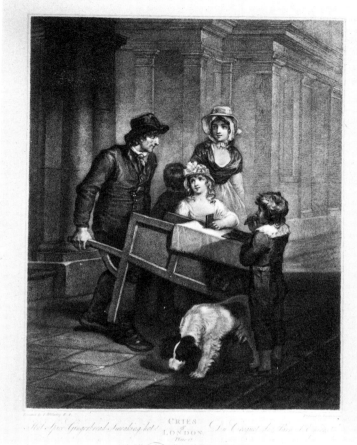

E122 ii

E123B ii

E121 The Water Cress Girl

F.Wheatley R.A. Invt & Delt. F.Bartolozzi Esqr. R.A. Sculpt.
London, Pubd as the Act Directs Janry 6, 1796 by Anthy
Molteno Printseller to her Royal Highness the Dutchess of
York No 76 St James's Street.

Etching and stipple engraving 15 × 12 in / 38.1 × 30.5 cm

LITERATURE A. de Vesme and A.Calabi, *Francesco Bartolozzi*
1928, no1301

E122 i A new Lowe Song only ha'penny a piece!

Painted by F.Wheatley R.A. Engraved by A.Cardon
London Publish'd March 1796 by Colnaghi & Co No 132 Pall
Mall.
Scratched letter

Stipple engraving 16⅝ × 13 in / 42.2 × 33 cm

ii Cries of London, Plate 11 (inset in centre) A New Love Song only ha'penny a piece Chanson nouvelles deux sols le livret

Painted by F.Wheatley R.A. Engrav'd by A.Cardon
London Pubd as the Act directs 1st March 1796 by Colnaghi &
Co. (late Torres) No 127 Pall Mall.

Stipple engraving 16⅝ × 13 in / 42.2 × 33 cm

E123A Cries of London Plate 12 (inset in see Fig 115 centre) Hot Spice Gingerbread Smoaking hot! Du Croquet de Pain d'Epices!

Painted by F.Wheatley R.A. Engraved by Vendramini
London Pubd as the Act directs May 1 1796 by Colnaghi & Co
No 132 Pall Mall.
6 figures

Stipple engraving 16¾ × 13 in / 42.5 × 33 cm

E123B i **Hot Spice Gingerbread –**
 Smoaking hot!
Painted by F.Wheatley R.A. Engraved by G.Vendramini
London Publish⁴ May the 1ˢ⁺ 1796 by Colnaghi & C° 132 Pall
Mall.
Scratched letter

Stipple engraving 16¾ × 13 1/16 in / 42.5 × 33.1 cm

ii **Cries of London Plate 12** (inset in centre)
 Hot Spice Gingerbread Smoaking hot!
 Du Croquet de Pain d'Epices!
Painted by F.Wheatley R.A. Engraved by Vendramini
London, Pub⁴ as the Act directs May 1, 1796, by Colnaghi &
C° N° 132 Pall Mall.

5 figures
Stipple engraving 16¾ × 13 1/16 in / 42.5 × 33.1 cm

E127

1797

E127 Rustic Benevolence
F.Wheatly Pinx⁺ G.Keating Sculp⁺

O, Charity! divinest guest of Earth!
Type of the Deity who gave thee Birth!
Still to Mankind thy melting Grace impart;
And fix thy Temple in the human Heart.

London, Published Jan⁷ 1ˢ⁺ 1797 by John Jeffryes Ludgate Hill.

Mezzotint and etching 20¼ × 15½ in / 51.4 × 64.8 cm

E128 The Itinerant Potters
Wheatley (erased) J.Whessell sculp⁺
London published Jan 1ˢ⁺ 1797 by T.Simpson S⁺ Paul's Church
Yard and Darling & Thompson, G⁺ Newport Street.

Stipple engraving 24 × 19¼ in / 61 × 48.9 cm

E129 The Woodman's Return see Fig 101
F.Wheatley R.A. pinx⁺ J.Whessell sculp⁺
London Published January 1ˢ⁺ 1797 by T.Simpson & S⁺ Paul's
Church Yard and Darling & Thompson, G⁺ Newport Street.

Stipple engraving 24¼ × 18⅞ in / 61.5 × 47.9 cm

E124 The Encampment at Brighton see Cat 66
F.Wheatley, R.A. pinx⁺ J.Murphy sculp⁺
Dedicated by Permission to His Royal Highness George Prince
of Wales, by His Royal Highness's most devoted & obedient
Servants / Colnaghi & Co.
London, Published May 1, 1796 by Colnaghi & C° N° 132
Pall Mall.

Mezzotint 20¾ × 25½ in / 52.7 × 64.8 cm

E125 The Departure from Brighton see Cat 67
F.Wheatley, R.A. pinx⁺ J.Murphy sculp⁺
Dedicated by Permission to Field Marshall His Royal Highness
the Duke of York, Commander in Chief of all His Majesty's
Forces, &c. &c. &c. by His Royal Highness's most devoted &
obedient Servants/Colnaghi & Co.
London: Published May 1 1796 by Colnaghi, & C° N° 132
Pall Mall.

Mezzotint 21 × 25¾ in / 53.4 × 65.5 cm

E126 Comedy of errors see Fig 128
Painted by F.Wheatley R.A. Engraved by J.Neagle
Act 1 Scene 1
Published Sept⁺ 29ᵗʰ 1796, by J. & J.Boydell, at the Shakspeare
Gallery, Pall-Mall, & N° 90, Cheapside, London.

Line engraving 16⅝ × 13¾ in / 42.2 × 33.7 cm

182

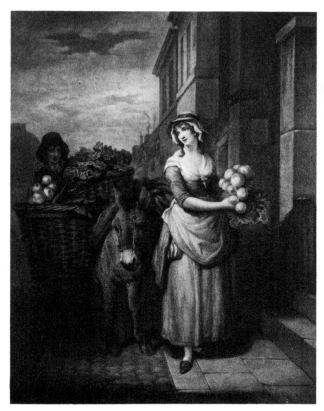

E131

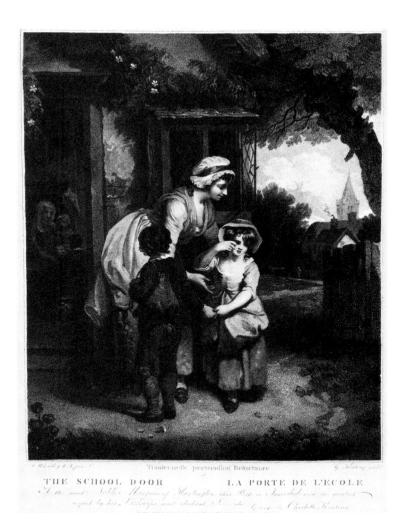

E133

E130 The Country-Girl going a reaping
F.Wheatley R.A. Delt F.Bartolozzi Esqr R.A. sculpt
London Published Jany 10th 1797 by Anthy Molteno.

Etching and stipple engraving 14⅞ × 11⅞ in / 37.7 × 30.2 cm

LITERATURE A. de Vesme and A.Calabi, *Francesco Bartolozzi*
1928 no1281

E131 Cries of London. Plate 13 (inset in
centre)
**Turnips & Carrots ho Carottes &
Navets**
Painted by F.Wheatly, R.A. Engraved by T.Gaugain
London Pubd as the Act directs, May 1, 1797 by Colnaghi,
Sala, & Co No 132, Pall Mall.

Stipple engraving 16¼ × 12⅞ in / 41.3 × 32.7 cm

E132 All's well that ends well see Cat 101
Painted by F.Wheatley R.A. Engraved by L.Schiavonetti
Act 2 Scene 3 The King, Helena, Lords, &c.
Published Sept! 1, 1797, by J.J.Boydell at the Shakespeare
Gallery, Pall Mall, & No 90, Cheapside.

Line engraving 16⅝ × 13¼ in / 42.2 × 33.7 cm

1798

**E133 Tenderness persuading Reluctance
The School Door La Porte de l'Ecole**
F.Wheatley R.A. pinx! G.Keating sculp!
To the most Noble Marquis of Hartington, this Plate is
Inscribed with the greatest respect by his Lordships most
obedient Servants / George & Charlotte Keating
London, Published Jany 1, 1798 by G. & C.Keating No 18,

Warwick Street, Golden Square.

Stipple engraving $16\frac{3}{8} \times 12$ in / 41.6×30.5 cm

A coarser stipple engraving in reverse, Bartolotti Sculp., was issued later (date unknown), same dimensions.

E134 Comedy of errors

Fig 127

Painted by F.Wheatley, R.A. Engraved by J.Stow
Act 4, Scene 4 Antipholis of Ephesus, Dromio, Courtesan, &c.
Pubd April 23 1798, by J. & J.Boydell, at the Shakspeare Gallery, Pall Mall, & at No.90, Cheapside.

Line engraving $16\frac{5}{8} \times 13\frac{1}{4}$ in / 42.2×33.6 cm

E135 Credulity

F.Wheatley R.A. Invt A.Cardon Sculpt
London Publish'd Augt 1st 1798, by Colnaghi Sala & Co late Torre, No 132, Pall, Mall.

Stipple engraving $13\frac{1}{2} \times 10\frac{3}{8}$ in / 34.3×26.3 cm

1799

E136 Preparing for Market

Painted by Fran.Wheatly R.A. Engraved by Richd Earlom
From the Original Picture, in the possession of B.B.Evans.
Published Jany 7th 1799 by B.B.Evans in the Poultry London.

Mezzotint $19\frac{1}{2} \times 24$ in / 49.5×61 cm

E137 Going to Labour

Painted by Fran.Wheatley R.A. Engraved by Richd Earlom
From the Original Picture in the Possession of B.B.Evans
Published Jan.7th 1779 by B.B.Evans in the Poultry, London.

Mezzotint $19\frac{1}{2} \times 24$ in / 49.5×61 cm

E138 Rustic Conversation

F.Wheatley R.A. pinxt T.Rickards Sculpt
Jan 23 1799

Stipple engraving $8\frac{7}{8} \times 10\frac{7}{8}$ in / 22.5×27.6 cm

1800

E139 Going out milking Le depart de la laitière

see Fig 102

F.Wheatley pinxt C.Turner sculpt
Se vend chez James Daniell, Graveur à Londres
London, Published Jany 1st 1800, by James Daniell No 6 Great Charlotte Street, Blackfriars Road.

Mezzotint & etching $22 \times 18\frac{1}{8}$ in / 55.9×46 cm

E140 The return from milking Le retour de la latière

see Fig 103

F.Wheatley pinxt C.Turner Sculpt
Se vend chez James Daniell, Graveur à Londres
London, Published Jany 1st 1800, by James Daniell, No 6 Great Charlotte Street, Blackfriars Road.

Mezzotint & etching $22 \times 18\frac{1}{8}$ in / 55.9×46 cm

E141 Hay Makers Going out

Painted by F.Wheatley R.A. Engraved by J.J.Van Den Berghe, late Pupil of F.Bartolozzi, R.A. Historical Engraver to His Majesty
London Publish'd Jany 15, 1800 by Anthy Molteno, Printseller to her Royal Highness the Dutchess of York No 29 Pall Mall.

Stipple engraving $14\frac{1}{4} \times 16\frac{3}{4}$ in / 36.2×42.5 cm

E142 Cottagers Returned

Painted by F.Wheatley R.A. Engraved by J.J.Van Den Berghe, late Pupil of F.Bartolozzi R.A., Historical Engraver to His Majesty.
Jan 15 1800.

Stipple engraving $14\frac{1}{2} \times 16\frac{1}{4}$ in / 36.8×41.3 cm

E143 Rustic Hours Morning Les Heures Champêtres Le Matin

see Cat 119

Wheatley pinxt H.Gillbank sculpt
London Published May 3r
Great Charlotte Street, Blackfriars Road.
Se Vend à Londres Chez James Daniell, Graveur, & Compie

Mezzotint $19\frac{1}{8} \times 23\frac{1}{8}$ in / 48.5×58.7 cm

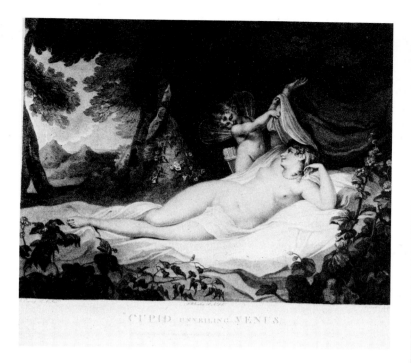

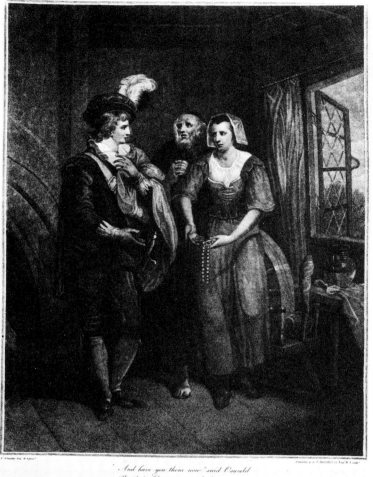

E144

E144 Cupid unveiling Venus
R.Cosway R.A.Invˑ F.Wheatley R.A.Delˑ A.Cardon Sculpˑ
London: Published as the Act directs May 15 1800 by
R.Ackermann at his Repository of Arts 101 Strand.

Line engraving 15 × 17¼ in / 38 × 43.8 cm

LITERATURE F.B.Daniell, *A Catalogue raisonné of the engraved
works of Richard Cosway, R.A.* London, 1890, p43, no173

**E145 Scene from The Old English Baron,
the proof of Edmund's parentage**
F.Wheatley Esqˑ R.A. pinxˑ P.Delatre, p. of F.Bartolozzi,
Esqˑ R.A. Sculpˑ
And have you them now? said Oswald
Yes that I have answered she.
Heaven be praised said Edmund
Hush – said Oswald
 Vide Old English Baron page 97
London Publish'd June 1ˢᵗ 1800, by Colnaghi, Sala & Co (late
Torre) Nº 23, Cockspur Street, opposite Suffolk Street,
Charing Cross.

Stipple engraving 17 × 12⅞ in / 43.2 × 32.7 cm

E145

E146 Rustic Hours Noon Les Heures see Cat 120
Champêtres Le Midi
F.Wheatley R.A. pinxˑ H.Gillbank sculpˑ
London Published June 29 1800 by James Daniell & Cº Nº 6
Great Charlotte Street, Blackfriars Road.
Sa vend à Londres chez James Daniell, Graveur & Compⁱᵉ

Mezzotint 19³⁄₁₆ × 23³⁄₁₆ in / 48.7 × 58.9 cm

E147 Rustic Hours Evening Les Heures see Fig 152
Champêtres La Soirée
Wheatley pinxˑ H.Gillbank sculpˑ
London, Published Septˑ 29ᵗʰ 1800, by James Daniell & Cº
Nº 6, Great Charlotte Street, Blackfriars Road.
Se Vend à Londres chez les Proprietaires James Daniell,
Graveur & Compⁱᵉ

Mezzotint 19 × 22⅞ in / 48.2 × 58.1 cm

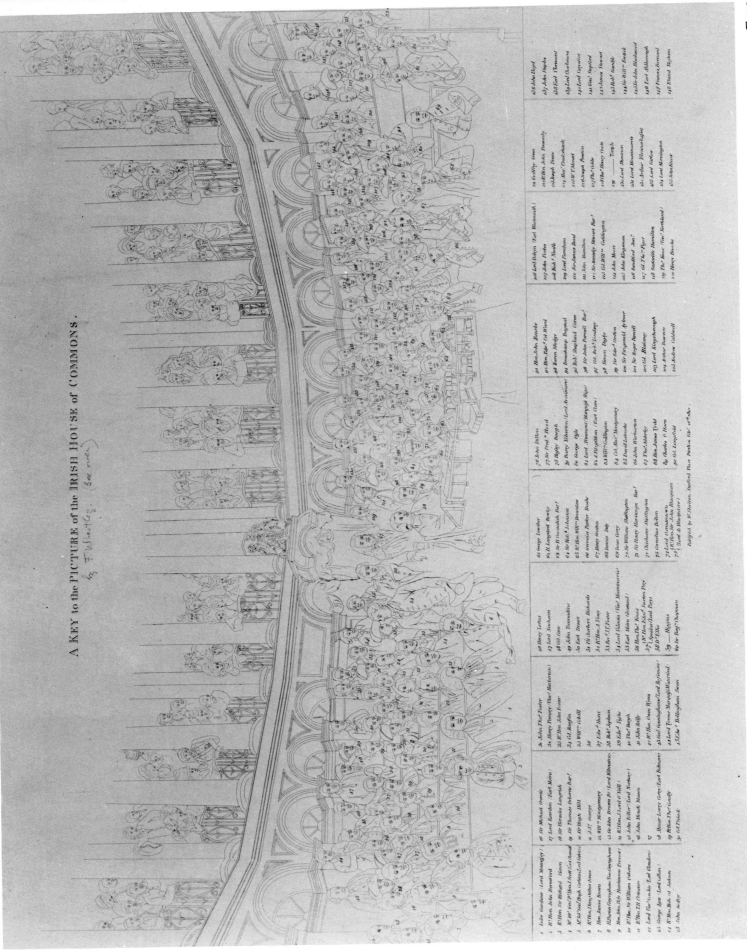

A KEY to the PICTURE of the IRISH HOUSE of COMMONS.
by F. Wheatley (see note)

E148 **Rustic Hours Night Les Heures** see Cat 122
 Champêtres La Nuit
Wheatley pinx. H.Gillbank sculp.
London Published Sept. 29, 1800 by James Daniell & C.^o N.^o 6
Great Charlotte Street, Blackfriars Road.
Se Vend à Londres chez James Daniell, Graveur & Comp.^{ie}

Mezzotint & etching 19 × 23 in / 48.2 × 58.4 cm

E149 **The Deserted Village**
Designed by F.Wheatley R.A. Engraved by A.Smith A.
His lovely daughter, lovelier in her tears,
The fond companion of his helpless years,
Silent went next, neglectful of her charms,
And left a lover's for her father's arms.
 The Deserted Village
Published 1st December 1800 by F.J.Du Roveray, London, in
The Poems of Oliver Goldsmith, 1800, p54.

Line engraving 7⅜ × 4⅝ in / 18.7 × 11.8 cm

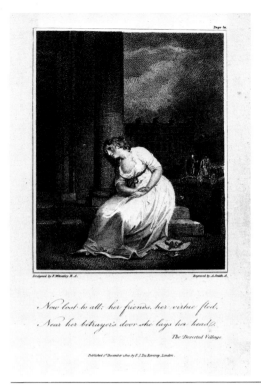

E150

E150 **The Deserted Village**
Designed by F.Wheatley R.A. Engraved by A.Smith A.
Now lost to all; her friends, her virtue fled,
Near her betrayer's door she lays her head.
 The Deserted Village
Published 1st December 1800, by F.J. Du Roveray, London, in
The Poems of Oliver Goldsmith 1800, p52.

Line engraving 7⅜ × 4⅝ in / 18.7 × 11.7 cm

E151 **The Traveller**
Designed by F.Wheatley R.A. Engraved by T.Medland
Ev'n now, where alpine solitudes ascend,
I sit me down a pensive hour to spend
 The Traveller
Published 1st December 1800 by F.J. Du Roveray, London,
in *The Poems of Oliver Goldsmith* 1800, p10.

Line engraving 7⅜ × 4⅝ in / 18.7 × 11.8 cm

1801

E152 **A Key to the Picture of the Irish**
 House of Commons
Publish'd by W.Skelton, Stafford Place, Pimlico. Feb.^y 26.th
1801.

Line engraving 20 × 24⅞ in / 50.8 × 63.2 cm

1802

E153 **The Basket Makers Les Feseuses des**
 Paniers
F.Wheatley pinxt. J.Baker sculpt.
London Published Jan.^y 21.st 1802 by H.Macklin, Poets Gallery
Fleet Street.

Etching and stipple engraving 16½ × 13⅞ in / 41.9 × 35.2 cm

E154 **The Alpine Lovers Les Amans des**
 Alpes
F.Wheatley pinx.^t Bransom Sculp.^t
London Published Jan.^y 21.st 1802, by H.Macklin Poets Gallery
Fleet Street.

Etching and stipple engraving 16¾ × 13⅞ in / 42.2 × 35.2 cm

E155 **The Dipping Well in Hyde Park** see Cat 113
 Le Puits à Baigner à Hyde Park
Wheatley pinxit J.Murphy excudit 1802 James Godby
sculpsit
London. Published July 3.^d 1802 by John Murphy N.^o 19
Howland Street, Fitzroy Square.

Stipple engraving 20 × 25½ in / 50.8 × 64.8 cm (cut)

1803

E156 Repairing to Market Allant au Marché Pl 1st
Painted by F.Wheatley R.A. Engraved by W.Annis
Published April 1803, by Morgan & Pearce, N⁰ 32 Clipstone
Street, Fitzroy Square, London, and by C.Josi, Amsterdam.

Mezzotint and etching $21\frac{7}{8} \times 17\frac{3}{4}$ in / 55.5 \times 45.1 cm

E157 At Market Au Marché Pl 2nd
Painted by F.Wheatley R.A. Engraved by W.Annis
Published April 1803, by Morgan & Pearce, N⁰ 32 Clipstone
Street, Fitzroy Square, London and C.Josi, Amsterdam.

Mezzotint $21\frac{7}{8} \times 17\frac{7}{8}$ in / 55.5 \times 45.4 cm

E158 Coming from Market Retour du Marché Pl 3rd
Painted by F.Wheatley R.A. Engraved by W.Annis
Published April 1803, by Morgan & Pearce, N⁰ 32 Clipstone
Street, Fitzroy Square, London and by C.Josi Amsterdam.

Mezzotint $22\frac{7}{8} \times 22$ in / 58.1 \times 57.8 cm

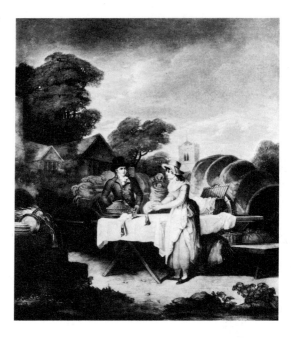

E157

E159 Returned from Market De retour du Marché Pl 4th
Painted by F.Wheatley R.A. Engraved by W.Annis
Published April 1803, by Morgan & Pearce, N⁰ 32 Clipstone
Street, Fitzroy Square, London, and by C.Josi, Amsterdam.

Mezzotint and etching $21\frac{7}{8} \times 17\frac{3}{4}$ in / 55.5 \times 45.1 cm

E160 The Fathers Admonition L'Avis Paternel
Drawn by F.Wheatley R.A. Engraved by Field
London Pubᵈ as the act dirᵗ the 1st of July 1803.

Stipple engraving $15\frac{3}{8} \times 18\frac{3}{8}$ in / 39 \times 46.6 cm

E162 Juvenile Opposition
Painted by F.Wheatley Engraved by J.Alais
Published June 24th, 1804, by T.Palser, Surry Side,
Westminster Bridge.

Mezzotint and etching $18 \times 21\frac{7}{8}$ in / 45.7 \times 55.5 cm

E163 Juvenile Reluctance
Painted by F.Wheatley Engraved by J.Alais
Published June 24ᵗʰ 1804 by T.Palser Surry Side, Westminster
Bridge.

Mezzotint and etching $17\frac{3}{4} \times 21\frac{3}{4}$ in / 45.1 \times 55.2 cm (cut
close)

1804

E161 Rural Repose see Fig 107
Painted by F.Wheatly R.A. Engraved by I.Geremia
Published May 1st, 1804, by Messrs Schiavonetti.

Stipple engraving $16\frac{1}{8} \times 19$ in / 41 \times 48.2 cm

1807

E164 Irish Peasantry crossing a Brook
Painted by Francis Wheatley Engraved by Richard Earlom
Published 12ᵗʰ March, 1807, by Robert Laurie & James
Whittle, N⁰ 53, Fleet Street, London.

Mezzotint and etching $19\frac{3}{4} \times 24\frac{7}{8}$ in / 50.2 \times 63.2 cm

188

1817

E165 Two Gentlemen of Verona see Cat 97
F.Wheatley R.A. Pinx.! R.Rhodes Sculp.
Act 5 Scene 4
Val. – Ruffian, let go that rude uncivil touch –

Published Jan.ʸ 1, 1817, by John Murray, Albemarle Street,
London.

Line engraving $14\frac{3}{4} \times 11$ in / 37.5 × 28 cm

E166 King Henry IV Part 2
F.Wheatley, R.A. pinx.! G.Noble sculp
Act 4 Scene 4
Prince Henry
– There is your crown,
and He that wears the crown immortally
Long guard its yours!

Published Jan.ʸ 1, 1817, by John Murray, Albemarle Street,
London.

Line engraving $16\frac{3}{8} \times 12$ in / 41.6 × 30.5 cm

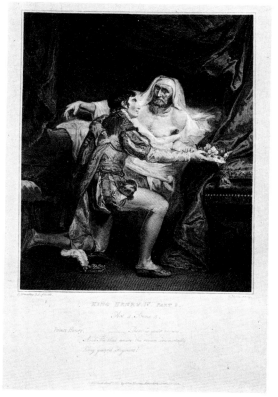

E166

1818

E167 Haymakers
From an original drawing by F.Wheatley in the possession of
the proprietor of this work.
London, Pub. by T.M^cLean July 1.1818.
J.Hassall, *Aqua Pictura, illustrated by a series of original specimens*
second ed.1818.

Line engraving $8\frac{7}{8} \times 5\frac{7}{8}$ in / 22.5 × 14.9 cm

1840

E168 Ruth and Boaz see Cat 70
Painted by F.Wheatley R.A. Engraved by H.B.Hall
'Then said Boaz to Ruth, go not to glean in another field.'
 Ruth II 8
Fisher, Son & Co. London & Paris, 1840.

Line engraving $11\frac{1}{2} \times 9$ in / 29.2 × 22.8 cm

Undated Engravings after Francis Wheatley

E169 Belinda
J.Barney
Not seen

E170 Fisherman Going out
J.Barney

$17\frac{1}{2} \times 21\frac{1}{2}$ in / 44.5 × 54.6 cm

Not seen

E171 The Fisherman's Return
J.Barney
Not seen

E172 Calculation
A.Cardon

Not seen

E173 The See-Saw
F.Wheatly invt Delatre sculpt

Stipple engraving *c* 6 in / 15.2 cm diam. (sight)

E174 Going out haymaking
R.Earlom

E175 The Jealous Rival
J.Eginton

E176 The Careless Husband
J.Eginton

E177 Arthur Phillip
Ermer [see **E59**]

E178 Itinerant Tinker
F.Wheatley R.A.pinxt A.Freschi Sculpt

Stipple engraving $8\frac{3}{4}$ × 11 in / 22.2 × 27.9 cm

E179 The Relentless Father
W.N.Gardiner

12 × 10 in / 30.5 × 25.4 cm

Not seen

E180 The Tender Father
W.N.Gardiner

12 × 10 in / 30.5 × 25.4 cm

Not seen

E181 A group of rustics by a wood
F.Wheatley del T.H.

Etching and aquatint $7\frac{3}{4}$ × $9\frac{7}{8}$ in / 19.8 × 25.1 cm

E182 The Cottage Door
G.Keating

Not seen

E183 Inattention
R.M.Meadowe

Not seen

E184 Attention
R.M.Meadowe

Not seen

E185 The Salmon-Leap
F.Wheatley delin T.Mitlon (*sic*) sculp.

Most Humbly Inscribed to Gen! Robert Sandford by Thos Milton
Publish'd as the Act directs by J.Walter Charing Cross London for the Author T.Milton in Dublin

Line engraving $6\frac{1}{4}$ × 8 in / 15.9 × 20.3 cm

E186 Death Bed Scene
F.Wheatley delt I.Mitan sculpt

Line engraving $9\frac{1}{8}$ × 6 in / 23.2 × 15.2 cm

E187 Fidelity rewarded
F.Wheatley del R.A. J.Ogborne Sculp.
. . . No 38 Great Portland St

Stipple engraving $9\frac{1}{4}$ × $7\frac{1}{2}$ in / 23.5 × 19.1 cm

E188 The Oyster Girl see Cat 79
Song cover: 'Oysters Sir, Written expressley for & Sung by Miss Graddon, Composed by Signor Rossini.'

Wheatley pinx D.Orm sculp!
Printed by W.Wybrow, 24 Rathbone Place. / Price 2ˢ/-

Stipple engraving 10¾ × 8½ in / 27.3 × 21.6 cm

E189 The Careless Servant
F.Wheatley Del! (*sic*) Eng. by C.Playter

Stipple engraving 13½ × 10⅝ in / 34.3 × 27 cm

E190 Rustic Conversation
F.Wheatley R.A. pinx! T.Rickards sculp!

Stipple engraving 9 × 11 in / 22.8 × 27.9 cm (cut)

E191 The Baptism see Cat 100
Michael Sloane

22½ × 17½ in / 57.1 × 44.5 cm

Not seen

E192 Clara attempts the life of Marianne
Painted by F.Wheatley Engraved by R.Stanier

Stipple engraving 14¾ × 18¾ in / 37.5 × 47.6 cm Proof before title
James Fennell, *Lindor and Clara ; or, the British Officer* 1791
Act V scene 6

E193 The identity of Clara revealed
Painted by F.Wheatley Engraved by R.Stanier

Stipple engraving 14¾ × 18⅛ in / 37.5 × 46 cm Proof before title

James Fennell, *Lindor and Clara ; or, the British Officer* 1791
Act V scene 6

E194 The Discovery see Fig 92
F.Wheatley pinx T.Simpson excudit R.Stanier sculp.

Stipple engraving 20¾(cut) × 16 in / 52.7 × 40.6 cm

E195 The Communion see Cat 99
J.Suntach

22½ × 17½ in / 57.1 × 44.5 cm

Not seen

E196 Lady on Horseback

Not seen

E197 Mary's Dream see Cat 115
W.Ward
She from her pillow gently raised
Her head to ask who there might be,
And saw young Sandy shiv'ring stand,
With pallid cheek and hollow eye.

Published by R.Ackermann

Not seen

E198 The Strawberry Girl
T.Watson

Not seen

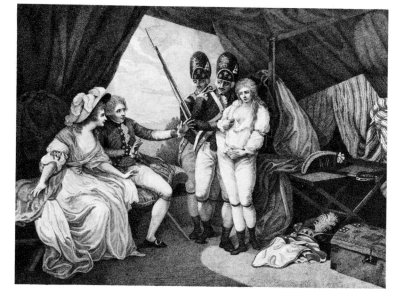

E193

**E199 A New Married Couple taking
 farewell of their mother**

Painted by F.Wheatley R.A. Engraved by J.H.Wright

On the blest Youth, a Mother's hand confers
The Maid his earliest, fondest wishes knew
Each soft enchantment of the soul is hers:
His are the joys to firm attachment due

Not seen

**E200 A visit to the Mother with the
 grandchild**

Painted by F.Wheatley R.A. Engraved by J.H.Wright

A Twelvemonth now, had sweetly pass'd away
When the fond Pair return'd with heartfelt joy
To the Old Cot, to keep their Wedding day:
And Shew the grandmother their darling boy

Not seen

E201 Milking time

No letter

Line engraving $4\frac{1}{4} \times 5\frac{3}{8}$ in / 10.8 × 14.3 cm

192

A
CATALOGUE
of the
VALUABLE COLLECTION
of Beautiful High-Finished
DRAWINGS etc.
of that eminent Artist
MR. WHEATLEY
which will be sold by auction
by MESSRS. CHRISTIE AND ANSELL
on Thursday 27th of May, 1784
N.B. In the above Sale, by Permission, will be
introduced a small Collection of Drawings mounted,
the Property of the Artist.

A
CATALOGUE
Thursday May 27, 1784

1 Two landscapes and a pair of frost pieces
2 Ditto
3 A moonlight, two landscapes and a frost piece
4 5 sea pieces
5 Four ditto oval
6 Two landscapes, a frost piece and a sea piece
7 Two landscapes and two frost pieces
8 Ditto
9 Ditto
10 Ditto

[in ink 2.10.–]

11 Ditto and two sea pieces

12 Ditto
13 Four sea views
14 A pair of landscapes and a pair of frost pieces
15 A landscape and a pair of sea pieces
16 A landscape, ruins and figures and a sea view
17 A landscape and a frost piece
18 Ditto
19 Ditto
20 Two sea views
21 A frost piece, a sea view and a landscape
22 Two small landscapes, a ditto larger and a frost piece

Capital DRAWINGS by Mr. WHEATLEY

23 View of part of Plymouth opposite Mount Edgecombe
24 Conway Castle, its companion
25 Study from nature, black chalk
26 View near Ennischerry, in Ireland
27 Donnybrook, in ditto
28 The hill of Howth, in ditto, its companion
29 Glen Molaur, in ditto
30 View of ruins near Reading, Berks
31 Ditto, its companion
32 A drawing in pen and ink, by Mortimer
33 Ditto in chalk, by ditto
34 Ditto, by ditto
35 Part of Donnybrook fair in Ireland
36 View on the Liffey in ditto
37 Ruins of a castle in ditto
38 Drawing in Bistre
39 Study from nature
40 Salmon leap at Leixlip, in Ireland
41 Ivy Bridge in Devonshire, its companion
42 View in Hyde Park
43 Ditto in Surrey, its companion
44 Part of Box-hill, Surry
45 Palmerstown Fair, in Ireland
46 Ditto, a whisky stand, its companion
47 Ruins of Beyham Abbey

[in ink 88. 2. 6]

48 View on the river Boyne in the Park of the Right Honorable
William Conyngham

49 Box-hill in Surry, its companion
50 Ruins of a bridge in Ireland
51 View in Dublin Bay, with the Wicklow Mountains taken from
 Clontarf
52 Palmerstown Fair, oval
53 Ditto
54 Donnybrook Fair, its companion
55 Cattle
56 Macbeth meeting the Witches, by Mortimer
57 Figure of a Woman, study from nature, by ditto
58 Stain'd drawing, by ditto
59 Rural courtship
60 A mill at Shaftsbury, Dorsetshire
61 Musidora, bathing
62 Fishermen
63 Ditto
64 Ditto
65 Fortune teller
66 Shepherdess
67 Study from nature, by Mortimer
68 Sketch, by ditto
69 Study from nature
70 Ditto
71 Cattle
72 The waterfall at the Dargle, the seat of the Right Honorable
 Lord Powerscourt

FINIS

[in ink 107.10.–]

Appendix II Sale May 1785

A
CATALOGUE
of a
Collection of Beautiful High-Finished
DRAWINGS AND PICTURES,
The Performance of that ingenious ARTIST,
MR. WHEATLEY;
Many of both Pictures and Drawings, are real
Views and Designs from MARMONTEL,
Intended for Publication:
Which will be SOLD by AUCTION,
BY MR. GREENWOOD,
At his Room, in LEICESTER-SQUARE,
On Thursday the 5th of May, 1785,
At One O'Clock

A
CATALOGUE, &c.
Thursday, May the 5th, 1785

————

D R A W I N G S

Mr. Barret
 1 TWO small views, stile of.
 2 A ditto, with a water fall.
 3 A landscape with figures, at sun setting.
 4 Ditto, ditto.
 5 Ditto, ditto.
 6 Ditto, larger.
 7 Ditto, the ruins of an antient castle, the companion.

Mr. Wheatley	8	A view of Rochester castle.
Ditto	9	Betham mill in Westmoreland.
Ditto	10	A large view of the Lakes.
Ditto	11	Lancaster castle.
Sandby	12	A humourous conversation.
Ditto	13	A landscape with figures.
Mr. Wheatley	14	A view on the coast of Wicklow, in Ireland, an evening.
Ditto	15	Keswith, from Penrith road, a foot bridge.
	16	Two views from Nature.
Mr. Barret	17	A view on the Lakes in Cumberland, stile of.
Ditto	18	A landscape with hay-makers.
Mr. Wheatly	19	Howths in Ireland.
Ditto	20	Fishermen mending their nets.
Mr. Wheatly	21	A view in Ireland.
Ditto	22	Ditto with female figures.
Ditto	23	Dargle, the seat of Lord Powerscourt.
Ditto	24	Women picking cockles.
Ditto	25	Basenthwaite water and skiddaw.
Ditto	26	Part of Coniston Lake.
Ditto	27	Gypsies stealing poultry.
Ditto	28	A view in Westmoreland with a girl going to market.
Ditto	29	Head of Coniston Lake, clearing up of a storm.
Ditto	30	View of the coast of Wales.
Ditto	31	Ditto, in Cumberland.
Ditto	32	Reading Priory.
Ditto	33	Salmon leap, at Leixlip.
Ditto	34	View on the Lancaster coast, at sun set.
Ditto	35	Lancaster Sands.
Ditto	36	The sheds of Cloutarf, in Ireland.
Ditto	37	Donnybrook fair, ditto.
Ditto	38	Palmerston fair, its companion.
Ditto	39	Hay-makers.
Ditto	40	View of Keswick Lake from Castle Cragg.
Ditto	41	Palmerston fair, large.
Ditto	42	Box Hill, from Mr. Lock's farm.
Ditto	43	Part of Winnandurmere.
Ditto	44	Coniston Lake, a morning.
Ditto	45	View on the coast of Ireland in Dublin Bay, with the ruins of a castle.
Ditto	46	Ditto, in Westmoreland.
Mr. Mortimer	47	Macbeth meeting the Witches.
Ditto	48	Satyr and Bacchante, its companion.
Mr. Wheatly	49	Dublin Bay.
Ditto	50	View from the 6-mile stone near Keswick.

o

PICTURES.

198

Appendix III Sale January 1795

A
CATALOGUE
of all the
CAPITAL PICTURES,
Valuable Drawings,
and other curious articles,
the property of
FRANCIS WHEATLEY, Esq. R.A.
at his house
Situate, Nᵒ. 14, on the West Side of RUSSELL PLACE,
FITZROY SQUARE
Which will be Sold by Auction
By MR. CHRISTIE,
On the Premises,
On Tuesday, January 13, 1795,
At Twelve o'Clock

To be Viewed Two Days preceding the Sale

Catalogues may be had on the Premises; at the Rainbow
Coffee House, Cornhill; and in Pall Mall

A
CATALOGUE,
&c. &c. &c.

Second Day's Sale,
TUESDAY, JANUARY the 13th, 1795.

PRINTS

1 Eleven prints, by Burke, Ward, &c.
2 Six Various, proofs, some damaged
3 Three proofs by Ward, and 9 landscapes, by Medeman, &c.
4 Thirteen small subjects, and several proofs by Bartolozzi
5 Sixteen ditto
6 Five, Bartolozzi, proofs, &c.
7 Five by Ward, from Mr. Wheatley, proofs
8 Two fine proofs by Fitler and 1 by Hodges, from Mr. Wheatley
9 The Duke of Newcastle, a fine proof, Bartolozzi
10 Two, Mr. Kemble in Richard III. ditto, and Mr. Howard visiting the
 prisons, fine proofs

Drawings

11 Eight drawings by old masters
12 Seven, Wouvermans, Teniers, &c.
13 Seven academy figures by Cipriani, &c.
14 Nine, by P. Veronesse, Vanni, L. Giordano, &c.
15 Seven drawings by Mr Wheatley
16 Seven ditto, Cipriani
17 Three ditto, fine
18 One, Maria, a fine drawing in colours by Mr. Wheatley, oval
19 Twelve by Angelica and 2 by Mortimor
20 Two views in colours, Conway castle, by Mr. Wheatly
21 Three by ditto, &c.
22 Seven unfinished studies by ditto
23 One large, the travelling Tinker, by ditto
24 One ditto, finished in colours
25 Rural life, domestic scenes, 2 interiors, framed and glazed, Mr. Wheatley
26 A cottage with children, by ditto, and a view from nature, in colours,
 by G. Barrett
27 A pair of tinted drawings of farm yards, by Mr. Wheatley

BOOKS

28 Raphael's frizes in the Vatican, by Bartoli
29 Buffon's natural history, 10 vol. half bound
30 Fielding's works, 11 vol. 5th vol. wanting, neatly bound
31 Boyd's translation of Ariosto, 2 v. neat
32 Johnson's Dictionary, large folio, elegantly bound in Russia
33 Bell's pantheon, ditto
34 Milton's Paradise Lost, printed 1688, with cuts

35 A parcel of portfolios with paper and a few loose books
36 Twelve gilt frames
37 Eleven ditto with glass
38 Five ditto with 1 spandle, $\frac{3}{4}$ size, &c.
39 A spinning wheel, 2 light horsemens hats, a straw hat, a colour stone and
 a small box with water colours
40 Two Derbyshire spar ornaments, 3 Wedgwood ditto and an inkstand
41 Two plaster casts of the legs of Hercules and 3 statues
42 Three ditto of Pluto and 2 female figures
43 Two ditto, large, Apollo and a shifting Venus, from the antique
43★ Eleven plaster casts on the upper shelves
43★★ 25 ditto lower shelves
43★★★ 10 ditto in the closet
44 Six canvasses, some with sketches and 2 unstained
44★ 11 primed canvasses
45 A lady's portrait, $\frac{3}{4}$, in a handsome gilt frame and 4 ditto without frames
46 Seven sketches, studies, various
47 Seven ditto, smaller
48 Four ditto
49 Three small pictures, a girl with a lamb, a ditto with doves, and a farm
 yard with horses
50 Thirteen numbers of select views of Great Britain by Meddyman and
 Milton
51 Two drawing books by Rawlinson and Hogburn
52 A battle piece, Borgognione
53 A blank canvas, whole length, a lady's portrait, ditto, and a pilgrim, ditto
54 A landscape with Ruth and Boaz, in an elegant gilt frame
55 A large ditto, peasants ploughing, with horses, &c
56 A mahogany easle and sundry stretching frames
57 Sundry oil bottles, a small copper plate and pieces of canvas

DRAWINGS by Mr. Wheatley.

58 One, a farm yard
59 One, a cottage, evening
60 One, labourer's return
61 One, winter
62 One, ditto
63 One, a camp scene
64 One, ditto
65 One, cottages and figures
66 One, a storm on Ryswick Lake
67 One, girl with water-cresses

PICTURES by Mr. Wheatley

FINIS

Appendix IV Works Exhibited by Wheatley during his lifetime

SOCIETY OF ARTISTS

Duke's Court, Bow Street, Covent Garden

1765	155	Portrait of a gentleman; three-quarters
1766	184	Miniature of a gentleman
1768	179	Small whole-length of a gentleman

At Mr. Turner's, Surgeon, St.Martin's Lane

1770	148	A Conversation
	149	Portrait of a child; in crayons
	150	ditto gentleman; ditto
1771	184	Portrait of a lady; in crayons
	185	ditto
	186	ditto

The Corner of the Little Piazza, Covent Garden

1772	374	A Scene in 'Twelfth Night,' Act III (The Duel)
	375	A small whole-length of a lady
	376	A portrait of a lady; in crayons
	377	ditto gentleman; ditto
1774	322	A portrait of a gentleman; small whole-length
	323	ditto ditto
	324	ditto ditto
	325	A Study on the Coast of the Isle of Wight, the figures by Mr.Mortimer
	326	ditto from nature; a landscape
	327	ditto ditto
	328	A Kitcat; small whole-length
1775	299	A portrait of a gentleman
	300	ditto small whole-length
	301	A portrait of a lady

302 An Offering to Concord – A family
303 A small whole-length of a gentleman
304 A Landscape – A study from nature
305 ditto ditto
306 ditto ditto
307 ditto ditto
308 ditto ditto
309 A portrait of a lady, whole-length (large as life, in the character
 of the Muse Erato)
310 A View near Battersea

Jermyn Street
1776 133 Portrait of an Officer
 134 Mr. Webster in the character of Comus
 135 Gentlemen Returned from Hunting
 136 A View of the Breakwater at Sheerness
 137 Ditto, part of Rochester Bridge and Castle
 138 A Landscape; study from nature
 139 Ditto, view on the Banks of the Medway
1777 160 A lady and her two children; small whole-lengths
 161 A family; ditto
 162 A Landscape; a study from nature
 163 Ditto
 164 Portraits of two gentlemen

Dublin
1783 320 Review of the Irish Volunteers in the Phoenix Park, Dublin

FREE SOCIETY OF ARTISTS
1779 176 A whole length of a lady

SOCIETY OF ARTISTS IN IRELAND
1780 163 A view of *College-green*, with a meeting of the Volunteers, on
 the 4th of November, 1779, to commemorate the birth-day
 of King William
 164 Portrait of a nobleman, small whole-length
 165 Ditto of a gentleman, with a horse
 166 A view from Clontarf
 167 Ditto from Dunleary

ROYAL ACADEMY
Jermyn Street
1778 333 Portraits of a family; small whole-length
 334 ditto ditto
 335 A Wood Scene, with Gypsies Telling a Fortune

336 View near Ivy Bridge, Devonshire

337 View near Boxhill, Surrey; drawing

1780 407 View of Conway Castle; drawing

408 ditto ditto

36 Gerrard Street

1784 55 Portrait of a gentleman (Mr.Swiney)

91 Part of Donnybrook Fair, in Ireland

1784 100 View of the Salmon Leap at Leixlip, in Ireland

178 Portrait of a gentleman (Mr.Swiney)

214 Portrait of a gentleman

23 Welbeck Street

1785 147 View in Lancashire

163 An Amorous Sportsman

1786 66 Portrait of a gentleman; small whole-length

107 ditto ditto

194 Brickmakers

237 Girl Making Cabbage Nets at a Cottage Door

458 Portrait of a lady; drawing

1787 135 A Girl Feeding a young Bird

212 The Recruiting Officer

1788 8 Girl with Water Cresses

12 The Rescue

31 Mr.Howard offering Relief to Prisoners

37 Girl Returning from Market, and Counting her Money

95 Peasants Relieving an Old Soldier

396 Portrait of a lady (Mrs.Wheatley)

49 Upper Charlotte Street

1789 17 Portrait of a nobleman returning from shooting (Duke of
Newcastle, and Col. Litchfield; View of Clumber – Walpole)

60 Children with a Bird-catcher

145 Study; from nature

217 Wheelwright's Shop; study from nature

1790 34 The Charitable Milkmaid

161 Preparing for Market

196 Jaques and the Wounded Stag. From "As you Like it."

241 Evening. From Cuningham's Poem

247 A Cottage in Cumberland

290 A Pilgrim

436 Portrait of a gentleman

1791 30 Cottage Children calld to Supper

85 Portrait of a gentleman with a horse and spaniel (Mr.Bond
Hopkins)

223 A Pedlar at a Cottage Door

20 Charles Street, Middlesex Hospital

1800 311 Scene from the "Deserted Village," for Du Roveray's edition of
Goldsmith's Poems
"The good old sire, the first prepar'd to go
To new found worlds, and wept for others' woe," etc.

313 Scene from the "Deserted Village," for Du Roveray's edition of
Goldsmith's Poems
"Ah, turn thine eyes
Where yon poor houseless shiv'ring female lies," etc.

1801 68 Morning
70 Noon
87 Evening
90 Night

Bibliography

Primary Sources

1 MANUSCRIPT

London, British Museum, *Whitley Papers*

London, Guildhall, MS 198

London, Public Record Office, KB 122.430 no1729

London, Royal Academy of Arts, *Council Meeting Minutes*

London, Royal Academy of Arts, MSS of the Society of Artists

London, Royal Society of Arts, *Minutes of Committees*

Windsor, Royal Library, *The Farington Diary*, transcript

2 PRINTED

J.Boydell, *A Catalogue of the Pictures, &c. in the Shakespeare Gallery*, London 1790

J.Boydell, *A Catalogue of the Pictures, &c. in the Shakespeare Gallery*, London 1802

H.Bromley, *A Catalogue of Engraved British Portraits*, London 1793

The Correspondence of Edmund Burke, ed T.W.Copeland, I, Cambridge 1958

A.Chalmers, *The General Biographical Dictionary*, London 1817

E.Dayes, *The Works of the late Edward Dayes*, ed E.W.Brayley, London 1805

R.Dossie, *Memoirs of Agriculture, and other oeconomical arts*, III, London 1782

E.Edwards, *Anecdotes of Painters*, London 1808

T.T.Faulkner, *The Dublin Journal*

J.Gandon and T.J.Mulvany, *The Life of James Gandon, Esq.*, Dublin 1846

Gentleman's Magazine

Hibernian Journal

Hibernian Magazine

Morning Chronicle

Morning Herald

Morning Post

J.H.Mortimer and T.Jones, *Candid Observations on the Principal Performances now exhibiting at the New Rooms of the Society of Artists,* London 1772

A.P.Oppé, 'Memoirs of Thomas Jones', *Walpole Society*, XXXII, 1946–8, London 1951

A.Pasquin, *An authentic History of the Professors of Painting, Sculpture and Architecture, who have practised in Ireland*, London 1796

A.Pasquin, *Memoirs of the Royal Academicians*, London 1794

Press Cuttings, albums, London, Victoria and Albert Museum

Public Advertiser

Quarterly Review, London 1809

H.Repton, *The Bee; or, a Companion to the Shakespeare Gallery*, London 1789

Betsy Sheridan's Journal, ed W.LeFanu, London 1960

Secondary Works

T.S.R.Boase, 'Illustrations of Shakespeare's Plays', *Journal of the Warburg and Courtauld Institutes*, X, London 1947, pp83–108

T.S.R.Boase, 'Shipwrecks in English Romantic Painting', *Journal of the Warburg and Courtauld Institutes*, XXII, London 1959, pp332–46

T.S.R.Boase, 'Macklin and Bowyer', *Journal of the Warburg and Courtauld Institutes*, XXVI, London 1963, pp148–77

M.L.Boyle, *Biographical Catalogue of the Portraits at Panshanger*, London 1885

J.Brinckmann and E.F.Strange, *Japanese Colour Prints and other engravings in the collection of Sir Otto Beit*, London 1924

J.Chaloner Smith, *British Mezzotinto Portraits*, London 1883

A.Cunningham, *The Lives of the most eminent British Painters, Sculptors and Architects*, V, London 1832

R.Edwards, *Early Conversation Pictures from the Middle Ages to about 1730*, London 1954

J.Frankau, *John Raphael Smith*, London 1902

J.T.Gilbert, *A History of the City of Dublin*, III, Dublin 1859

M.H.Grant, *A Chronological History of the Old English Landscape Painters – in oil – from XVIth century to the XIXth century*, I, London 1926

J.Grego, *Rowlandson the Caricaturist*, I, London 1888

S.C.Hutchison, 'The Royal Academy Schools, 1768-1830', *Walpole Society*, XXXVIII, 1960-2, London 1962, pp123-91

W.E.H.Lecky, *A History of Ireland in the Eighteenth Century*, II, London 1908

W.M.Merchant, *Shakespeare and the Artist*, London 1959

C.Mitchell, 'Benjamin West's "Death of General Wolfe" and the Popular History Piece', *Journal of the Warburg and Courtauld Institutes*, VII, London 1944, pp20-33

F.O'Donoghue, *Catalogue of Engraved British Portraits in the British Museum*, London 1908-25

W.Roberts, *F.Wheatley, R.A.*, London 1910

J.L.Roget, *A History of the 'Old Water-Colour' Society*, I, London 1891

M.C.Salaman, 'Wheatley's "Cries of London" ', *Apollo*, X, London 1929, pp251-6

F.Siltzer, *The Story of British Sporting Prints*, 2nd ed, London 1929

W.G.Strickland, *A Dictionary of Irish Artists*, II, London and Dublin 1913

W.M.Torrens, *Memoirs of the Right Honourable William second Viscount Melbourne*, I, London 1878

A. de Vesme and A.Calabi, *Francesco Bartolozzi*, Milan 1928

E.K.Waterhouse, 'English Painting and France in the Eighteenth Century', *Journal of the Warburg and Courtauld Institutes*, XV, London 1952, pp122-35

R.Watson, 'Francis Wheatley in Ireland', *Irish Georgian Society*, IX, Dublin 1966, pp35-49

M.Webster, *Francis Wheatley R.A.*, exhibition Aldeburgh and Leeds, London 1965

M.Webster, 'A Regency Flower Painter, Clara Maria Pope', *Country Life*, CXLI, London 1967, pp1246-8

M.Webster, 'Francis Wheatley's Cries of London', *Auction*, III, 1970, pp44-9

W.T.Whitley, *Artists and their friends in England, 1700-1799*, London and Boston 1928

A.Whitman, *Valentine Green*, London 1902

List of Owners

Private Collections

United Kingdom

Her Majesty the Queen **24**
R.E.Alton Esq MC Fig 110
John H.Appleby Esq Fig 16
Colonel G.A.Barnett Fig 57
The Viscount Bearsted TD Figs 96, 97, 98, 99, 116
M.Bernard Esq Figs 135, 151, **15, 81, 113**
R.A.Bevan Esq **29**
W.A.Brandt Esq Fig 14
Trustee of First Lord Brocket Will Trust Figs 9, 73, 102, 103, **42**
Mrs B.L.Brookes Fig 146
Major W.H.Callander **66, 67**
Mrs Chamberlayne Macdonald Figs 133, 134, 138
Colonel Sir Ralph Clarke KBE Fig 76
Mrs Pamela de Meo **79**
The Countess of Drogheda **116**
Edward Eden Esq Fig 26
The Garrick Club Fig 18
J.Paul Getty Esq **53**
Major Philip Godsal Figs 100, 154, 155
Gooden & Fox Ltd **92**
The Earl of Harrowby Fig 83
Mrs Kathleen Houfe Fig 85
George Howard Esq Fig 38
Mrs Mary Lightbown **E47**
Trustees of the Seventh Duke of Newcastle, deceased Fig 143
D.Cherry Paterson Esq **48**
R.A.Paterson Esq Fig 88
The Viscount Rothermere **21**
Colonel D.G.C.Sutherland **16**
Theatre Royal, Drury Lane Fig 120
Arthur Tooth & Sons Ltd Fig 25
Jeremy Tree Esq Fig 43
The Executors of the late Lord Wharton Fig 23
Mrs D.A.Williamson Figs 54, 59
F.E.B.Witts Esq Fig 19
The Dean and Chapter of York **99, 100**

Private Collections

Overseas

EIRE

The Lord Dunleath TD **73**
The Lord Farnham Fig 40
The Lord Talbot de Malahide CMG Fig 45

JERSEY, CI

Mrs Dorothy Hart **114**

USA

The Estate of Miss Marion Davies **103, 104**
Mrs Lucius Peyton Green Fig 71
Mr Robert Halsband Fig 74
Mr Lincoln Kirstein Fig 118
Miss Frederica Leser **39**
Mrs Eleanor G.MacCracken Fig 101
Mr and Mrs Paul Mellon Figs 12, 13, 21, 24, 27, 30, 50, 52, 56, 61, 62, 87,
 111, 121, 144, 145, 148, 152, **6, 47, 80, 97, 119, 120, 122, E10, E15, E39,**
 E50, E88, E89, E112, E157
Mr Eli W.Tullis **68**

Public Collections

United Kingdom

Bedford, Cecil Higgins Art Gallery Fig 46
Birmingham, Barber Institute of Fine Arts, University of Birmingham Fig 11
Birmingham, City Museum and Art Gallery Fig 58, **60**
Buckinghamshire, The National Trust, Waddesdon Manor Fig 37
Brighton, Art Gallery and Museum **5**
Cambridge, Syndics of the Fitzwilliam Museum Figs 70, 142
Edinburgh, National Gallery of Scotland Fig 84
Leeds, City Art Galleries Figs 36, 93, 132
London, Trustees of the British Museum Figs 5, 48, 51, 63, 64, 65, 66, 67, 68,
 69, 72, 75, 78, 79, 80, 81, 82, 90, 105, 106, 109, 112, 113, 117, 119, 123, 124,
 125, 126, 127, 129, 130, 149, **E3, E12, E20, E56, E72, E97, E98, E103,**
 E104, E105, E106, E107, E113, E115, E116, E117, E122, E123B, E127,
 E131, E133, E144, E145, E150, E165, E193
London, The Fine Art Society Fig 108
London, Guildhall Art Gallery **78**
London, Ministry of Public Buildings and Works, Crown Copyright **71**
London, National Maritime Museum **54**
London, National Portrait Gallery Figs 39, 41, 139
London, Royal Academy of Arts Figs 1, 95, 131, 156
London, Royal Institute of British Architects Fig 8
London, Royal Society of Arts Fig 2
London, Tate Gallery Figs 20, 28, 29

London, H.M.Treasury **74**
London, Victoria and Albert Museum Figs 15, 34, 44, 77, 104, 137, **87**
Manchester, City Art Gallery Fig 17
Nottingham, Castle Museum and City Art Gallery Fig 10
Southampton, City Art Gallery Fig 49
Stratford-upon-Avon, Royal Shakespeare Theatre Picture Gallery Fig 128

Public Collections

Overseas

AUSTRALIA

The Mitchell Library, Sydney Fig 140

AUSTRIA

Graphische Sammlung Albertina, Vienna Figs 107, 136

CANADA

Art Gallery of Ontario, Toronto **43**

DENMARK

The Royal Library, Copenhagen Fig 7

EIRE

National Gallery of Ireland, Dublin Figs 32, 35, 47, 153, **115**

FRANCE

Bibliothèque Nationale, Paris Figs 3, 114
Musée du Louvre, Paris Fig 6
Musée des Beaux-Arts, Tours Fig 4

HOLLAND

Museum Boymans-van Beuningen, Rotterdam Fig 60
The Rijksmuseum, Amsterdam Fig 150

USA

Detroit Institute of Arts Fig 33
Folger Shakespeare Library, Washington Fig 122
Henry E.Huntington Library and Art Gallery, San Marino, California
 Figs 53, 55, 86, 141
Philadelphia Museum of Art **110**

In spite of every effort I have not been able to trace the present owners of
some of the works by Wheatley reproduced, and I would ask them to accept
my apologies for the omission of their names.

Acknowledgment to Photographers

Annan, Glasgow; Chandlers of Exeter; Cliché des Musées, Versailles;
A.C.Cooper Ltd, London; Courtauld Institute of Art, London;
R.B.Fleming & Co Ltd, London; John R.Freeman & Co Ltd, London;
Photographie Giraudon, Paris; Ideal Studio, Edinburgh;
Sydney Newberry, London; Photo Studios Ltd, London;
Tom Scott, Edinburgh; Stearn & Sons, Cambridge;
Donald A.Stevens, Whitchurch

Index

All references are to PAGE NUMBERS, and not to illustration numbers or catalogue numbers.

Titles of pictures and books are printed in *italic*; a page number printed in italic indicates that the picture is reproduced on that page. If the page contains both a reproduction and information about the picture, the page number appears twice, once in roman type and once in italic.

After titles of works by Wheatley, the words 'by Wheatley' have been omitted throughout in the interests of brevity.

Where necessary, titles have been inverted in order to make the main subject-word the first word.

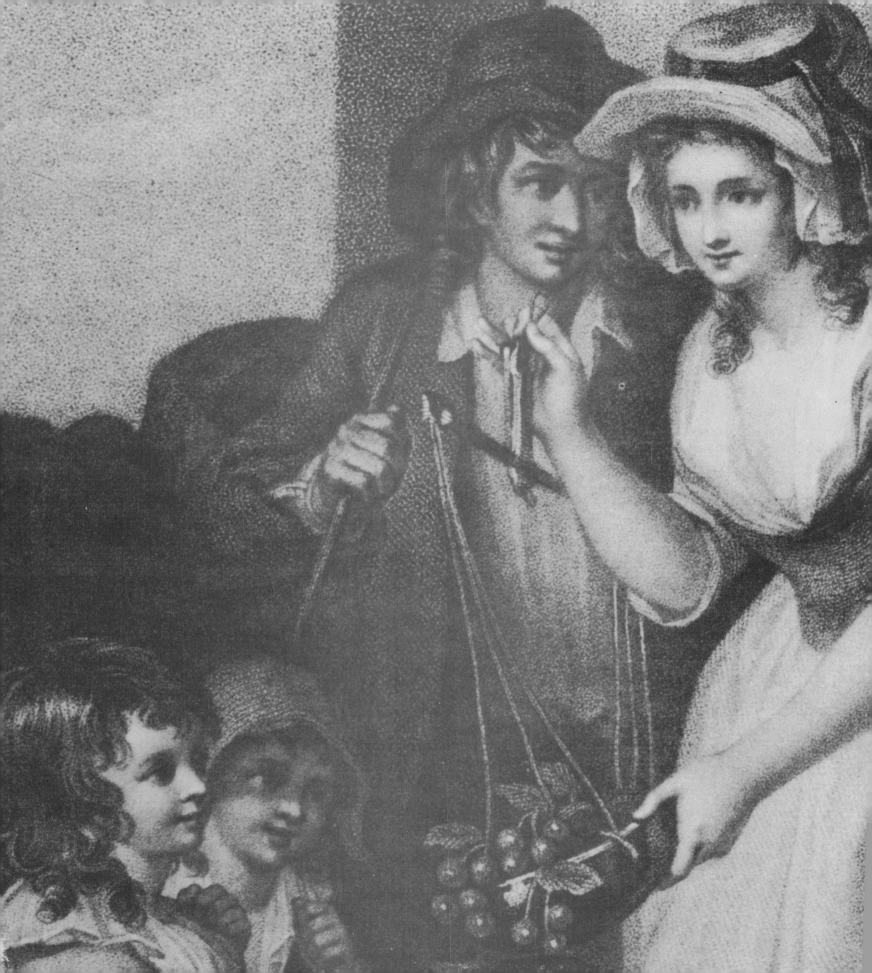